Drawn
to Yellowstone

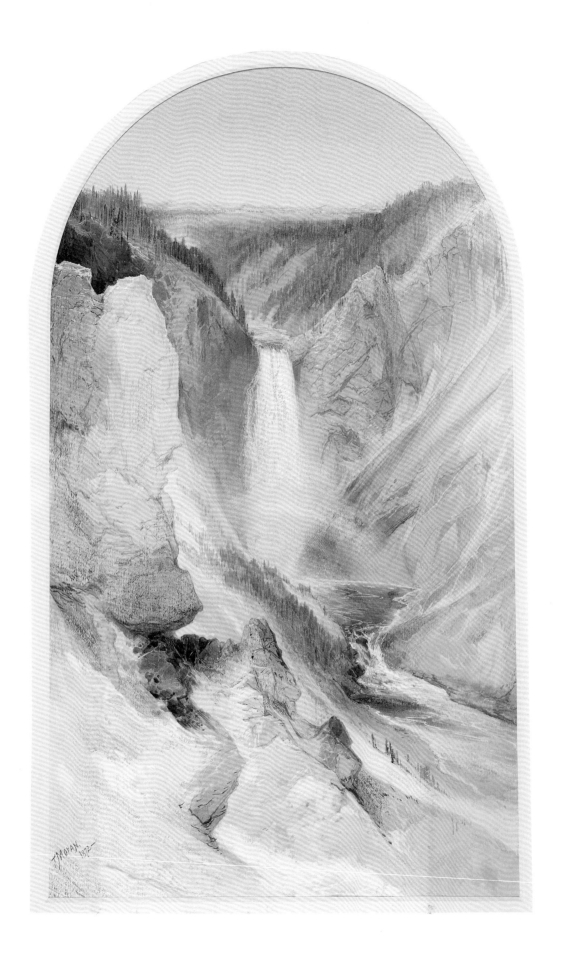

Drawn to Yellowstone

Artists in America's First National Park

PETER H. HASSRICK

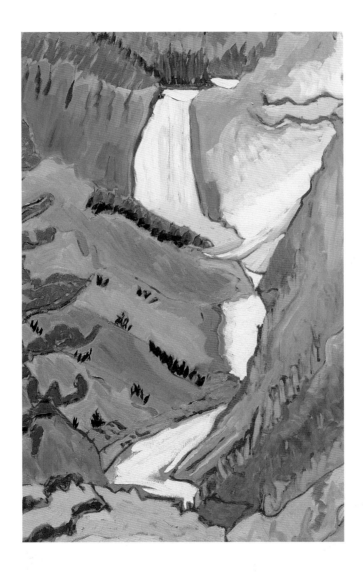

Autry Museum of Western Heritage *Los Angeles*
in association with
University of Washington Press *Seattle and London*

To my grandson, Silas Heyl Hassrick,

and the next generation to enjoy Yellowstone National Park

This publication was made possible in part by a grant from the Joan Paterson Kerr Fund.

Copyright © 2002 Autry Museum of Western Heritage
Printed in Singapore
Designed by Veronica Seyd

Library of Congress Cataloging-in-Publication Data
Hassrick, Peter H.
Drawn to Yellowstone : artists in America's first national park / Peter H. Hassrick.
p. cm.
Includes bibliographical references and index.
ISBN 0-295-98173-3 (alk. paper)
1. Yellowstone National Park—In art. 2. Art, American—West (U.S.)—19th century.
3. Art, American—West (U.S.)—20th century. I. Title.

N8214.5.W4 H38 2002
760'.0443678752—dc21
2001027893

The paper used in this publication meets the minimum requirements of American National Standard for Information Sciences-Permanence of Paper for Printed Library Materials, ANSI Z39.48-1984.

Frontispiece: Thomas Moran (b. England; 1837–1926). *Wyoming Falls, Yellowstone River*, 1872. Pencil and watercolor on paper; 13 x 7 ½ in. 0236.1452. From the Collection of the Gilcrease Museum, Tulsa, OK.

Title page: Alyce Frank (b. 1932). *The Falls at Yellowstone* (detail), 1993. Oil on canvas; 48 x 40 in. From the collection of Edgar E. Coons and Liane Waite.

Contents

Foreword

Peter Hassrick reminds us that the story of art in Yellowstone is a "narrative that speaks to timely and compelling forces; important, because even today through a car window at forty-five miles per hour, Yellowstone is, for most people, first and foremost, a thing to be seen." The compelling natural beauty and eccentricities of Yellowstone have attracted artists, especially painters, since just before establishment of the region as a national park in 1872. But, as Hassrick points out, the park was more than just "a vast and inspiring studio for artists." He helps us to see why the individual perceptions of each artist, contributing as they do to the collective visions of the region, are a worthy "focal point in American pictorial history."

In his numerous studies of art in the West, Hassrick is particularly skillful at providing context and understanding. Along with coauthor Patricia Trenton, he produced *The Rocky Mountains: A Vision for Artists in the Nineteenth Century* (University of Oklahoma Press, 1983), a broad view of regional visions tied to national history and art. Through monographs like *Frederic Remington* and *Charles M. Russell* (Harry N. Abrams, Inc., 1973 and 1989, respectively), he has illuminated the cultural impact of individual artists. In *Treasures of the Old West: Paintings and Sculpture from the Thomas Gilcrease Institute of American History and Art* (Harry N. Abrams, Inc., 1984), Hassrick placed pictorial works of the West within the context of American genre painting.

It is just this sort of interpretation and perspective that makes *Drawn to Yellowstone* a perfect fit for the Autry Museum. It is an ideal study of how a region has been perceived and what that perception has meant to larger issues of culture and art. While the Autry's publications program began modestly in 1990, it has grown to include volumes as diverse as studies of women artists in the West (*Independent Spirits: Women Painters of the American West, 1890–1945*, copublished with the University of California Press, 1995) and views of how the West has been consumed and interpreted visually and internationally (*Western Amerykanski: Polish Poster Art for the Western*, copublished with the University of Washington Press, 1999).

Creation of the present volume would not have been possible without the generous underwriting of key supporters. We would like to acknowledge the Dr. Ezekiel R. and Edna Wattis Dumke Foundation, the Mary A. H. Rumsey Foundation, and Cindy and Alan Horn. Without their faith in and support of both the author and the museum,

this project would not have been possible. Thanks go as well to Pat Soden, Director of the University of Washington Press and to Julidta Tarver, Managing Editor, who enthusiastically embraced the book as soon as they learned of it. We would also like to thank the many collectors, artists, and institutions that have made it possible to reproduce works from their collections in this volume. Finally, the Autry Museum's publications program began with the support of founding and now retired President and CEO Joanne D. Hale, who endorsed publication of *Drawn to Yellowstone*. The project has come to completion with the enthusiastic backing of her successor, Executive Director and CEO John L. Gray. Former Publications Director Suzanne G. Fox really made it all happen—most sincere thanks go to her.

James H. Nottage
Vice President and Chief Curator
Autry Museum of Western Heritage

Preface

I was first drawn to Yellowstone National Park in the spring of 1975. During an airplane flight from Dallas to Seattle, as luck would have it, my wife Buzzy and I were sitting on the right side of the plane when it passed directly over Yellowstone. It was a beautiful, clear day, and we could see the crystalline lake and tiny, cottony puffs of steam rising from the geyser basins below. Such a remarkable sight, such a dazzling invitation. We were hooked. That summer, we packed our two sons and our duffels into the station wagon, just as my family had done some twenty years earlier when I was a boy, and headed for America's flagship park in the northwest corner of Wyoming.

Several important results came of our summer's visit, that is, beyond my welcome and enjoyable reacquaintance with the park and its wonders. Two of them were complementary but antithetical responses. The first was an understandable reaction, an overwhelming feeling invested in me by the sheer power of Yellowstone's presence, its broad sweep of forests and water and the sublime, often mesmerizing natural features that abounded. The second was a corollary, yet rather contradictory, reaction. For the first time in my life, I was not so impressed with the grandeur of an area's scenery as by the inexorable way in which that particular mix of elements engaged people to *see*, to appreciate nature through firsthand *visual* experience. As I came away from the park, on our way down the road toward Cody, I could not help reflecting that my recollections were as much about people responding to nature as they were about nature itself. I had been watching people watch nature and had been profoundly intrigued with their interaction. Yellowstone for me had not been so much about bears or buffalo, lodgepole forests or geysers, crashing cascades or boiling springs; it had been about human curiosity and the collective response to nature as visual stimulus.

When we reached Cody, I had a most felicitous meeting with Peg Coe, chairman of the Buffalo Bill Historical Center's board of directors. As a result of that and subsequent events, I became director of that fine museum, a position I proudly and happily held for more than twenty years. That then was the third result of our swing through Yellowstone in 1975.

During my years in Cody, I began to build on my earlier reactions to Yellowstone. At the museum we constructed a number of artists' studios in an effort to encourage visitors to respond to the process of art as much as to its aesthetic value and subject content. I eventually came to see the park in that light as well—holding forth on

numerous occasions about the fact that Yellowstone was not just a scientific laboratory but also a vast and inspiring studio for artists. Some of America's finest artists had worked in its environs and, given my slant on it as a visual realm, had provided credence to the notion that the park appealed to the visual in fundamental ways.

In 1977 I was honored by an invitation from the park's chief naturalist, Alan Mebane, to join the board of directors of what was then known as the Yellowstone Library and Museum Association (now the Yellowstone Association). It was our job, as a not-for-profit cooperating agency, to help direct financial, intellectual, and moral support to the park's interpretive branch. One of our first tasks involved the rejuvenation of a summer educational program, the Yellowstone Institute. Within a few years, given encouragement from the board and a requisite but modest infusion of monetary support, the institute succeeded beyond all expectations. So substantial was its growth that before long the course offerings included one that I would teach for a couple of years under the title "The Artists of Yellowstone."

As I recall, the classes were reasonably full and the students enthusiastic. We all learned a good deal from the experience. For me, the class affirmed a set of notions I had harbored for some years: that Yellowstone played a unique role in our nation's artistic as well as conservation history; that artists of great import had been drawn into the park's embrace; and that the results of the union between artists and the park formed a chapter of art history deserving to be written. I came to recognize, moreover, that nearly everyone, from the most astute ranger to the most inquisitive visitor, perceived Yellowstone as a field for scientific examination, yet experienced the park as a visual sensation. A book on the subject might enlighten us all about why we see Yellowstone and nature the way we do; why the visual interpretation and pictorial extrapolations form such important patterns for our cultural fabric; and why this has been so for generations. The purpose of this book is to explore these thoughts as well as to pay appropriate tribute to the many artists who, each in her or his unique way, shared their vision of America's first park with us.

In the course of my research on this topic I have uncovered information on many more artists than there is room to include here. This volume, therefore, can only be regarded as a beginning. My effort has been to feature the high points in Yellowstone's artistic heritage. Many aesthetic insights and manifold painters and topographers, sketchers and sculptors, remain to be included as part of either broader publishing endeavors or more targeted research. Among the creative talents who have responded to Yellowstone over the past century or more, but who do not appear in this study, are the photographers. It was not because, as some feel, photographers and their products are empirical and render service to science while the "artists" and their works are ideal and offer a higher form of response. To the contrary, photographers and painters often worked side by side, jointly establishing aesthetic perspectives on the

park and its wonders. Many artists were servants of science; many photographers demonstrated profound dedication to the aesthetic. The photographers are excluded here because their story is a long and complex one that lies outside the confines of this study simply because of the sheer scale of the subject.

So, given the limitations of this work, the story of the visual interpretation of Yellowstone is only partly told here. Perhaps there is enough, though, to open our eyes a bit more to the park as a remarkable focal point in American pictorial history.

Acknowledgments

During my twenty-year tenure as director of the Buffalo Bill Historical Center in Cody, Wyoming (1976–1996), I came to recognize Yellowstone Park as a special place not only for its beauty and natural history, but for its human history and the remarkable cultural presence that the park has enjoyed over the years. In the late 1970s when I became a board member of the Yellowstone Library and Museum Association, I became even more keenly cognizant of the human story in Yellowstone. Through park naturalists and historians, like R. Alan Mebane, John A. Tyers, and Timothy R. Manns, I was introduced to the substantial archival collections of the park and to its interesting and quite significant art collection. The Historical Center also began to collect art related to Yellowstone and I started to make files on various artists who painted and sculpted in that environment. I am indebted to those Park Service employees who first introduced me to the idea of Yellowstone as a place for artists and Yellowstone in artistic views. In particular, I want to thank Gene Ball, who invited me to teach a class on artists in Yellowstone at the Yellowstone Institute. I did that for a couple of summers with help from Beverly Whitman in the Library and the Historical Center's library staff as well. Additional thanks go to Susan Kraft, the Yellowstone Museum's curator, Anne R. Lewellen, and Beth Blacker. Dr. Lee H. Whittlesey, National Park Archivist at Yellowstone, not only provided fundamental insights and historical background on park characters and events, but was kind enough to read my original manuscript and make welcome critical remarks.

This project could not have moved forward without the financial support of the Buffalo Bill Historical Center, which helped me by building an art collection and library resources related to artists and the park. In addition, special thanks go to Charles C. Rumsey, Jr., and the Mary A. H. Rumsey Foundation, as well as Nancy H. Schwanfelder and the Dr. Ezekiel R. and Edna Wattis Dumke Foundation for their generous subsidy of the color reproductions in the book. Joanne D. Hale encouraged the project with support from her institution, the Autry Museum. She and Suzanne Fox spearheaded the project from its earliest phase. I also continue to owe a debt to Dr. Patricia Trenton, with whom I worked two decades ago in writing the book *The Rocky Mountains: A Vision for Artists in the Nineteenth Century*. In that joint effort many of the artists discussed in the present volume first came to light for me.

Many major institutions across the country have provided assistance, opened their

collections for review, and shared their talented staff with me as I worked through the years of tracking and recording artists in the Yellowstone region. I extend my profound thanks to the following institutions and personnel and professional colleagues: the American Museum of Natural History, and in particular Matthew Paulick, Paula Willey, and Joel D. Sweimler; the Amon Carter Museum, Milan R. Hughston, Helen M. Plummer, and Dr. Jane Myers; the Archives of American Art; Autry Museum of Western Heritage, Michael Duchemin, James Nottage, Sandra Odor; the Beinecke Rare Book and Manuscript Library, Yale, Dr. George A. Miles, Bridget Burke; the Brooklyn Museum, Dr. Linda S. Ferber; Buffalo Bill Historical Center, Elizabeth Holmes, Nathan E. Bender, Joanne Patterson, Dr. Sarah Boehme, Theresa Robertson, Al Minnick, Frances Clymer, Dr. Paul Fees; Chesterwood, Paul W. Ivory, Wanda M. Styka; Christie's, Andrew Schoelkoph; the Corcoran Gallery of Art, Marisa Keller, Cindy Rom; Denver Public Library, Western History Department, Eleanor M. Gehres; the Detroit Institute of Arts, James W. Tottis, Nancy Rivard Shaw, Samuel Sachs II; Fisher Gallery, University of Southern California, Jennifer A. Easton; the Gilcrease Museum, Sarah Erwin, Anne Morand; Glenbow Museum, Patricia Ainslie, Jennifer Churchill; Henry Ford Museum & Greenfield Village, Lanette K. Chisnell; Hirschl & Adler Galleries, Inc., Stuart P. Feld, Debra Wieder; Milwaukee Art Museum, Dean Sobel; Minnesota Historical Society, Steve Nielsen, Thomas O'Sullivan; Montana Historical Society, Dr. Robert Achibald, Dr. Brian Cockhill, Susan R. Near, Kirby Lambert, Delores Morrow; Montana State University Special Collections Library, Richard Saunders; Museum of New Mexico, David Turner; Museum of the Rockies, Steve Jackson; National Archives, John A. Dwyer; the National Museum of Wildlife Art, Julianne M. Canali; Nebraska State Historical Society, Karrie L. Dvorak; The Oakland Museum, Arthur Moore, Arthur Monroe; Oregon Historical Society, J.D. Cleaver; Portland Art Museum, Bette Holman, Deborah Royer, Prudence F. Roberts; the Rockwell Museum, Michael Duty; the Saint Louis Art Museum, James D. Burke, Dr. Michael E. Shapiro; Smithsonian American Art Museum, Pat Lynagh, Reference Librarian; Sotheby's, Valerie L. Westcott, Dara Mitchell; the State Historical Society of Colorado, Georgiana Contigulia; the United States Department of Interior, Geological Survey, Carol A. Edwards, M. Diane Brenner, James Keogh, Paula Erickson, Clifford M. Nelson, Anne James; National Park Service, David Nathanson; University of Wyoming, Coe Library, Jean S. Johnson; the Utah Museum of Fine Arts, Allison Shiba, Thomas V. Southam; the White House, Donna A. Hayashi, Betty C. Monkman, Anne Dettre; Wyoming State Museum and Archives, Cindy L. Brown, Terry Kreuzer, Dominique Schultes, Paula West Chavoya; the Yellowstone Association, Patricia Cole.

In addition to those mentioned above, a host of individuals have been helpful in this project. Some of them are fellow art historians, and others are artists or descendents of artists. I would like to gratefully acknowledge their contributions and offer my sincere thanks to Dr. Nancy K. Anderson of the National Gallery of Art, Gary

Arnold of the Ohio Historical Society, Bruce C. Bachman of the R. H. Love Galleries, Inc., Lynn Bama, Dr. Richard A. Bartlett, Mrs. John M. Brenner, Judith Bushnell of the Geneseo College Libraries, H. Russell Butler, Jr., D. Harold Byrd, Jr., Priscilla Vail Caldwell of James Graham & Sons, Ismail Hakki Celayir of the Dolmabahce Palace, Istanbul, Phimister P. Church, Dr. Carol Clark of Amherst College, John Claybaugh, Donna Climenhage of the Charles Hosmer Morse Museum of American Art, the late Doris Clymer, Dr. Rena N. Coen, Michael Coleman, Michael Conforti, Jack and Susan Davis of Olde American Antiques, Elizabeth A. Dear of the C. M. Russell Museum, Roderick Dew of the Colorado Springs Fine Arts Center, Dorothy Dines, Dr. Brian Dippie, Carl H. Droppers, Bob Drummond, Joseph M. Erdelac, Elizabeth Farley, John B. Fery, Ron Fields of the University of Puget Sound, Nora Fisher, Michael Frost of J. N. Bartfield Galleries, Patricia A. Fuller, Sue Simpson Gallagher, Dr. Ulrike Gauss of the Graphische Sammlung, Stuttgart, Mary Anne Goley, Dr. Frank Goodyear, Aubrey L. Haines, Dr. H. Duane Hampton of the University of Montana, Jonathan Harding of the Century Association, Susan H. Haskell of the Peabody Museum, Harvard University, William P. Healey, Don Hedgpeth, Carl N. Hensel, Sir Simon Hornby, David C. Hunt, Dr. Joel C. Janetski of Brigham Young University, Frank G. Jewett III, Patricia Johnston, Dr. Sona Johnston of the Baltimore Museum of Art, William R. Johnston of Walters Art Gallery, Sharon Kahin, Dr. Donald Keyes of the Georgia Museum of Art, Mrs. Eugene Kingman, Marty Kruzich of the Martin-Harris Gallery, Richard Lampert of the Zaplin Lampert Gallery, William Lang of the Free Library of Philadelphia, Dean Larson (personal library in Provo), Christi Lee, Cheryl Liebold of the Pennsylvania Academy of the Fine Arts, Bill McKenzie, John McKirahan, Karen Merritt, Ronald Michael of the Birger Sandzén Memorial Gallery, Thomas Minckler, Philip F. Mooney of the Coca-Cola Company, Robert F. Morgan, Ruth F. Oliver, Vivian Paladin, William S. Paxson, Dr. Lisa N. Peters, Arthur J. Phelan, Jr., Robert S. Pirie, Trev and Ellie Povah, Frederic G. and Ginger Renner, Carole Reynolds, Dr. Alfred Runte, Jennifer Saville of the Honolulu Academy of Arts, Dr. Carlos A. Schwantes of the University of Idaho, Colin Shimpton of Alnwick Castle, England, Ruth Smith, Carol Spaulding of Deep Creek Productions, Allen and Marilyn Splete, Dr. Michael Stemff of the Stattliche Graphische Sammlung, Munich, Amy Batson Strange, Will Thompson of the Telluride Gallery of Fine Art, Thurlow E. Tibbs, Jr., William H. Truettner of the Smithsonian American Art Museum, Betty Wallace, Barbara B. Webster of the Cleveland Museum of Natural History, Melissa Webster, John Whyte, Frances J. Woodworth of the Red Oak Public Library, Gerold M. Wunderlich, Richard T. York of the Richard York Gallery, Anne Young, Stephen Zimmer of the Philmont Museum.

Peter H. Hassrick
Founding Director Emeritus
Charles M. Russell Center, University of Oklahoma

Drawn
to Yellowstone

Artists in America's First National Park

I have wandered over a good part of the Territories and have seen much of the varied scenery of the Far West, but that of the Yellowstone retains its hold upon my imagination with a vividness as of yesterday. . . . The impression then made upon me by the stupendous & remarkable manifestation of nature's forces will remain with me as long as memory lasts.

Thomas Moran

Yellowstone National Park is neither the first nor even a particularly rare example of America's natural marvels to have served as studio and subject for artists over the past two centuries. Virginia's Natural Bridge, the Catskills along the Hudson, Niagara Falls, and once-remote Yosemite Valley joined a host of other features of the national landscape to command attention from painters and sketchers by the mid-1800s. In subsequent decades, various cadres of artists commandeered whole regions, especially in the West, to explore and exploit their pictorial richness. Thus one group of late-nineteenth-century landscape painters was dubbed, if rather inappropriately, the Rocky Mountain School, and others laid claim to the Grand Canyon, the Teton Range, and Glacier National Park. At one point in the 1880s, Yosemite housed an artist, Thomas Hill, who established an elaborate studio at Wawona, the gateway to what was soon to become a national park, and another, Charles Dorman Robinson, who maintained a summer residence and studio in the valley itself. These two were, of course, complemented by countless other painters of a more transitory variety.

Despite lofty exhortations to the contrary, Yellowstone's scenery, when compared with other splendors of the Rocky Mountain West, ranks as somewhat subdued—remarkable as much for its repertoire of marvelous eccentricities as for its dramatic scope. But in the long history of America's search for national identity and artistic satiation in such places of natural wonder, Yellowstone has played an extraordinarily important and beneficial role. For it was this remote corner of Wyoming Territory, with the universal appeal of its countenance, that became a unique symbol of wildness and beauty in American culture. It was from this region that flowed, like the waters pulsing from its geysers, an artistic energy that at once captivated a nation and contributed to its philosophical and aesthetic history.

From the first Anglo accounts of the area, Yellowstone has been presented and

understood as a visual experience. Its very name, of course, is a combination of art and science—a primary color appended to a geological phenomenon. And it was to those elements that the initial visitors responded. Daniel T. Potts, a young trapper who in the mid-1820s passed through what is today the park, penned the first written description of the area to be published. In a letter to his brother Robert, which appeared in *Niles Register* in 1827, Potts recounted his impressions.

> The Yellow Stone [River] has a large fresh water lake near its head on the very top of the mountain, which is about one hundred by forty miles in diameter, and as clear as crystal. On the south border of this lake is a number of hot and boiling springs, some of water and others of most beautiful fine clay . . . of a white and a pink color.[1]

From that simple recollection by a mountain man, generations have embellished on the visual impact of the park's scenery. "Everything in 'Yellowstone' seems on a scale out of proportion to ordinary experience and conventional habits of thought," observed a writer for *Scribner's Monthly* in 1872, shortly after the park was established.[2]

Hyperbole became universal idiom. One of its first explorers and chroniclers, Nathaniel P. Langford, rhapsodized about the Lower Falls of the Yellowstone in 1870 as if he were describing an epiphany. "It must be seen to be felt," he said of the dizzying scene. It would bring a viewer to his knees, though eventually one would rise from a "prostrate condition and thank God that he had [been] permitted to gaze, unharmed, upon this majestic display of natural architecture." "A grander scene . . . was never witnessed by mortal eyes."[3] Such exclamations served as a tonic for a nation that had recently rended itself asunder and was searching for symbols of national unity and salves for the collective conscience.

The New York painter and sculptor of western life Frederic Remington visited there on several occasions. On his first tour in 1893 he responded to the "gorgeous color" of the Lower Geyser Basin with enthusiasm slightly less ecstatic than Langford's, yet claimed he had never in his life "seen nature so generous in this respect." And John Muir, America's champion of wilderness ideals and a visitor to Yellowstone in 1885, would wax eloquent about nature's boundless graciousness. "Like a generous host," he wrote, "she offers here brimming cups of endless variety, served in a grand hall, the sky its ceiling, the mountains its walls, decorated with glorious paintings and enlivened with bands of music ever playing."[4]

Not every artist in America cared to accept this invitation from nature's host. Some demurred because the challenge loomed too great, either the subject or its distance from their home studios proving insurmountable, and some like landscapist Sydney Lawrence were simply not interested. He declined an offer from the Northern Pacific Railroad on the premise that he "couldn't paint smells."[5] Many were no doubt

intimidated by the writers who in great profusion professed that neither pen nor brush could ever come close to recording such splendor as Yellowstone afforded. Such declarations provided a common disclaimer for those who at least tried to render the park's likeness in word or paint.

What is surprising, though, is how many artists, from varied backgrounds and experiences and with diverse motivations and results, did come to Yellowstone to try their hand. To those artists, America owes gratitude for the artistic legacy that has developed. For it is those artists who, through their collective oeuvre, corroborate the spirit of the political act that created Yellowstone as the world's first national park. In that creation, the American nation, for the first time in its history, made a major policy decision based in part at least on aesthetic as much as on practical political, economic, or strategic considerations. Congress set aside the park as worthy of preservation because of its remarkable geothermal features, the geysers, but also on account of its special beauty and engaging visual spectacle. Many of the decisions in subsequent park history have been predicated on the principle of preserving its visual splendor. The artistic history of the park thus provides the underlying, though usually unrecognized, foundation as well as the obvious illustrations for a compelling story that spans five generations.

The legislation that established Yellowstone National Park in the spring of 1872 called quite simply for "a public park or pleasuring ground for the benefit and enjoyment of the people" and sufficient regulations to preserve from "injury or spoliation" any and all of its "natural curiosities, or wonders."[6] Modern historians point out that the park was preserved primarily as a means of "proving up" the West and making it attractive to future tourists and settlers. It was also important that the area be retained in its natural, unadulterated condition and that its scenic integrity be maintained to inspire cultural nationalism. The American public was by that date somewhat conditioned to expect that, as part of their Jeffersonian pursuit of happiness, they had the right to unfettered contemplation of nature. Romantic idealism, combined with a call for enhanced quality of life and a common patriotic desire to keep up with or, if possible, best Europe as a cultural exemplar, helped to account for this move to create and preserve America's scenic places. In cities, parks were springing up to satisfy this demand. The January 1871 issue of *Scribner's Monthly* applauded the trend in a feature on Philadelphia's recently upgraded Fairmont Park. The public relished the idea of having nature constructed for their enjoyment—their experience shaped by pre-planned prospects and contemplation points to help direct their gaze and enhance their reaction (fig. 1). "In all of the leading cities during the past decade new parks have been opened. . . . In Central Park, New York, art and nature in league have formed one of the most important works of the kind in the world."[7]

Unlike New York, Boston, or Philadelphia, art and nature were already in league

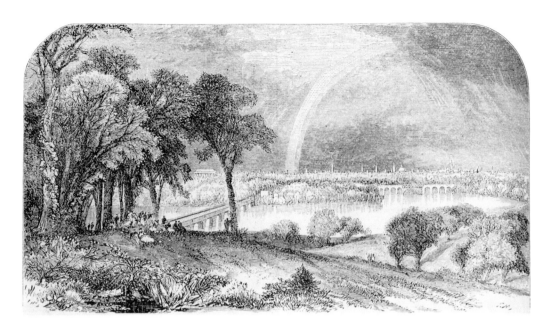

Fig. 1. Thomas Moran (b. England; 1837–1926). *View [of Fairmont Park] from Judge Peters's Farm*, 1871. *Scribner's Monthly*, January 1871. Wood engraving; 2³/₄ x 5 in. AP2 C4. Reproduced by permission of the Huntington Library, San Marino, CA.

in full measure in Yellowstone. It contained, according to the park's strongest congressional advocate, Representative Henry L. Dawes of Massachusetts, "the most sublime scenery in the United States except the Yosemite valley."[8] No embellishments, no modifications were necessary—just the will to set it aside and preserve and protect it. The last mandate became the larger challenge by far. Beauty, to be properly consecrated, must be unadulterated. It was a principle repeated over and over by America's leading exponent of value in natural parks, Frederick Law Olmsted,[9] but it was hard for the public to resist picking and scratching Yellowstone to pieces, as seen in the *Scribner's Monthly* illustration of 1871, *Getting a Specimen* (fig. 2).

Through years of park management, the authorities, be they civilian superintendents, the army, or the Park Service, have worked to save Yellowstone's picturesque elements from desecration. Captain George S. Anderson, the park's third and most effective military superintendent, wrote in 1897 regarding the priorities of his oversight. The first was the "protection of the beauties and wonders of the park from destruction by tourists and sight-seers."[10] That he and others have, for the most part, succeeded in this vexing task has been recognized as a national victory of monumental proportions. The novelist and historian Emerson Hough praised the effort in "An Appreciation of Yellowstone National Park," published in 1926, when he recognized the park as "the noblest sweep of unspoiled and yet fully accessible mountain coun-

Fig. 2. Unknown artist. *Getting a Specimen*, 1871.
Scribner's Monthly, May 1871. Wood engraving; 2⅝ x 3½ in. AP2 C4.
Reproduced by permission of the Huntington Library, San Marino, CA.

try to be found within and without our National Park limits." Furthermore, he sermonized, "Thank God, you Americans, that Yellowstone is now [more than fifty years after its founding] and ever shall be—your own! Thank God that there you still can see a part of the Old West—your own West—as it was in the Beginning!"[11]

Given Yellowstone's public accessibility, its acknowledged aesthetic characteristics like sublimity and picturesqueness, and its exotic appeal as a place apart from civilization, the park was from the beginning ripe fruit for artistic pickings. It did not quite equal what the painter George Catlin had called for in 1841, when he futilely beseeched Americans to reserve the whole of the great western plains and Rockies as "a *Nation's Park* containing man and beast in all the wild and freshness of their nature's beauty."[12] But it provided a remarkable artistic asset. Here nature had colored and sculpted itself so that artists of another medium, painters primarily, could render it in two dimensions. By the sounds of some observers, it lay ready for the copyist, the palette preset and the accessories in place. "All that I can say," recounted Rudyard Kipling after his 1889 visit to Yellowstone's Grand Canyon, "is that . . . I looked into a gulf 1,700 feet deep, with eagles and fish-hawks circling far below. And the sides of that gulf were one wild welter of color—crimson, emerald, cobalt, ochre, umber, honey splashed with port wine, snow white, vermilion, lemon, and silver-grey in wide washes."[13]

Even so, most visitors to the park questioned whether the scenery could be adequately pictured. Kipling, following his eloquent description of the canyon, stated that

"neither pen nor brush could ever portray its splendours adequately."[14] Yellowstone Falls, the Golden Gate, and many of its other wonders invited the same disclaimer. William O. Owen, who took the first bicycle tour of the park in 1883, commented on the falls: "Confined as it is by vertical walls of rock, and secluded by somber forests of pine, it forms a picture that . . . the most skillful artists could not hope to reproduce."[15] Artists in particular were intimidated. In 1893 Frederic Remington said of the Golden Gate, "It is one of those marvelous vistas of mountain scenery utterly beyond the pen or brush of any man. Paint cannot touch it, and words are wasted."[16]

Despite these reservations, artists did try and did succeed in varying degrees to capture the essence of even the most spectacular of Yellowstone's views and the most ephemeral of her splendors. That so many made the effort may speak to the relative ease with which the park was reached. Even in the earliest years of its history, railroads spanned most of the route to Yellowstone. By the time of its founding as a park, the Union Pacific rolled through southern Wyoming, and within another decade the Northern Pacific laid tracks to the north. By comparison with the efforts required of western artists during the first three-quarters of the nineteenth century, the paths to the park proved smooth. While most who ventured there probably did not know the difference and considered Yellowstone's wilderness experience rather daunting under any circumstances, a few did. Before his first park visit, the grand-manner landscape painter Albert Bierstadt ventured to Wyoming's Wind River Mountains in 1859, riding most of the way on a horse and in a surveyor's wagon. Four years later, he endured a bouncing stagecoach journey to California in order to see and paint Yosemite. By comparison, his 1881 trek to Yellowstone, mostly by train, was a luxury package.

Despite the difficulties, artists were drawn by the lure of landscape. Whether painting Yosemite or Yellowstone, Colorado's Mount of the Holy Cross or Arizona's Grand Canyon, they were exercising a grand cultural imperative, even as they were being compensated by the railroads. They were pictorially discovering and, if lucky, publicly presenting new and convincing evidence of what they perceived as America's national superiority, gathered in bountiful harvest from her extraordinarily rich store of western scenery. Of course, a few iconoclasts were heard, like a writer who only offered his initials P. F. Jr. for an 1870 article on western travel, in which he argued that the Rockies and the Sierras could not come close to standing up to the Swiss Alps. In Colorado, he contended, "Let it be candidly confessed that we lose in the scenery's grandeur and beauty . . . the awful majesty and sublimity of the Alps are wanting."[17] But for the most part, the Rockies had everything needed to measure up to or better European scenery. For antiquity, Pikes Peak would suffice, as it "like an old castle 'majestic, though in ruin,' lies dim and dreamy against the sky." To compete with continental royalty, a view of the Snowy Range would induce the response that "Nature spreads before us such a panorama as never feasted the eye of monarch in his palace."

And if divine confirmation were required, one gaze from Yosemite's Inspiration Point would strike a national chord.

> No Swiss mountain view carries such majestic sweep of distance, such sublime combination of hight [*sic*] and breadth and depth; such uplifting into the presence of God; such dwarfing of the mortal sense, such welcome to the immortal thought. It was not beauty, it was sublimity; it was not power, nor order, nor color, it was majesty; it was not a part, it was the whole; it was not man but God, that was about, before, in us.[18]

In the decades prior to Yellowstone's formal discovery and ascendancy to national park status, artists had worked beside writers and photographers to portray the West, its scenery and its people, in iconic dimensions. The railroads made it easy, at least for a certain affluent segment of the population, to get there and were praised openly for their service to humanity and art. "Builders of Pacific Railroads receive a golden shower," wrote one western promoter in 1871. "Shall they go athirst who open new thoroughfares to enjoyment and culture, and bring back treasures of beauty for all of us?"[19] But as a result of the artists, the publicists, and the railroads, there developed a paradox that would forever haunt the West, and Yellowstone in particular. With celebrity came people to enjoy it, and their presence and sheer numbers would compromise the very nature of the preserved reaches, the perceived wilderness and the scenery that made the region inviting. General Nelson A. Miles, who toured the park in 1878 and again in 1892, found on his second visit "a railroad, hotels, stagecoaches and other evidences of civilization, but less of the ideal picture of nature."[20]

In a real sense, Yellowstone is man-made. It is contained at and for our human pleasure and has been spectacularized by and for human appetites and consumption. Its animal populations rise or fall in number and variety in accordance with the vicissitudes of scientific and political opinion. And the scenic wonders are rather packaged and predisposed by accessible, predefined vantage points. This anthropocentric arcadia and the paradox of its existence would seem to vitiate its appeal and diminish its significance. Yet Yellowstone National Park remains perhaps the world's finest experiment in effecting a benevolent interaction between nature and culture. And it is that interaction that is mirrored in Yellowstone's art.

The park came about for myriad interesting reasons, some enlightened even by modern standards, based in nineteenth-century Romantic ideals, and others nearly repugnant to today's mind, given the overt mercenary and entrepreneurial zeal with which they took shape. When Congress established the park, it justified its action on the premise that by doing so "no harm" would come "to the material interests of the people."[21] As one scholar, Lisa Strong, has pointed out, "It was not America's desire to preserve nature that resulted in Yellowstone's establishment as a park, but its need

to make the best use of land which was unfit for farming."[22] And it was not so much how the region was exploited as by whom. Environmental historian Roderick Nash has contended that nowhere in congressional deliberations did "the rationale for action take account of the aesthetic, spiritual, or cultural values of wilderness which had previously stimulated appreciation," but rather there was simply a desire to "prevent private acquisition and exploitation of geysers, hot springs, waterfalls and similar curiosities."[23] To a degree this posture was understandable, given the disastrous consequences that private commercialization had historically wrought on other scenic wonders, namely Niagara Falls. The railroads recognized the park as a mid-continent tourist bonanza. They and countless unknown enterprising sorts would, without government intervention, devastate the park's assets, both physical and spiritual.[24]

Other practical considerations included the call for Yellowstone National Park to serve as a sanctuary for endangered animals. One naturalist dreamed in 1874 that the park might provide a home where the bison could escape extinction, for example.[25] Animals, like the natural features, however, were to be protected from "wanton destruction" and exploitation for commercial purposes, but not from being hunted for food and sport by early tourists.[26] In fact, it was not until the Lacey Act, twenty years later, that sport hunting came to a real close in the park.

Perceptions of the scientific value of the park ranged widely. Ferdinand Vandeveer Hayden, who guided the first U.S. Geological Survey expedition there, was only one of many who acknowledged the area's worth as a mecca for the study of geology. "I venture to say that nowhere in our country, not even in the truly wonderful cañon of the Colorado, is so much geological history crowded into such narrow limits," observed Hayden's contemporary Theodore Comstock in *The American Naturalist* in 1874. Beyond that, "in nearly every department of science . . . the earnest student of nature will always find an abundance of fresh matter for research."[27] Even *Picturesque America*, the quintessential exponent of the aesthetic response to nature, saw merit in the park as a health spa and medical facility with its "hot springs for bathing invalids."[28] Certainly, many viewed it as a healthful antithesis to urban industrial life in the East.

There existed a host of less tangible benefits to having a national park. One of the most pervasive played on the old theme of jingoist one-upmanship. General John Gibbon, who took a military tour of Yellowstone in the late summer of 1872, provided an exemplary early testimonial on that score. After enumerating the superior virtues of everything from American soil to American women, as well as the largest army and the best revolvers and the finest government, he concluded: "And now, to cap the climax and the continent, have we not the greatest National Park on the face of God's earth, filled with every beauty which the eye of humanity delights to rest upon . . . ?"[29] That superlative scenery, combined with the fact that it was theoretically available for

all to see, proved for many a defining affirmation of the democratic process. What had been claimed with Yosemite was even more strongly touted about Yellowstone—that America had at least one unique and superior thing above other nations, and that was its scenery. It was God's gift, and the country and its people were commensurately sanctified as the recipient.

One of the least tangible rationales for establishing Yellowstone as a national park proved also to be one of the most compelling—its aesthetic significance. Visitors consistently attested to its sheer beauty as a place, with and without the layer of patriotic fervor. Visual ecstasies abounded. There was something for every taste and pictorial predisposition. Certainly one did not have to be an artist to discover that some of the most rewarding experiences there were visual. One did not have to be a painter to craft vivid, emotionally engaging, and lasting images.

The naturalist John Burroughs visited Yellowstone in 1903. His most enduring pictorial recollections were of a celestial place. Of Mammoth Hot Springs he recalled a "vision of jasper walls, and of amethyst battlements." From above they "looked marvelously clear, cerulean, but boiling, pools . . . the water seemed as unearthly in its beauty and purity as the gigantic sculpturing that held it."[30] Conversely, many others regarded it as otherworldly in the opposite extreme. To them the features resembled something out of Dante's *Inferno*. These, and every other individual reaction, had their personal variations. It seemed to fulfill the two polar expectations of wilderness that flourished in the nineteenth century—that of the wilds as a heavenly domain and that of the wilds as the province of hell.[31] In the larger scheme of things, however, it was the general principle of setting aside for enjoyment and preservation a pictorial treasure house like Yellowstone that portended significant things for the future. "It will help," wrote one hopeful citizen in 1872, to "confirm the national possession of the Yosemite and may in time lead us to rescue Niagara from its present degrading surroundings."[32]

It was, of course, the artists (and a cadre of photographers who are beyond the scope of this study) who responded most vigorously to the aesthetic underpinnings of the park. In so doing they provided a fundamental and often overlooked service. If one of the prime motivations behind the park was public enjoyment, the artists played a vital secondary role. Though perceived as a grand democratic gesture, the park throughout much of its history was physically available to only a prosperous few, since the economics of travel put Yellowstone beyond the reach of a great many Americans. The art found wide public dissemination and proved to be a far more effective manner of communicating the scenic wonders of Yellowstone than the written word. It thus made the park accessible and allowed for a vicarious taste of Yellowstone's array of natural splendors. Whether in grand halls at world's fairs or on calendars at the corner barbershop, the pictorial message got out.

In 1886 *The Northwest*, a publicity organ for the Northern Pacific Railroad, published a piece on the "Wonders of Yellowstone Park." In it the author recounted a recent trip there, observing that nature had been "bent upon producing a masterpiece." There are "some wonders," he wrote, "some beauties of nature which cannot be conveyed to the mind except through the medium of that most blessed of gifts to man, the sense of sight."[33] It would be up to artists to provide the experience when firsthand visits were not possible. Thus the democratic experiment was at least partially fulfilled through their efforts.

The same writer also made what was a common observation regarding the sacred character of the place. Standing before the canyon, he was emotionally transfixed by the experience. "I can conceive of no spot where one is so strongly imbued with the idea of Divinity as at that grand canyon."[34] Eons were spread before him, sublime spectacle and grand beauty as well. His was a logical reaction. It was for him, as for many, cathartic. Through the nineteenth century, as America became increasingly industrialized and its society and cultural conventions more and more secularized, people felt they needed a sacred place like this. Writers of an earlier generation, in discussing the mountain men's adventures on the upper Yellowstone River, had termed the region a "perfect Elysium."[35] Others would associate it with biblical allusions to Eden. It was paradise, it was inspiriting, and Americans felt then, as surely they do today, that they deserved to have a few heaven-on-earth corners of their world within reach. If travel proved impossible, artists would supply the requisite substitute.

The notion of an Edenic garden is, of course, a complex one, with at least a couple of meanings and equally as many applications to the Yellowstone experience. The standard Euro-American conception revolves around the metaphor of cornucopia: a region like the park that is a reservoir of natural resources to be exploited or cultivated. It is a utilitarian ideal and one that has influenced and plagued Yellowstone over the years. Although no one could farm or mine the wonderland, there was still much to harvest, especially tourist dollars. There is a second interpretation of the garden that also applies—an Emersonian version that sees the garden as wilderness, a sacred space to be reverently treated and spiritually embraced. It involves an intuitive response as opposed to a practical one. It too has influenced park history in a fundamental way and, by virtue of its ascendance at the public's insistence, has ultimately prevailed. Many, like the preservationist John Muir and to some degree Stephen Mather, the first National Park Service director, dedicated their lives to seeing the latter mode succeed. Artists too, though often servants to commercial interests like concessionaires and the railroads, have helped to preserve the idea and the ideal of Yellowstone as a sacred place.[36]

Long before Yellowstone became central to the American debate about the relative importance of wilderness and beauty versus what John Muir referred to as its

antithesis, "human use," Thomas Cole, the father of the Hudson River school painters, had defined wilderness as an essential symbol of the American character. Artists had the responsibility to study the untrammeled wilds and reveal through their works fundamental clues to the nature of mankind. Sometimes the artists exposed a transparently venal association, as was suggested by art critic S. G. W. Benjamin in 1882:

> Never before has there been a nobler opportunity afforded the artist to aid in the growth of his native land and to feel that, while ministering to his own love of the sublime and the beautiful, he was at the same time a teacher and a coworker with the man of science, and the soldier, who cleared, surveyed and held this mighty continent.[37]

At other times they were overt in their support of the industrial tide, as seen in paintings and drawings celebrating the technological harnessing of nature's wonders, as with images of the dam in California's Hetch Hetchy Valley. But mostly they sought a redemptive angle, presenting grand landscape spectacles,with which Yellowstone was replete, often peopled with human figures to suggest a symbiosis between man and the wilderness and "the possibility of mutual comprehension between place and person."[38] These themes, with the latter appearing to command the largest public sway, worked their way into generations of artworks—paintings, sculptures, drawings, lithographs, book and magazine illustrations, engravings and photographs. Together they helped to convince a nation to establish such a park and to guide and enlighten its populace toward its proper continuance and appreciation.[39]

Brushes with Discovery

The area that is now Yellowstone National Park served as home and hunting ground for Native Americans over several centuries prior to its "discovery" by Anglos in the early nineteenth century. The Indians' reaction to the region and its unique geology was as variant as individual responses could possibly be. In recent years, scholars have especially debated what Indians thought of the geysers. In brief, the most recent conclusions state that Indians, especially the Shoshone, Crow, Blackfeet, and Sheepeaters, used the park actively for hunting purposes. They camped near the geysers, according to archaeological findings, and were not, contrary to earlier speculation, particularly repulsed by the geological activity.[1]

From the perspective of this study, however, the area seems to have had little impact on their creative energies. One Crow account states that women collected a white substance from around the geysers and used it to whiten deer hides during tanning.[2] However, scholars have found no artistic records such as winter counts (pictographic calendars) to suggest that Yellowstone or events in tribal histories related to the region became part of their cultural legacies.

Nearly half a century passed between the time the first accounts of Euro-American explorers were heard and the first known artists arrived in Yellowstone. In that time, a number of artists came close in intention, if not physical presence. These are worthy of brief mention.

Stephen H. Long's 1819–1820 exploration of the Colorado Rockies was originally conceived by Secretary of War John C. Calhoun as the "Yellowstone Expedition." The expedition's intended path led along the Missouri River to its junction with the Yellowstone and then up to, and possibly into, the Rocky Mountains. Had the original plan not been changed at the last minute, sending the troop up the Platte River rather than the Yellowstone, Long might have actually reached the area of today's park. A landscape painter, Samuel Seymour, and a naturalist-artist, Titian Ramsay Peale, accompanied Long's forces. They could have been the first artists to record Yellowstone's wonders.[3]

Among the fables passed down in literature over time was one apocryphal account incorrectly attributed to mountain man Jim Bridger and incorrectly located at Obsidian Cliff in the park. It is a curious tale of images nonetheless. The story, adapted to the park by one of its superintendents, P. W. Norris, recounts that Bridger

was hunting elk one day in Yellowstone. He saw a particularly big bull and, leveling his sights on it, pulled the trigger and waited for his prey to fall. But nothing happened. The bull continued to graze peacefully in front of him. So, Bridger reloaded and repeated his previous actions. Once again, the bull was unfazed. The hunter, "exasperated," took his rifle by the barrel and rushed at the animal. With that, he "crashed into an immovable wall, which proved to be a mountain of transparent glass." It even turned out that the glass acted as a lens, and the elk was really twenty-five miles away. Thus was composed one of the early illusionary pictures of Yellowstone's wildlife and nature's preservation of animals there, protecting them from man's exploitation.[4] Bridger's other stories, such as his account of "the place where hell bubbled up," the steam heated by friction, and his well-known petrification tale, are equally illusionary. They paint in words a picture of engaging fantasy.[5]

Equally illusionary was an account that back in the 1830s artist George Catlin had "picked out the Yellowstone region for a park." This theory was touted by Dr. William J. Youmans in his book *Pioneers of Science in America* (1896) and further corroborated by the secretary of the Smithsonian Institution, Professor Joseph Henry, who wrote in 1871 that "George Catlin made a proposition to the Government in 1832 to reserve the country around these geysers as public park."[6] Catlin erroneously claimed to have visited the Rocky Mountains in 1833 and had, indeed, stood the year before at the mouth of the Yellowstone River. He called for Congress to set aside the whole trans-Mississippi West for a national park but had neither visited the park area nor singled out the Yellowstone region as a reserve. So, while an artist may have offered one of the first formal propositions of the park idea, Catlin was not a champion of Yellowstone per se.

A few years later, in the spring of 1837, a rather rowdy brigade of American Fur Company trappers moved into the Yellowstone Park area in search of beaver pelts. Theirs was an inexorable pursuit, to collect as large a bounty of furs as possible to trade at the Green River rendezvous that summer. It turns out that they found more Blackfeet than beaver, the former being distinctly more aggressive and resistant to their presence than the latter. In the course of multiple engagements with the Indians, one of the trappers, Joseph Meek, had a particularly epic encounter. It took place in or near the north end of the park and became so celebrated in American frontier annals that at least one major artist of the period, the New Jersey genre and history painter William Tylee Ranney (1813–1857), immortalized it in a couple of extremely popular canvases. In 1850 Ranney exhibited *The Trapper's Last Shot*—one version in New York's American Art-Union and another in Cincinnati's Western Art-Union.[7] An engraving (plate 1) was then issued, followed shortly by a lithograph published and distributed by Currier & Ives.

The painting depicted Meek's drama at the high point of the final battle. He and

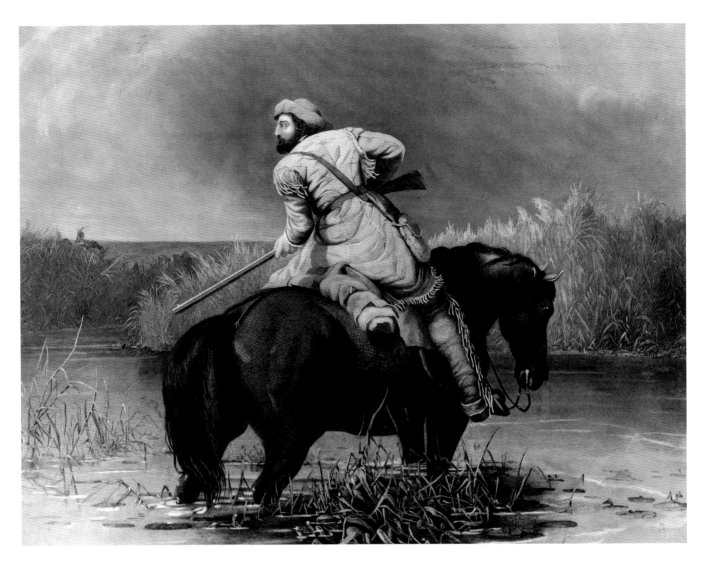

Pl. 1. After William Tylee Ranney (1813–1857). *The Trapper's Last Shot*, 1850.
Engraving; 17³/₄ x 23⁵/₈ in. 1963.002.1449–D. Courtesy of the Bancroft Library,
University of California, Berkeley.

his cohorts had been feuding with the Blackfeet all the previous winter. This was the
showdown, a skirmish that provided the perfect theatrical tableau around which Ran-
ney could construct his powerful image. Later accounts described the scene as Meek
turning "upon his horse, a fine and spirited animal, to discharge his last shot at an
Indian pursuing."[8] In Ranney's hands it took on mythic proportions—the humble pro-
fession of pelt hunting elevated to the stature of heroic endeavor.

Ranney had experienced the West in the mid-1830s when he went to Texas to take
part in the rebellion against Mexico. He may have met trappers at that time and, encour-
aged by the hype surrounding the Mexican War a decade later, he chose to adopt pop-

ular western themes such as Meek's adventure. Following the success of his painting *The Trapper's Last Shot*, he produced a half dozen other related, though less heroic, canvases, culminating in 1854 with a full-length equestrian portrait of the most celebrated of all mountain men and guides, Kit Carson.[9]

Other artists depicted the scene of Meek in distress in subsequent years. The highly acclaimed painter of western Indian portraits and lifeways John Mix Stanley (1814–1872) completed two works in 1851 interpreting Meek's scrap with the Blackfeet. Titled *Flight of a Mountain Trapper* and *The Trapper's Escape*, they were incorporated in his renowned gallery of *North American Indians*, then exhibited in the Smithsonian Institution.[10] Unfortunately, no images of the paintings remain, and the canvases themselves are thought to have been destroyed in the Smithsonian's fire of 1865.

Meek never met Ranney, though he did later know Stanley in Oregon City in 1847. When he escaped from the Blackfeet in 1837, he took refuge in Yellowstone and got lost. In the process he saw the geyser basins and, when he emerged to make the 1837 rendezvous on the west slope of the Wind River Mountains to the south, he was no doubt full of stories.[11]

Among the people at the rendezvous that summer were a young artist from Baltimore, Alfred Jacob Miller, and his Scottish patron, Captain William Drummond Stewart. Miller was actually the first serious artist to paint the mountain men. He met Meek at the rendezvous and is said to have painted a portrait and an episode in the trapper's life, a near fatal encounter with a grizzly bear—neither of which is known to survive.[12] Stewart and Miller enjoyed themselves in the Wind River Mountains and did not venture far enough north to enter the Yellowstone area. But Meek's tales of the sights he had seen there must have intrigued the Scotsman, for when he returned to the Rockies in 1843 he ventured as far north as Yellowstone Lake. Miller had not joined him on this subsequent adventure—he remained home in Baltimore, still suffering from rheumatism caused, he surmised, by the physical extremes of his 1837 trek. But Stewart did not lack artistic accompaniment—a young journalist, Matthew Field from the New Orleans *Picayune*, traveled with him, as did a French painter, P. Pietierre. Unfortunately, because of Stewart's inhospitable and imperious manner, Pietierre left the expedition at Fort Laramie and returned home before reaching the Rockies. Somewhat more resilient fellow travelers were a lawyer whom Stewart met in New Orleans, George Wilkins Christy, and a doctor from Baltimore, Stedman Richard Tilgham, both of whom produced sketches of the trip.[13]

Field described an area around Yellowstone Lake on a cold August morning as exhibiting "hot boiling bubbles many feet high, puffing and hissing like a steamboat."[14] Kennerly Clark (William Clark's nephew), who was also on the expedition, painted one of the first word pictures of a geyser basin by an Anglo outside the trapper fraternity.

On approaching, we had noticed at regular intervals of about five or ten minutes what seemed to be a tall column of smoke or steam, such as would arise from a steamboat. On nearer approach, however, we discovered it to be a geyser, which we christened "Steam Boat Geyser." Several other geysers were found near by, some of them so hot that we boiled our bacon in them, as well as the fine speckled trout which we caught in the surrounding streams. One geyser, a soda spring, was so effervescent that I believe the syrup to be the only thing lacking to make it equal a giant ice cream soda of the kind now popular at the drugstore. We tried some experiments with our first discovery by packing it down with armfuls of grass; then we placed a flat stone on top of that, on which four of us, joining hands, stood in a vain attempt to hold it down. In spite of our efforts to curb Nature's most potent force, when the moment of necessity came, Old Steam Boat would literally rise to the occasion and throw us all high into the air, like so many feathers. It inspired one with great awe for the wonderful works of the Creator to think that this had been going on with the regularity of clockwork for thousands of years, and the thought of our being almost the first white men to see it did not lessen its effect.[15]

It was not until 1860 that another formal expeditionary force, this time a military one, would attempt to bring an artist into the region. Known as the Yellowstone Expedition and led by Captain William F. Raynolds, this two-year trek was the last complete western mission of the Army Corps of Topographical Engineers. Its expressed purpose was exploration of "the region of the country through which flow the principal tributaries of the Yellowstone river, and of the mountains in which they, and the Gallatin and Madison forks of the Missouri, have their source."[16] In Raynolds's mind, it represented a true terra incognita and "the most interesting unexplored district in our widely expanded country."[17] And though he is recorded in history as a rather uninspired bureaucrat concerned mostly with avoiding trouble and preaching Christianity to his unheeding ranks, Raynolds did marshal an impressive troop to confront the challenge. Jim Bridger was invited to guide the party and Ferdinand Vandeveer Hayden served as doctor and naturalist. And Raynolds named two trained artists, James D. Hutton (dates unknown), as topographer and assistant artist, and Anton Schonborn (1829–1871), official meteorologist and artist, as part of his troop.[18]

Schonborn was a watercolorist of some considerable skill. His works are tightly drawn and meticulously finished, full of light and charm that caused Raynolds on more than one occasion to proclaim them "admirable" productions. His portrait of Hayden at work in the Black Hills during the early months of the expedition (fig. 3) reveals the freshness of his observations and the exacting nature of his craft.

Hutton, a deft draftsman by comparison, produced a series of delightful views of mountain scenery traversed by the troop as they, through the summer of 1860, cir-

Fig. 3. Anton Schonborn (b. Germany; 1829–1871). *Canyon of Rapid Creek, Black Hills*, 1859. Watercolor; 7 x 10 in. Yale Collection of Western Americana, Beinecke Rare Book and Manuscript Library, Yale University, New Haven, CT.

cumnavigated Yellowstone in a tedious and frustrating clockwise swing. The party could not penetrate the park area from the south, since "an immense body of snow baffled all our exertions,"[19] so they moved west below the Tetons and then north along the Snake River and Henry's Fork to the Madison River. Hutton completed a hasty pencil sketch of the west side of the Tetons (fig. 4), but was sadly never able to capture the features of Yellowstone. Raynolds and Bridger, for some unexplained reason, moved north down the Madison rather than east toward its headwaters, in what would seem to have been a relatively simple approach to their prescribed destination, the heart of Yellowstone.

Despite the frustration of not reaching the goal, Raynolds's expedition was a valuable exercise and his report contributed significantly to general understanding of the area. Sadly, his report was not illustrated, perhaps because of poor timing and costs involved. It was not even published until well after the Civil War, in 1868. Maybe also it was not illustrated because the terrain they traversed demanded, in Raynolds's mind,

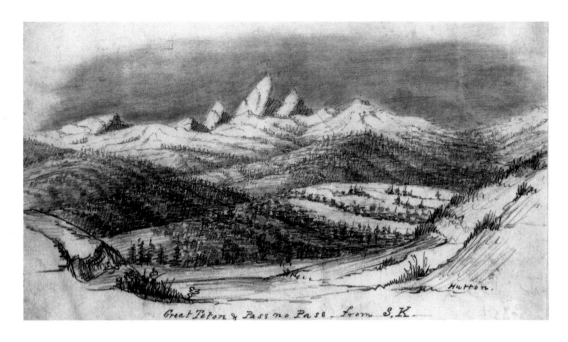

Fig. 4. James D. Hutton (active 1860s). *Great Teton & Pass No Pass from S.K.*, 1860.
Pencil on paper; 12½ x 17 in. Yale Collection of Western Americana, Beinecke Rare
Book and Manuscript Library, Yale University, New Haven, CT.

more than simply a topographer's touch. At one point, when the party was in the shadow
of the Gros Ventre Mountains, he wrote tellingly:

> Upon our left smooth ridges clad with pine rose to nearly equal height, while behind
> us lay the various-hued bluffs, amid whose singular and picturesque vistas we had
> for days been journeying. Through the valley, in the centre, the stream could be
> seen placidly winding its way, a subduing element in the grandeur of a scene whose
> glories pen cannot adequately describe and only the brush of a Bierstadt or a Stan-
> ley could portray on canvas.[20]

This and Raynolds's summary remark in the published report—"I cannot
doubt . . . that at no very distant day the mysteries of this region will be fully
revealed"[21]—provided an open invitation to others to keep trying. Hayden and Schon-
born, as it turned out, would be back.

Schonborn is known to have returned to the West after the Raynolds party dis-
banded in Omaha in 1860. He spent several years creating exquisite watercolor
bird's-eye views of western forts, presumably commissioned by the army. During these
years too, between 1865 and 1868, a civilian itinerant painter by the name of Alfred
E. Mathews (1831–1874) traveled through the Rocky Mountain West collecting mate-
rial for a series of elaborately illustrated books on panoramic views of Colorado and
Montana. It was a time that invited Americans to proclaim their scenery, at home and

Fig. 5. Alfred E. Mathews (b. England; 1831–1874). *Exit of the Yellowstone from the Mountains, Plate VII*, 1868. Toned lithograph; 5 $^{11}/_{16}$ x 9 $^{3}/_{16}$ in. 1969.31.8. Amon Carter Museum, Fort Worth, TX.

afar, as a worthy antidote to the horrors of war and the divisiveness of sectional differences. *Harper's Monthly* in May of 1866 heralded Yosemite as the "grandest rock-temple Nature has erected in our world," thus conferring divine sanction on the splendors of the nation's landscape. In November of the same year, the magazine attested to the successes of man-made environments closer to home. New York's newly completed Central Park was regarded as an easily accessible place that effectively "harmonizes the work of Art with that of Nature."[22] Mathews felt that the Rockies should share in that limelight and he, as a recorder of their grand countenance, in the rewards of the celebration.

Exploring the mountains and valleys directly north of the Yellowstone area in 1867, Mathews produced four elaborate panoramic drawings to add to a set of views published as lithographs under the title of *Pencil Sketches of Montana*.[23] His plates *Exit of the Yellowstone from the Mountains* (fig. 5) and *In the Yellowstone Valley* were among the images that elicited praise from Montana papers in 1868, the year that volume was published. "The scenery in the panorama[s] is purely western," hyperbolized a writer for the *Montana Post*, "all the beauty and grandeur of the American Switzer-

land is transferred to the canvas with a master's touch."[24] Other critics, outside the borders of Montana, were not so charitable. Used to seeing paintings of the Rockies by Bierstadt and Thomas Worthington Whittredge, a writer for *Putnam's Magazine* would conclude that "Either Mr. Mathews is no artist, or he is no lithographer; or, being both, it is not within the power of lithography to reproduce the larger forms of nature."[25] Mathews was a self-trained artist and a publisher and peddler of illustrated books. He did not pretend to compete with the grand manner landscape painters and could not be concerned that his works lacked distance in the backgrounds, richness in their surface details, and magnitude in the scale of presentation. But such works were charmingly inviting pictorial tributes to Yellowstone's gateway. Another artist, Abby Williams Hill, who looked up the same Yellowstone Valley toward the park in 1905, wrote in her diaries that what Mathews had drawn could not in itself be considered as "beautiful but suggest[s] so much of what is beyond."[26]

Mathews did not wish to venture too far off the not-so-beaten path when he prepared his sketch *In the Yellowstone Valley*, but he had heard of the spectacular sights farther along, at "the source of the Yellowstone." There could be found, he surmised, "a clear, deep beautiful lake, far up among the clouds. . . . Near this lake the river makes a tremendous leap down a perpendicular wall of rock, forming one of the highest and most magnificent waterfalls in America."[27]

Reports had begun to appear in Montana newspapers about the wonders of the upper Yellowstone. Davis Willson of the *Montana Post* in August 1867, the year Mathews was sketching farther down the river, wrote about some wide-eyed local adventurers who had seen "living streams of molten brimstone" and a huge lake that earned the description of "the greatest wonder of the age."[28] But the first group to venture into the present confines of the park with the specific intent of describing and analyzing its natural curiosities did not show up until a year later. Called the Cook-Folsom expedition after its joint leaders, Charles W. Cook and David E. Folsom, the party entered the area in the autumn of 1869 and explored it for several weeks. While they had no artists in their numbers, Folsom's written account of the trip, published in the *Western Monthly* magazine in July 1870, was so resplendent with painterly language that brushes and pigments were almost not required. "Folsom's word picture of the wonders he had witnessed," wrote park historian John H. Raftery around 1910, "remains . . . one of the most graphic, convincing, and detailed accounts ever to be published."[29]

Folsom described the Yellowstone's Lower Falls, for example, as the quintessential "fulfillment of Omnipotent will." The cloud of mist that they generate was alone worthy of his most exalted eloquence. It

> conceals the river for two hundred yards, but it dashes out from beneath the rainbow-arch that spans the chasm, and thence, rushing over a succession of rapids

and cascades, it vanishes at last where a sudden turn of the river seems to bring the two walls of the cañon together.[30]

Nonetheless, he admitted that it would ultimately take artists to picture such scenes adequately. "Language is entirely inadequate to convey a just conception of the awful grandeur and sublimity of this masterpiece of nature's handiwork."[31] His call was soon heeded.

Folsom had offered his article to a number of national periodicals including *Scribner's Monthly*, a new magazine in New York that would normally feature such material. The author received rejections from all but the *Western Monthly* in Chicago because the editors thought his observations too fictional and fantastic. It would not be long, however, before *Scribner's Monthly* and the majority of American magazines were scrambling into print to popularize the region.

Machine Makers at the Brink

*If you could only hear that gurgling river, lashing with puny strength the mas-
sive walls that imprison it and hold it in their dismal shadow, if you could but see
a living thing in the depth beneath you, if a bird would but fly past you, if the wind
would move any object in that awful chasm, to break for a moment the solemn
silence which reigns there, it would relieve that tension of the nerves which the
scene has excited, and with a grateful heart you would thank God that he had
permitted you to gaze unharmed upon this majestic display of his handiwork. But
as it is, the spirit of man sympathizes with the deep gloom of the scene, and the
brain reels as you gaze into this profound and solemn solitude.*

Nathaniel Pitt Langford

In the autumn of 1870, when the historic Washburn Expedition made one of the first
serious forays into Yellowstone, so little was known of what could be found there that
no trained artists or photographers accompanied the troop. The West had been opened
to easy, though not inexpensive, travel, yet Yellowstone could be seen on no itineraries
save those of a very select number of adventurers. To the contrary, Yosemite and Cal-
ifornia's "Big Trees" were the popular rage, and few who could afford the time, travel,
and exertion would restrain the impulse to affirm the bloviations of the hyperbolic travel
guides. "The grandest scenery on the American continent, if not in the world, is to be
seen in the Valley of the Yo Semite," proclaimed *Crofutt's Trans-Continental Tourist's
Guide* at that time. "Here is *majesty! enchanting! awe inspiring! indescribable!*"[1] As
proof of his boasts, Crofutt encouraged would-be tourists to purchase the profusely
illustrated book *Scenes of Wonder and Curiosity in California* by the artist J. M. Hutch-
ings, then available in shops from New York to San Francisco.

Despite the efforts of Hutchings and a host of other painters, it was a New York
grand manner landscapist, Albert Bierstadt (1830–1902), who laid firmest artistic claim
to Yosemite, achieving success with huge panoramic canvases and chromolithographic
copies that toured and sold in an exhilarated American and European market. Bier-
stadt's theatrical spread *The Domes of the Yosemite*, painted in 1867 and circulated
as a chromolithograph (fig. 6) in 1870, brought him solidly into the limelight. Reviews
were so mixed and had so excited the community of art critics that one among their
ranks referred to the debate as "the most contentious battle since the Civil War."[2]

Fig. 6. Albert Bierstadt (b. Germany; 1830–1902). *The Domes of the Yosemite*, 1870.
Chromolithograph; 22³/₁₆ x 33¹/₁₆ in. 1968.42. Amon Carter Museum, Fort Worth, TX.

Commissioned by New York financier Le Grand Lockwood and recorded as the artist's largest canvas, the painting was exhibited in major cities along the East Coast before coming to rest in Lockwood's mansion in Norwalk, Connecticut. In 1870 it was published as a chromolithograph in Düsseldorf and distributed internationally. A smaller version of the painting toured in England.

What Bierstadt did not know then was that Yellowstone, just a few miles north of the Wind River Mountains that he had visited in 1859 and that had brought him his initial fame, would soon become a mecca for artists and a serious pictorial rival to Yosemite. What Bierstadt also did not know, or at least heed, though he was remarkably well plugged into the business community, was the promising potential that existed for a transcontinental railroad to run north of Yellowstone. Financier Jay Cooke was looking to create the Northern Pacific Railroad and wished to affirm that there were locations along the way that represented commercial, as well as tourist, attractions worthy of his projected one hundred million dollar enterprise. Before he would call upon an artist to aggrandize the lure of the Yellowstone region, Cooke needed a pub-

licist and explorer to certify its potential appeal. The person he chose for the task was Nathaniel Pitt Langford, a past collector of internal revenue for the Montana Territory, a man with substantial political ambitions and a man also, in 1870, out of work.[3]

Langford was beckoned to Cooke's estate outside Philadelphia, given his instructions, and released to do his job. He hastened back to Montana and in concert with the territory's surveyor general, Henry Dana Washburn, organized a troop of civilians and a small military escort to explore Yellowstone's mysteries. Though numbering only nineteen, the band of zealous adventurers performed legion service for Cooke and the many commercial interests in Montana that stood to benefit from a report of interest to potential investors and tourists.

Washburn served as troop leader. In addition to Langford with his considerable skills as an observer and writer, there were two journalists, Cornelius Hedges and Walter Trumbull (1846–1891), eldest son of Senator Lyman Trumbull of Illinois. First Lieutenant Gustavus Cheney Doane led the military contingent and would file the first-ever official report on Yellowstone at the conclusion of the expedition. His troop consisted of one sergeant and four privates of Company F, Second Cavalry, one of whom, a Canadian named Charles Moore (1840–1930), proved to have sufficient drawing skills to

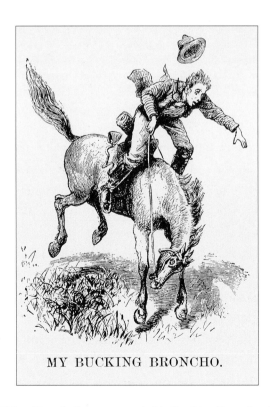

MY BUCKING BRONCHO.

Fig. 7. Walter Trumbull (1846–1891). *My Bucking Broncho*, 1880.
Wood engraving from a pencil drawing; 3 x 2 ¹/₂ in. Yellowstone National Park Library,
Mammoth Hot Springs, WY. Photograph by W. Garth Dowling, Jackson, WY.

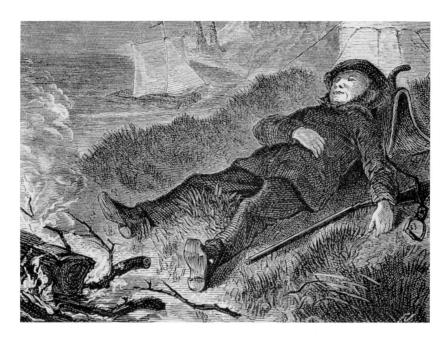

Fig. 8. Charles Moore (1840–1930). *On Guard on Yellowstone Lake*, 1871.
Scribner's Monthly, June 1871. Wood engraving; 2 $\frac{1}{8}$ x 2 $\frac{3}{4}$ in. AP2 C4.
Reproduced by permission of the Huntington Library, San Marino, CA.

be referred to in Langford's journals as "our artist."[4] Trumbull also sketched, and it was to these two that Langford and Washburn turned when they required a scene to be recorded pictorially.

It appears that neither Trumbull nor Moore had any formal art training but that they did enjoy turning out rough sketches of scenery and events. Trumbull, for example, made a sketch of Langford nearly being thrown from a pack horse he saddled one morning (fig. 7). It was given in jest to Langford, who considered the rendition "an exaggeration" in that he was sure he had "hugged the saddle in better form than it indicates."[5] On another occasion Langford asked Moore to make a sketch of Jake Smith, the one member of the party whom Langford considered recalcitrant and lazy. Smith was caught sleeping on guard duty and a drawing was called for to provide proof. Both artists put their hands to the task. Moore's version appeared as an illustration, probably redrawn, in Langford's subsequent account published in *Scribner's Monthly*. Titled *On Guard on Yellowstone Lake*, the drawing shows the slumbering sentry, feet to the fire and left arm resting on his rifle (fig. 8). Trumbull's sketch, inscribed "Jake Smith on Guard" (fig. 9), pictures the same scene except both hands are folded over his middle and the rifle is faced in the opposite direction. Langford feared Indian attacks, a sentiment not shared by Smith. The bubble over Smith's head in the Trumbull drawing reads, "My lone watch I'm keeping . . . Indian dont bodder me."

JAKE SMITH "DOING GUARD DUTY."
ORIGINAL SKETCH BY WALTER TRUMBULL.

Fig. 9. Walter Trumbull (1846–1891). *Jake Smith on Guard*, 1870.
Bookplate from a pencil drawing; 1⅝ x 3½ in. Yellowstone National Park Library,
Mammoth Hot Springs, WY. Photograph by W. Garth Dowling, Jackson, WY.

Both Trumbull and Moore made sketches of the major geological features as well. Their pencil drawings of the Upper Falls of the Yellowstone (figs. 10 and 11) exemplify their naïve attempts at rendering the spectacle that confronted them. Langford had considered this cascade less grand than the Lower Falls but concluded that what it lacked "in sublimity is more than compensated by picturesqueness."[6] Doane preferred the Upper Falls, commenting that "in scenic beauty the upper cataract far excels the lower; it has life, animation, while the lower one simply follows its channel."[7] Moore's sketch captures those qualities of picturesqueness and animation more successfully than Trumbull's, but of course neither does the sight justice.

Trumbull published an ebullient account of the expedition in the *Overland Monthly* the next spring. He recalled the experience fondly, recounting the adventures and hardships as well as the restful moments.

> During the pleasant evening, and the long summer twilight peculiar to a northern latitude, some made rough sketches of the magnificent scenes by which we were surrounded; others wrote up their notes of the trip, while the rest serenely smoked their pipes, and listened to reminiscences from each other of by-gone times, or other scenes somewhat similar to those we then enjoyed.[8]

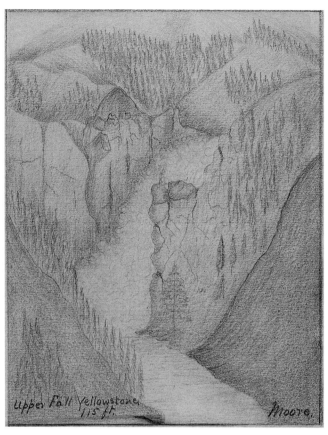

Fig. 10. Walter Trumbull (1846–1891). *Upper Falls of the Yellowstone, 115 feet*, 1870. Pencil on paper; 6 x 4³/₄ in. National Park Service, Yellowstone National Park, WY. Photograph by W. Garth Dowling, Jackson, WY.

Fig. 11. Charles Moore (1840–1930). *Upper Falls, Yellowstone, 115 feet*, 1870. Pencil on paper; 8 x 5⁷/₈ in. National Park Service, Yellowstone National Park, WY. Photograph by W. Garth Dowling, Jackson, WY.

Trumbull had visited Yosemite prior to his Yellowstone tour and made several comparisons. Vernal Falls in its pure brilliancy, he contended in retrospect, was more commanding of sublime effect than even the Lower Falls of the Yellowstone. He concluded prophetically,

> When, however, by means of the Northern Pacific Railroad, the falls of the Yellowstone and the geyser basin are rendered easy of access, probably no portion of America will be more popular as a watering-place or summer resort than that which we had the pleasure of viewing, in all the glory and grandeur of its primeval solitude.[9]

Moore produced perhaps as many as three versions of his most important landscape studies.[10] One set of these, possibly along with Trumbull's, was given to Langford as the basis for illustrations in an article he proposed to *Scribner's Monthly*. The magazine's editor, Richard Watson Gilder, was anxious to publish the article, but the accompany-

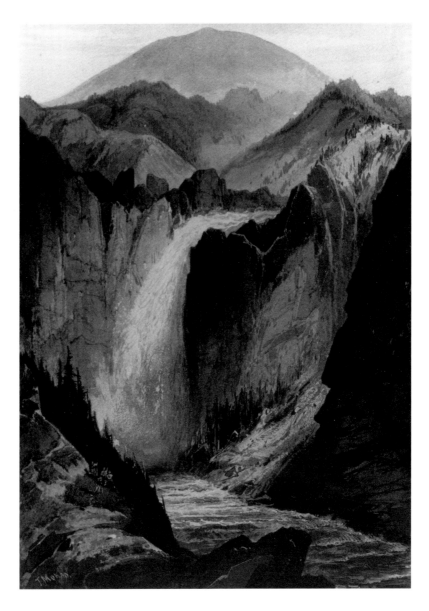

Fig. 12. Thomas Moran (b. England; 1837–1926). *Upper Falls*, 1870.
Ink wash on paper; 10³/₈ x 7¹/₂ in. 0226.1689. From the Collection of
the Gilcrease Museum, Tulsa, OK.

ing visual material he considered too rough to use without considerable enhancement.
A young Philadelphia artist named Thomas Moran (1837–1926), who worked part-
time for the magazine, was asked to flesh out the field studies and make the scenes pre-
sentable and effective for the purpose at hand.[11]

Moran set to work, quickly producing a series of ink-wash drawings that were
then reproduced as wood engravings for Langford's two-part article, "The Wonders
of the Yellowstone," that appeared in the May and June issues of *Scribner's Monthly*.

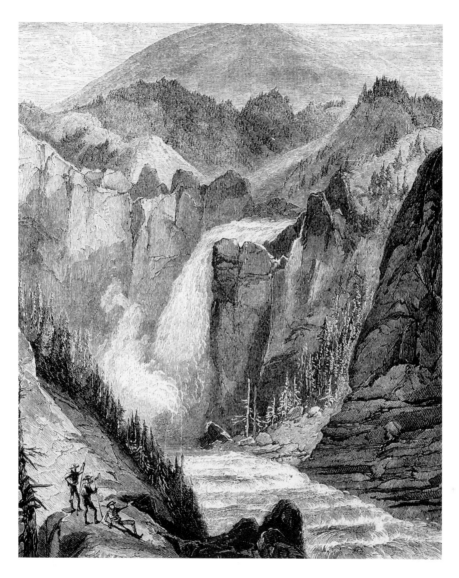

Fig. 13. Thomas Moran (b. England; 1837–1926). *Upper Falls of the Yellowstone, Wyoming*, 1871. *Scribner's Monthly*, May 1871. Wood engraving; 5½ x 4⅝ in. AP2 C4. Reproduced by permission of the Huntington Library, San Marino, CA.

His drawing, *Upper Falls* (fig. 12), exemplifies the astonishing transformation that took shape as he converted the awkward, brittle pencilings to highly finished, naturalistic washes of imaginary beauty. The wood engraving of the scene, *Upper Falls of the Yellowstone, Wyoming* (fig. 13), provided the public's first view of that "grandeur" and "primeval solitude." It was altered in scale and perspective and may have been the product of Moran's hand as well. Moran, who had been working for the new magazine since its inception a few months earlier, saw this commission as a once-in-a-lifetime opportunity. Somewhere between the effusive embroiderings of Langford and the

child-like scratching of Moore and Trumbull, he recognized the magnitude of the implications for an artist with the skills and vision to render its countenance fairly. He had watched Bierstadt lay artistic claim to the Rocky Mountains of Wyoming and the glories of Yosemite. He witnessed the great Frederic Church's meteoric rise to fame with his luscious panoramas of South American jungles and cordilleras and William Bradford's successes with his paintings of ships, their sails like opalescent mirrors in the icy glow of the North Atlantic. If Church could create the great American canvas, as was commonly proclaimed when he painted his *Niagara* in 1857, why could Moran not rival such exertions with views of this new wonderland? Why could Moran not plant a first foothold in this place called Yellowstone and claim it as *his* special domain, an exotic, distant, almost mythical axis of natural America from which his ascendant star might rise? He did not linger in search of answers to these questions but rather set immediately to paint himself into the larger American art picture by taking the fullest possible advantage of the situation. He could also not avoid, as photographer and companion William Henry Jackson would recall years later, the sheer allure of the "romance . . . surrounding the discovery" of Yellowstone.[12] A trip to the wilds of Lake Superior ten years before had whetted his appetite for adventure and convinced him he could stand up to the rigors of outdoor life. His sketching trips into Fairmont Park for *Scribner's Monthly* at this time, "in search of nature,"[13] while resulting in illustration work and an enhancement of his local reputation, did not satisfy his quest for grander scenes and a potential spot in the national limelight.

The same forces that had encouraged Langford's efforts—Cooke, his Northern Pacific Railroad, and the editors of *Scribner's Monthly*—conspired to give Moran his chance. A. B. Nettleton, an agent for Cooke, contacted the geologist Ferdinand Vandeveer Hayden, who was planning to take his branch of the United States Geological and Geographical Survey of the Territories to explore Yellowstone that summer. Nettleton's letter introduced Moran and beseeched Hayden to consider the artist as an adjunct member of his party. Hayden knew of Moran through his magazine images of Yellowstone and had been captivated by one of Langford's lectures on the region that he attended in early 1871. Hayden was a firm believer in employing artists to enhance his scientific observations and reports. He had welcomed painter Sanford Robinson Gifford as part of his survey of southern Wyoming in 1870, and he typically took a couple of topographical artists and a photographer or two on his trips as a matter of course. He understood full well the popular appeal and the scientific value of photographs and paintings. For him, "collecting photographs and pictures of the West was similar . . . to collecting fossils and natural history specimens."[14] The pictorial and physical evidence could be subsequently amassed and linked together for the grand image of the West that he had been assigned to record and bring forward for public comprehension. Nettleton described Moran as an artist of "rare genius" who would

make a "very desirable addition" to Hayden's expedition.[15] A positive agreement was struck at once. It would make a felicitous association for all parties. Hayden saw his reputation being made on this venture to Yellowstone, no less than did Moran and Cooke. *Scribner's Monthly*, too, would stand to profit considerably.

Nettleton had written Hayden a week earlier that Bierstadt might wish to join the Yellowstone expedition,[16] but for some unknown reason this did not happen. Perhaps Bierstadt learned that Moran was to be included in the roster and balked at the competition. Perhaps he felt that he had bigger rail barons to court. July would find him high in the Sierras with Collis P. Huntington, making sketches for a sweeping panorama of sunrise over Donner Pass. Then, too, the Grand Duke Alexis of Russia had plans to visit America. Bierstadt, always bucking for potential future patrons abroad, volunteered himself for the arrangements committee. Nonetheless, busy as Bierstadt was, Moran's successes resulting from his few months in Yellowstone in 1871 would ultimately chisel deep furrows of envy into Bierstadt's brow.

Though inexperienced as an outdoorsman and equestrian, Moran took to the challenge of exploring with high spirits. "To all outward appearances," wrote his traveling companion Jackson, Moran "had not the physique or capacity for endurance required." Yet no veteran "was ever more uncomplainingly cheerful under the exactions of poor fare and a hard bed, long hours in the saddle and indifferent weather conditions—rain or shine, hot or cold—and yet withal one of the jolliest of the crowd." He worked hard, excited enthusiasm for the "unceasing quest for beauty" that drove him and his compatriots Hayden and Jackson, and was one of the most humble of his profession.[17] Nonetheless, he had an artist's flair, and when mounted, he put in a "picturesque appearance" with his jaunty hat, his drawing portfolio under his arm, and a rifle hanging from his saddle horn.[18]

The troop consisted of thirty-five members, several of whom, besides Moran and Jackson, were intending to serve Hayden's desire to return well-armed with images of the "mythical" region. Henry Wood Elliott (1846–1940), who had been with Hayden since 1869, was again his official artist, along with the topographical artist Anton Schonborn.[19] There was also a military escort provided by the Corps of Topographical Engineers and commanded by Captains D. P. Heap and J. W. Barlow. They employed their own draftsman, W. H. Wood, and Chicago photographer Thomas J. Hine. In addition, a freelance photographer from Bozeman, J. Crissman, had joined the group.[20]

They entered the Yellowstone area from the north in mid-July, first stopping at Mammoth Hot Springs, an area that had not been visited by Doane and Langford's expedition. Beyond his own work of sketching the sights, Moran took special interest in photography. His younger brother John was a photographer and had, on numerous earlier occasions, worked side by side with the painter. Now, in union with Jackson, he "was always one of the little party that lingered behind or wandered far afield

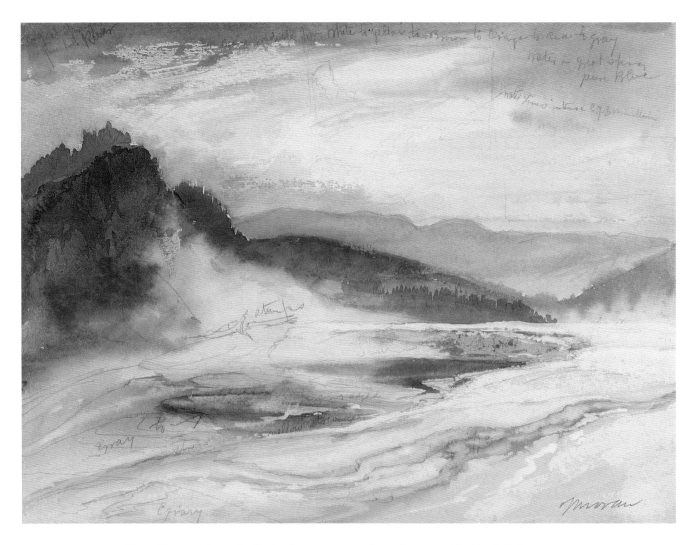

Pl. 2. Thomas Moran (b. England; 1837–1926). *Great Springs of the Firehole River*, 1871.
Watercolor; 8 1/8 x 11 1/8 in. National Park Service, Yellowstone National Park, WY.

to portray the picturesque or remarkable along the way."[21] They shared an interest
in selecting points of view that would produce compelling compositions, Moran "hav-
ing in mind," according to Jackson, "the good use he could make of the photographs
later in some of his own compositions."[22]

At that first stop among the delicate terraces of Mammoth Hot Springs, Hayden
must have realized what an invaluable asset Moran proved to the effort. In his report
he described the striking colors that engaged him at every turn—looking "down into
the beautiful ultra-marine depth at the bottom of the basin," or admiring the "coral-
like forms" along the sides of the terraces "ornamented . . . with a great variety of
shades, from pure white to a bright cream-yellow, and the blue sky reflected in the

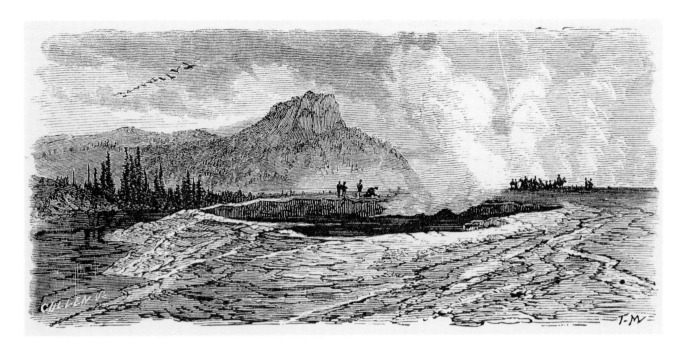

Fig. 14. Thomas Moran (b. England; 1837–1926). *Great Springs, Fire-Hole Basin*, 1872.
Scribner's Monthly, February 1872. Wood engraving; 2³/₄ x 3¹/₂ in. CA, AP2 C4.
Reproduced by permission of the Huntington Library, San Marino, CA.

transparent waters" that gave "an azure tint to the whole which surpasses all art."
Well, at least it surpassed the noble photographic efforts, as he explained in describ-
ing a photograph of the "Great spring at the Gardner River." "Even the photograph,
which is so remarkable for its fidelity to nature, falls far short. It fails to give the exquis-
itely delicate contrasts of coloring which are so pleasing to the eye."[23]

Over the course of the next two months, the Hayden team visited most of the impor-
tant features of the Yellowstone caldera. Moran continued to impress his fellow
explorers with his physical tenacity, his companionable nature, and his skills as an
angler and cook. But mostly it was his tireless quest for color and beauty that caught
their attention and gratified their leader. At the Great Blue Spring (today, Excelsior
Geyser Crater) on the Firehole River at the Lower Geyser Basin, Hayden made a typ-
ical observation of his artist: "Mr. Thomas Moran, the distinguished artist, obtained
studies of these beautiful springs and from his well-known reputation as a colorist, we
look for a painting that will convey some conception to the mind of the exquisite vari-
ety of colors around the spring" (plate 2).[24]

One Moran view of this scene appears as an illustration (fig. 14) in Hayden's first
published accounts of the trip printed in *Scribner's Monthly* early the next year.[25] It
was also a plate in Hayden's government report. But more in the spirit of Hayden's

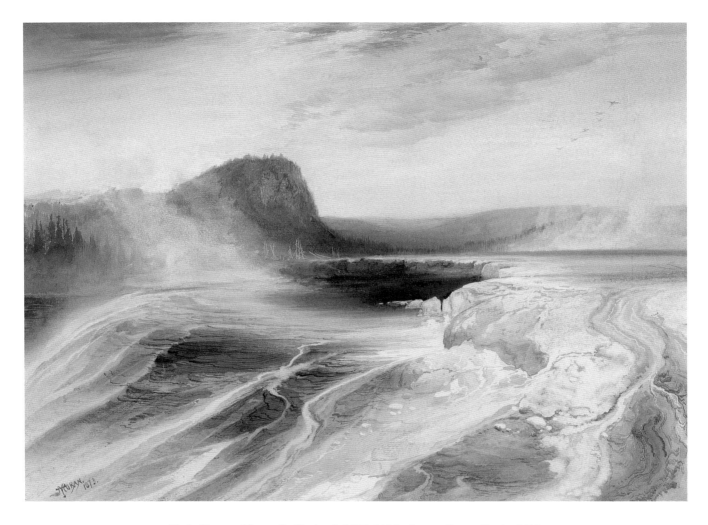

Pl. 3. Thomas Moran (b. England; 1837–1926). *Lower Geyser Basin*, 1873.
Watercolor; 9½ x 13¾ in. 0226.1365. From the Collection of the Gilcrease Museum, Tulsa, OK.

conjecture, Moran produced several finished watercolors in subsequent years (plates 3 and 4), and they lived up to the geologist's boast.

As a pictorial climax to the trip, the Falls and the Grand Canyon of the Yellowstone kept the party enthralled for about two weeks. Moran sketched the canyon walls, recording their extraordinary formations and hues. He worked with Jackson to photograph the falls from various vantage points. Despite the fact that he "exclaimed" to Hayden "with a kind of regretful enthusiasm that these beautiful tints were beyond the reach of human art," Moran was there, on the spot, conceiving his early magnum opus inspired by those weathered but brilliant cliffs and the dramatic, plunging falls.[26]

Shortly after Moran's return to the East Coast, he moved his family and his astonishing portfolio of Yellowstone studies and memories from Philadelphia to Newark.

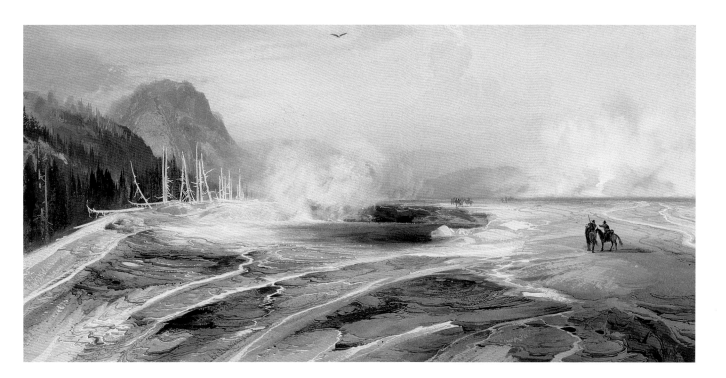

Pl. 4. Thomas Moran (b. England; 1837–1926). *Big Springs in Yellowstone Park*, 1872.
Watercolor; 9 x 19 in. Private collection. © 1999 by Sotheby's Inc.

Even before he had settled in, a reporter from the *Newark Daily Advertiser* appeared
on his doorstep and filed the following story.

> Mr. Moran says he could only describe it as a country bespattered with rainbows.
> It seemed unreally strange, like a dream-land, and he could hardly believe at times
> that he was not in a dream instead of an exploring expedition. He fears that he will
> need strong affidavits to defend his pictures against the charge of exaggeration.
> The wonderful brilliancy of his mineral specimens, confirm, however, on a small
> scale, both description and picture. It is a very happy fortune that this *terra incog-
> nita* is to be introduced to the eyes of men by an artist of Mr. Moran's extraordi-
> nary genius for natural scenery. Those best acquainted with his works anticipate
> that the new pictures will take a rank in American Art as eminent as the subjects
> they illustrate hold among the characteristics of the American continent.[27]

Moran's first views of Yellowstone appeared, ironically enough, as black and white
illustrations in the February 1872 issue of *Scribner's Monthly*. He had drawn the images
on wood blocks to be cut by the magazine's engravers. Just a month earlier he had
brazenly and vicariously invaded Bierstadt's domain, illustrating from photographs
a story on "The Big Trees and the Yosemite" that was published by the same maga-

zine.[28] But it was his Yellowstone images that stirred the air. They would be useful to enthusiasts from many quarters, especially agents of the Northern Pacific Railroad, who were advocating that the Yellowstone area be set aside as a national park.[29] Some watercolors had been completed as he worked on his huge canvas and these, along with Jackson's photographs, proved remarkably effective props for Hayden and other forces as they worked to persuade Congress to take the historic step toward wilderness and scenic preservation.[30] Moran's role in the formation of the park was so paramount, in fact, that he soon added a "Y" to his monogram to signify that "Yellowstone" was his middle name. From that time forward he was considered one of the prime founders of the world's first national park.

Moran's wood engraving, *The Great Cañon and Lower Falls of the Yellowstone* (fig. 15), may have served as an initial compositional template for his final epic work, *Grand Cañon of the Yellowstone* (plate 5), but it was only a suggestion of the artist's genius. Hayden had consulted with him on the geological veracity of the work, and Moran had explained to more than one person the artistic liberties that were required to succeed with such a grand creation. His letter to Hayden, written in March 1872 when the painting was about one-half complete, not only described what process was underway but also remains as one of the most articulate of Moran's expressions regarding his artistic philosophy.

> By all Artists, it has heretofore been deemed next to impossible to make good pictures of Strange and Wonderful Scenes in nature; and that the most that could be done with such material was to give topographical or geologic characteristics. But I have always held that the Grandest, Most Beautiful, or Wonderful in Nature, would, in capable hands, make the grandest, most beautiful, or wonderful pictures, and that the business of a great painter should be the representation of great scenes in Nature. All the characteristics attach to the Yellowstone region, and if I fail to prove this, I fail to prove myself worthy [of] the name of painter. I cast all my claims to being an Artist, into this one picture of the *Great Cañon* and am willing to abide by the judgment upon it.[31]

A monumental painting like *Grand Cañon of the Yellowstone* was an expression of public art. Its intent was to "satisfy the myth of a bigger, newer, America" and to enlighten the nation as well as entertain its people.[32] Such large-scale pieces were the offspring of the famous rolling panoramas that were popular before the Civil War and were frequently referred to as "machines." Some observers, when they saw the large canvases, wondered aloud when the image would move.[33] Despite its static presence, the format provided Moran with an artistic voice that was operatic in dimension.

By the time his big machine of a painting had been pieced together using his color studies and notes, Jackson's photographs, and his own vivid memory, the national park

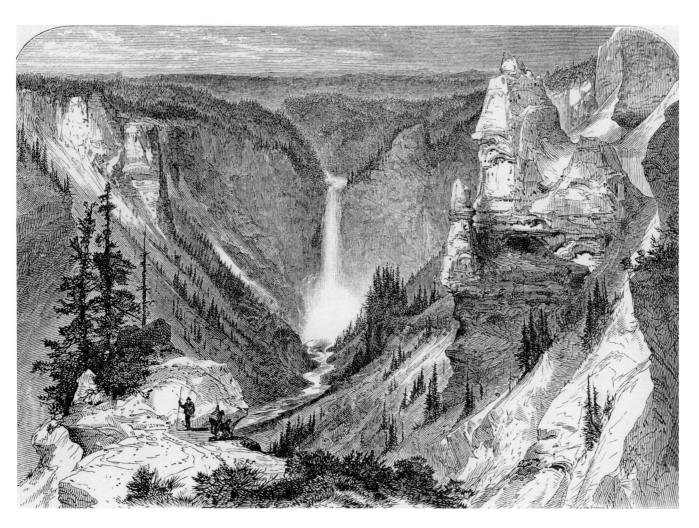

Fig. 15. Thomas Moran (b. England; 1837–1926). *The Great Cañon and Lower Falls of the Yellowstone*, 1871. *Scribner's Monthly*, February 1872. Wood engraving; $4^{3}/_{8}$ x $6^{1}/_{8}$ in. AP2 C4. Reproduced by permission of the Huntington Library, San Marino, CA.

was a fait accompli. The *New York Times* announced the painting's first public show-ing in early May at Clinton Hall. The subject, they opined, was "a difficult one," but Moran had "treated it most successfully, and with great technical power."[34] A few days later a full review appeared in the *New York Post*—a critique that soon found its way into western newsprint in San Francisco and Helena.

The first view of this picture causes a feeling of disappointment, owing to its extreme brilliancy of color, but after a few moments of study the composition is felt to be in harmony throughout; the gorgeous tones of the foreground blend in subtle gra-dations with the receding colors which lead off into the perspective, and are in effect refined and beautiful. The picture is carefully painted, and, what is remark-

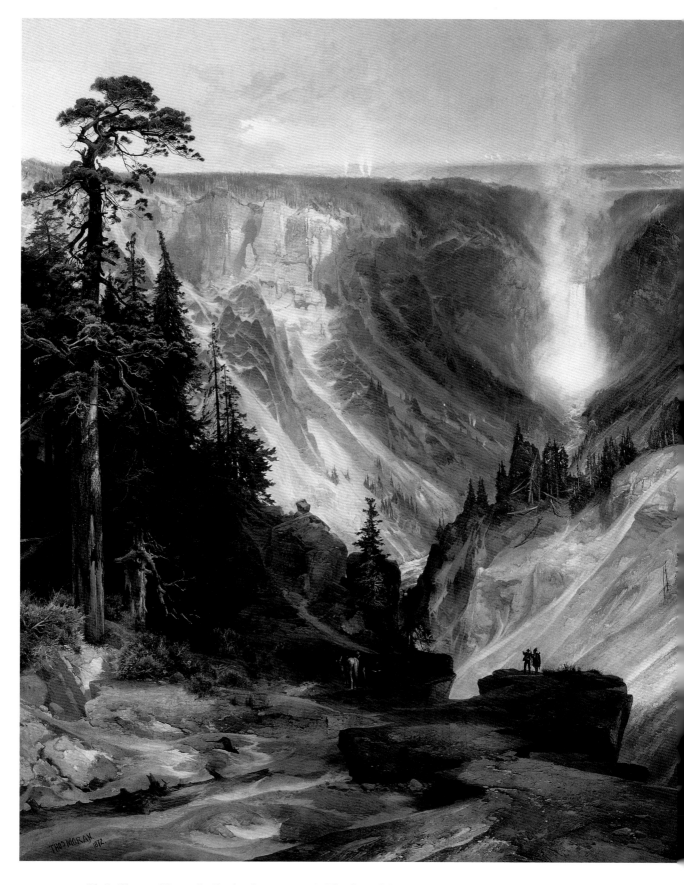

Pl. 5. Thomas Moran (b. England; 1837–1926). *The Grand Cañon of the Yellowstone*, 1872.
Oil on canvas; 84 x 144$^{1}/_{4}$ in. Smithsonian American Art Museum, Smithsonian Institution,
lent by the Department of the Interior Museum, Washington, DC.

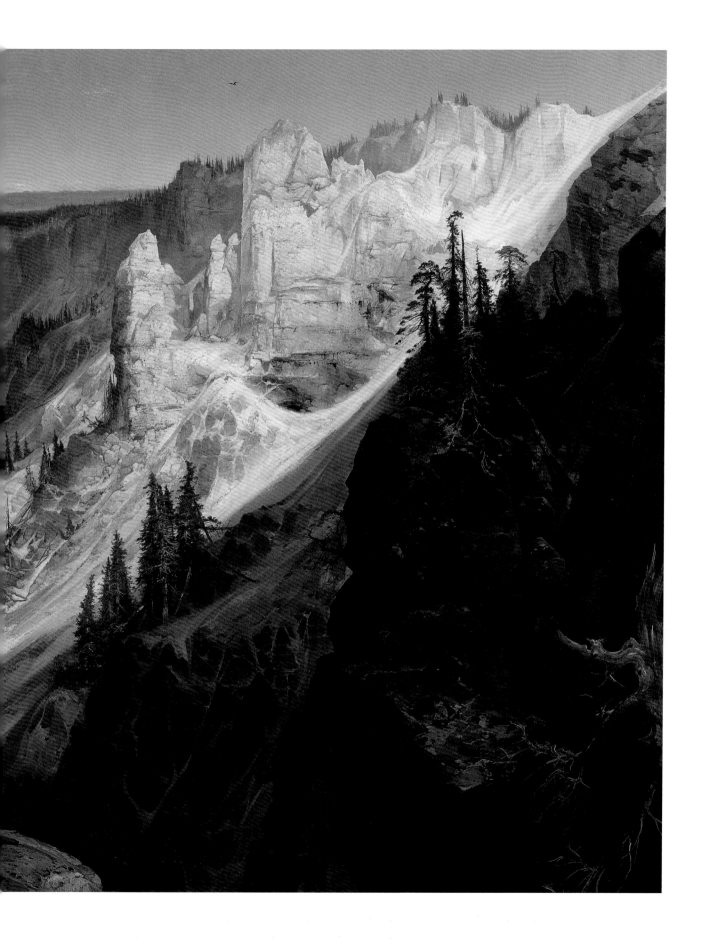

able in so large a work, it will bear a close examination. The structure, texture and character of the rocky formation of these remarkable cliffs are most vividly rendered, and the artist is to be congratulated upon the success of his work.[35]

The painting that had created a sensation in New York was soon shipped to Washington, D.C., at Hayden's suggestion and encouragement. And with the explorer's assistance, Congress eventually purchased the canvas for the U.S. Capitol. It was a coup for Moran and a welcome relief for savvy observers of federally commissioned art that decorated, though some felt desecrated, the marble halls of the nation's seat of government.

This was the first landscape painting to hang in the Capitol, where the walls were resplendent with giant history machines like William H. Powell's *Discovery of the Mississippi by DeSoto* (1847–1853) and Emanuel Leutze's *Westward the Course of Empire Takes Its Way* (1861). Moran's spread could be considered a history painting too, albeit on the surface natural history, with the tiny figures posed at the brink of Yellowstone's gaping canyon. Yet it was fresh and pleasing to the tastes of the time, not one of those "unhappy productions" with their "academically severe glimpses" of America's past, as mentioned above, that rankled the critics and the public.[36] It was a celebration of America's first national park. In picturing the canyon's dramatic erosive elements, the painting featured some of the country's most ancient remnants. Those spires and minarets psychologically associated with Europe's antiquities thus provide a homegrown legacy to sate America's appetite for a history that might reach back further than one hundred years. The surging water over the distant falls proclaimed the nation's power and suggests a continuity of greatness over time to come. And the explorer Hayden and his troop, gathered before the splendor, showed proof in subtle but visionary artistic rhetoric that Americans could conquer even the remotest corner of their continent. The Indian at Hayden's side, turning his back on the scene but directed by Hayden's gesture to gaze back over his shoulder, scripted a capping metaphor for the painting as an expression of progress. As America subdued its wilderness, preparing its "unexampled richness" for what *Scribner's Monthly* in May 1872 termed "the pleasure tourist" and ensuring "the region . . . shall be kept in the most favorable condition to attract travel and gratify a cultivated and intelligent curiosity," the Indian was left facing in the other direction. As dependent pupil of the white "discoverer," the handsomely regaled warrior was effectively removed from the broader implication of the West as a capstone to progress.[37]

The painting was important too on purely aesthetic grounds. Moran, who throughout his career attached his artistic inspiration to American tendencies and subjects, had grown up in Philadelphia. His family had emigrated from England in 1844, and he studied art under his older brother, Edward, and a painter of romantic

42

seascapes, James Hamilton. Encouraged by both mentors, Thomas escaped America during the Civil War to study the works of J. M. W. Turner in England and in order to understand John Ruskin's fascination with Turner's landscapes. Ruskin had praised Turner for his imaginative landscapes such as those of the Alps in which he added glory to the mountains, not by simply copying them but by endowing them with his own emotional power, thus creating a "noble landscape."[38] Moran admired that as well and, at least in his early career, was interested in combining the emotional sway with what Ruskin and his Pre-Raphaelite followers would applaud—a literal transcription of nature. The lessons he took from England served him well as he painted his *Grand Cañon of the Yellowstone*. When Hayden confirmed the veracity of Moran's geological forms, the literal interpretation was preserved, while the scale and drama of the painting proved that the artist, in creating a truly noble landscape, had invested it with the full measure of his emotional reserve.

Historian Wallace Stegner has said that Moran "in training and inspiration" was merely "Turner superimposed on Bierstadt."[39] But the art critics and public of the day saw the two artists in far more dichotomous terms. Moran was a "truth teller," while Bierstadt was regarded sadly enough as little more than "clap-trap." Though both explored their imaginations in rendering their final panoramic machines, Moran tended to veil the "awful and desolate" in nature by accentuating its "beauty and variety of color."[40] It was commonly regarded at the time that Bierstadt just did not have "what old Ruskin calls for."[41] While Moran's *Grand Cañon of the Yellowstone* was spoken of as "a singularly beautiful and original work, . . . the composition skillfully managed, and the harmony of color . . . instinctive . . . as the true poet's verse," Bierstadt's monumental *Domes of the Yosemite*, which was featured publicly in New York only a few days after Moran's premiere, garnered far less flattering reviews. Such works, according to James Jackson Jarves, satisfied only those "Americans who associate them with the vulgar idea of 'big things' as business."[42] Freed from Bierstadt's bombast, Moran's artistic voice was in key with Ruskin's omnipotent paean to nature's eloquence. Moran's subject and ambition required a symphonic response delimited by his search for clarity of articulation and detail.

Moran also had a quieter mode. At the same time that he was creating his huge canvas, and particularly following its successful completion, he embarked on a series of jewel-like watercolors that attracted nearly as much attention and proved the breadth of his talents. Moran produced several sets, one for Jay Cooke in payment for the money advanced by the railroad to subsidize the artist's Yellowstone trip and another for a British industrialist, William Blackmore. Examples from the latter's collection were exhibited in New York in 1872 and elicited critical acclaim. They were the "most brilliant and poetic pictures that have been done in America thus far."[43] At the New York

Exhibition of Watercolors in 1873, where Moran showed next to Ruskin, the critics relished the American's delicate oddities, as reported in the *Penn Monthly*.

> For myself, I prefer Thomas Moran's rich Yellowstone country. There are two or three in the exhibition, and although I am not sure that the freaks of nature are the manifestations we most love, I am convinced that Mr. Moran gives them to us with true scientific pleasure, and perhaps scientific indifference. The schools of science and of impression in art seem to be growing farther and farther apart, and it is curious to see an observer like Mr. Moran turn aside to give us a couple of blots—fantastic "suggestions," he calls them, full of weirdness and dream.[44]

The watercolors, such as *Lower Geyser Basin* (plate 3), afforded Moran an opportunity to explore, even more richly than in oil, the splendor of Yellowstone's color. He was also able to connect more immediately with his fieldwork like *Great Springs of the Firehole River* (plate 2) and reflect the intimacy of firsthand observation and response to nature. In these smaller, more personal renderings, Moran could avoid the criticism that some had thrown at his big canvas when they said he had lost the "magic which converts crudity into splendor."[45] The finished watercolors were indeed magical.

And like the large oil, the watercolors ultimately enjoyed a significant public dimension. In 1875 a writer for the *Gentleman's Magazine* observed that "precipices and mountain-scenes are no longer in favor. I think the artists and the public right in preferring what tranquilizes and seduces to what violently excites the imagination."[46] While Moran was not about to abandon either the precipices or the mountain-scenes, he did discover a means of seducing the public with the more tranquil watercolor images. In anticipation of the nation's centennial, he therefore planned not another vast stretch of landscape canvas but a series of watercolors to be reproduced for public consumption by Louis Prang, the popular chromolithographer from Boston. Among the fifteen extraordinary color prints pulled for the elaborate portfolio, *The Yellowstone Park, and the Mountain Regions of Portions of Idaho, Nevada, Colorado, and Utah* (1876), nine derived from Yellowstone images. *The Great Blue Spring of the Lower Geyser Basin* (plate 6) was one of the most stunning of the group.

Prang published one thousand copies of the portfolio, which sold for a relatively accommodating price of sixty dollars each. Various observers of the period, from savants to cultural rubbernecks, contended that chromolithographs fulfilled only the meanest of aesthetic needs and were at best meant for those of mediocre taste and artistic vision. Moran and Prang proved them wrong. Even Edwin L. Godkin, editor of *The Nation*, who had pejoratively dubbed the whole of post-Civil War America as the "Chromo-Civilization," recanted when he saw these exquisite prints.[47]

Of course, there were other public dimensions to the imaging of Yellowstone as America's first national park. Hayden's report of the 1871 survey was illustrated, for

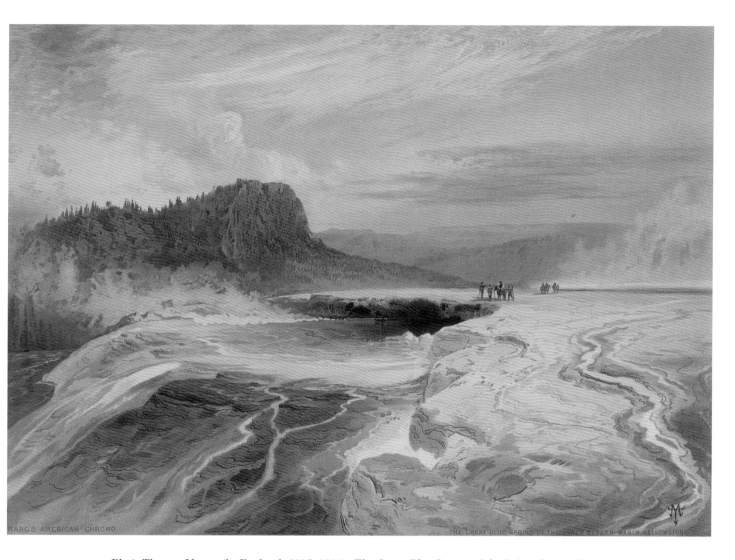

THE GREAT BLUE SPRING OF THE LOWER GEYSER BASIN YELLOWSTONE

Pl. 6. Thomas Moran (b. England; 1837–1926). *The Great Blue Spring of the Lower Geyser Basin*, 1876. F. V. Hayden, *Yellowstone National Park*. Chromolithograph; 21 x 24³⁄₄ in. QE74 H4. Reproduced by permission of the Huntington Library, San Marino, CA.

example, by his official artist as well as by Moran. While eclipsed by Moran's limelight, Henry Wood Elliott (1846–1930; fig. 16) produced some fascinating, quite intimate, and profoundly articulate views of Yellowstone's scenery.[48] A devoted topographical artist and naturalist, Elliott was born and raised in Ohio. He served as private secretary to the Smithsonian's secretary, Joseph Henry, between 1862 and 1878. During this time he was assigned to the U. S. Geological Survey from 1869 through 1871, employed each summer with Hayden in the field. Elliott and Jackson worked side by side with painter Sanford Robinson Gifford during the 1870 survey in southern Wyoming.

Fig. 16. William Henry Jackson (1843–1942). *Camp Study—H. W. Elliott*, 1870.
Photograph; 3 x 3 in. U.S. Geological Survey Field Records Library, Denver, CO.

Where Elliott learned to draw is unknown, but it is certain that Hayden valued his services very highly. During the 1871 expedition Hayden sent his principal assistant, Jim Stevenson, and Elliott to begin exploring Yellowstone Lake in "Anna," the first Anglo-made boat to sail its waters. Elliott was subsequently assigned to make "a topographical and pictorial chart" of the full shoreline.[49] His watercolor, *Yellowstone Lake* (plate 7), no doubt resulted from studies taken on that assignment. A charming and lyrical view of the lake, this watercolor appears to be the only surviving example of its kind from Elliott's hand. It was painted probably near the lake's outlet into the Yellowstone River. Both Moran and Jackson made studies of the same scene. Moran's view, a somewhat more romanticized version, was published in Hayden's 1872 *Scribner's Monthly* article over the title *Yellowstone Lake* (fig. 17). Elliott's quiet, pastoral rendition, which glorifies the wild animals and the western sky as much as the lake, is additionally noteworthy in its passing reference to man. Moran's version shows part of the expeditionary force riding toward its camp to the south. Elliott's view, although it pictures the "Anna" on the lake and the tents and campfire smoke to the right, mirrored in spirit Hayden's comments that "so far as beauty of scenery is concerned, it is probable that this lake is not surpassed by any other on the globe."[50] This may explain why Elliott seemed content to concentrate his efforts on one, and apparently only one, finished work portraying Yellowstone.

Elliott employed a traditional topographical technique of panoramic, highly articulated drawings that encompassed a broad sweep of territory. Pen and ink drawings

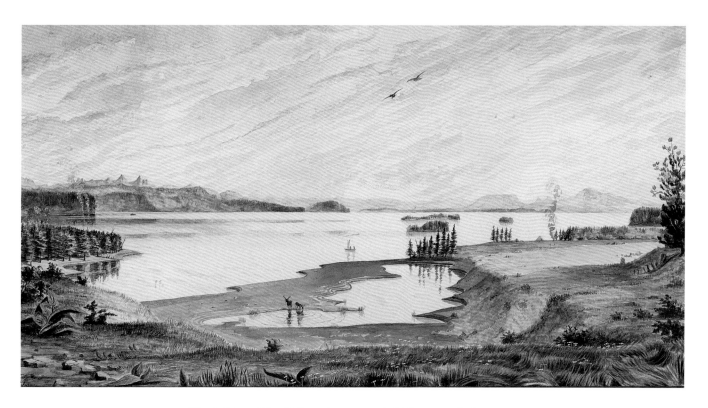

Pl. 7. Henry Wood Elliott (1846–1940). *Yellowstone Lake*, 1871.
Watercolor; 10 x 19¼ in. Phoenix Art Museum. Gift of Mr. and Mrs. Kemper Marley.

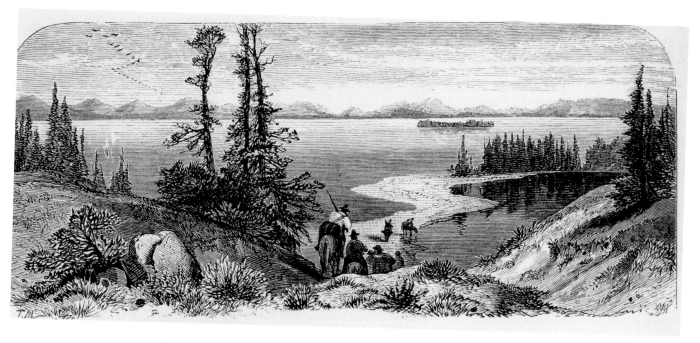

Fig. 17. Thomas Moran (b. England; 1837–1926). *Yellowstone Lake*, 1872.
Scribner's Monthly, February 1872. Wood engraving; 2⅛ x 4⅞ in. AP2 C4.
Reproduced by permission of the Huntington Library, San Marino, CA.

(figs. 18 and 19), with their expansive, horizontal reach and intricately crosshatched details delineating geomorphic contours, are masterful examples of the topographer's art. It was small wonder that Hayden's regard for Elliott was so high. On a miniature scale, these exquisite drawings were equivalents to the grand canvases of Moran or Bierstadt; they simply required closer examination and scrutiny.

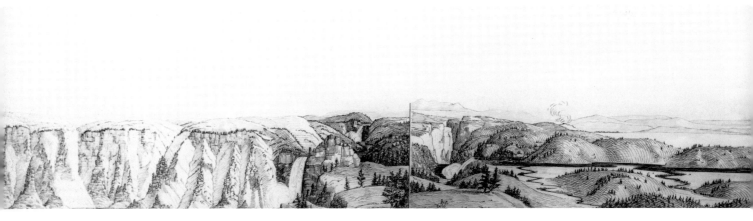

Fig. 18. Henry Wood Elliott (1846–1940). *The Turn*, 1871.
Pen and ink; 3 x 10⅛ in. National Park Service, Yellowstone National Park, WY.
Photograph by W. Garth Dowling, Jackson, WY.

When Elliott returned to Washington after the Yellowstone expedition, he was quickly persuaded to take on a venture even more distant and remote. Professor Spencer Fullerton Baird, a renowned zoologist and at that time assistant secretary of the Smithsonian, persuaded him to accept an appointment as assistant treasury agent for the Pribilof Islands off Alaska. He reported there in March 1872. Two months later he wrote Baird to say he would soon be resigning his government position and returning to private life, where, he wrote, "I can devote myself entirely to art, for I have already made such progress with the management of color during the past winter that I do not fear entering into competition with the best of the artists."[51] But this was an idle boast. He remained in Alaska for several years, married a local, and eventually moved back to his hometown, Cleveland, Ohio, to manage the land and agricultural interests owned by his family. He is known to the history of American conservation for his defense of the Aleutian seals and for a letter written in the late 1920s to the *New York Herald-Tribune* condemning congressional and commercial efforts to revise the boundaries of Yellowstone Park.[52] Although his heart remained true to Yellowstone, Elliott's dream of becoming an active artist faded over the years.

The other official artist with Hayden in the summer of 1871, Anton Schonborn,

left no lasting record of his experience. A skilled watercolorist, he had been with Hayden back in 1859 and 1860, in the employ of William F. Raynolds, when they made the first abortive effort to enter Yellowstone from the south. In the intervening years, Schonborn worked for the Army Quartermaster Department, making bird's-eye views of western forts. Several series of watercolor gems, each a minutely detailed portrait

Fig. 19. Henry Wood Elliott (1846–1940). *Lower Fire Hole Basin from the North East*, 1871.
Pen and ink; 4⅝ x 16½ in. National Park Service, Yellowstone National Park, WY.
Photograph by W. Garth Dowling, Jackson, WY.

of some western military settlement, attest to Schonborn's talent and the appeal of his work. It is little surprise that Hayden would remember the German-born topographer and invite him to join the 1871 expedition. His job would involve collaborating with Elliott to provide illustrations for the final report and to produce maps of the region traversed. Schonborn's response was gratifying to Hayden and showed that the artist was a bit bored with his lot in the army. Yes, he would go, at least in part because he "would much rather . . . explore some new country than run up and down on these forts here continually."[53] After the expedition, Schonborn returned to Omaha, where he had been headquartered. There he was to complete the official maps. Unfortunately for Hayden and for history, he became despondent and ended his own life before completing his task. His paintings of Yellowstone have been lost.

When Hayden decided to return to Yellowstone for the season of 1872, he had to look for fresh new artistic talent. Schonborn was dead, Elliott was counting seals in the Bering Strait, and Moran resided in Newark, basking in the glow of increasing public approbation and working assiduously on his watercolor commission for Blackmore. As testament to Hayden's ability as a judge of artistic talent, he made a superb choice. He selected another man from Ohio, William Henry Holmes (1846–1933), who

Fig. 20. William Henry Holmes (1846–1933). *On Yellowstone Lake*, 1872.
From "Random Records of a Lifetime, 1846–1931." Wood engraving.
Smithsonian American Art Museum, Smithsonian Institution, Washington, DC.

would become one of America's leading figures in the fields of science and art. When Hayden met him, Holmes was employed at the Smithsonian sketching specimens for Professor Baird. He had studied art with a well-regarded Washington painter, Theodore Kaufmann, and was anxious to apply those lessons to fieldwork, especially if it meant a trip to the now-famous Yellowstone.

Holmes's drawings, like Elliott's, varied from free, quick sketches to finished, elaborate panoramic vistas. Hayden found them useful for illustrating his geological reports, given that Holmes had training and experience drawing specimens, and for the preparation of maps. Holmes actively recorded images of camp life as well, capturing a scene of himself and industrialist William Blackmore, a guest on the trip, catching and cooking trout in an adjacent spring (fig. 20). He spent much time keeping his journal and "geologizing" with Hayden. And during a protracted stay in the Lower Geyser Basin, he "found time to observe pretty carefully all the geysers of any considerable importance." The pencil study from his sketchbook, *Steady Geyser, Lower*

Fig. 21. William Henry Holmes (1846–1933). *Steady Geyser, Lower Basin*, 1872.
Pencil on paper; 9 x 12 in. Peabody Museum, Harvard University, Cambridge, MA.
Photograph by Hillel Burger.

Basin (fig. 21), is representative of his effortless if somewhat naïve rendition of the enchanting and dynamic scene before him. He referred to the geysers in the area as "very chaste and delicate in form as well as color" and the broad vista of the basin as "uniquely beautiful" beyond anything he had ever seen.[54] Ironically, if Holmes painted in color during this or subsequent trips, or produced finished watercolors later in his studio using his field notations, none has ever come to light.

Elliott had sketched *Steady Geyser, Lower Fire-Hole* (fig. 22) the year before, and the drawing, lacking Holmes's sense of perspective and subtlety in modeling, was illustrated in the 1872 Hayden *Report*. Hayden, in looking over the same Lower Geyser Basin, had offered a seemingly odd but rather often-made observation. "The valley," he wrote in late August 1871, "was literally filled with columns of steam, ascending from more than a thousand vents. I can compare the view to nothing but that of some manufacturing city like Pittsburgh, as seen from a high point, except that instead of the black coal smoke, there are here the white delicate clouds of steam."[55] Thus, in a roundabout fashion, he agreed with Holmes in finding Yellowstone a "chaste" haven of unique beauty in an increasingly smoky industrial world.

Fig. 22. Henry Wood Elliott (1846–1940). *Steady Geyser, Lower Fire-Hole*, 1871.
From F. V. Hayden, *Geological Survey of Montana and Portions of Adjacent Territories*.
Wood engraving; $3^{1}/_{2}$ x $5^{1}/_{4}$ in. QE74 H4. Reproduced by permission
of the Huntington Library, San Marino, CA.

Holmes's "geologizing" with Hayden in 1872 stood him in good stead with the master of such pursuits. In 1878 Holmes returned to Yellowstone as geologist rather than artist. The drawings that resulted are sophisticated topographical renderings that led one of his many later biographers to proclaim him a "master artist of geological subjects and scientific interpretation of scenery."[56] Hayden too was impressed. "Mr. Holmes," he wrote, had "made sketches covering every square mile of the park, an area of 3,500 square miles." His drawings, mostly published as foldout plates of broad vistas (fig. 23), were, Hayden noted, "panoramic views with wonderful distinctness."[57] His abilities to portray more intimate scenes had improved since the 1872 visit. The drawing of an unidentified geyser pool (fig. 24) demonstrates his increased facility as a draftsman. These drawings and similar work from sites he documented across the West have led scholars like Wallace Stegner to position them as "the highest point to which geological or topographical illustration ever reached in this country." And, "once when pure geology was art, he made such pictures as no one has made since."[58] Henry Fairfield Osborn of the American Museum of Natural History lavished on Holmes the claim that he was "the greatest field artist America has produced."[59] Although Jack-

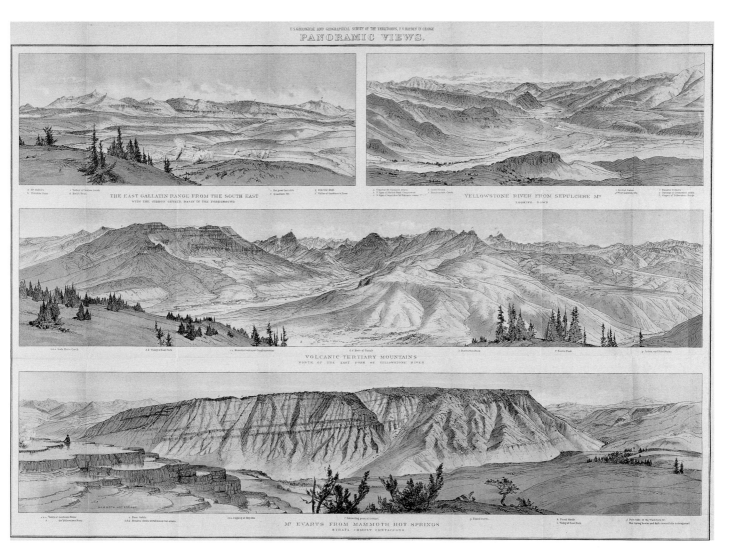

Fig. 23. William Henry Holmes (1846–1933). *Panoramic Views:*
The East Gallatin Range from the South East, Yellowstone River from Sepulchre Mt.,
Volcanic Tertiary Mountains, Mt. Evarts from Mammoth Hot Springs. Toned lithograph;
23 x 34$\frac{1}{2}$ in. Buffalo Bill Historical Center, Cody, WY. Gift of Donald G. Browne.

Fig. 24. William Henry Holmes (1846–1933). *Sketches Made on a Trip from Point of Rocks to Yellowstone Park*, 1878. Pencil; 7 1/8 x 11 7/8 in. U.S. Geological Survey Field Records Library, Denver, CO

son accompanied Hayden and Holmes on this trip and emerged with a bulging portfolio of magnificent photographs, Holmes's images take the viewer beyond them into a realm of super-reality. Holmes made the facts of Yellowstone beautiful. Contrary to Moran's interpretations, his were emptied of mystery, but brimming with nuance and a scintillating poetry of line.

The U.S. Geological Survey under Hayden was closed down by Congress in 1879 and neither Holmes nor Hayden would return to Yellowstone again as explorers. Holmes was invited back for a tour by park Superintendent Horace Albright in 1925, but by that time he was director of the National Gallery of Art and his duties in that regard were "so exacting that the time could not be spared."[60] Despite the fact that Holmes's and Elliott's images of Yellowstone were widely dispersed, it was always Thomas Moran who set the standard for pictorial representation of its beauties. Holmes and Hayden held immense regard for Moran, even insisting that the report of their final Yellowstone expedition of 1878, published belatedly in 1883, be lavishly illustrated with chromolithographic plates by Moran.[61] Few visitors or long-distance observers could envision the park without seeing it through Moran's tinted washes. General John Gibbon, who dragged an enthusiastic but rather rag-tag troop through the park in 1872, recognized the connection immediately. After scribing a flamboyantly colorful account of the Lower Falls as pure "majesty" revealed through a "veiled mist" and the plung-

ing torrent as a "bright sea-green surface flecked here and there with white," he cred-
ited Moran with helping him to paint such a verbal picture of nature's marvel. He fell
short when provincially describing the canyon walls as brushed with a "Milwaukee
brick-yellow" but concluded by saying that "the novelty and beauty of the scene" were
guaranteed in that "these slopes are colored with the most brilliant hues, not one par-
ticle exaggerated by the brush of Moran in his view of the Falls."[62]

Despite these affectionate affirmations, Moran had his adversaries. Eugene Top-
ping, who in 1872 led one of the earliest tourist parties into the park, recalled a decade
later the essential argument of one of Moran's primary detractors. The story, recounted
rather matter-of-factly, went like this:

> Prof. Hayden, the United States geologist, with a corps of topographers and
> naturalists, explored the headwaters of the Yellowstone and Madison rivers the
> summer of 1871. With him was Moran, the great colorist. He made a picture of
> the Yellowstone falls and canyon, for which congress gave ten thousand dollars,
> and now it hangs in the old hall of representatives. Many of his brother artists crit-
> icized its high coloring. Among these critics was Bierstadt. In 1881 the latter artist
> came to the National Park and, after seeing the vivid and varied coloring of the
> canyon, remarked that he owed and should give an apology to Moran, for no
> colors in art could do justice to nature's, as shown here.[63]

In the early 1880s, even though he was loath to admit it, Albert Bierstadt's fame
was on the wane. He had persisted in allying himself with a passing fashion in art, the
theatrical and exaggerated pictorial idiom of the Düsseldorf Academy. It was a lan-
guage that he had learned early in life and to which he pledged far too much of his
considerable talent. Long before Turner's and Ruskin's lessons would become passé,
the arrogant pictorial bombast of Düsseldorf had slipped from favor. Bierstadt was
considered old school.[64] Yet he was tenacious, stubborn, and not interested in con-
ceding defeat. Above all, he was not about to relinquish his place as America's grand
master of the western machine to a younger but substantially more frail, wispy, and
whiskered neophyte from Newark. When Bierstadt arrived at Yellowstone's thresh-
old in July 1881, his baggage included his palette and paints, his camping gear, and
an extravagant political agenda that would consume almost as much energy as the artis-
tic challenge ahead of him. He had been scheming since the mid-1860s to convince Con-
gress to purchase at least one of his "Great Pictures," a panoramic western landscape,
for the Capitol. He might easily have preceded Moran in providing the first monu-
mental American landscape to adorn those hallowed halls, but he demanded a capi-
tal price for his efforts and the congressmen demurred. Eventually Bierstadt prevailed
and turned out two undistinguished historical tableaux a decade later and at a much
reduced rate.[65]

In an effort to curry favor in government circles, Bierstadt made a practice of rubbing shoulders with people in high places. Presidents were a specialty for him, and he sustained favor in the White House over several administrations. When President Rutherford Hayes and his son Webb came to visit Holmes in March of 1878 and look over his work, Bierstadt was in tow. He had spent a month in residence at the White House, attending state dinners and promoting his cause for state patronage. He must have been impressed by Holmes and his art, as he returned to visit his fellow painter in May, just before Holmes's second trip to Yellowstone.[66]

Perhaps because of this and other contacts with Holmes, Bierstadt made plans to visit Yellowstone himself.[67] In July 1881 Bierstadt, accompanied by a small but distinguished party that included the brothers John and General William T. Sherman, started west for a several weeks' tour of the park.[68] Later that fall Bierstadt granted an interview to the *New York Express* in which he recounted his adventure.

> Yes, I have enjoyed myself—far more than I expected. I roughed it because it was necessary, and I think that I feel better for it. Why, I have become so accustomed to robust exercise that now I am in the midst of civilization I hardly know what to do with myself. While I was in the park we lived in tents almost exclusively. There are no houses anywhere near the geysers, and hence we found it sometimes very lonely. I say lonely because I did not find people to converse with; but, ah! how can one be lonely when one is surrounded by all the glories of a most glorious nature, and overhung by a sky unequaled by any in the world? I do not think that the coloring of nature is more vivid in the West, and particularly in the National park, than in the East. The Yellowstone region is several thousand feet above the level of the sea, and the only tree with which one grows familiar is the evergreen. To see these trees clothing the sides of the loftiest mountains, fringing the edges of cascades and the shores of rivers, gives a peaceful although somewhat monotonous character to the scene. The turf is dark, and, except where a few wild flowers spring through the verdure, the tone is a very rich one. This is not the first season I have spent about the Rocky mountains, but it is my first introduction to the geysers of the Yellowstone. To use the word wonderful is simply to use a relative term. But I have never been so impressed with the infinite divinity of the types of nature as I was by these same geysers. I went West with the fixed intention of spending the greater part of my time about the geysers, and also to study them as thoroughly as I could in the protracted period I had allotted to myself. I have always had an inclination towards geological studies, and here I had a whole world of geological phenomena spread before me. You can understand I took advantage of it, and I am impressed more than ever with the surpassing beauties of the earth itself, as it is naked and unadorned save by its manifold parts.[69]

There were several reasons for Bierstadt's choosing to visit Yellowstone at that time. Some are apparent from the interview, and others are not. First of all, this was a chance to have some fun and a taste of adventure with friends. He enjoyed proving his mettle and wanted to continue to be known for his physical stamina and skills as an outdoorsman. He was obviously much enamored of the geology and, not wishing Moran or even Holmes, who really deserved it, to lay sole claim to being students of such interesting physical features, he wanted to let the public see that he could appreciate and understand fact as well as fancy as an underpinning of art.[70] He may also have gone in hopes of observing animal life there. One of his dreams at this time was to produce a series of animal paintings that could be engraved and distributed as a commercial venture. A book he had illustrated in 1879, A. Pendarves Vivian's *Wanderings in the Western Land*, was a precursor to such an enterprise. However, so far as it is known, Bierstadt did not paint animals in the park in 1881, regardless of the fact that "elk, deer, antelope and bear were plentiful."[71]

Bierstadt was also in search of new material and an opportunity to confirm his standing as one of the triumvirate of artistic heroes of the western scene mentioned in the first systematic review of the nation's art, published in 1880. Critic and historian S. G. W. Benjamin in his book *Art in America* glorified Moran, Bierstadt, and Thomas Hill (1829–1908) for their larger-than-life efforts in bringing western landscape subjects to the public's attention. These men, Benjamin adulated, had "dared, discovered, and delineated for us the scenery of which we were hitherto the ignorant possessors."[72] It might not seem logical that Bierstadt would have felt he needed such a puff or that new scenery or fresh inspiration was so critical. However, his old paintings, which because of the nation's current economic jitters were being placed on the secondary market, were bringing disastrously low prices.[73] Since he could not control everything, he wisely chose to search for new and, he hoped, attractive material. Yellowstone would perhaps help sustain not just his physical vigor but his aesthetic and commercial viability as well.

While Benjamin had grouped Bierstadt as one of the real adventurers among America's landscapists, he also found plenty of room for criticism. Bierstadt was too wedded to sensationalism and searching for the ideal aspects of nature and thus, lamentably, had lost sight of the gentler side of things and "local truth" that could be revealing and gratifying.[74] There are qualities in his Yellowstone work that show the artist may have taken the critic's observations to heart.

Bierstadt's admitted fascination with Yellowstone's geysers is reflected in the number of paintings that he produced using them as themes. Unlike Moran, Bierstadt did not make quick watercolor studies in the field. Rather, he employed a method of working in oil on paper and executing fairly finished pieces at the site. John Sherman remembered watching Bierstadt "make a sketch of 'Old Faithful,' showing Mr. [Alfred A.]

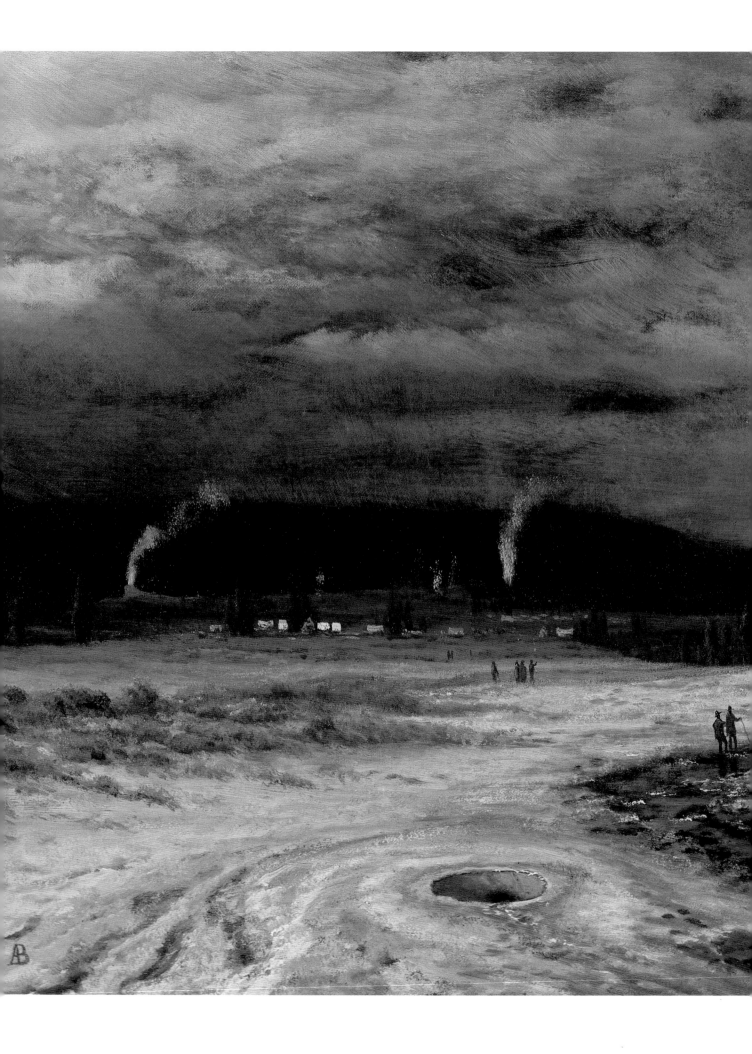

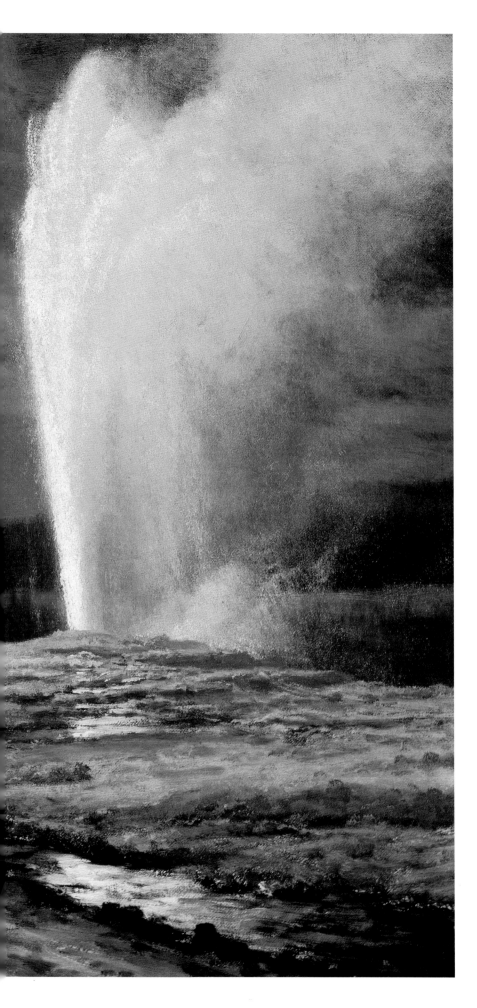

Pl. 8. Albert Bierstadt
(b. Germany; 1830–1902).
Old Faithful, c. 1881.
Oil on canvas;
14 x 20 in. Collection
of Karen H. Bechtel.

Hoyt and myself in the foreground, with the geyser in full action. He subsequently expanded this picture into a painting, which I now own and greatly prize" (plate 8).[75] Other more light-filled and dynamic studies include [*Castle*] *Geyser, Yellowstone Park* and *Fountain Geyser at Yellowstone* (plates 9 and 10). Contrasted with his conventional, monumental landscapes infused with Claudian glow and other theatrical effects, these studies are intimate and naturalistic. It seems a bit ironic that his view of Castle Geyser is nearly identical to the compositions already published by Moran and Jackson (figs. 25 and 26), but the prospect was compelling, and Bierstadt captured a strikingly more dramatic and playful pose than had his predecessors.

The party only spent one day at the falls. The Shermans entertained themselves pushing boulders into the canyon, while Bierstadt was hard at work. He made at least two important studies of the Lower Falls and one of the Upper Falls. One intimate close-up view (plate 11) is a remarkable study in light and texture. The distant view (plate 12) endeavors more to achieve a resolution of compositional possibilities and atmospheric tonal experimentation. The author of one of Yellowstone's early guidebooks and a famous tour guide, William Wylie, had occasion to observe Bierstadt creating this sketch. He later recalled, "The author had the pleasure of sitting beside and conversing with the famous American artist, Bierstadt, as he was seated on a point in the Grand Canyon about 400 feet below the surface engaged in reproducing in oil, upon canvas, the Grand Canyon and Falls. It was indeed marvelous to see with what rapidity and accuracy these scenes were by him transferred to the canvas."[76]

At least two large versions of this scene resulted from these studies. One measuring nearly sixty inches in height, *Yellowstone Falls* (fig. 27), presents a clear, sunlit view with grand but not overly theatrical presentation. The other version of the same title (plate 13) is more dramatic, though smaller. With its opalescent tonality and diaphanous mists, this interpretation suggests the mystery and divine association that Bierstadt says he felt in the park. Its softened details, reflecting rather closely the spirit of the distant sketch, represent a stylistic change from his earlier, more literal transcriptions of nature's details. Perhaps, as art historian Donald Keyes has suggested, Bierstadt was making a move toward tonalism, "fluid colors," and a more modern mode of portraying nature through suggestion as much as tight pictorial translation.[77] In concentrating on a vertical format, Bierstadt may also have felt he was providing a compositional corrective—a solution that Moran would explore in later paintings of the falls. And by bringing the falls up relatively close to the viewer, Bierstadt avoided repeating Moran's composition and broke away from his own traditional Wagnerian panorama. This, along with the relatively smaller scale of these finished paintings, allows the viewer to focus on the emotion and pictorial effect without being distracted by a monumental ensemble of orchestrated but disparate effects. For once, Bierstadt's public voice and his private vision were not at odds with one another.[78]

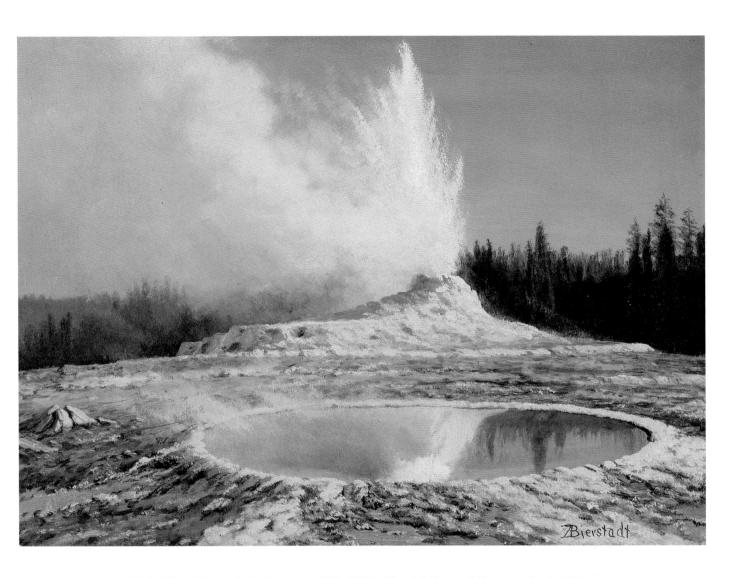

Pl. 9. Albert Bierstadt (b. Germany; 1830–1902). *[Castle] Geyser, Yellowstone Park*, 1881.
Oil on paper; 14 x 19$\frac{1}{2}$ in. Courtesy of the Museum of Fine Arts, Boston, MA. Gift of Mrs.
Maxim Karolik for the M. and M. Karolik Collection of American Paintings, 1815–1855.

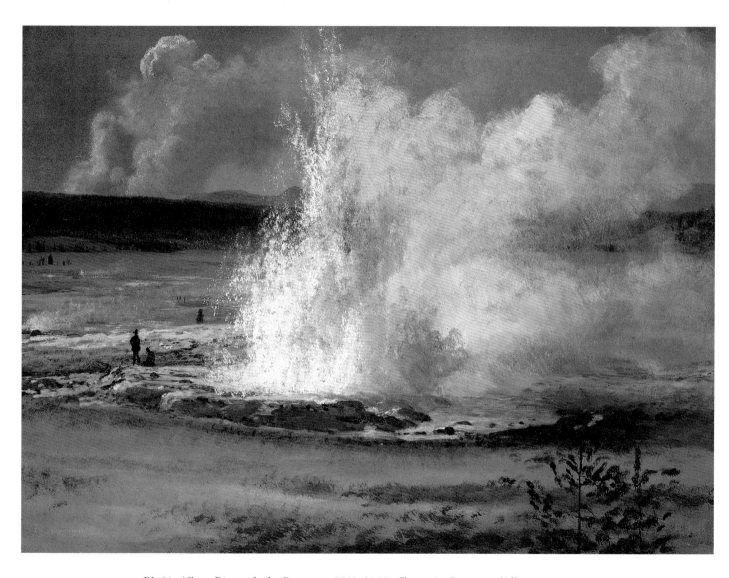

Pl. 10. Albert Bierstadt (b. Germany; 1830–1902). *Fountain Geyser at Yellowstone*, 1881.
Oil on paper; 13$\frac{1}{2}$ x 18$\frac{1}{2}$ in. On loan from Robert Coe to Buffalo Bill Historical Center, Cody, WY.

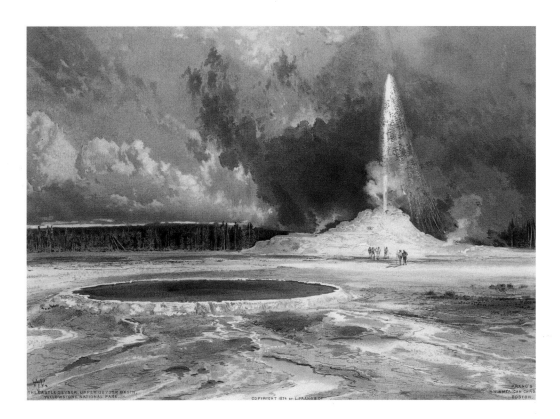

Fig. 25. Thomas Moran (b. England; 1837–1926). *The Castle Geyser, Upper Geyser Basin*, 1876.
From F. V. Hayden, *Yellowstone National Park*. Chromolithograph; 21 x 28³/₄ in. RB 289000.
Reproduced by permission of the Huntington Library, San Marino, CA.

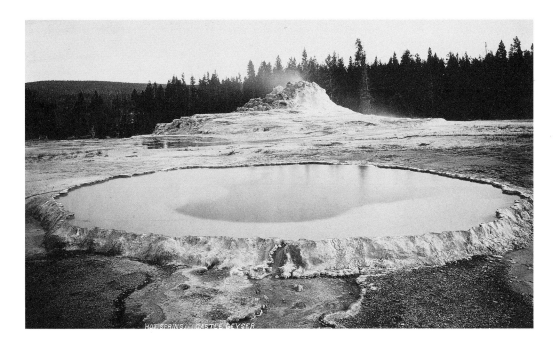

Fig. 26. William Henry Jackson (1843–1942). *Hot Spring and Castle Geyser, Yellowstone*,
undated. Photograph. Yale Collection of Western Americana, Beinecke Rare Book
and Manuscript Library, Yale University, New Haven, CT.

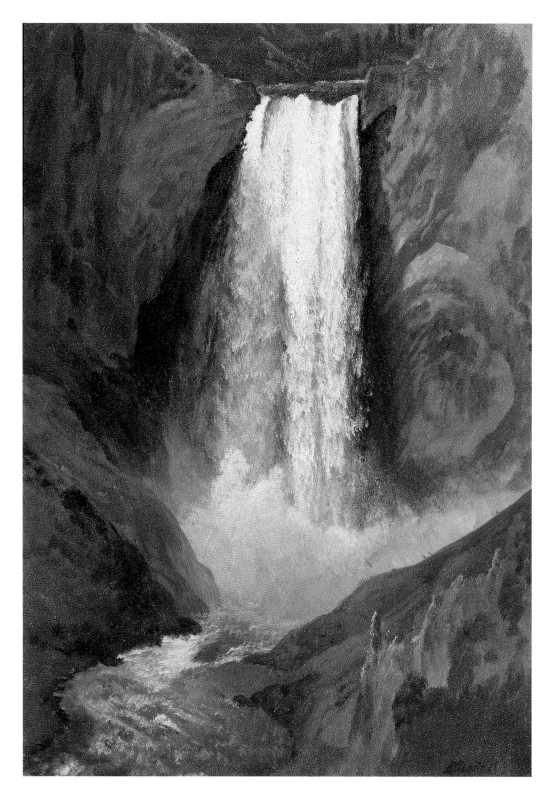

Pl. 11. Albert Bierstadt (b. Germany; 1830–1902). *Falls of the Yellowstone*, 1881.
Oil on paper; 18^7/$_8$ x 13^1/$_2$ in. Private collection of J. R. Butler.

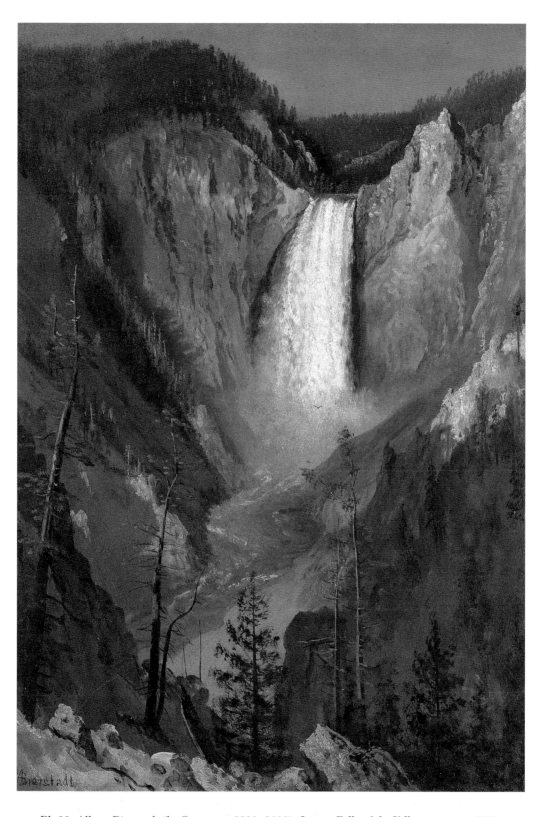

Pl. 12. Albert Bierstadt (b. Germany; 1830–1902). *Lower Falls of the Yellowstone*, ca. 1881.
Oil on paper, mounted on canvas; 19$^{1}/_{4}$ x 13$^{1}/_{2}$ in. GMOA 45.6. Georgia Museum of Art,
University of Georgia, Athens, GA. Eva Underhill Holbrook Memorial Collection
of American Art. Gift of Alfred H. Holbrook.

Pl. 13. Albert Bierstadt (b. Germany; 1830–1902). *Yellowstone Falls*, 1881.
Oil on canvas; 44$\frac{1}{4}$ x 30$\frac{1}{2}$ in. Buffalo Bill Historical Center, Cody, WY.
Gift of Mr. and Mrs. Lloyd Taggart.

Fig. 27. Albert Bierstadt (b. Germany; 1830–1902). *Yellowstone Falls*, 1881–1883.
Oil on canvas; 59½ x 37½ in. Courtesy of the R. W. Norton Art Gallery, Shreveport, LA.

Fig. 28. J. F. Jarvis. *Mrs. Harrison's Reception Room*, c. 1890.
Stereoview; 4³/₈ x 4 in. The White House, Washington, DC.

Even with these changes, however, Bierstadt was not about to relinquish his grip,
rather desperate at this point, on the potential arbiters of culture. No sooner had he
returned to his studio and produced a set of finished works suitable for an upscale
American salon, than he shipped off three Yellowstone paintings to the newest resi-
dent at the White House, President Chester A. Arthur. Moran had received a breveted
appointment as an honorary member of the U.S. Geological Survey some years
before. Bierstadt, a master at one-upmanship, would be the painter to the presidents.
It was another route for his continued search for official approbation. The president
took the works seriously, decorating two of the White House rooms with them (fig. 28).
He was also spurred by them to visit the park himself—"go out and see the originals,"
so he said—and in 1883 made his own much publicized tour of Yellowstone.[79]

It was apparent that Bierstadt had not seen all he wanted to see on his 1881 visit.
In the winter of 1883 he wrote to Frank J. Haynes asking for photographs of hunting
scenes and a dozen prints of "geysers in eruption" and the Upper Falls taken from
below.[80] Perhaps he was just then working on one of the larger versions and wanted
corroboration of facts, or his Yellowstone subjects may have been selling briskly enough
that he needed additional settings to explore.

"Some of the qualities we have learned to look for in vain in the canvases of Bier-
stadt," wrote S. G. W. Benjamin in 1880, "we find emphasized in the paintings of

Thomas Hill, who succeeded him as court painter to the Monarch of the Rocky Mountains."[81] Hill's domain had been the White Mountains of New Hampshire and California's Yosemite Valley, into each of which he had followed Bierstadt's footsteps. In August 1884, San Francisco's newspaper *The Argonaut* announced that Hill, one of the city's most eminent painters, had left for Yellowstone "where he expects to remain for several months."[82] There he could test his skills against both Bierstadt and Moran, who were wont to paint in his own favorite sanctuary, Yosemite. There he could prove whether or not Benjamin's assessment of his talents as compared to Bierstadt's was valid, that Hill was "a good colorist, bold and massive in his effects, and a very careful, conscientious student of nature."[83] But, actually, Hill was escaping a failed marriage and one of nature's more severe lessons: his studio in Yosemite had been destroyed by a horrendous windstorm.[84]

Exactly how long Hill remained in Yellowstone is unknown, but certainly not "several months." He was there long enough to make a sizeable number of spirited field studies, which like Bierstadt's were made in oil. Many of those studies were surprisingly monochromatic for a proclaimed colorist. Yet, as with [*Upper*] *Yellowstone Falls* (plate 14), the virtuoso brushwork, the clarity of atmosphere and light, and the honesty of observation stand up to Benjamin's assessment.

Hill spent the following winter in New Orleans. There he produced some stunning, and wonderfully imaginative, large studio pieces. The canyon had left its mark on his soul. Finished studio works such as *Great Falls of Yellowstone* (plate 15), with its imaginary bird's-eye vantage point that includes a peek at the Teton Range to the south (which cannot be seen from the canyon area), are so full of light and so engagingly reflective of painterly lessons he had absorbed from mentors in Paris during the 1860s that they represent Hill at his very best. That same winter he produced one of the major paintings of his career, *The Grand Canyon of the Yellowstone* (plate 16). Like Moran's great machine of 1872, Hill's composition was a horizontal one in which the falls are nearly obscured by a veil of spray. Fanciful thermal plumes are seen up the river from the falls, and again he placed the Tetons in the distance (an imaginary addition that Moran had made to his magnum opus as well). The forests in the foreground, richly cloaking the cliffs, seem more reminiscent of the verdure of Fontainebleau from his student days in France than testaments to him as a conscientious pupil of nature. But such fancy was made up for by his enthusiastic treatment of the canyon's surfaces and textures and the brilliant, and somewhat uncharacteristic, triumph of perspective that he achieved through the use of atmospheric effects. The ospreys, nested and prominently presented in the composition, may have been mistaken for eagles and thus meant as a symbol of the park's national significance.

It was with personal, professional, and national pride that Hill exhibited this grand panorama in the World's Industrial and Cotton Centennial Exposition during

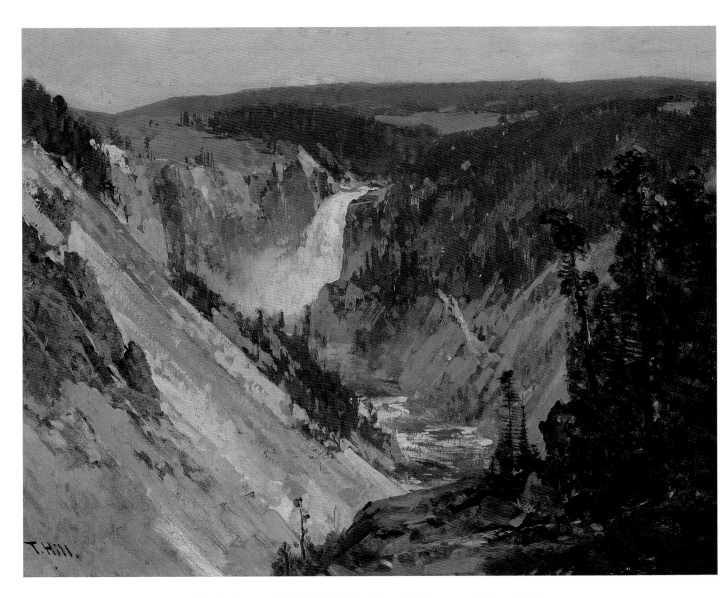

Pl. 14. Thomas Hill (1829–1908). *[Upper] Yellowstone Falls*, c. 1884.
Oil on canvas; 18 x 24 in. Courtesy of Mrs. Charles Smith.

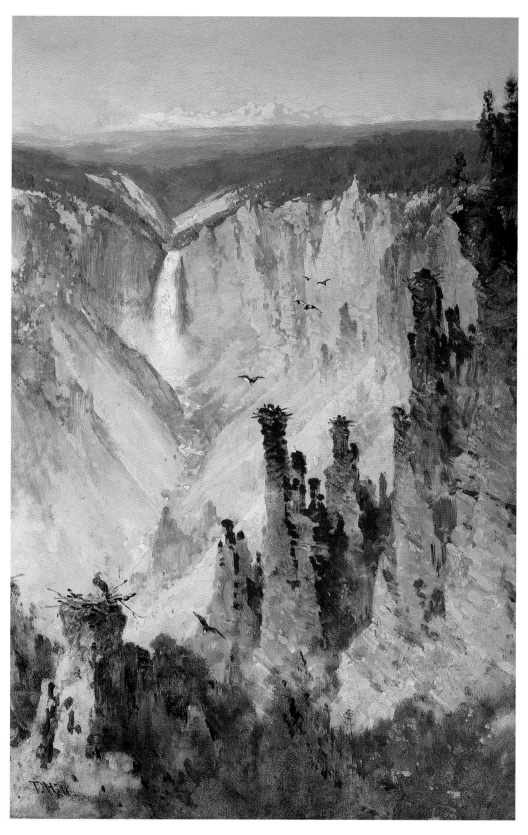

Pl. 15. Thomas Hill (1829–1908). *Great Falls of Yellowstone*, c. 1884.
Oil on canvas; 30 x 20 in. National Museum of Wildlife Art, Jackson, WY.

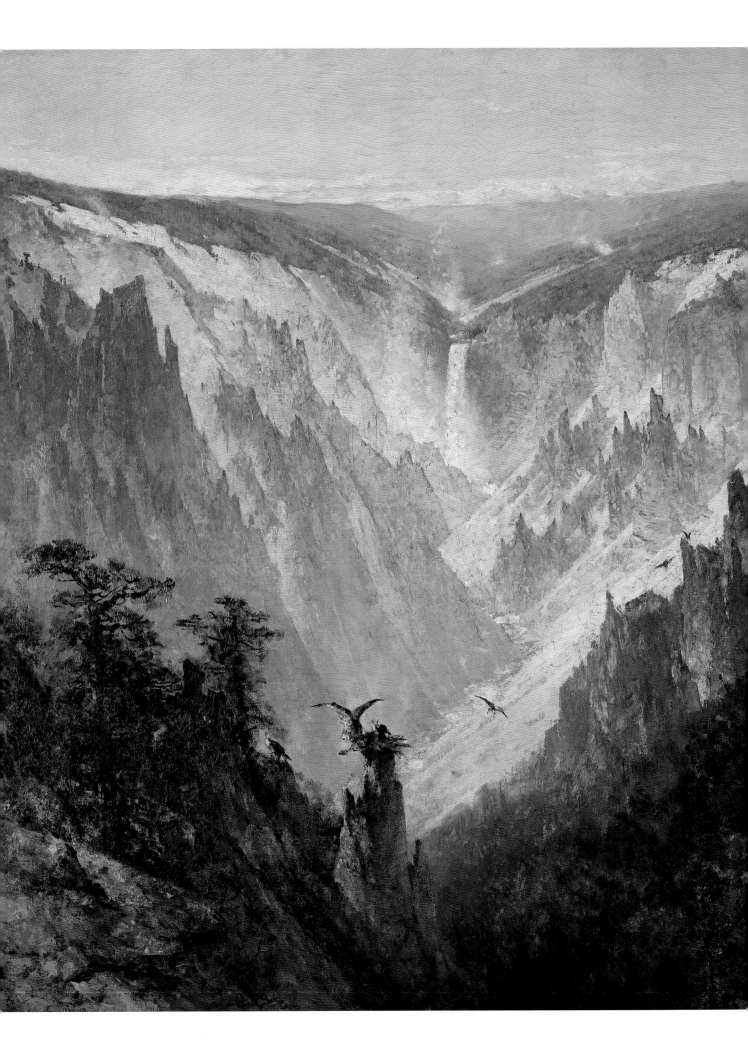

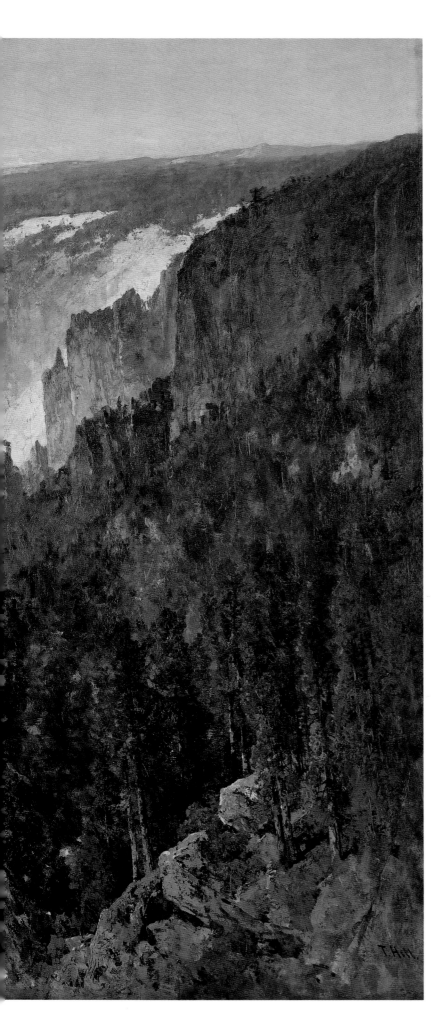

Pl. 16. Thomas Hill (1829–1908).
*The Grand Canyon of the
Yellowstone*, c. 1884.
Oil on canvas; 66 x 92 in. The
Detroit Institute of Arts. Gift
of Mrs. George O. Robinson.

the winter of 1884–1885.[85] John Muir was impressed. He visited Yellowstone in 1885 and, attesting to the impression made on him by the canyon and Hill's painting of it, included it as a plate in his monumental volume, *Picturesque California*.[86] By the summer of 1885, Hill had settled into a comfortable new studio near the Wawona Hotel just outside Yosemite. So even if Hill's plate in Muir's book was not a California scene, the artist was a favorite son of the state and his latest effort worthy of inclusion.

Muir would write of Yellowstone's celebrated canyon in terms that describe the painting as well as Hill's interpretation of it. He began with a summary of sorts, saying that it is "a weird, unearthly-looking gorge of jagged, fantastic architecture, and most brilliantly colored." But then he focused his remarks, as if reciting the compositional nuances of Hill's canvas.

> It is not the depth or the shape of the cañon, nor the waterfall, nor the green and gray river chanting its brave song as it goes foaming on its way, that most impresses the observer, but the colors of the decomposed volcanic rocks. With few exceptions, the traveler in strange lands finds that, however much the scenery and vegetation in different countries may change, Mother Earth is ever familiar and the same. But here the very ground is changed, as if belonging to some other world. The walls of the cañon from top to bottom burn in a perfect glory of color, confounding and dazzling when the sun is shining,—white, yellow, green, blue, vermilion, and various other shades of red indefinitely blending. All the earth hereabouts seems to be paint.[87]

Hill had also spent much time and attention on the geysers. It was the play of their watery spray against the Wyoming sky that fascinated him, and his studio works like *Geysers in Yellowstone* (plate 17) evidence the vitality and freshness of the artist's memory. They stand in striking contrast to the comparatively somber though elegant later renditions by Bierstadt, as in *Old Faithful* (plate 18).

Like Moran, Hill was born in England and came to America with his family at a young age. He studied art in Moran's hometown of Philadelphia, attending classes at the Pennsylvania Academy of the Fine Arts. His initial dream was to be a history painter, but further study in Europe, especially among the Barbizon painters and in the Paris studio of the German Paul Meyerheim, convinced him of his proclivities toward landscape. His first grand painting of *The Yosemite Valley* (1871) was published as a chromolithograph by Prang and subsequently exhibited at the Philadelphia Centennial Exhibition of 1876,[88] proving that the young painter had made a wise choice.

In July 1883 the *Livingston Enterprise* reported that a topographer of considerable skill and reputation, John Henry Renshawe (1852–1934), was preparing to depart Washington, D.C., on his way to Yellowstone National Park. Renshawe's purpose, according to the account, was to make a topographical survey of the park in

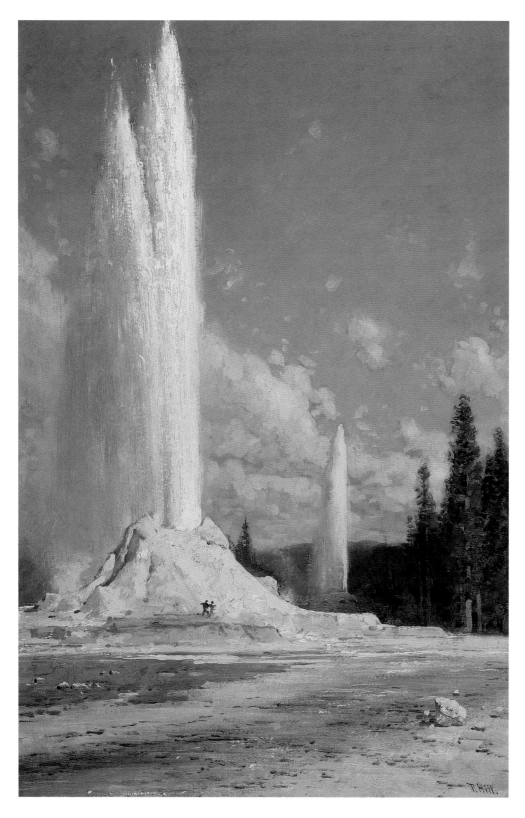

Pl. 17. Thomas Hill (1829–1908). *Geysers in Yellowstone*, c. 1884.
Oil on canvas; 30 x 20 in. Private collection. Courtesy of William Doyle Galleries.

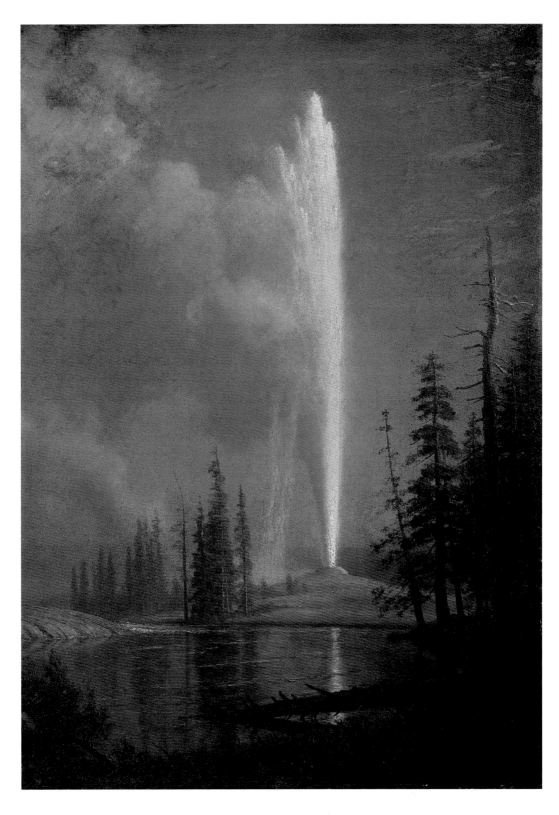

Pl. 18. Albert Bierstadt (b. Germany; 1830–1902). *Old Faithful*, c. 1881.
Oil on canvas; 28$\frac{1}{2}$ x 20$\frac{1}{4}$ in. Private collection. © 1999 Sotheby's, Inc.

concert with geologist Arnold Hague of the U.S. Geological Survey for whom he worked. The effort put into the project by Renshawe would consume much of that season and the one to follow.[89]

Little is known about Renshawe's early life other than that he was born in Pattonsburg, Illinois, and, after teaching high school for a few years, joined John Wesley Powell's survey in 1872 as a general assistant. He subsequently worked with Powell as a topographer until 1879, when Clarence King assigned him as a topographer with the new U.S. Geological Survey. During the years between 1882 and 1885, Renshawe directed the Montana [Geographical] Division's mapping section, a position he held during his two summers in Yellowstone. By the time he retired in 1925, Renshawe had spent more than fifty years as a geographer and mapmaker for the U.S. government.[90]

What Renshawe is remembered for today, however, is not his maps but rather a set of five watercolors executed in Yellowstone during and perhaps shortly after his summer tour of 1883.[91] Somewhat drier and more controlled than Thomas Moran's work of a decade earlier, Renshawe's watercolors exude a sunny clarity and velvety warmth that is found in no other Yellowstone art of the period. *Upper Geyser Basin, Firehole River* (plate 19) speaks to his exceptional facility as a watercolorist.

As distinctive as Renshawe's work appears to be, he clearly labored in Moran's shadow. Renshawe's *Tower Creek* (plate 20), with its vantage of the pinnacles from above the falls, suggests that he was intimately familiar with Moran's depiction of the same scene in the chromolithograph *The Towers of Tower Falls* (fig. 29), from the 1876 Louis Prang portfolio. Renshawe had, in fact, replicated Moran's view almost exactly, indicating that this piece was not done from nature but rather as a studio pastiche or practice study to aid him with painting in the style of Moran. Renshawe even reproduced the imaginary golden aura from the setting or rising sun against which the grandest and most phallic of the spires is silhouetted. It was an invented device that could not, by the lay of the land, have occurred in nature.

Bierstadt, Hill, and even Renshawe stand in time between Moran's first trip to Yellowstone with Hayden in 1872 and a purposeful return twenty years later. They also bridge dramatic changes in style and in the perception of the sublime and real in nature. Although Bierstadt and Hill repeated scenes from Yellowstone in the years immediately following their respective visits, Moran rekindled a love affair with the park, igniting a spiritual and artistic flame that would burn for the remainder of his long and productive life.

The circumstances of Moran's second visit to Yellowstone were recorded by the *Rocky Mountain News* when he passed through Denver in mid-June 1892. "Mr. Moran is on his way to the Yellowstone national park. He will be accompanied on his trip by W. H. Jackson of this city and the world's fair commissioners of Wyoming, the object of the trip being to secure materials for a large picture to be exhibited at the world's

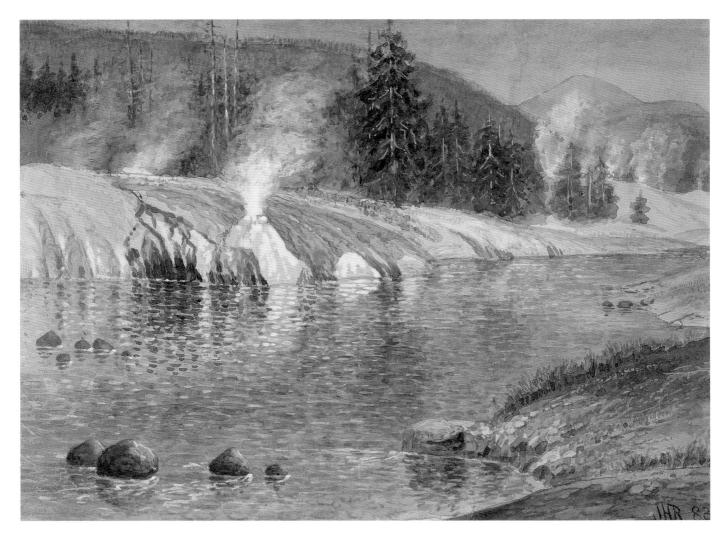

Pl. 19. John Henry Renshawe (1852–1934). *Upper Geyser Basin, Firehole River*, 1883.
Watercolor; 8 x 11 in. National Park Service, Yellowstone National Park, WY.
Photograph by W. Garth Dowling, Jackson, WY.

fair.”[92] Moran's trip west had been paid for by the Santa Fe Railroad, and he had made a swing to the Grand Canyon of the Colorado on his roundabout way to Denver to make sketches for a painting promoting those business interests. His work in Yellowstone was similarly motivated by commercial appetites, this time sponsored by Wyoming's tourism offices in the interest of increased visibility for the new state. The party made a detour north to Devil's Tower, which Moran sketched and later wrote about in an article for *Century Magazine*,[93] then over the Big Horn Mountains, through the upper Clarks Fork drainage, and into the northeast corner of Yellowstone.

Moran found that he was something of a celebrity in those familiar haunts. “I have been made much of at all the places in the park as the great and only 'Moran,'

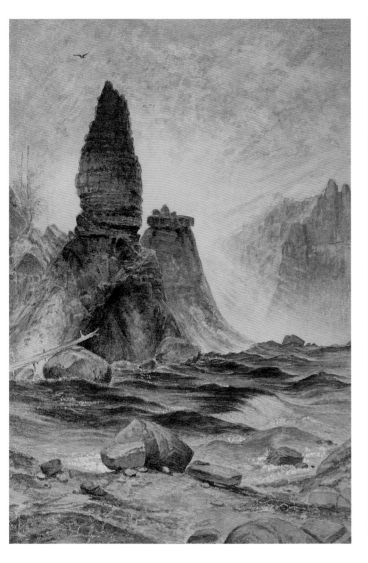

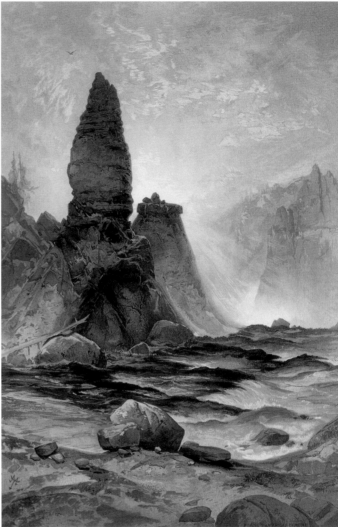

Pl. 20. John Henry Renshawe (1852–1934).
Tower Creek, 1883. Watercolor; 13³/₄ x 9³/₈ in.
National Park Service, Yellowstone National Park, WY.
Photograph by W. Garth Dowling, Jackson, WY.

Fig. 29. Thomas Moran (b. England; 1837–1926). *The Towers
of Tower Falls*, 1876. F. V. Hayden, *Yellowstone National Park*.
Chromolithograph; 12¹/₂ x 8⁹/₁₆ in. RB 289000. Reproduced by
permission of the Huntington Library, San Marino, CA.

the painter of the Yellowstone," he wrote to his wife Mary in late July. He took plea-
sure in seeing the geysers again but was ecstatic at his reacquaintance with the canyon
and the Lower Falls. "It is as glorious in color as ever and I was completely carried
away by its magnificence. I think I can paint a better picture of it than the old one
after I have made my sketches."⁹⁴ And there was so much to sketch that he returned
to the canyon for several more days at the end of his trip, just to record additional
details. The sketches, in pencil and watercolor or mixed, reveal Moran's growing sophis-
tication as a draftsman. *East Wall of the Cañon from Inspiration Point* (fig. 30) is an

astonishingly beautiful record of facts collected on paper with vigor and originality of vision. Although not intended for sale or completion as Bierstadt's and Hill's studies in oil were, the picture is a fully resolved composition, an entrancing visual moment.

Even with an ample portfolio of sketches, Moran faced a challenging and different world in 1892 than he had met twenty years earlier. His family and his commodious Long Island studio welcomed him home. As his daughter Ruth later wrote, "He seemed always to be starting off or coming back from strange, beautiful places, wild countries,"[95] and this was no exception. His public applauded such peripatetic wanderlust from the ever-adventurous Moran. But their expectations of his resulting work had changed and demanded not just a "better picture" but an altogether new approach. In January of that year, a group of watercolors and oils belonging to L. Prang & Company was exhibited in Boston and New York, among them some of his earlier Yellowstone pieces. A review in the *New York Post* provided a reassurance in saying that the scenes from Yellowstone, dating back now to the mid-1870s, "are quite equal to much he has done since"—Turneresque views of Venice and Vera Cruz mostly. But the reviewer also questioned the Yellowstone works as "high art," recognizing in them an intent as illustrations.[96]

Moran had watched his cherished Pre-Raphaelite focus on detail dim in the eye of the public and the critics. He had endured being chastised by Ruskin in 1882 for abandoning the detailed, intimate view and the "little true landscape absolutely from nature," in favor of "that flaming and glaring and splashing and roaring business" that went into his current subjects.[97] But moral and artistic perfection could no longer be found in Ruskin's sanctuary of realistic truth. Moran wanted desperately to find an American as well as a personal way, just as his compatriot George Inness had, of rejecting Ruskin and even the topographical exactness of the unfashionable Hudson River school painters, and to glory in introspective nuances, universal spiritualism, and the emotional, hidden power of everyday places.[98] Except, of course, that Yellowstone, Moran's proven favorite, was not so common a place—he had, in fact, helped construct it as a mythic wonderland that was as large in the public conception as the West itself. His challenge then involved finding a way to evoke a personal mood, a way of touching an individual chord of a single soul through epic rather than mundane subject matter.

Inness had proclaimed in 1884 that "a work of art does not appeal to the intellect. It does not appeal to the moral sense. Its aim is not to instruct, not to edify, but to awaken emotion."[99] Moran recognized such sentiments as the regurgitation of what was to him an unattractive Barbizon school didactic. In a search to find himself in this changing world and not pander to foreign (by which he meant French or German) dictum, Moran effected a compromise. Because of his patriotic inclinations and the

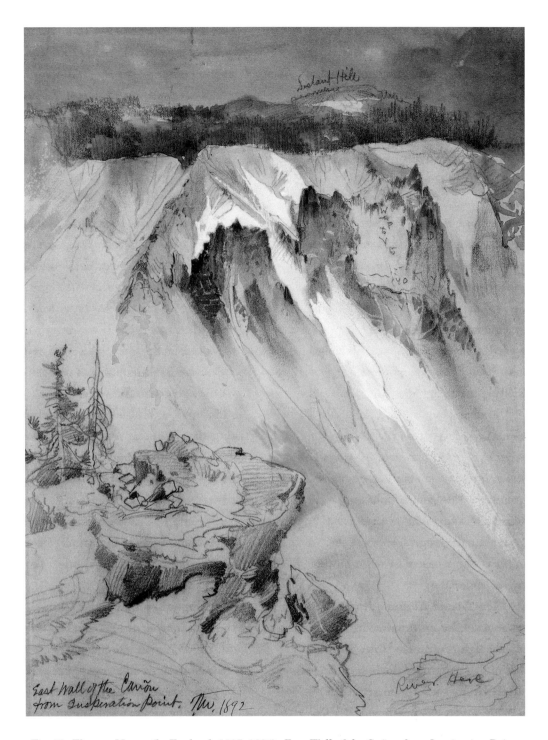

Fig. 30. Thomas Moran (b. England; 1837–1926). *East Wall of the Cañon from Inspiration Point*, 1892. Watercolor with pencil; 12³/₄ x 9³/₄ in. National Park Service, Yellowstone National Park, WY.

distinctly American themes of his most popular creations, he chose not to abandon the moral slant of art as national imperative. It did not need to serve the intellect, though, or be particularly informative. If art awakened emotion, as the Yellowstone experience had obviously done for him personally, then his goals would be met. Soften the lines, enhance the color, orchestrate the lighting effect, excite the textural marvels, compose nature's elements in a way, almost suggestively Freudian, to be evocative for an American audience, and stay tuned to a time-honored national symbol—that is all it took to produce the 1893 version of *The Grand Cañon of the Yellowstone* (plate 21).

Although he felt he was moving forward with this and similar paintings, Moran was also lapsing into eighteenth-century pictorial rhetoric of the sublime. By giving up Ruskin's lessons in nature and Hayden's studied texts of geology, Moran underwent a philosophical retroflexion that would view such scenes as the Lower Falls with "terrible joy" and "delightful horror," reactions intended to overwhelm the viewer with savage emotion.[100] Unlike the earlier version, with its idealized tribute to the Euro-American conquest of the continent, this new work seemed to stand as the very symbol of creation itself. This was not a history painting with a dramatic backdrop, but a painter's painting involving high emotional commitment from the artist and the viewer alike.

Moran's emotional journey in paint was, as planned, exhibited at the World's Columbian Exposition in Chicago in 1893. No doubt the Wyoming tourism interests were thrilled, but it received surprisingly little notice. Even in Denver, where it was shown first at a special one-man exhibition, organizers were disappointed with poor attendance. Moran had told the people of Denver, before he and Jackson left for Yellowstone, that as much as he preferred "to paint Western scenes, . . . Eastern people don't appreciate the grand scenery of the Rockies. They are not familiar with mountain effects and it is much easier to sell a picture of a Long Island swamp than the grandest picture of Colorado."[101]

The Grand Cañon of the Yellowstone did not sell in either Denver or Chicago. Its most vociferous fan was, ironically, none other than the master of geological nuance and the tight, contoured line, William Henry Holmes. In 1917, over a dozen years after Moran had repainted the behemoth canvas, making its contours and atmosphere even softer, Holmes wrote the artist that he considered it "the greatest work in landscape that the world has produced."[102] The painting was made the centerpiece for an exhibition organized that year by Holmes, mounted at the National Gallery of Art, in honor of the recently founded National Park Service.[103] Holmes had been curator there since 1910 and ten years later would be named the gallery's director. The painting was still in Moran's possession at the time of the artist's death in 1926. Through the efforts of Holmes and Ruth Moran and the generosity of George D. Pratt of New York, Moran's painting was donated to the National Gallery of Art in 1928. It was described at the

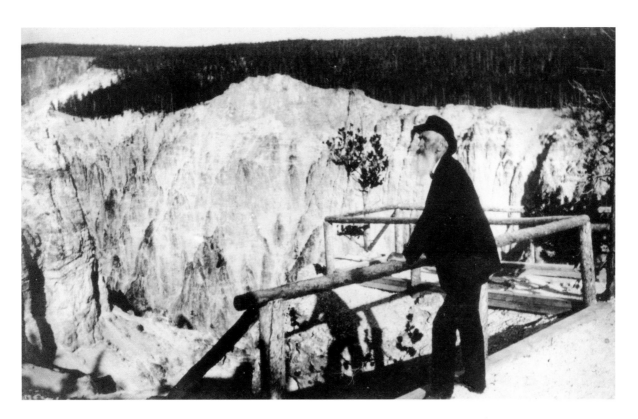

Fig. 31. Unknown photographer. *Thomas Moran in Yellowstone*, 1900.
Photograph. Courtesy of the East Hampton Library, East Hampton, NY.

time by the *Art Digest* as a canvas "painted with a skill bordering on the marvelous, . . .
[its] forms, colors and effects as exquisitely beautiful as can be conceived without tran-
scending the verities of earthly landscape."[104]

Moran visited Yellowstone a third time, in his later years. Following his wife Mary's
death in 1900, he escaped once again to the West and the reverie of Yellowstone's mar-
vels (fig. 31). As a result, he found his spirit invigorated and not only reworked the
1892 painting but also produced a variety of exuberant new paintings of the subject.
The art magazine *Brush and Pencil* published an article written by Moran, who had
become by that date *the* venerable defender of American art. Proclaiming "the for-
eign subject" an opiate for the feeble-minded in art, Moran certified America as "richer
in material" for the painter who might seek "individual development than any coun-
try in the world." He reminisced about earlier American masters, Church and John
Frederick Kensett in particular, praising them for their diligence and adherence to
American themes. As for his own successes, he credited knowledge of his subject, thus
oddly harkening back to Ruskin's lessons and Hayden's insights. "I have to have knowl-
edge. I must know geology. I must know the rocks and the trees and the atmosphere
and the mountain torrents and the birds that fly in the blue ether above me." With

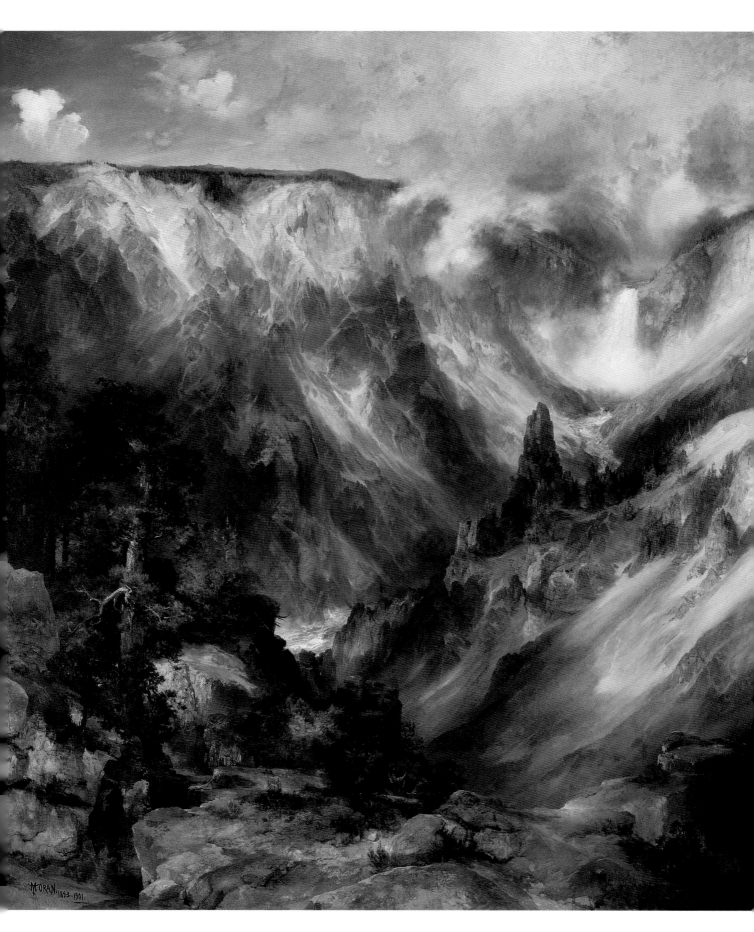

Pl. 21. Thomas Moran (b. England; 1837–1926). *The Grand Cañon of the Yellowstone*, 1893.
Oil on canvas; 96$\frac{1}{2}$ x 168$\frac{3}{8}$ in. Smithsonian American Art Museum,
Smithsonian Institution, Washington, DC. Gift of George D. Pratt.

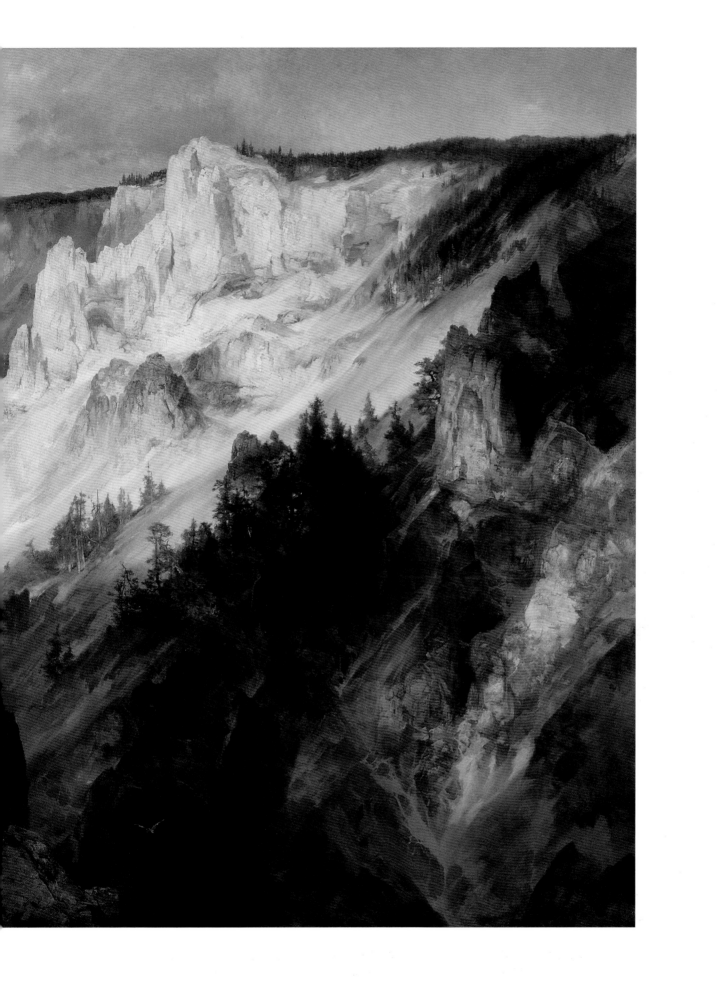

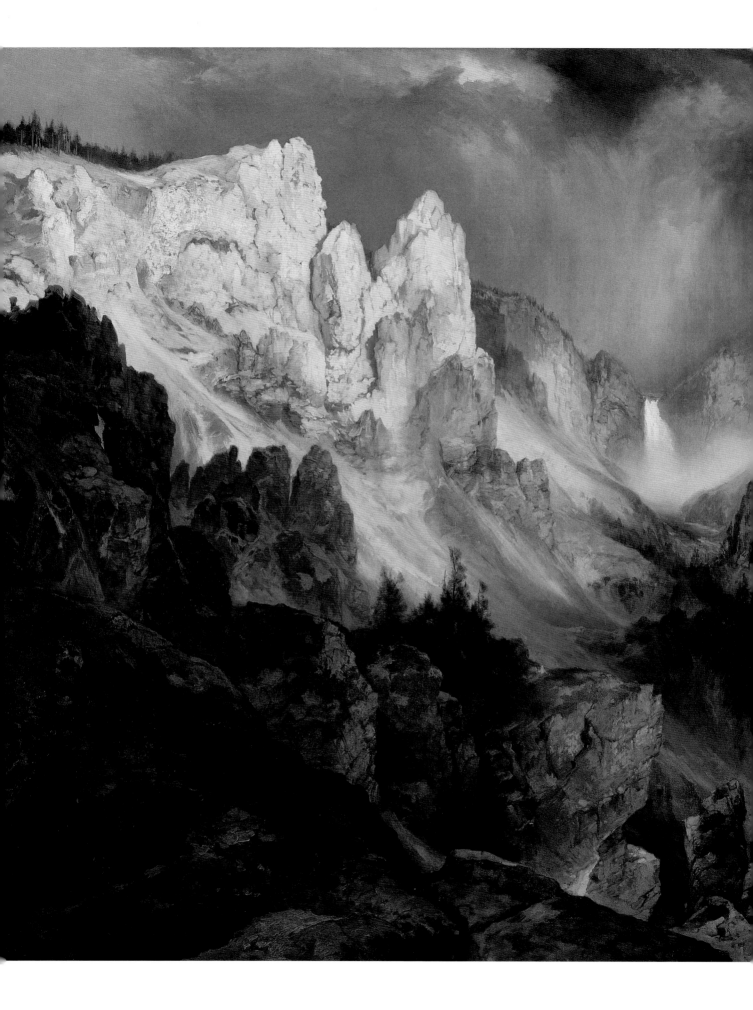

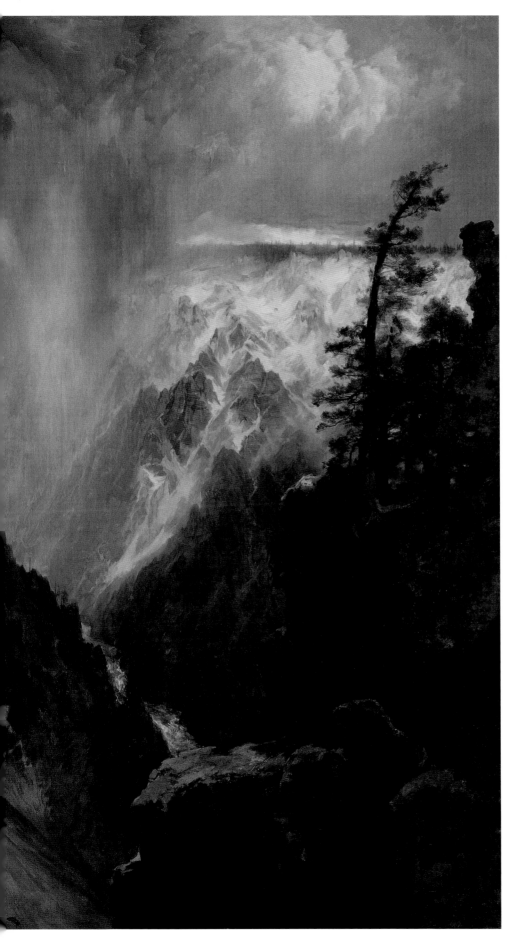

Pl. 22. Thomas Moran
(b. England; 1837–1926).
Mists in the Yellowstone, 1908.
Oil on canvas; 30 x 45 in.
Collection of the Modern Art
Museum of Fort Worth, TX.
Gift of the Amon G. Carter
Foundation, Fort Worth.

this foundation of knowledge, he felt comfortable taking liberties and allowing his emotive response to take sway. And he thanked Emile Zola for providing a definition of art that suited him—"art is nature seen through a temperament." "An artist's business is to produce for the spectator of his pictures the impression produced by nature on himself."[105] His painting *Mists in the Yellowstone* (plate 22) exemplifies this synthesis of thought, reaction, virtuosity, and accumulated wealth of information.

In his early career, Moran had made credible what was regarded as most incredible. He had been an important part of Yellowstone's history and the evolution of the national park idea in America. He had helped construct the way one should look at nature and in the process helped mythologize the park and the West in general. He, along with Bierstadt, had been central to the complex ironies and tensions among westward expansion, the concomitant spoliation that their art promoted, and the sacred places that their art glorified. His later works eliminated reference to man, ignoring the fact that he and Hayden and Jackson had created "the Tourist's West"[106] and oblivious to the haunting admonition offered back in 1880 by S. G. W. Benjamin. "Did the artist realize that with every stroke of the brush he was aiding the advance guard of civilization, and driving away the desolation which gave additional grandeur to one of the most extraordinary spots on the planet?"[107] It was enough to hope that, as it did, history would remember him for creating "a type of landscape essentially American."[108]

CHAPTER 3

Yellowstone by the Book

Tourists have given to the reading public occasional pencilings of the wonders of
this region, but a description which would convey an adequate idea of the won-
derful scenery which everywhere startles with amazement and delight . . . would
fill the largest volume; but language . . . is utterly insufficient to enable the reader
to form a just conception of the grandeur and sublimity, the exquisite beauty, the
immensity and picturesqueness of the natural features and scenery here presented
to view. The whole vast region is a grand panorama of perpetual surprise and
delight, a numberless succession of pictures painted by the Almighty, the setting,
the eternal hills.

Dr. I. Winslow Ayer

Two basic forms of western literature dominated the popular market in America
during the 1880s. One was based on a formulaic fictional interpretation of frontier
adventure that had been adopted from James Fenimore Cooper's plots and ritualized
to conform to maturing eastern tastes and expectations. These were the dime novels.[1]
The other was an increasingly elaborate and verbose genre that concentrated on pro-
moting travel opportunities in the West. Aimed at eastern and European audiences,
this filled nearly as many pages as the pulp fictions and surely as many hearts. It was
the ubiquitous tourist literature, read by stay-at-home, armchair travelers and car-
ried into the field by the more adventuresome voyagers to the park.

Although the railroads excelled at publicizing their favored destinations, there
were dozens of independent authors who, with and without the benefit of firsthand
exposure, touted the park's curiosities. Generally, they recounted someone's ramblings
through or roughing it in Yellowstone, advertising the pleasures and edification one
might experience in visiting America's wonderland. They played to a burgeoning affluent
upper middle class who had acquired, concurrently with wealth, nomadic habits and
longings for controlled adventure.[2]

Typical of the traveler's guides was one assembled by J. R. Bowman in 1882 and
titled *The Pacific Tourist*. It contained railroad routes, hunting regulations, hotel list-
ings, and mileage charts for travel planning, as well as a chapter on "The Yellowstone
Park" written by Ferdinand Vandeveer Hayden and illustrated by Thomas Moran.

89

Hayden's chapter provided an eloquent description of the park and a discussion of its inception and history. It also revealed a classic Victorian paradigm, organizing the potential visitor's experience into recognizable, complementary elements. Here tourism, art, and science found union in service of the ultimate goals of entertainment and instruction. In Yellowstone, the tourist was invited by Hayden to savor "the grandest pleasure ground and resort for wonderful scenery on the American Continent." "To the artist, and lover of nature, are presented combinations of beauty in grand panoramas and magnificent landscapes, that are seldom equaled elsewhere." And for the student of science, the park was resplendent with geology's "strange phenomena" and untamed animals "sufficient to furnish innumerable zoological gardens."[3] Enjoyed together, the artistic, scientific, and tourist experiences could reward the visitor with practical as well as moral lessons, such as enhanced understanding of and humility toward nature through personal discovery. There was pleasure and virtue to be found in proper submission to the sublime and in personal revelation at the picturesque. And Yellowstone could provide an ample dose of either.

According to the eminent behavioral scientist Dean MacCannell, "leisure-time users of nature" are traditionally "of two main types, recreational and esthetic."[4] Certainly this was no secret to the writers and publishers of late-nineteenth-century tourist guides. They pitched recreation as de rigueur for the gentry and would-be aspirants to that class, and they did so by tinting the experience with an aesthetic wash of respectability. Just as they were able to package recreation so as not to confuse or overexert its practitioners, the tour books also ordered or institutionalized the scenery for ease of consumption. Through thoughtful manipulation and selection of scenes and landmarks, the tourist guides could effectively pattern public response to selected areas and experiences. The readers were preprogrammed for rapture. Through written testimonials and artists' renditions, readers and the beholders of scenes could rest assured that, as historian Earl Pomeroy has written, "competent and fashionable critics of scenery had had time to enshrine nature in words or paint, and were available to point out and interpret to him what he ought to see."[5]

In some instances, the tourists were themselves the writers as well as the adventurers and aesthetes. Such was the case with the Irishman Windham Thomas Wyndham-Quin, the fourth earl of Dunraven. Dunraven, as he is referred to in the history books, was a sedulous pursuer of pleasure. Known as an explorer and big-game hunter who sought adventure through recreation in many remote corners of the North American continent, he took advantage of an opportunity to visit Yellowstone in 1874. Uncharacteristically, he confessed, "It was less for any special design of hunting than for the satisfaction of my curiosity and the gratification of my sight-seeing instincts that I really decided to attempt the trip."[6] He also wanted to collect sufficient information on the park to produce a western adventure book that would attract international attention

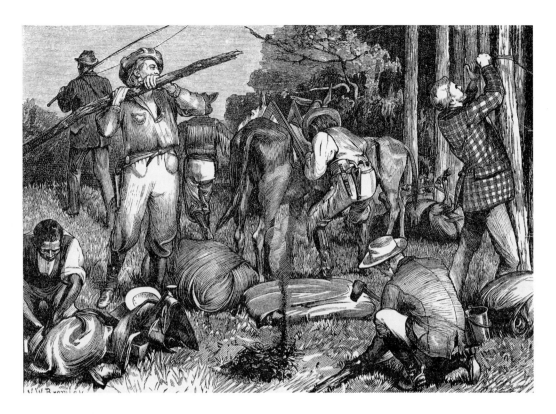

Fig. 32. Valentine W. Bromley (b. England; 1848–1877). *Making Camp*, 1876.
From Earl of Dunraven, *The Great Divide*. Wood engraving; 4 x 5 in.
Autry Museum of Western Heritage, Los Angeles, CA.

to the recreational opportunities in the region. His book *The Great Divide* was published two years later.

Dunraven was also a patron of the arts. Once back home in Ireland, he commissioned a young English artist, Valentine Walter Bromley (1848–1877), to illustrate the book on his Yellowstone adventure. His countryman William Blackmore, who had visited the park with Hayden in 1872 and was one of Thomas Moran's early patrons, loaned the earl some W. H. Jackson photographs showing scenes in the geyser basins. Bromley was called upon, using verbal descriptions from Dunraven, to depict elements of camp life during the excursion. *Making Camp* (fig. 32) shows the party at work. Captain C. Wynne, the earl's cousin, carries a pole in the foreground for a lean-to. George Kingsley, the earl's personal doctor, attaches a cord to a tree for the same purpose, and the earl, with his back to the viewer, chops wood for the fire. The figures are effectively drawn, the composition is complex, and the scene is animated, all attesting to Bromley's skill as an artist and Dunraven's wisdom in selecting him. Bromley was praised in the book's introduction for having "graphically carried out" the author's "ideas."[7] Although he did not travel with the earl to Yellowstone, the artist captured

the essence of the experience with the spirit that he brought to the illustration work he did for his other employer, the *Illustrated London News*.[8]

The Great Divide enjoyed healthy sales in Europe and America. Dunraven had initiated a publishing trend that would carry forward for a full generation or more. He lauded Yellowstone for its recreational potential and enhanced his written narrative with elaborate images of the experiences he promoted. While his was not a tourist guide per se, it served much the same function.

At the Upper Geyser Basin, Dunraven had found the air full of diabolical sounds. It was as if he could hear "distant grumblings of dissatisfied ghosts" or "imprisoned devils."[9] A Methodist preacher, Edwin J. Stanley, had visited the park a year earlier and, to the contrary, sought and discovered among the park's irregularities an inspiriting countenance which evidenced at every turn "the handiwork of the Master-Artist."[10] Although claiming that his writing was inadequate to the job and his "efforts at pen-picturing . . . sadly felt," Stanley created a charming book, *Rambles in Wonderland*, which first reached the bookshops in 1878. It was clearly organized as a tourist guide and offered instruction on everything from how to set one's course of tour to the latest theories on erosion and how to sit a bucking "cayuse." To aid him in the matter of communicating the joy of his experience, Stanley employed a well-known *Harper's Weekly* illustrator, Alfred R. Waud (1828–1891).

Like Bromley, Waud was born in London. He came to America in 1850 and found work as an artist in New York and Boston. Particularly celebrated were his depictions of Union army life during the Civil War, which found their way into the pages of *Harper's*. He covered the Chicago fire as one of *Harper's* special artists in 1871 and provided illustrations for four chapters in *Picturesque America*.[11]

Despite his peripatetic nature, Waud did not travel to Yellowstone. Rather, he worked from Jackson photographs, adding groups of figures to animate the scenes in Stanley's book. His spirited illustration of *In the Geyser Basin* (fig. 33), while somewhat generalized in its interpretation of the area's features, is a case in point. Stanley described his party's farewell to the Upper Geyser Basin on September 1, 1873.

> We mounted and commenced our homeward march, nearly thirty persons, all on horseback, with about twenty pack-animals—quite a caravan, and rather a novel scene, too, to one not accustomed to mountain-life, and a stranger to this mode of traveling. It is rather amusing to see the little ponies (commonly known in the mountains as *cayuses*) trudging along with the great, bulky loads on their backs, now wading through almost fathomless swamps, winding their way among the densely-crowded pines, or ingeniously working a passage amid a network of fallen timber so complicated as often to present difficulties almost insurmountable. It is won-

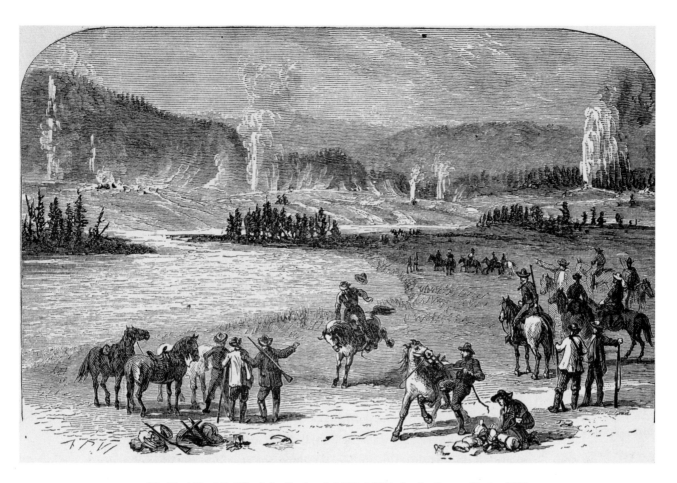

Fig 33. Alfred R. Waud (b. England; 1828–1891). *In the Geyser Basin*, 1878.
From Edwin J. Stanley, *Rambles in Wonderland*. Wood engraving; 3½ x 5 in.
Autry Museum of Western Heritage, Los Angeles, CA.

derful to see the caution they will use in choosing the trail and avoiding contact
with the trees, as though they felt themselves responsible for the safe delivery at
night of the charge committed to them. Sometimes, however, patience gives way
under the pressure, the virtue of forbearance is forgotten, and novelty and humor
are lost in vexation, as you are called to urge your way through such a trackless
wilderness; though now and then an amusing incident occurs, as a man gets caught
in a net of fallen trunks or overhanging boughs, loses his hat or part of his cloth-
ing, or perhaps is brought by awkwardness or the sudden gyrations of his cayuse
to his all-fours, face-foremost in the mud, which, though far from being laughable
to him, furnishes amusement to those more fortunate, reviving the spirits of all,
and verifying the truth of the old adage that "variety is the spice of life."[12]

Waud had been described by a friend during the Civil War as "blue-eyed, fair-
bearded, strapping and stalwart, full of loud, cheery laughs and comic songs."[13] It

was little wonder that the joie de vivre manifest in Stanley's writings was so effectively translated into pictorial form by an artist of such similar characteristics. It was little wonder too that such scenes as Stanley described would capture the fancy of many subsequent writers of travel books. Rossiter W. Raymond, who had visited Yellowstone in 1871, published his book *Camp and Cabin: Sketches of Life and Travel in the West* in 1880. Wrote Raymond, "Nothing can be lovelier than the sight, at sunrise, of the white steam-columns tinged with rosy morning, ascending against the background of dark-pine woods and the clear sky above."[14] For his guide, Raymond recalled carrying two copies of Langford's *Scribner's* articles. He did his best to expand on that account.

In 1881 L. P. Brockett published his guide, *Our Western Empire: or the New West Beyond the Mississippi*, with a brief account of Yellowstone and a fanciful view of the Tower Falls (fig. 34) created by Frederic B. Schell (1838–1905), a future art editor at *Harper's*. This composite scene showing the sun setting behind Tower Falls addresses the notion of accessibility to Yellowstone's ostensibly remote wonders. The three hikers gaze at the scene that, despite its inaccurate translation from Moran's paintings, is blessed and made welcoming by a revealed higher power.

That same year, Robert E. Strahorn would produce a highly elaborate, illustrated volume on *Montana and Yellowstone National Park* featuring a half-dozen handsome plates by Moran and Holmes.[15] As with the Schell illustration, these pieces often place man in a prominent pose within the landscape, once again selling the idea of accessibility. Strahorn went on to produce many books on the West as an inviting travel mecca. In the early years of the 1880s, dozens of similar guides, usually illustrated, also made their way onto the market. A few titles and authors, not already mentioned, give an idea of their popularity: W. W. Wylie, *Yellowstone National Park; or the Great American Wonderland* (1882); Almon Gunnison, *Rambles Overland: A Trip across the Continent* (1883); Eugene V. Smalley, *History of the Northern Pacific Railroad* (1883); Henry J. Winser, *The Great Northwest; A Guide-Book and Itinerary for the Use of Tourists and Travellers over the Lines of the Northern Pacific Railroad . . .* (1883); and P. W. Norris, *The Calumet of the Coteau . . . Together with a Guide-Book of the Yellowstone National Park* (1883).

By 1883, the Northern Pacific Railroad had added a connector line, the "Yellowstone Branch," from Livingston, Montana, down to the park's north boundary. The railroad's vast advertising literature promoted America's wonderland as idyllic and encouraged visitors to take a grand tour. Tourists and artists could reach and ramble through the park with relative ease. As a consequence, promotion began to expand exponentially. Magazines, like book publishers, were loath to miss out on an opportunity to feed their readers an appealing diet of richer and richer Yellowstone fare.

Following the tide of enthusiasm, *Harper's Weekly* sent a young art instructor

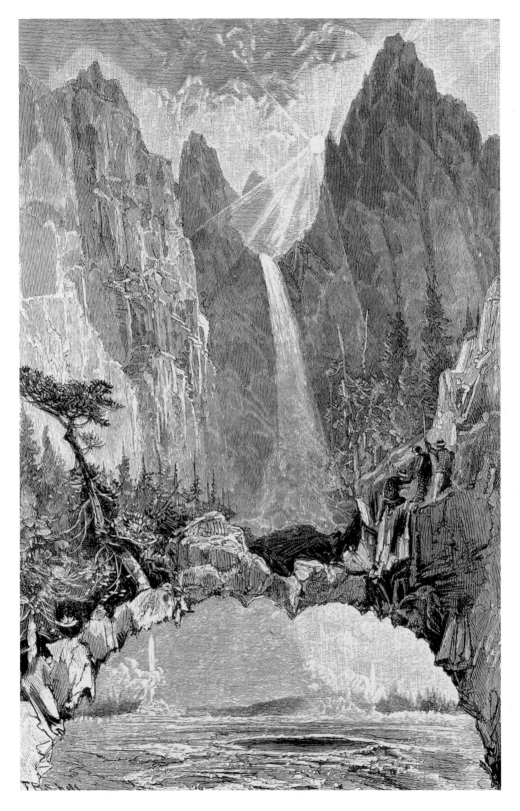

Fig. 34. Frederic B. Schell (1838–1905). *Falls of the Yellowstone*, 1881.
Wood engraving; 7³⁄₈ x 4⁷⁄₈ in. Autry Museum of Western Heritage, Los Angeles, CA.

from Princeton University to the park in the summer of 1883. He had done fieldwork for them before, having traveled to New Orleans on assignment two years earlier. Now he was to capture the fleeting beauty of Yellowstone's geysers. His name was John White Alexander (1856–1915), and he carried formidable credentials. Having grown up in the Pittsburgh area, he had embarked on an art career before age twenty. By 1875 he had moved to New York City and was working for *Harper's* as a political cartoonist and illustrator. Lured to Europe in 1877, he quickly settled in with Frank Duveneck and William Merritt Chase at the Royal Academy of Fine Arts in Munich. There he learned to use free, bold brushwork to render figures and landscape with spontaneous freshness. He toured Italy with his mentor, one of a cadre called "Duveneck's boys," and met James McNeill Whistler, who would later become a close friend.[16]

Alexander's Yellowstone assignment resulted in a published full-page composite drawing of the Upper Geyser Basin (fig. 35). An accompanying story, "The Yellowstone Geysers," asserted that geysers on other continents "sink into insignificance" compared to what Alexander had seen. The author, however, did not attempt to discuss more than the most rudimentary details of the various features. The "picturesque results" of Alexander's trip were left to his paintings, which, although monochromatic, were fresh and vigorous in execution and design. The original ink wash drawing *Grotto* (fig. 36), incorporated as part of the composite illustration, is a masterful example of minimal statement. Unlike Moran's plein air studies that were intended as preliminaries for finished, highly detailed watercolors, Alexander's works were completed in the field. His generous use of Chinese white vitalizes the features silhouetted against the tan paper. There is a cool remoteness to the paintings, with the white deposits around the geysers giving "a wintry effect to Mr. Alexander's sketches."[17] His painting *Rapids* (plate 23) profits from the addition of watercolor, which helps to accentuate the surge of the Yellowstone River as it approaches the Upper Falls.

Alexander soon left the world of illustration and returned to Europe, this time Paris, for further training. He became a painter of grand, sweeping figural works possessed of psychologically charged forms, theatrical lighting, and wonderfully engaging line.

While Alexander's essentially black-and-white work was poetic and subtle, another special artist for the magazines visited the park in the early 1880s and produced equally evocative illustrations that stood out for their dramatic clarity, fantasy, and boldness. This was a German artist, Rudolf Cronau (1855–1939), who arrived in America in 1881 as an artist-correspondent for his homeland newspaper, *Die Gartenlaube*.[18] Assigned to capture the essence of America's West for German audiences, Cronau embarked on a two-year reconnaissance of the trans-Mississippi region. During the summer of 1882, in the company of two fellow Germans, Cronau made a swing

Fig. 35. John White Alexander (1856–1915). *The Geyser of the Upper Basin, Yellowstone National Park*, 1883. *Harper's Weekly*, November 1883. Wood engraving; 9 x 12⅝ in. AP2 H32. Reproduced by permission of the Huntington Library, San Marino, CA.

through Yellowstone. There before him was spread a bizarre and wonderful landscape that called forth the best of his romantic nature and almost surreal artistic vision.[19]

Cronau had received his art training at the Academy in Düsseldorf. There he was taught tight, meticulous drawing methods and theatrical composition techniques that contrasted sharply with the lessons provided in Munich to his contemporary, Alexander. Although both worked in black and white, Cronau's field pieces were highly finished, meticulously crafted productions that were especially striking because of the bold contrasts of light and dark. That he relished the fantastic forms of the geysers

Fig. 36. John White Alexander (1856–1915). *Grotto*, 1883. Watercolor, ink wash, and Chinese white on paper; 10 x 14½ in. Courtesy of James Graham & Sons, Inc.

Pl. 23. John White Alexander (1856–1915). *Rapids*, 1883. Watercolor, ink wash, and Chinese white on paper; 10¼ x 14½ in. Autry Museum of Western Heritage, Los Angeles, CA.

Fig. 37. Rudolf Cronau (b. Germany; 1855–1939). *Mammoth Hot Springs at Gardiner
River Falls, Yellowstone Park*, 1882. Pencil and ink on paper;
11¼ x 16¾ in. Lindemann Collection.

and hot springs can be seen in *Mammoth Hot Springs, Yellowstone* (fig. 37). It was an
eerie place, well suited to his heightened romantic disposition. Even his peaceful genre
scenes, such as *A Camp in the Forest of Yellowstone Park* (fig. 38), are imbued with a
hint of ominous brooding created by the thick shroud of night and trees that surrounds
and isolates the central figures in their wilderness camp.

Cronau sold his images to American as well as German newspapers. His *Mammoth Hot Springs, Yellowstone* was a full-spread illustration in the Northern Pacific
Railroad's promotional paper, *The Northwest*, in May 1884. The artist also, upon his
return to Germany, published two books on his American adventures, along with an
illustrated album, *Von Wunderland zu Wunderland* (1886), in which many of the Yellowstone images appeared.

Cronau's efforts in the early 1880s were but one in many appeals to international
audiences. The park's attendance grew rapidly in these years. An assistant park superintendent, G. L. Henderson, exaggerated expansively when he announced in the Liv-

Fig. 38. Rudolf Cronau (b. Germany; 1855–1939). *A Camp in the Forest of Yellowstone Park*,
1882. Pen and ink wash with wash on artist's board; 5⅝ x 7 in.
Courtesy of Jane and Ron Lerner, Bozeman, MT.

ingston, Montana, paper in 1883 that visitations were projected to leap from 10,000
the year before to 25,000 that summer. A substantial percentage of the 5,000 tourists
who actually did visit, however, were from abroad.[20] The *London Daily Telegraph*,
for example, fanned the glowing enthusiasm with stories of how easy it was to reach
Yellowstone and what a refreshing alternative it was to the timeworn sights of Europe.

> To those who have had more than enough of the Alps and the Tyrol, of Saxony,
> Switzerland, and the Pyrenees, of cathedrals and picture galleries of Europe, we
> strongly recommend a trip across the Atlantic and a visit to that marvelously beau-
> tiful National Park on the Yellowstone, which is commonly spoken of by our enthu-
> siastic kinsmen as "Wonderland."[21]

Such stories had caught the eye of a young English artist, Arthur Brown (dates
unknown), who arrived at wonderland's doorstep in July 1883. He spent two months
in the park and executed about twenty finished watercolors. A schoolteacher from Min-
neapolis, Margaret Andrews Cruikshank, was enjoying the grand tour of the park that

summer and found Brown hard at work overlooking the Lower Falls. She wrote in her diaries:

> Resident (for some weeks) at the Falls for the purpose of making sketches was an English artist, a Mr. Arthur Brown of Newcastle-upon-Tyne. A grey-headed man, he had lost the savings of his life by unfortunate speculations. It had been said to him, "Why don't you go to America and paint up its wonderful scenery?" "Can't afford it; that hope is over!" But [one] Earl Percy [had] seen and admired a picture of his and [paid] his expenses to [have painted] certain pictures for him of Yellowstone Park.[22]

The editors of the Livingston newspaper had a peek at the paintings in September when Brown headed home. They were impressed with them as "fine works of art" and felt they would "attract universal attention, not only to themselves and the artist, but to our Yellowstone Park." Brown's plan was to return to England and, using the watercolors and a collection of gathered specimens, "prepare and deliver a series of lectures upon the Park and this portion of America."[23]

The watercolors or "sun pictures," as they were called, have yet to be found. Shown on stages across England and illuminated by a "powerful oxy-hydrogen light," they attracted enthusiastic response along with the "specimens of magnesian incrustation from Mammoth Hot Springs, of agatfied wood, of obsidian and of various colored rocks, [which] were shown on a table in front of the [lecture] platform."[24]

Brown returned to the park in 1885 and, according to Montana newspapers, sold his paintings of Yellowstone scenery to the Northern Pacific Railroad. They were subsequently exhibited in Saint Paul, Chicago, Milwaukee, and some unidentified eastern cities.[25] Unfortunately, the railroad has no record today of owning these pieces.

While Brown was working on his second Yellowstone series, a French artist, Albert Charles Tissandier (1839–1906), visited the park in search of visual material for a travel book on America. Trained as an architect at the École des Beaux-Arts, Tissandier was a skilled draftsman and an astute observer of nature. His velvety pencil drawings, such as *Hot Sulphur Springs* (fig. 39), are complex renderings with refreshingly unpretentious presentation.

Tissandier's travels were documented with a detailed diary that was published in his book *Six Mois aux États Unis* (1886). Many of his drawings served as illustrations for the book, including his view of Old Faithful, the geyser that he found to be the most "impressive and interesting" of all.[26]

Late in the decade, American and English tabloids sent special sketch artists to Yellowstone to record the scenery and the human activity generated by the park's popularity. One of *Harper's Weekly*'s most prolific and popular painters of the period, Charles Graham (1852–1911), was offered the challenging assignment of picturing Yel-

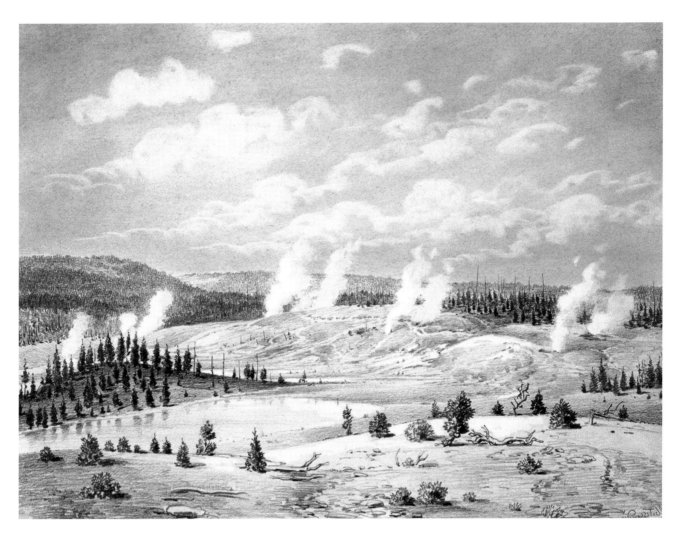

Fig. 39. Albert Charles Tissandier (1839–1906). *Hot Sulphur Springs*, 1885.
Pencil, wash on paper; 10³⁄₈ x 13⁵⁄₈ in. UMFA Acc. 1978.360. Utah Museum of Fine Arts,
University of Utah, Salt Lake City.

lowstone in winter. Graham had watched the park from a distance for many years. He had hired out early in his career as a topographer for the Northern Pacific Railroad survey, a welcome outdoor reprieve from his livelihood as a painter of theater backdrops in Chicago. He was present at the completion of their transcontinental rail line in 1883, and his illustrations recorded the coming of the rails for *Harper's Weekly*. The Northern Pacific loved his work, retaining him afterward to paint a series of views along the western route. They bragged of his talents in their promotional literature.

Mr. Graham's manner in the treatment of landscapes is a happy medium between the hard realism of many artists who sketch for the illustrated papers, and the vague, imaginative work of the impressionist school which is just now somewhat

the fashion with the magazines. His pictures are true to nature, and are at the same time imbued with a fine poetic feeling.[27]

Graham appears to have lacked formal training, but where he was short on instruction he was long on intrepidity . . . or maybe not. His biographer, Robert Taft, claimed that Graham accompanied explorers Frederick Schwatha and Frank J. Haynes on their famous 1887 trek through the park, the historic first winter expedition. Although a related illustration, *The Yellowstone in Winter—A Surprise* (fig. 40), signed by Graham, appeared on the cover of *Harper's Weekly* in April that year, and although there is a Haynes photograph from the trip titled *"Our Sketch Artist" at Norris Geyser Basin*, Graham was not actually among the ranks. The sketch artist's name was Henry Bosse,

Fig. 40. Charles Graham (1852–1911). *The Yellowstone in Winter—A Surprise*, 1887. Wood engraving. *Harper's Weekly*, April 9, 1887. AP2 H32. Reproduced by permission of the Huntington Library, San Marino, CA.

Fig. 41. Thomas Henry Thomas (1839–1915). *Characters in Hall of Mammoth Hot Springs Hotel*,
1888. *The Graphic*, August 11, 1888. Wood engraving; 3 x 9 in.
Los Angeles Public Library.

about whom little is known, except that he worked for the *New York World*, the sponsor of the venture. Graham has gotten credit for being party to what turned out to be an exceedingly arduous and perilous odyssey, while in fact he created his view of the expedition's final day and the surprise encounter with a herd of elk at Yancey's cabin from the comfort of his studio in Chicago.[28]

Somewhat less plucky but considerably more credible was the visit in the summer of 1884 by the Welsh portrait painter and illustrator, Thomas Henry Thomas (1839–1915). In the employ of the London *Graphic*, he toured the park with sketchbook in hand and later filled stories in two issues of the magazine with his landscapes and depictions of tourist life. Thomas's party was well acquainted with Dunraven's account and, like Tissandier, carried a copy of Hayden's report as a trusted guide to the park's features. They, like Dunraven, sensed an "impression of sublimity and comicality" when viewing many of the park's "phenomena." They took in the full sweep of tourist impressions and reported with levity the reactions in word and picture. "Faint with heat, sick with sulphur-fumes, constantly startled by steam-jets and the crumbling of the floor beneath the feet, the time the tourist spends here is not a very happy one," they observed. Yet the activity of the geysers, along with their beauty, "makes amends."[29]

The sheer variety of fellow tourists fascinated the *Graphic*'s team. At the Mammoth Hot Springs Hotel, park visitors were arranged in long processions, generally amassed before mealtime. "Around huge upright stoves in the long corridor groups of tourists, carters, and hunters, most characteristic of Western ways, are seen, and in

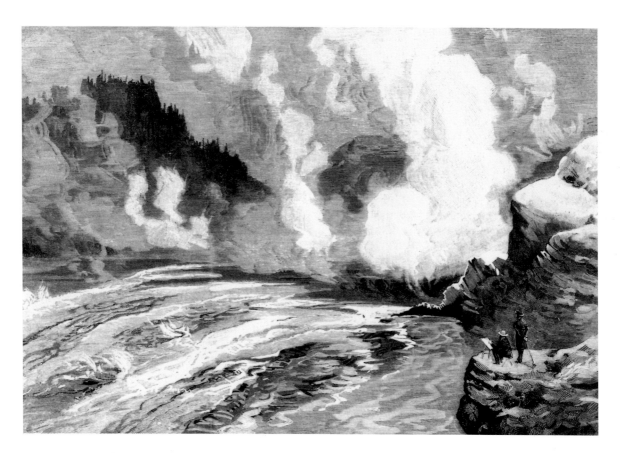

Fig. 42. Thomas Henry Thomas (1839–1915). *Gulf of "Excelsior" Geyser, and Overflow to Fire-hole River*, 1888. *The Graphic*, August 18, 1888. Wood engraving; 5⅞ x 9 in. Los Angeles Public Library

long, long perspective a line of classically shaped, vermilion spittoons extends in an array at once economically convenient and severely architectonic."[30] Thomas captured the scene in his illustration *Characters in Hall of Mammoth Hot Springs Hotel* (fig. 41). The cross-section of humanity is amusingly diverse, while the spittoons are more tests of sobriety than architectural statements.

Thomas's scenic views were quite engaging. The two-part *Graphic* article features a number of accomplished crayon or charcoal drawings of the falls and canyon of the Yellowstone River. One of the most compelling derives from a watercolor or wash drawing of the *Gulf of "Excelsior" Geyser, and Overflow to Fire-hole River* (fig. 42). It pictures the artist and an associate or onlooker viewing "a chasm of rugged outline" where an "impetuous monster beneath has hurled up the strata bodily." It was perhaps one of the impulses behind Rudyard Kipling's 1889 visit to Yellowstone, a landscape he would define as "a howling wilderness of three thousand square miles, full of all imaginable freaks of fiery nature."[31]

CHAPTER 4

The Nation's Art Gallery

Scenic nationalism had proven a prime and worthy rationale for the establishment of Yellowstone as the first national park in 1872. As a concept, it was largely subsumed in the broader national park idea. Together, the notions had been experiments and, if early public response were any test, the designs and realities that unfolded after the park's first two decades led the founders to claim success. They could also boast that a model had been found for similar future experiments in other locations around the country. Yellowstone, which was popularly denominated as "The Nation's Art Gallery" by the early 1890s, could and should be supplemented by other galleries of comparable beauty and grandeur.[1] The experiment in wonderland would soon be played out elsewhere.

A prime example of the spread of these concepts was Yosemite National Park, which was established in 1890. The motivation behind its founding was similar to Yellowstone's, but the players were different. This time the push came from two proponents of aesthetic conservation, John Muir, the nation's leading proponent of scenic wilderness preservation, and his publicist and sponsor, Robert Underwood Johnson, editor at *Scribner's* in the 1870s and later at *Century Magazine*. Although Yosemite had already been set aside for public use as a state park in 1864, Muir and Johnson brought to the nation's attention the fact that, under the lenient stewardship of the state of California, human interaction with the area was spoiling it.

Muir and Johnson hoped that the brilliant accommodation between man and nature that had been effected in Yellowstone might be carried over in this California scene. In this they aspired not only "to make nature esthetically available" to man but "by man." After the two visited Yosemite in the summer of 1889, Johnson wrote an open letter to *Century Magazine* admonishing that while "the wonders of the Yosemite [were] confessedly supreme in American scenery," human amenities and improvements attendant on progress were compromising its beauty. "In walking and driving over the valley, one's feelings of awe at the unspoilable monuments of nature are often marred by the intrusion of the work of unskilled hands upon the foreground of the picture." It was man's responsibility to enhance nature's picture, to properly frame it for public consumption and to administer such a place so as to enhance, not diminish, nature's good work.

Common sense would seem to dictate that in making this wonderland accessible to visitors, the treatment of the floor of the valley from the start should have been put in the hands of the very best experts, with a view not only to preserve and enhance the composition, unity, and natural charm of the pictures presented to the eye, but to see that nothing be done to disturb the rare sentiment of the scene. The unthinking may sneer at sentiment, but in such matters the sentiment is everything— the first consideration, the only "sense."[2]

Johnson and Muir were of like minds, and the editor persuaded the naturalist to write two articles for *Century Magazine* that further amplified their shared feelings.[3] Due in large measure to their joint efforts, to their convincing arguments for an aesthetic imperative, Congress set Yosemite aside as a national park in 1890.

Muir had visited Yellowstone in 1885, collecting impressions for an essay that would be published later in the century. Although he was ill while he was there and the weather was miserable, Muir wrote glowingly of what he saw. His field notes record how harmoniously nature can compose itself, even when introducing such curious anomalies as geysers. Trees and grasses grew next to and feared "not those merrily boiling pots of Nature as if saying in confidence you also are one of us strange tho you are."[4]

For Muir, Yellowstone was the epitome of nature's finest statement. It was an art gallery of magnificently grand proportions and one in which all, "old and young side by side, blooming and fading, full of hope and fun and care," could feel comfortable. At the canyon he wrote as if standing within an artist's monumental studio:

The walls of the cañon from top to bottom burn in a perfect glory of color, confounding and dazzling when the sun is shining—white, yellow, green, blue, vermilion, and various other shades of red indefinitely blending. All the earth hereabouts seems to be paint. Millions of tons of it lie in sight, exposed to wind and weather as if of no account, yet marvelously fresh and bright, fast colors not to be washed out or bleached out by either sunshine or storms. The effect is so novel and awful, we imagine that even a river might be afraid to enter such a place. But the rich and gentle beauty of the vegetation is reassuring. The lovely *Linnoea borealis* hangs her twin bells over the brink of the cliffs, forests and gardens extend their treasures in smiling confidence on either side, nuts and berries ripen well whatever may be going on below; blind fears vanish, and the grand gorge seems a kindly, beautiful part of the general harmony, full of peace and joy and good will.[5]

Standing among the geysers, he compared the scene to the most welcoming but wonderful concert hall and museum. Here, "Nature's sources never fail. Like a generous host, she offers here brimming cups of endless variety, served in a grand hall, the sky its ceiling, the mountains its walls, decorated with glorious paintings and enlivened with bands of music ever playing."[6]

Muir employed his pen and words just as an artist uses brushes and paint, observed K. E. M. Dumbell in his book *Seeing the West*. Although Muir's facility of expression did not include sophisticated drawn or painted images, his written "descriptions are the most exquisite of pictures."[7] He approached nature as a painter, composing observations as if producing sketches, then reworking his initial studies into finished compositions that mirror his philosophical leanings toward nature as a perfect reflection of a higher order. This process and this mode of observation suggest why Muir was, in fact, so compatible with painters of his day. His close relationship with the early landscape artists of Yosemite was legendary. He worked side by side with painters like William Keith, searching for compositions that would reveal ideal beauty, much as Moran and Jackson had joined in portraying Yellowstone.

Muir encouraged not only an aesthetic perspective on nature but also a firsthand one. It was not enough just to empathize with preservation goals vicariously through art or literature. True proponents must follow Muir's example of communing directly with nature. In so doing, he extended his philosophy into paradox. While the wise-use proponents of utilitarian conservation like Gifford Pinchot, against whom Muir fought tirelessly, called for harvesting natural resources, Muir and his aesthetic purists appeared to hold the higher ground. But his call for public participation in nature was to have, in the long run, just as profound an impact on nature as the former. Sheer numbers of people would diminish the wilderness that Muir so vociferously championed, just as effectively as lumbering and grazing did.

Over the years, the call for public participation in Yellowstone was voiced loudly and clearly by the artists who followed Muir's footsteps to the park. In the mid-1880s, a number of painters set themselves up in Yellowstone to take advantage of the tourist presence. The growing ranks of park visitors became their subjects as well as their patrons.

Exemplary of that trend was the painter James Everett Stuart (1852–1941). Born in Bangor, Maine, Stuart moved to California with his family in 1860. There he studied painting at San Francisco's School of Design under Raymond Yelland and Virgil Williams. In his early years he associated with Thomas Hill, who had visited Yellowstone earlier in the decade, and with William Keith, who had shared experiences with Muir in their favorite wilderness haunt of Yosemite. Stuart established a studio in Portland, Oregon, in 1881 and began producing landscape interpretations of the Northwest that would ultimately bring him reputation and financial success. His robust style, painterly and dashingly facile, attracted enthusiastic clients and allowed him to be incredibly productive during his long career.[8]

In 1885 Stuart traveled from Portland to Yellowstone. He camped in the park for several weeks, making sketches and experiencing its wonders along with hundreds

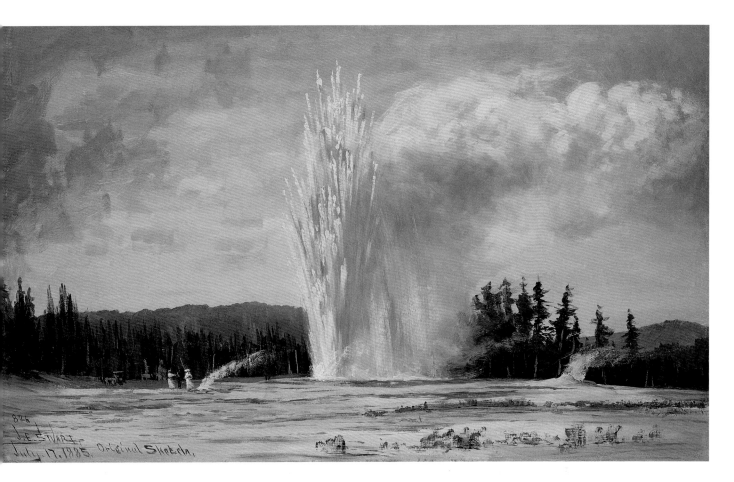

Pl. 24. James Everett Stuart (1852–1941). *Splendid Geyser, Yellowstone National Park,*
1885. Oil on canvas; 18 x 30¼ in. Buffalo Bill Historical Center, Cody, WY.

of other tourists. What he found was not only appealing subject matter but also avid
fellow enthusiasts who wanted pictorial reminders of their own experiences.

The trip began in early July and by August 10 he was back in his Portland stu-
dio, refreshed, inspired, and generously supplied with studies. During the outing he
had proven his prowess as an outdoorsman and adventurer. His skills as a fisherman
had kept him well fed; he had tracked a mountain lion, climbed Electric Peak, and
nearly fallen to his death from the Grand Canyon rim. But most importantly, he had
made the grand tour of Yellowstone filling his sketchbooks and small canvases. On July
17, for example, his diary recorded a typical day.

Made a color sketch of Old Faithful in forenoon. Also a color sketch of Splendid
[plate 24] in afternoon. Had beans and bacon for supper. The mosquitos tormented
us most dreadfully. Mr. Lee [Stuart's traveling companion] has gone to bed snor-
ing regardless of the mosquitos.[9]

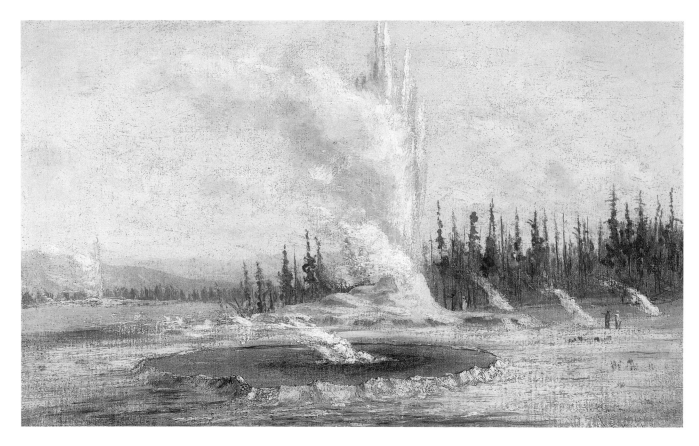

Fig. 43. James Everett Stuart (1852–1941). *Castle and Old Faithful Geyers, Yellowstone,*
1885–1887. Oil on canvas; 18 x 30 in. Collection of Arthur J. Phelan.

A week later he visited the Lower Falls of the Yellowstone for the first time. The
canyon, he wrote, was "a most grand work of nature," surpassing in color and bril-
liancy anything he had ever seen. "Pinnicle [*sic*] after pinnicle towers heavenward
with the most fantastic forms." He spent a full week testing his skills, charmed though
somewhat daunted by the colors and one "grand view" after another.

One thing that Stuart had learned in the park was that there was tremendous
potential for sales of his artwork, such as *Castle and Old Faithful Geysers, Yellow-
stone* (fig. 43). The new hotel at Mammoth Hot Springs might someday have a space
for artists to display and market their paintings of the park. He found the tourists fas-
cinated with his sketches, and though he returned to Portland broke, a new world had
opened for him to explore and perhaps even to reap for profits.

By January of 1886 he was in correspondence with F. F. Oakes of the Northern
Pacific Railroad, inviting him to consider exchanging a free railroad pass for paint-
ings. Oakes initially refused to bargain but eventually conceded, thus allowing Stuart
to spend part of another summer in Yellowstone. In the meantime, his diaries record

work on several paintings with park themes, including a large version of *Great Falls of the Yellowstone*, which consumed most of the month of February. Patrons and critics recognized the extra spirit and vitality that Yellowstone themes brought to Stuart's work. In March he exhibited a view of *Giant Geyser* at the Portland Art Club. The *Oregonian* would acknowledge the effort when it wrote that "the effect of the monster as it hurles [*sic*] itself in the air is striking and full of fascination. Artistically it surpassed most of the artist's former attempts."[10]

At the end of his summer's work in Yellowstone in 1886, Stuart used his train pass to move east. He landed in New York, where he established a studio that would be his formal workplace for the next four years. It was there, at 145 West 55th Street, that he began his monumental six-by-ten-foot canvas, *Great Falls and Canyon of the Yellowstone*. Although its location is unknown, it was considered one of his finest works at the time of his death.

Through the remainder of the decade Stuart continued to collaborate with the railroad, securing passage west to Yellowstone in exchange for paintings. He also negotiated with Charles Gibson of the newly formed Yellowstone Park Association. Gibson oversaw the park's hotels where Stuart sought to feature his paintings for sale. Sadly, arrangements were less than satisfactory. Gibson was a tough bargainer and though an "Art Gallery" was set up at the Mammoth Hot Springs Hotel and Stuart evidently sold works from that venue, things were not to the artist's liking. His diary for September 29, 1887, recounted that "the Art Gallery is in poor order & I am thoroughly disgusted with the association for the shabby manner in which they have treated me. I do not expect to exhibit in any of their Hotels again."

What time Stuart did not spend painting he used to encourage commissions from passersby (fig. 44) and sold work to interested tourists from his tent. A not atypical entry in his diary reads, "I was chatting to tourists about paintings most of the day but made no sales." Some days he could neither peddle his canvases nor even paint them. "I brought in my drawn sketch Looking Down the Canyon. It was snowing all day therefore could not work outside. I wrote several letters." That sketch ultimately became the larger oil on canvas *Looking Down Yellowstone Canyon from Point Defiance*, dated September 12, 1887 (plate 25).

The park was Stuart's favorite studio in those years. He laid claims to its scenery, as well as its vantage points, referring in his diaries to one canyon overlook as "Stuart's Point." "Give me nature with its grand simplicity," he later wrote in his diary at a desk in his New York studio on February 18, 1887. "I do not like studio work."

Although Stuart actively incorporated Yellowstone scenery in his paintings in future years, he stopped visiting the park after 1889, turning instead toward Alaska and the majestic Coastal Range. For most of the 1890s he lived in Chicago, and from 1912 until his death in 1941 he occupied a large studio in San Francisco near Union

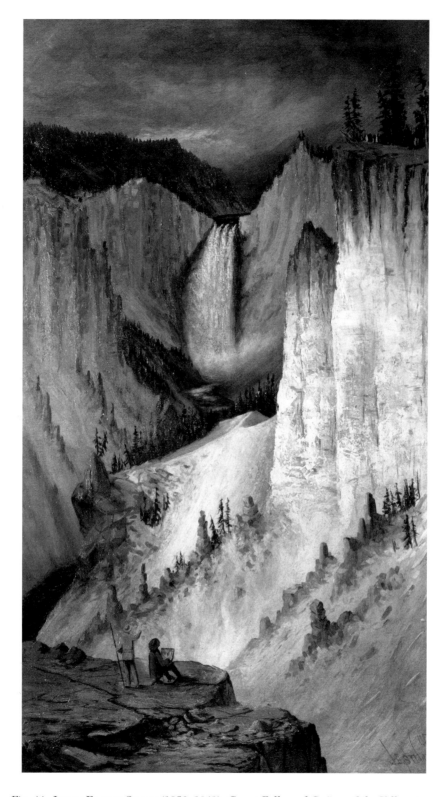

Fig. 44. James Everett Stuart (1852–1941). *Great Falls and Cañon of the Yellowstone*,
1887. Oil on canvas; 36 x 22 in. Collection of Carolyn and Scott Heppel,
on loan to Yellowstone National Park.

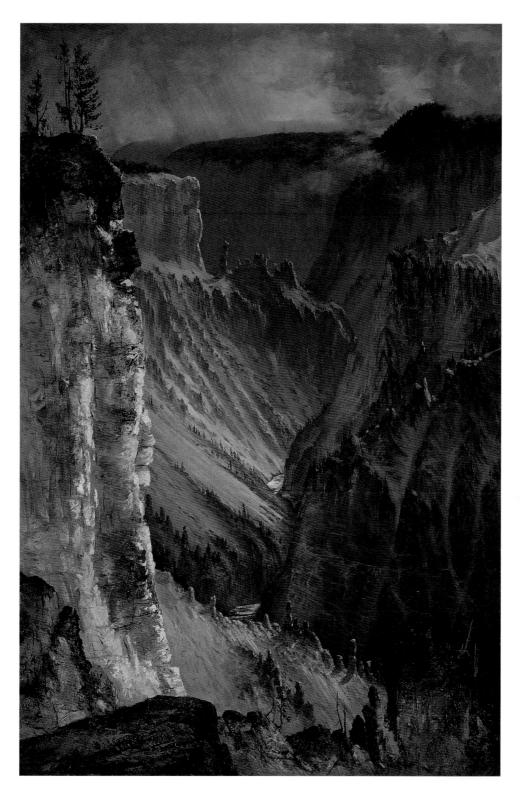

Pl. 25. James Everett Stuart (1852–1941). *Looking Down Yellowstone Canyon
from Point Defiance*, 1887. Oil on canvas; 54¼ x 36 in.
Buffalo Bill Historical Center, Cody, WY.

Fig. 45. Grafton Tyler Brown (1841–1918). *Yellowstone National Park, and Pacific Coast Scenery*, 1886. Promotional leaflet; 12 x 17 in. Burlingame Special Collections, The Libraries, Montana State University, Bozeman.

Square. As years went on, Stuart became extremely successful and his fresh and richly colored, spontaneous canvases exceedingly popular. As one Philadelphia critic would conclude in 1902, "An imperishable art, an art so wonderful in its conception, its treatment, its perfection of realism, technique and its possibilities, that painters and critics alike marvel at the audacity of its creator, has been accomplished by J. E. Stuart."[11]

California seemed to have no shortage of audacious creators. The same summer of 1885 when Stuart first visited Yellowstone, another painter who had practiced in California and was then residing in Portland came to Yellowstone to capture its likeness and a bit of the glory as well. This was Grafton Tyler Brown (1841–1918), an African American painter, son of a freed slave, who had moved to San Francisco in the early 1860s and taken employment as a draftsman for the lithographic firm of Kuchel and Dressel.[12] He worked his way up to a management position within the firm by late in the decade. The company produced music sheets, bank notes, and remarkably beautiful city views using color lithography.

YELLOWSTONE NATIONAL PARK.

AND

PACIFIC COAST SCENERY.

SERIES 1886.

G. T. BROWN, ARTIST,

127½ FIRST ST., PORTLAND, OREGON.

I herewith present for your perusal a Catalogue and Outline Diagram of scenes sketched in Oil at Yellowstone Park during the past summer.

The subjects are careful studies from nature, and embrace the most prominent features of the Park The paintings produced from them will have all the truths in color of that famous locality, together with such artistic effect as will make them appreciable to all who have visited that section.

Should you desire to favor me with an order for one or more, they will receive prompt attention.

Respectfully yours,

N. B.—These subjects are only painted to order, and will not be found on sale any where.

In 1879 Brown sold out his interest in the business and turned his hand to painting. He traveled throughout the Northwest in itinerant fashion for a while, eventually settling in Portland, where he was listed in city directories between 1886 and 1890. According to Brown's records, he visited Yellowstone during the summer of 1885. In a handsome promotional brochure he published the next year, titled *Yellowstone National Park, and Pacific Coast Scenery*, Brown advertised twenty-eight different park views. These were illustrated in individual, numbered line drawings (fig. 45) from which prospective clients could choose geyser or canyon views, river scenes or the Absaroka Range reflected in Yellowstone Lake. Purchasers were assured that their finished oil painting would be delivered with fidelity to the scene and in full consonance with standards of artistic excellence.

The subjects are careful studies from nature, and embrace the most prominent features of the park. The paintings produced from them will have all the truths in color of that famous locality, together with such artistic effects as will make them appreciable to all who have visited that section.

He also promised "prompt attention" to any orders.[13]

One of the more popular views was Brown's *Grand Canyon of the Yellowstone from Hayden Point*. It was listed as "No. 4" in the brochure and showed the falls set back at some distance and lit with brilliant morning light. At least two versions of this are extant, one dating from 1890 (fig. 46) and another from 1891 (plate 26).[14] Brown's style is tighter and drier than Stuart's. He attends more to clear articulation of form while avoiding the virtuoso brushwork that Stuart employed.

Brown and Stuart knew each other, at least through their work. They were both members of the Portland Art Club. In his diary for September 18, 1887, Stuart referred to Brown as that "would be artist," who had apparently had dealings with Charles Gibson and his hotel's "Art Gallery." The offhanded negativism of Stuart's remark may have been born of professional jealousy. Brown's painting of a lumber camp along the Truckee River, exhibited alongside Stuart's *Giant Geyser* at the 1886 Portland Art Club show, won substantially higher praise, "the whole scene being very effective and good in conception."[15] Northern Pacific Railroad literature held Brown's work up for favorable comparison with Thomas Moran's, a compliment that was never similarly granted to Stuart's efforts, despite the fact that the company owned several of Stuart's paintings.[16]

In 1892 Brown moved to Saint Paul, Minnesota, where, following his proclivities for drawing, he worked as a draftsman for the United States Army Corps of Engineers. He later worked for the city's Civil Engineering Department in a similar capacity though he continued to paint and listed himself in city directories as an artist.

The 1890s welcomed a host of artists to Yellowstone who did not so much find fascination with the scenery as with the human history that was unfolding within its borders. The *Livingston Enterprise* had reported back in 1886 that the traffic was increasing one hundred percent over the previous year. "The unparalleled scenery and matchless grandeur of the World's Wonderland is just becoming known to the millions of leisure and means."[17] It held a strong appeal for average folks as well. "This park is an immense thing for the American bourgeoisie," wrote Owen Wister a few years later. "Popper takes mommer and children in a big wagon with two mules and their kitchen and beds, and forth they march hundreds of miles and summer in the park."[18] Because of the pressing inadequacy of park administration and the burgeoning number of people who were virtually loving the splendors to death, the U.S. Army

was sent in to manage things in 1886. According to most historians, the military's intervention saved the park from destruction at the hands of both the public and pernicious business interests.

Frederic Remington (1861–1909), the popular painter and illustrator from New Rochelle, New York, came to Yellowstone in the summer of 1893 to work up a story on the military for *Harper's Weekly*. He claimed right away that the scenery was beyond his skills.

> Posed on the trestled road, I looked back at the Golden Gate Pass. It is one of those marvellous vistas of mountain scenery utterly beyond the pen or brush of any man. Paint cannot touch it, and words are wasted. War, storms at sea, and mountain scenery are bigger than any expression little man has ever developed. Mr. Thomas Moran made a famous stagger at this pass in his painting; and great as is the painting, when I contemplated the pass itself I marvelled at the courage of the man who dared the deed. But as the stages of the Park Company run over this road, every tourist sees its grandeur, and bangs away with his kodak.[19]

But he was there to admire and document the soldiers in action and he achieved that goal. "Just back from . . . the Yellowstone Park," he wrote to his friend Poultney Bigelow in late August. "Made the d—est ride with a detachment of 6th Cav. over the mountain. One would not believe where a horse will go."[20]

According to a story he wrote and illustrated that appeared a year and a half later in *Harper's Weekly*, Remington joined a reconnaissance trip into the backcountry. Led by the park's acting superintendent, Captain George S. Anderson, the expedition rode out of Mammoth for a tour of the park in search of poachers. Animal populations were being decimated by unscrupulous hunters and trappers, and Anderson sought to check the blight by surveillance and by leaving his tracks in places off the beaten path where perpetrators might otherwise think their nefarious operations could succeed unheeded. Remington dubbed the maneuver "Policing the Yellowstone."

Remington viewed Yellowstone as "a great game-preserve and breeding-ground" that, if left undisturbed, "must always give an overflow into Montana, Wyoming, and Idaho, which will make big game shooting there for years to come."[21] He also made the point that game protection was woefully inadequate, not due to a lack of attention from men like Anderson but because of weak laws regarding punishment of offenders.

Remington's story and the accompanying illustrations were intended to bring public attention to the park's problems. There is no evidence that he was invited to Yellowstone or, once there, that Anderson urged Remington to join the cavalry's excursion. The painter probably worked his way into the action by virtue of his national reputation as an artist-correspondent with the American military. He had accompanied

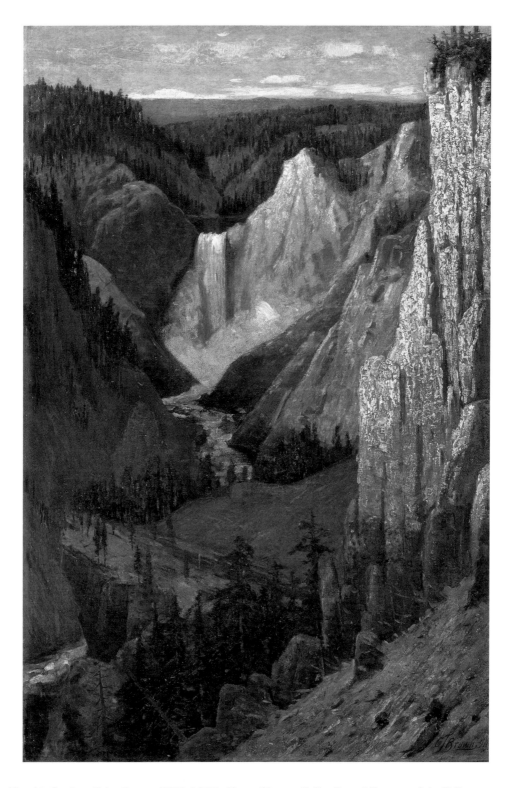

Fig. 46. Grafton Tyler Brown (1841–1918). *View of Lower Falls, Grand Canyon of the Yellowstone*, 1890. Oil on canvas; 30$\frac{1}{4}$ x 20$\frac{1}{8}$ in. Smithsonian American Art Museum, Smithsonian Institution, Washington, DC. Museum purchase through the Luisita L. and Franz H. Denghausen Endowment and the Smithsonian Collections Acquisitions Program.

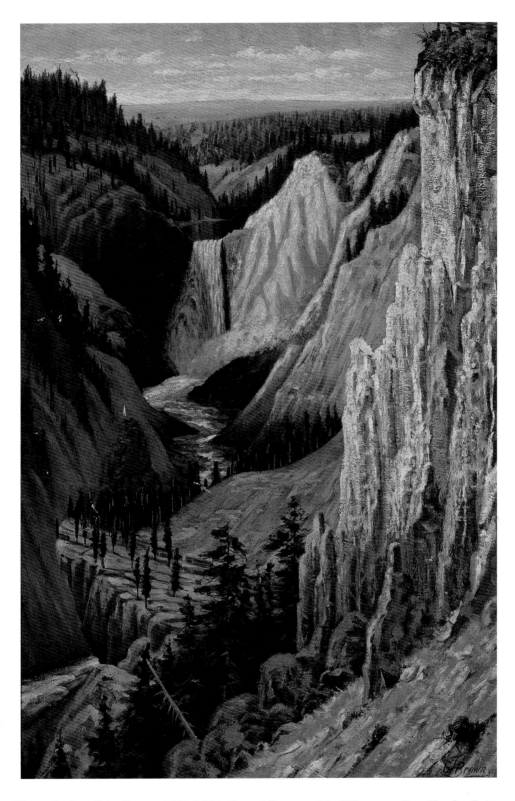

Pl. 26. Grafton Tyler Brown (1841–1918). *Grand Canyon of the Yellowstone from Hayden Point*,
1891. Oil on canvas; 24 x 16 in. The Oakland Museum of California, Oakland, CA.

the 10th Cavalry during the mid-1880 Geronimo campaigns in Arizona and had been close to the scene at the infamous battle at Wounded Knee in 1890. Although he had never formally been a part of the military ranks, he was a welcome advocate and supporter of their activities. Anderson was no doubt gratified to have someone of Remington's caliber and distinction on board. His skills as a writer and painter would promote the superintendent's cause of pushing forward national legislation to put teeth into the enforcement of regulations for game preservation.

Remington's motivations as a writer and an artist were threefold—to produce portraits of the leading figures in the story, to capture a sense of everyday life in the field, and to invigorate the narrative with scenes of dramatic action. His words and his pictures coalesce brilliantly to achieve those ends. Among the seven illustrations for his story, the most effective portrait depicts *On the Headwaters—Burgess Finding a Ford* (plate 27). This shows Felix Burgess, who was, in title, the commissioned deputy U.S. marshal for the park from 1891 through the end of the century. The author Emerson Hough in 1894 described him as the "only scout whom the munificent (read that as irresponsible) U.S. Government provides for the protection of this peerless domain—a domain which any other power on earth would guard jealously as a treasure vault."[22] He had a big job, and by the looks of his determined expression, he was up to the task. A year after this portrait was made, Burgess captured a particularly tenacious and dangerous poacher, Ed Howell, an accomplishment that garnered him a citation of honor from the army and national recognition from the Boone and Crockett Club.

Remington's extraordinary ability as a draftsman and watercolorist, especially in the rendering of horseflesh, is evident in the Burgess portrait as well as an action piece, *The Bell-Mare over a Bad Place* (fig. 47). Since, as Remington observed, "Burgess despised ease," the troop was maneuvered through all manner of thin and hazardous terrain. At one place they were called upon to "bucket over" a "nasty seam" that was six feet deep at the base of an already steep canyon. When Burgess led them through the thickest mazes of downed timber, Captain Anderson would chortle, "'Burgess is on the trail now'; and when it was fairly good going, 'Now he is off.'"[23]

Remington met the Philadelphia writer of western novels, Owen Wister, in Norris and dined with him at the Mammoth Hot Springs Hotel on his way out of the park. The artist's prodigious girth and rather patriotic zeal impressed Wister. "Remington is an excellent American. . . . He thinks as I do about the disgrace of our politics and the present asphyxiation of all real love of country," Wister penned in his 1893 Yellowstone journal. He "weighs about 240 pounds and is a huge rollicking animal."[24]

Like Wister, that rollicking heavyweight was a great admirer of the park. Although his article was published a bit after political efforts had achieved Anderson's dream of enforceable laws against poaching—Congress passed the Lacey Act in

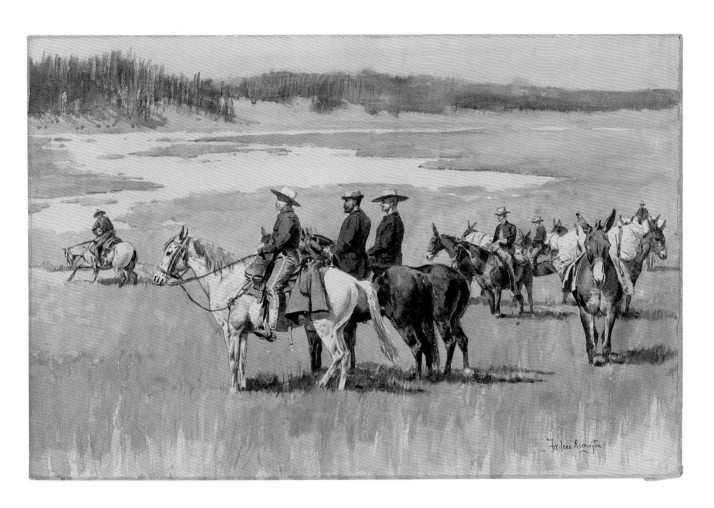

Pl. 27. Frederic Remington (1861–1909). *On the Headwaters—Burgess Finding a Ford*,
1893–1895. Watercolor on paper; 20¹/₂ x 30¹/₂ in. The Metropolitan Museum of Art,
New York, NY. Anonymous gift, 1962 (62.241.2).
Photograph courtesy of the Metropolitan Museum of Art.

1894—Remington participated in the solution. His story and its images helped solid-
ify public opinion behind the military's beneficial role in park management and the
need for stricter game controls within its boundaries. He was additionally outspoken
about the mindless physical depredation of park features. His article concluded with
a powerful admonition to *Harper's* readers.

> Americans have a national treasure in the Yellowstone Park, and they should guard
> it jealously. Nature has made her wildest patterns here, has brought the boiling
> waters from her greatest depths to the peaks which bear eternal snow, and set her
> masterpiece with pools like jewels. Let us respect her moods, and let the beasts she
> nurtures in her bosom live, and when the man from Oshkosh writes his name with

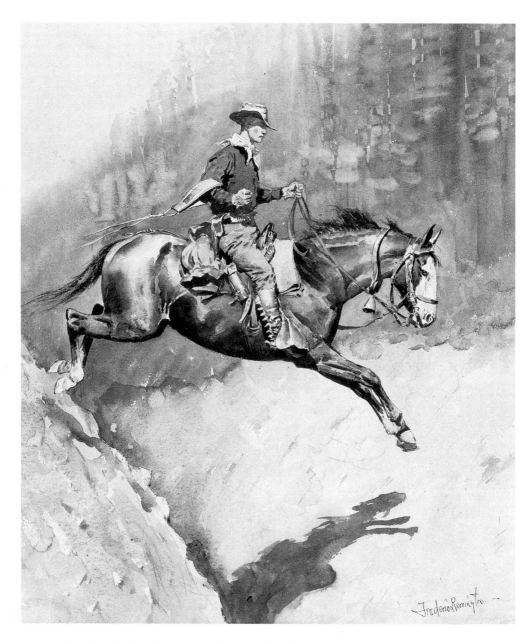

Fig. 47. Frederic Remington (1861–1909). *The Bell-Mare over a Bad Place*, 1893.
Watercolor; 24 x 21³/₄ in. © 1999 Sotheby's, Inc.

a blue pencil on her sacred face, let him spend six months where the scenery is cir-
cumscribed and entirely artificial.[25]

Because of Remington's affection for Yellowstone, he was asked to illustrate a
story by Lieutenant Elmer Lindsley, "A Winter Trip through Yellowstone Park," in
Harper's Weekly in 1898. The four images, all of which were probably based on pho-

THE OUTLAW

DRAWN BY FREDERIC REMINGTON

MOUNTAIN LIONS IN YELLOWSTONE PARK—"THERE IS A STRONG REGULATION REGARDING THE ABSOLUTE LETTING ALONE OF WILD THINGS IN THE PARK. IT IS A PROPER INTENTION TO LET NATURE TAKE ITS COURSE, BUT WHEN THE SUPERINTENDENT CLEARLY SEES THAT A BAND OF MOUNTAIN LIONS WILL SURELY EAT UP ALL THE MOUNTAIN SHEEP IN A VERY SHORT TIME . . THE TWO SCOUTS WHITTAKER AND MORRISON GIRD THEMSELVES WITH RIFLE AND SKI AND PROCEED TO EQUALIZE THINGS"—(SEE P. 14)

Fig. 48. Frederic Remington (1861–1909). *The Outlaw*, 1900. *Collier's*, March 17, 1900.
University of Illinois at Urbana-Champaign.

tographs by Frank J. Haynes, lacked the spirit of the work he had done in the field with Anderson five years earlier. But the commission did revive his interest, and in February 1900 he returned to the park for a winter trek into the backcountry in pursuit of mountain lions. This time he traveled with two scouts, James G. Morrison and George Whittaker, at the behest of acting superintendent Colonel Oscar J. Brown, and on skis rather than horseback. And this time the scouts were hunting animals rather than poachers—the lions were devastating the bighorn sheep population and merited an adjustment in their own population. Remington's story, "Mountain Lions in Yellowstone Park," appeared with a single illustration, *The Outlaw* (fig. 48), in the March 17, 1900, issue of *Collier's*. It effectively reinforced the park's current wildlife management philosophy.

As with his previous experience in Yellowstone, the 1900 trip was invigorating for Remington. He wrote his close friend, Captain Jack Summerhayes,

> Say if you could get a few puffs of this cold air out here you would think you were full of champagne water. I feel like a d—kid—
>
> I thought I should never be young again—but here I am only 14 years old—my whiskers are falling out.
>
> Capt. Brown of the 1st cav. wishes to be remembered to you both. He is Park Superintendent. Says if you will come out here he will take care of you and he would.[26]

But not all artists had the cooperation from park officials that Remington enjoyed. The German-born big game animal painter Carl Rungius (1869–1959) came to America in 1894 after several years' training in Berlin art academies. He established a studio in New York City and ventured west on his first sketching trip in 1895. Wyoming and Yellowstone were his destinations.

Rungius had been issued an invitation to visit the area by a colorful outfitter and rancher, Ira Dodge from Cora, Wyoming. The young artist and his cousin, Karl Fulda, spent three and a half months in northwest Wyoming, headquartered at the Box-R Ranch along the east fork of the Green River in the shadow of the Wind River Mountains. There he gained the first true inspirations for his life's work of depicting western life and animals. Rungius loved to hunt, and his prey became his models. Wyoming proved to be fertile ground for his prodigious sportsman's appetite, and he established there a practice of painting from his trophies.

The 1895 Wyoming trip included a late September swing north from Cora through Jackson Hole and along the east slope of the Tetons into Yellowstone. His diaries record a lukewarm initial reaction. First the soldiers confiscated his firearms, leaving him feeling somewhat vulnerable. Then the lodgepole pine forests, reminding him of German woods, seemed "rather dull." But the scenery soon improved. Paintings were being composed before his eyes—"came to Yellowstone Lake, beautiful lake, background mountains . . . warm fountains at the lake, holes with boiling water everywhere. . . . The landscape is more beautiful, wonderful valleys, granite rocks on both sides, beyond is a bubbling rivulet along the way."[27] Although the weather deteriorated along with their victuals, since they could not hunt for meat, Rungius wrote that "the ride gets all the time more beautiful," especially after they moved through the geyser basins from Old Faithful north to Norris.

By the first of October, the party reached the Yellowstone River. "The beauty of the canyon and the Yellowstone River falls surpasses all our expectations; grand, not possible to describe it." The next day he spent the morning working on two studies

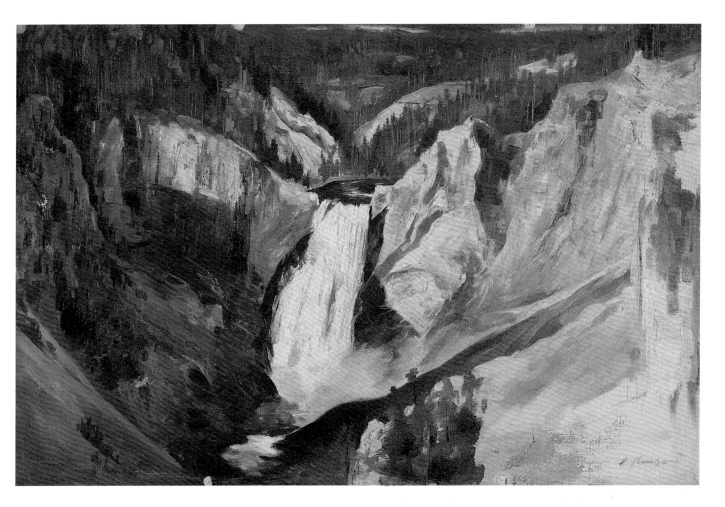

Pl. 28. Carl Rungius (b. Germany; 1869–1959). *Waterfall [Lower Falls of the Yellowstone]*, 1895. Oil on canvas; 15¹/₂ x 23¹/₂ in. Glenbow Museum, Calgary, Alberta, Canada.

(plates 28 and 29). A rainstorm forced him to stop after two hours, but he had captured their essence with quick, broadly faceted, bold strokes of color. This was the turning-around point of their pack trip. Their provisions were reduced to bread and an occasional fish. Snowstorms and cold weather further exacerbated the situation—"froze my ears when I baked bread the evening before," he wrote in his diary on October 4. By the next day they exited the park, "got rifles back," and once again could happily supply their larder with meat.

Rungius and Fulda returned to Brooklyn in late November. Sadly, none of the field studies from Yellowstone appear to have become backdrops for later studio paintings. Nonetheless, the trek became a high point of what he called his "Wild West Trip." He would return to Wyoming many times over the next dozen years. Ultimately, it

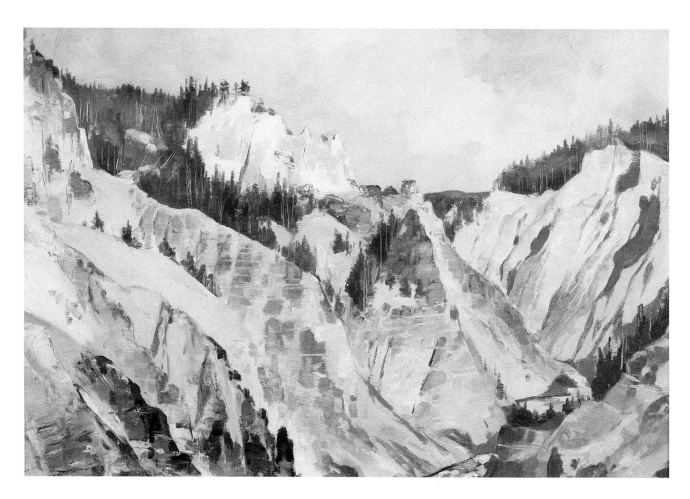

Pl. 29. Carl Rungius (b. Germany; 1869–1959). *Rocky Canyon [Yellowstone Canyon]*, 1895.
Oil on canvas; 14³/₄ x 22¹/₄ in. Glenbow Museum, Calgary, Alberta, Canada.

was the Canadian Rockies that called him, and he established a permanent western summer studio in Banff to complement his formal atelier in New York City. Frederic Remington would later write of Rungius's work,

> For a long time I have said "This man Rungius knows our big game animals and he knows their backgrounds and he paints it so it looks all right to me; and I am going to own one sooner or later. There is not likely to be another fellow who will have the opportunity to study big game as you are doing, and I think records of us fellows who are doing the 'Old America' which is so fast passing will have an audience in posterity."[28]

Although Rungius's field studies of Yellowstone Falls and canyon reveal a spontaneity and freshness suggestive of modern artistic trends of the day, his studio style at the time was very much a part of the German romantic realist tradition. Finished paint-

ings that resulted from the Wyoming trip are relatively somber academic works, richly painted and tightly drawn. They lack the freshness of plein-air work and the sense of color as light that the impressionists were exploring at the time. While Rungius was not among their novel ranks, the park was about to lend itself to the new tradition.

The director of the Pennsylvania Academy of the Fine Arts had accepted a challenging assignment in early 1892, when his venerable museum, known equally for its roles as a collecting and a teaching institution, presented to its eager audience the works of French impressionist painter Claude Monet. The show opened in late January, and its accompanying catalogue listed four Monet paintings on the same page with a Turneresque vision of Venice by Thomas Moran. It was not the first time impressionist works had been shown in Philadelphia, but it was the premier occasion for singling out such canvases as exemplary of a unique style deserving special recognition. As it turned out, most of the critics were pleasantly indulgent. One responded, for example, that "it is not proper to rail at Impressionism, even if one does not understand it. It is by such movements as this that art in general is helped along." But other observers, including most of the public, were not so lenient. They demurred that art did not need such help, that work of this ilk was a "freak of fashion" and that it was all well beyond the comprehension, much less appreciation, of the average gallery patron of the day.[29] One reviewer particularly lambasted a Monet painting titled *The Shining Stream*. It was, in his estimation, the product of failing eyesight—astigmatism—the same infirmity that others had used to explain away Turner's late paintings. It gave the critic "the impression of a scene in the Yellowstone National Park," in which one of the paint pots "has just exploded, and covered the visible landscape with flecks of bright yellow, red and purple. Through the midst of this chromo-circus runs a stream which recalls the Schuykill when the coal banks affect their color up on its swollen waters."[30]

And so it was that French impressionism, one of the most powerfully revolutionary forces to course the chapters of western art history, was claimed by the populist press as faulty on multiple counts. As a new and distinct style it represented a capricious vogue, a pungent anomaly of nature transgressed by a flowing blight of industrial pollution as seen through ailing eyes. Furthermore, and perhaps of greater concern, this international trend was infiltrating (some would say infecting) the ranks of homegrown artists. In fact, it had.

Among the Americans who were exhibiting impressionist works alongside those of Monet in exhibitions across the country that year was the Connecticut painter John Henry Twachtman (1853–1902). Born in Cincinnati, Twachtman developed in his short career one of the most distinctive and highly praised personal interpretations of the impressionist idiom of any practitioner in America. He studied originally, beginning in 1871, with Munich-trained artist Frank Duveneck of Cincinnati and one of his

teacher's friends in Munich, Ludwig Loefftz. Later he attended the Académie Julian in Paris. Each of these periods of training produced distinct and compelling styles of painting for Twachtman. But it was his experiences and associations after Paris, from 1885 on, that produced the mature manner for which he is most celebrated today. At that time, particularly with the encouragement of American impressionist J. Alden Weir and the influence of James McNeill Whistler, Twachtman developed a soft, lyrically poetic version of impressionism. Harrison S. Morris, director of the Pennsylvania Academy from 1892 to 1905, referred to these late paintings as Twachtman's "fragile dreams in color," and it was with one such chromatic musing, a painting titled *Autumn*, that he won a Temple Gold Medal at the Pennsylvania Academy's 1894 annual exhibition.[31]

The Philadelphia critics did not cotton to Twachtman's form of impressionism in 1894 any more than they had to Monet's two years earlier. Once again, their reaction was for the most part one of confusion and chagrin at how a small impressionist painting like *Autumn* could be other than a "passing fancy." The public seemed equally unsure of how to react, confirmed in the fact that Twachtman's works sold poorly. Thus it must have come as something of a relief that year for the artist to receive a commission from Charles Carey in Buffalo, New York, to paint a series of works focused on Niagara Falls.

Fig. 49. John Henry Twachtman (1853–1902). *Letter to Major William A. Wadsworth*, 1895. Pen and ink on paper. Wadsworth Family Papers, College Libraries, SUNY Geneseo, Geneseo, NY.

For an artist whose contemplative reveries in paint had concentrated for nearly a decade on intimate views of seasonal changes in the Connecticut woods near his studio, Niagara must have presented a formidable challenge. Yet the physical omnipresence of the powerful cascade, while overtly antithetical to Twachtman's poetic nature, invigorated his work and added a literal dimension that was both refreshing and, to some, appealing.[32]

In 1895 Twachtman was granted a similar commission from another New York patron, Major William A. Wadsworth of Geneseo. This time he was to travel farther afield, to Yellowstone, to produce a series of paintings on the park's wonders. He was elated with the experience and favorably challenged by the circumstances. While many of his mature paintings communicate an elegiac air, Twachtman's responses to Yellowstone sang out as robust anthems to nature's splendor. He was dazzled by the falls and aglow with the brilliance of the crystalline clarity of features like Emerald Pool.

Most accounts suggest that he probably arrived in the park in mid-September. On the twenty-second of that month he wrote his sponsor the following letter (fig. 49), effusively demonstrating his pleasure at being exposed to such glory.

I am overwhelmed with things to do that a year would be a short stay. Your reply to my telegram came and I thank you for your liberality. This trip is like the outing of a city boy to the country for the first time. I was too long in one place. This scenery too is fine enough to shock any mind. We have had several snow storms and the ground is white—the cañon looks more beautiful than ever. The pools are

more refined in color but there is much romance in the falls and the cañon. I never felt so fine in my life and am busy from morning until night. One can work so much more in this place never tiring. My stay here will last until the first, perhaps. I want to go to Lower Falls, they are fine. There are many things one wants to do in this place. Believe me.[33]

Twachtman's letter, especially his claim that the scenery would shock any mind, suggests that the dose of Wyoming's altitude and grandeur was wholesomely invigorating. And yet, as western views go, this was relatively subdued and thus comprehensible to him. The park's early historian, Hiram Martin Chittenden, produced the first edition of his book *The Yellowstone National Park* while Twachtman was enjoying his stay there. He reflected on the park's scenery that it "is not so imposing as that of Colorado and some other parts of the Rocky Mountain region; but it is more varied and beautiful. The eye is not wearied with the constant sight of vast and bare mountain cliffs."[34]

Twachtman painted many views of the "romance" shared by the canyon and the falls. In them he generally presents a frontal view with reduced tonal values that tend to flatten the perspective and the illusion of space and harmonize the various elements. "The result," according to Novelene Ross, "is a tension between an illusion of nature in three dimensions and the two-dimensional patterns of the painting's design. This tension is the hallmark of Twachtman's mature style."[35] Geological shapes and details, dissolved in light, were left to glow in an iridescent, hushed spectacle as seen in *Waterfall in Yellowstone* (plate 30).

Less ethereal and rather more literal is Twachtman's *Canyon in the Yellowstone* (plate 31). Less abstract too than the previous work, this painting more adequately captures the contrasting force of the falls and the tranquility of the river below. The low horizon line concentrates attention on the watery display, as do the sunlit canyon walls. Atypical of his paintings of the period, this piece presents a relatively strong illusion of space that accompanies his characteristic portrayal of shimmering light.

When Twachtman turned to the pools as subjects, he produced formal abstractions of sensuous beauty and rich color. The serenity and engaging depth of *Emerald Pool* (plate 32) mirror the description that Chittenden would, in a later edition of his history, lavish on Morning Glory Pool and other similar features. "In this beautiful object the quiescent pool is at its best. Its exquisite bordering and the deep cerulean hue of its transparent waters make it, and others like it, objects of ceaseless admiration."[36]

Both Twachtman and his patron were proud of his Yellowstone series. Twachtman took advantage of the new work almost immediately upon his return east, presenting a couple of the canyon and falls paintings at the spring 1896 exhibition of New York's Society of American Artists. Wadsworth, who apparently purchased a number

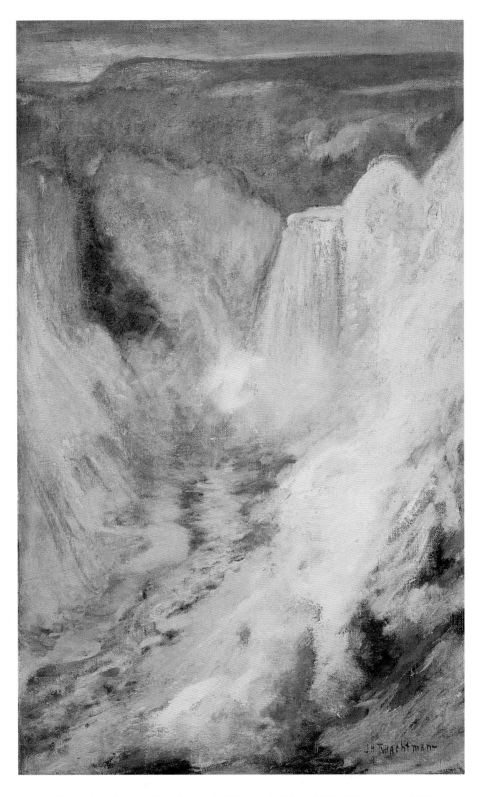

Pl. 30. John Henry Twachtman (1853–1902). *Waterfall in Yellowstone*, 1895.
Oil on canvas; 25³/₈ x 16¹/₂ in. Buffalo Bill Historical Center, Cody, WY.
Gift of Mr. and Mrs. Cornelius Vanderbilt Whitney.

Pl. 31. John Henry Twachtman (1853–1902). *Canyon in the Yellowstone*, 1895.
Oil on canvas; 30$^{1}/_{2}$ x 25 in. Courtesy of the Berry-Hill Galleries, New York, NY.

Pl. 32. John Henry Twachtman (1853–1902). *The Emerald Pool*, 1895.
Oil on canvas; 25 x 25 in. Courtesy of the Phillips Collection, Washington, DC.

of the resulting pieces, exhibited a group of them at the Buffalo Fine Arts Academy in 1913. The critics generally praised what they saw, suggesting in one instance that through the "eye of a modern painter," Yellowstone might be "rediscovered" and with felicitous results.[37]

Twachtman's compatriot Theodore Robinson saw the Yellowstone Park series in February of 1906. He recorded in his diary that several were "quite handsome," but he felt also that "they are done too easily and it is a country I shouldn't care for—it is not enough in time. There is undeniably an interest in savagery—wilderness and it is new and curious. One thinks of Wister's stories."[38] What Robinson may be implying here is that Twachtman took advantage of a new and unexplored domain, unlike northern France where Robinson so successfully painted. The results were raw, new and savage like the West, without the cultural patina and historical tradition of Europe to assure its acceptance as subject matter. It was natural that such a scene would have provided discomfiture, would be "not enough in time" for someone whose focus was European rather than American themes. Thus it was not for Robinson to recognize the remarkable contributions Twachtman had made with his Yellowstone works.

But others of his contemporaries could and did. Thomas Dewing wrote in an homage to Twachtman published in 1903 that beyond his mastery of harmonious atmosphere and values, he had "also painted studies of the more spectacular parts of America, like the Yellowstone Park . . . interesting because of their point of view, as examples of the modern rendering. . . . These places will probably not be finally treated in art for many centuries." Twachtman had set the stage for others to follow, discovering in the park occasions for exploring the fundamental beauty of design, the graceful rhythms of nature's countenance, and the joy of rendering its colors so splendidly arrayed. As Twachtman's letter to Wadsworth testified and his paintings reflected, the artist felt a special connection to this distant place. His fellow impressionist J. Alden Weir would summarize Twachtman's contribution to American art in a phrase that encapsulated the Yellowstone experience. In "Twachtman's canvases," he wrote, "one is made to feel the spirit of place and the delight with which his work is done."[39]

Twachtman had been in the park at the same time as Carl Rungius. So far as is known, they did not meet—at least Rungius, the only one of the two known to have kept a diary, does not mention it. Although Rungius harbored a true penchant for painting animals, neither he nor Twachtman came away with any images of Yellowstone's rich and unique store of wildlife. That would be left to one of America's preeminent artist-naturalists of the period, Ernest Thompson Seton (1860–1946), who settled in for the summer of 1897 at Yancey's shanty near the junction of the Yellowstone and Lamar Rivers.

Seton was born in England and came with his family to Canada as a boy. Against his father's wishes he sought and was awarded a multiyear scholarship at the Royal

Academy of Arts and Sciences in London. He thus returned to England when he was eighteen. There he became acquainted with the natural history collections of the British Museum and so, over the course of several years, he devoted himself to studying art and nature together. In 1883 he moved to New York and began life as an illustrator specializing in portraying animals. There he also began writing and illustrating a book on animal anatomy, an effort that he continued in 1890 when he took up studies in Paris at the Académie Julian. The book was completed in 1896 and published under the title of *Studies in the Art Anatomy of Animals*.[40]

Recognized by then as an authority on natural history, Seton was invited by the editor of *Recreation Magazine*, George O. Shields, to produce a series of articles on western wildlife, especially the bountiful store found in Yellowstone National Park. The offer accepted, Seton and his wife, Grace, traveled west to the park in early June 1897. He brought with him a philosophical bias that fundamentally distinguished him from his contemporary, Carl Rungius. Seton was convinced that artists must avoid painting from the dead animal, which was Rungius's standard method of working. Instead, the painter should "model from the living, using as guides the best anatomical diagrams available," while also giving sway to the elements of the moment, "the greater essentials of light, colour, and movement."[41] The reason that Rungius painted no finished canvases of Yellowstone and its animals may simply be that he had been forced to leave his rifle at the entrance gate. Without some trophy of the hunt, Rungius had nothing to paint: without killing the subject he had no way to record it. Seton, who was also a hunter and outdoorsman, left his rifle at home. He brought with him two other aids that proved to have equal power, his sketchbook and brushes. These were all he needed to find an artistic connection with Yellowstone.

Seton's journal for the summer of 1897 is a wonderful and lively account of a man searching for connections between man and nature. Living far from the busy hotels, he was able to spend his days well-removed from the growing surge of tourist mania. He passed his time communing with the lowly woodchuck, counting and drawing beaver, or listening for the songs of the hermit thrush and the coyote. Images in his journals vary from views of Frank J. Haynes's home and studio at Mammoth (fig. 50) to sketches and entries recording a variety of animals observed over several days (fig. 51).

In his book *Wild Animals At Home*, published in 1913, Seton told of his only serious frustration with Yellowstone.

> When we went to the Yellowstone in 1897 to spend the season studying wild animal life, we lived in a small shanty that stood near Yancey's, and had many pleasant meetings with Antelope, Beaver, etc., but were disappointed in not seeing any Bears. One of my reasons for coming was the promise of "as many Bears as I liked." But some tracks on the trail a mile away were the only proofs that I

Fig. 50. Ernest Thompson Seton (b. England; 1860–1946). *F. J. Haynes's Home and Studio*, 1897.
From *The Sketchbooks and Journals of Ernest Thompson Seton*. Watercolor; 10 x 7 in.
Transparency number 7680(2). Courtesy of the Department of Library Services,
American Museum of Natural History, New York, NY. Photograph by Jackie Beckett.

found of Bears being in the region. One day General [Samuel Baldwin Marks]
Young, then in charge of the Park, came to see how we were getting along. And I
told him that although I had been promised as many Bears as I liked, and I had
been there investigating for six weeks already, I hadn't seen any. He replied, "You
are not in the right place. Go over to the Fountain Hotel and there you will see as
many Bears as you wish." That was impossible, for there were not Bears enough
in the West to satisfy me, I thought. But I went to the Fountain Hotel. . . .

Early next morning I equipped myself with pencils, paper and a camera, and
set out for the garbage pile [behind the hotel]. At first I watched from the bushes,
some seventy-five yards away, but later I made a hole in the odorous pile itself,

Fig. 51. Ernest Thompson Seton (b. England; 1860–1946). *Sketches of Chipmunk, Badger, and Black-Tailed Deer*, 1897. From *The Sketchbooks and Journals of Ernest Thompson Seton*. Pen and ink; 10 x 7 in. Transparency number 7676(2). Courtesy of the Department of Library Services, American Museum of Natural History, New York, NY. Photograph by Jackie Beckett.

Fig. 52. Ernest Thompson Seton (b. England; 1860–1946). *Sketches of Bears*, 1897.
From *The Sketchbooks and Journals of Ernest Thompson Seton*. Pen and ink; 10 x 7 in.
Transparency number 7672(2). Courtesy of the Department of Library Services,
American Museum of Natural History, New York, NY. Photograph by Jackie Beckett.

and stayed there all day long, sketching and snapshotting the Bears which came and went in greater numbers as the day was closing.

A sample of my notes [fig. 52] made on the spot will illustrate the continuity of the Bear procession, yet I am told that there are far more of these animals there to-day than at the time of my visit.[42]

Seton's travels took him from British Columbia to Mexico in search of animals, yet he claimed that he "found no place more rewarding than the Yellowstone Park, the great mountain haven of wild life." Here animals and man enjoyed a special relationship. Yellowstone's establishment had given birth to

a new era of protection of wild life; and, by slow degrees, a different attitude in these animals toward us. In this Reservation, and nowhere else at present in the northwest, the wild things are not only abundant, but they have resumed their traditional Garden-of-Eden attitude toward men.[43]

Seton and his wife would return to New York at summer's end. He worked up a series of articles for *Recreation*, where appeared illustrations of many of his paintings and drawings of the people and animals that he had met. He would visit the park several times in future years, including trips in August 1912 and January 1914. Each experience enhanced his wildlife consciousness. Each convinced him further of his initial perception of Yellowstone as the benevolent garden.[44]

Some have contended that Seton's work lacked maturity and sophistication. He was even unfairly dragged into the "nature faker" controversy by John Burroughs in 1903 with the contention that he exploited nature for personal gain and gave back only puerile, unscientific pap.[45] Despite the fact that he tended in his writings and his art to anthropomorphize the animals he portrayed and wash them with a tint of sentimentality, he was a serious naturalist and a painter whose interpretations impacted significantly on generations of Americans.[46] Yellowstone served as his laboratory, his studio, and his sanctuary. His journals, in a hushed tone of reverence for both science and art, reveal the immense gratification that can be achieved through an intimate and personal communion with nature.

CHAPTER 5

The Coming of Age of Aesthetic Conservation

Apparently William Penn was the first to honor our scenery, and Bryant, with poetry, won a literary standing for it. Official recognition came later, but the establishment of Yellowstone National Park was a great incident in the scenic history of America—and in that of the world. For the first time, a scenic wonderland was dedicated as "a public park or pleasure ground for the benefit and enjoyment of all the people."

Enos Mills

The passage of the National Park Service Act in 1916 was, like the initial founding of Yellowstone National Park, a defining moment in American conservation history. It represented victory in a long and hard-fought battle between the utilitarian and aesthetic conservationists—between the ranks of Gifford Pinchot, who strove for multipurpose development of America's wilderness, and the forces of John Muir, who championed the ideal of preserving natural scenery for its own sake. While Muir can be regarded as spiritual leader of the cause for scenic conservation, it was Stephen T. Mather, an assistant secretary for the parks under Secretary of the Interior Franklin K. Lane, and Mather's administrative assistant, Horace M. Albright, who brought about the structural and philosophical changes that assured the salvation and perpetuation of the concept. It was their energies and determination that led to the establishment of the National Park Service. And, as historian Donald Swain has written, it was "the rise of the National Park Service [that] marked the coming of age of aesthetic conservation in the United States."[1]

Mather had become assistant secretary for the parks in January 1915. Through a complicated orchestration of political and promotional maneuvers, he and his supporters prevailed in their efforts by August of the following year. President Woodrow Wilson signed the bill creating the National Park Service, the hallmark of a new era for Yellowstone and America's other national parks.

Mather celebrated his victory by calling for a national parks conference, the biggest that had ever been held. As a complement to the conference and a testament to his appreciation for the aesthetic in nature and the role of art in public life, he also arranged for a major loan exhibition to take place at the National Gallery of Art in Washington, D.C. William Henry Holmes was curator of the art collections (he would become

director four years later) and, as a close friend, no doubt helped Mather select the twenty-seven artists and forty-five artworks for the show. Thomas Moran, Albert Bierstadt, and Thomas Hill were each represented by works from their favorite parks, Yellowstone, Rocky Mountain, and Yosemite, respectively. John Twachtman's *Waterfall, Yellowstone Park* was loaned by the City Art Museum of Saint Louis.[2]

Early in the twentieth century, the park system had expanded to encompass scenic areas in Montana and Colorado—Glacier National Park in 1910 and Rocky Mountain National Park in 1915. Both had won congressional support only after protracted and agonizing public debate about the wisdom of removing them from the domain of practical commercial utility. The argument of U.S. Representative Edward T. Taylor of Colorado, that the area to be set aside as Rocky Mountain National Park was of "no value for anything but scenery," essentially repeated the logic that had won the day for Glacier Park five years earlier.[3]

From an artist's perspective, such justification appeared to be ample reinforcement for the notion that scenery had exceptional value in and of itself. One of Mather's closest artist-friends,[4] Charles M. Russell (1864–1926), saw Glacier, for example, as "good picture country." Once it was turned into a national park, it would also "be one of the gratest game country in the West [*sic*]."[5] Although there is every indication that Russell's strongest attachments were to Glacier (from 1906 until his death, he maintained a cabin at Lake McDonald, west of the park), there are suggestions that he felt similarly about Yellowstone. In June 1892, a Montana newspaper reported that he was headed for Yellowstone Park to paint for the summer, a trip that was anticipated to produce canvases of the area "as only Russell can."[6] Unfortunately, no paintings or sketches are known to have resulted. Whether he even got to the park is questionable. One of his two autobiographical accounts, published in 1903, suggests that he worked that summer on the Milk River as a night wrangler.[7]

Ten years later, however, after he had settled down, married, and formally dedicated himself to the life of an artist, Russell and his wife, Nancy, did tour the park.[8] Again, there are no known large paintings that resulted from the Yellowstone visit, but the experience did provide him with material for a number of fresh and spirited illustrations for subsequent commissions. The first came in 1907, when Alice Harriman-Browne published a love story set in Yellowstone. The frontispiece of a coach full of tourists roaring past an erupting geyser is one of Russell's few silhouette drawings (fig. 53).[9] Several years later he would illustrate another book, Carrie Adell Strahorn's *Fifteen Thousand Miles by Stage*. One chapter recounted a stage ride through the park in 1880, with a couple of deft pen and ink drawings to embellish the story.[10] One of them, *Lords of the Yellowstone* (fig. 54), suggests Russell's focus on the park as a wildlife preserve. Reputed since the early 1890s to be "one of the best animal painters in the world," Russell viewed ideal nature as a bountiful and uncontaminated realm where

Fig. 53. Charles M. Russell (1864–1926). *Untitled [Yellowstone Coach]*, 1907.
From Alice Harriman-Browne, *Chaperoning Adrienne: A Tale of the Yellowstone National Park*.
Bookplate; $3^1/_2$ x $5^3/_4$ in. Autry Museum of Western Heritage, Los Angeles, CA.

Fig. 54. Charles M. Russell (1864–1926). *Lords of the Yellowstone*, 1907.
From Carrie Adell Strahorn, *Fifteen Thousand Miles by Stage*.
Pen and ink; 9 x 12 in. Private collection.

the presence of humans was excused only if they were neutral observers or part of nature's cycles, as the Indians had been in his estimation.[11] He loathed the idea of hunting in the parks and regarded Yellowstone as an inviolate sanctuary for wild animals. At least here the bison, driven almost to the brink of extinction by man, was preserved. By inference, the title of Russell's drawing implies that wild animals like the bison are in fact superior to humankind, reigning supreme in nature's scheme despite the sad irony that man was still controlling the beasts' destiny.

In 1915 Nancy Russell returned to the park alone. She visited there not to enjoy another tour but to set up an exhibition of her husband's paintings "in a special art-room in the big park hotel" at Mammoth Hot Springs. Nancy, who served as the artist's publicist and agent, saw the display as an opportunity "to enlighten the tourists that flock through the big national playground that the west has produced a man of ability along artistic lines."[12] It may well have served that purpose. More than fifty thousand visitors rode or drove (this was the first year automobiles were allowed) through the park's gates that season, twenty-seven thousand of them staying in the hotels.[13]

Charles Russell did not join Nancy, and it is thought that he never, in fact, returned to the park after his tour of 1902. He came close several times, though. Once in 1917, when he was visiting a sick friend, John Matheson, in Chico Hot Springs, he was tempted. On the train he had met E. W. Shaw, a general partner in the Shaw-Powell Camping Company that operated guided tours and tent facilities in Yellowstone. Evidently, according to an exchange of correspondence that followed, the two men had discussed Yellowstone's wild animal population. Shaw probably boasted that, as Robert Sterling Yard had proclaimed in his popular *National Parks Portfolio* of 1916, "the park was one of the largest and most popular game preserves in the world." Or perhaps he cited the opinion of the eminent Dwight Elmendorf, that Yellowstone was "a vast outdoor museum for . . . all living creatures that found their way there."[14] Russell remained skeptical, it seems, likely parroting the typical tourist complaint that the animals were inaccessible for viewing along the standard travel routes.

Shaw wrote Russell from the park, hoping to catch the artist before he left Chico for home in Great Falls.

> I have just been up to the park headquarters at Mammoth Hot Springs and return. There is plenty of game in sight of the road between Gardner and Mammoth.
>
> I counted 15 mtn. sheep, 397 elk and many deer both black and white tail. The sheep and in fact all of the game would hardly get out of the road.
>
> My reason for writing you is that in mentioning you to Mr. [Chester Allen] Lindsley, the Supervisor of the Park, and in telling him of your interest in game— he urged me to extend you an invitation to come up to the Post at Mammoth. He

said that not knowing you he hardly felt like writing you, but he wished me to assure you he would be very glad to extend to you the hospitality of the post.[15]

Russell's tongue-in-cheek response, in a handsomely illustrated letter (plate 33), revealed his fundamental conservatism and antipathy for anyone, including the government, who wanted to impose change on "God's Country."

I did not get your letter till I reached home but I thank you and Mr. Lindsley for the kind invitation and if that invite holds good I may visit him some other time maby next year I would like to have one more look at a game country before they turn the parke in to a sheep range and they geysers to a steam laundrey theirs an awfall wast of hot water in the YellwStone park enough to wash in side and out all the reformers in the state and theirs a fiew on them.[16]

Through the years Russell continued a distant association with Yellowstone. The Haynes Picture Shops, photo and curio shops in the park run by Frank J. Haynes (and, after 1921, by his son Jack), proudly offered reproductions of the artist's work in their sales catalogues. And Russell was featured as one of the celebrities, along with Mather and Albright, intended to be present at the opening ceremonies dedicating the Howard Eaton Trail in July 1923. Despite his close ties to Eaton, there is no evidence that Russell attended the events.[17] Russell was an influence on several artists who also worked in the park. Irvin Shope (1900–1976) of Helena, an illustrator and painter, produced pen-and-ink drawings of western themes that were reminiscent of Russell's style. In 1926 he illustrated an adventure story by R. D. Kenney, *From Geyserdom to Show-me Land*. The introductory plate, *The Long Line Skinner, Affable and Picturesque* (fig. 55), reveals his debt to Russell's vigorous delineation of horseflesh.[18]

Much closer to the park and Russell was his protégé, Joe DeYong (1894–1975). Born in Webster Groves, Missouri, DeYong initially tried acting in western films as a career. An attack of spinal meningitis left him entirely deaf, and he later turned to art. He admired Russell's work and came to know him personally in 1916. The admiration went in both directions, and DeYong was invited to share his mentor's studio and a warm place in the Russells' hearts and home.[19]

Through the Russells, DeYong met Howard Eaton, and from the late teens through the twenties spent much time at Eaton's Ranch and on the pack trips organized by the Eaton brothers through Glacier and Yellowstone Parks. DeYong found these pack trips to be not only exciting backcountry experiences but also inviting opportunities to see and paint new scenes and generate commissions for work. Yellowstone was particularly profitable in the latter regard, and he produced a wide variety of small works, especially of the Lower Falls (plate 34), for his companions on the ride.[20]

In 1920, during his first Yellowstone trek, he wrote to his parents from the Old

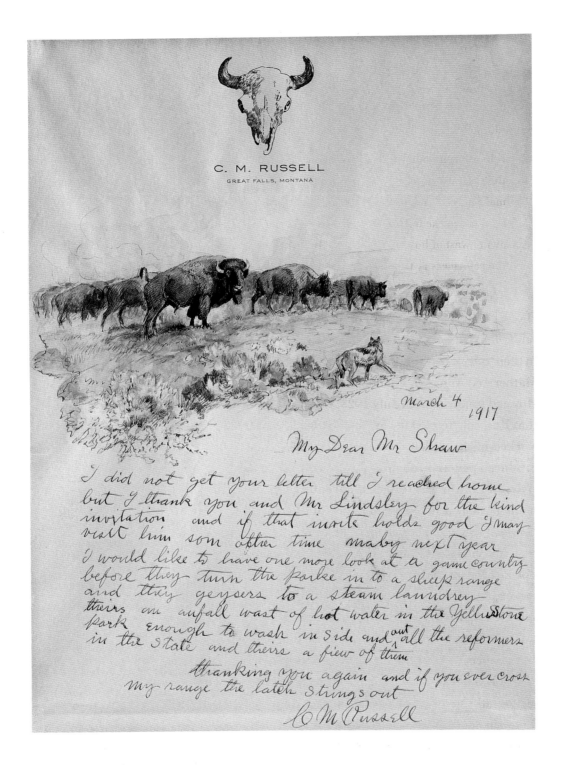

C. M. RUSSELL
GREAT FALLS, MONTANA

March 4 1917

My Dear Mr Shaw

I did not get your letter till I reached home
but I thank you and Mr Lindsley for the kind
invitation and if that invite holds good I may
visit him som other time maby next year
I would like to have one more look at a game country
before they turn the parke in to a sheep range
and they geysers to a steam lanudrey
therrs an aufall wast of hot water in the Yellustone
park enough to wash in side and out all the reformers
in the state and therrs a fiew of them
 thanking you again and if you ever cross
my range the latch strings out
 C M Russell

Pl. 33. Charles M. Russell (1864–1926). *"Game Country,"* 1917.
Pen and ink and watercolor; 11 x 8¹⁄₂ in. Rockwell Museum, Corning, NY.

Fig. 55. Irvin Shope (1900–1976). *The Long Line Skinner, Affable and Picturesque*, 1926.
R. D. Kenney, *From Geyserdom to Show-Me Land*. Bookplate; 3¼ x 5 in.
Buffalo Bill Historical Center, Cody, WY.

Faithful Inn, near which his group was camped. "This is a surprising country & beautiful to [*sic*] in a way tho nothing to compare with Glacier Park—even so I'm glad of a chance to see it—." He went on to describe Yellowstone as a restful place for an artist, "a beautiful sleepy country." But, perhaps echoing Russell's reaction to the scenery in 1902, he concluded, "We've seen all kinds of boiling, bubbling, churning springs & a few small geysers—all of this freak stuff is a great sight to have seen but there's almost nothing one can paint."[21]

DeYong is known to have accompanied the Eatons into Yellowstone on at least the next two summer pack trips. He continued to make small studies of the park's scenery and to establish useful and profitable contacts for future large commissions. Priced around ten dollars, his small Yellowstone oil studies became readily accessible souvenirs for his fellow dudes to take home with them. As late as 1927 he was still spending summers at Eaton's and, since Russell had died the year before, he was also developing his future roles as his mentor's artistic heir and guardian of his creative legacy.[22]

Among the largely untrained artists of traditional bent like Russell and DeYong was a landscape painter from Colorado, Charles Partridge Adams (1858–1942). His vision was fresh and spontaneous, his love was Rocky Mountain scenery, and his tech-

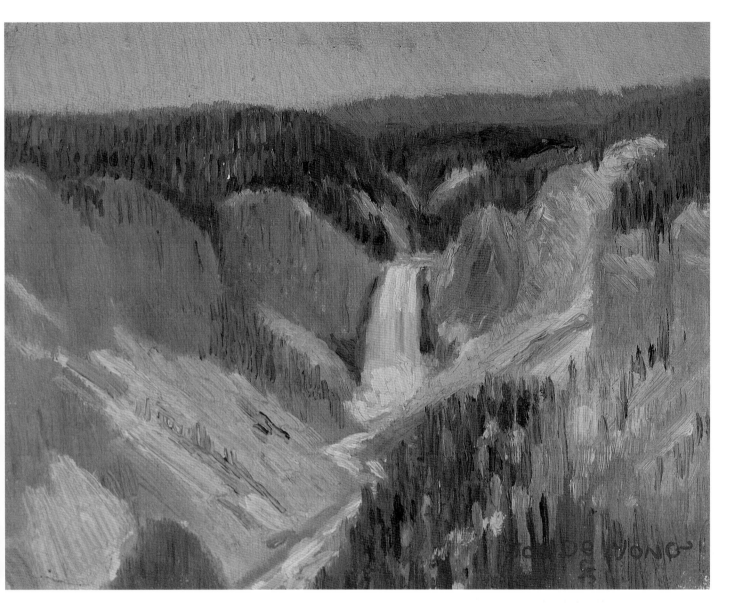

Pl. 34. Joe deYong (1894–1975). *Yellowstone Falls*, c. 1920.
Oil on academy board; 6 x 8 in. 80.18.028. National Cowboy Hall of Fame,
Oklahoma City, OK.

nique was plein air. DeYong had written to his parents from Canyon Camp in the summer of 1921 about an artist who needed help understanding those fundamental qualities. "There was a woman artist from Butte [identity unknown] here last night—she had some fairly good work but it showed too much Art School influence—Once in a while she forgot herself and painted what she saw. Then she did well—."[23] Adams did not share that fault—he painted directly, he painted what he saw, and he painted well.

Pl. 35. Charles Partridge Adams (1858–1942). *Lower Falls of the Yellowstone*, 1934.
Oil on canvas; $10^3/_4$ x $7^3/_4$ in. Courtesy of Mr. and Mrs. Bruce Dines.

Fig. 56. Unknown photographer.
*[Charles Partridge] Adams Sketching
at Yellowstone Canyon, August, 1934,*
1934. Photograph. Courtesy of
Mr. and Mrs. Bruce Dines.

Adams is thought to have been in Yellowstone at least twice, once in 1904 and again in 1934. His home base until 1921 was Denver, and he usually spent summers in Estes Park, working in his studio known locally as "The Sketch Box." In 1920 he moved to Los Angeles and later to Laguna Beach, where he lived until his death. From time to time he would take swings farther afield, and Yellowstone was a favorite haunt on those occasions.

As with DeYong's Yellowstone production, Adams's only known surviving painting from that area is a field study (plate 35). It is thought to coincide with a photograph of the artist at the Lower Falls taken in 1934 when he was seventy-four years old (fig. 56). He had long been praised for his special skills as a colorist and for his vigorous and freely handled brushwork, qualities that are evident in this spirited pictorial record of the falls on a sunny summer morning. Its brilliant colors veritably sparkle; the air, radiant with light, breathes life into the spectacular view.

Stephen Mather and his associates were not the only ones promoting the parks in the early decades of the new century. The railroads, too, continued to take a substantial interest, although their focus began to change as the definition of their clientele, the "tourist," took on new meaning. In previous years the tourist had been viewed primarily as a potential investor in land or business opportunities in the regions served by the rails.[24] The parks and their use were but a minor part of the railroad's agendas. By the turn of the century travelers of the cultured and wealthy class, who had essentially been the ones who could afford to travel to places like Yellowstone, were being replaced by excursioners of more modest means. Both Mather and the railroads dearly wanted to address all classes and encourage their use and enjoyment of the parks. As part of a move toward cultural nationalism, they designed and implemented a campaign known as "See America First" that fostered travel in the continental United States in hopes of diverting people from European vacations and leisure time abroad. Mather's and Yard's efforts to promote a national park system and popularize the experience as much as possible were part of that "See America First" initiative. The railroads, especially the Great Northern that served Glacier National Park, built sophisticated promotional programs based on the same scheme. Regardless of the fact that in this period tourists were valued primarily for their potential as settlers, entrepreneurs like Louis Hill, president of the Great Northern, could envision the day when sufficient numbers would visit the parks to make the process of touring lucrative in and of itself. Hill saw dollars from his "See America First" plan, and Mather saw future advocates of the national park idea.[25]

In 1910 Hill employed a painter, John Fery (c.1859–1934), to aid in his promotional enterprise focused on Glacier Park. The project involving Fery, an exceedingly productive artist, aimed to create vast numbers of large and engaging views from the park to be hung in Great Northern stations and ticket offices around the country. The art, it was conjectured, would excite interest in visiting the park and attract business for the railroads and their hotels. Fery was the perfect choice. His style of painting, involving colorful, boldly conceived, and dramatically presented landscapes of Rocky Mountain scenery, met the necessity of appealing to the newly emerging tourist class.

Fery was born in Austria, and biographers contend that he studied at the Vienna Academy of Art, as well as in Munich and Düsseldorf.[26] His rich yet somber palette and bravura brushwork suggested Munich antecedents. He had been part of the German-American artist community in Milwaukee in the mid-1880s and moved his young family permanently to the United States in 1886. Enamored of the Rocky Mountains, he initially tried to make a living guiding European hunters into places like Wyoming's Jackson Hole area. He visited Yellowstone in 1891 and wrote his account of a subsequent hunting trip, "Eine Jagd in Wyoming" (A Hunt in Wyoming), for a European sporting magazine. This was not his first trip there. He noted in the introduction to

Fig. 57. Unknown artist. Cover illustration from *Where Gush the Geysers*, 1910.
Promotional brochure for Union Pacific Railroad. Buffalo Bill Historical Center, Cody, WY.

the article that he "knew the park with its geysers, terrace formations and picturesque gorges already from my previous frequent visits."[27]

In 1914, after several frenzied years of painting Glacier Park scenes for Hill, Fery was loaned out to the Northern Pacific to produce a series of works on Yellowstone Park. The commission required Fery to paint about a dozen oils of Yellowstone themes. Two paintings that survive today portraying the park's scenery, *Kettle Geyser* and *Yellowstone Lake* (plates 36 and 37), may have resulted from that arrangement. There was something especially apropos about such vigorous and spirited work in connection with advertising. The Union Pacific Railroad had been using similarly energetic paintings, by an unknown artist (fig. 57), to promote its service to the west gate of the park. It was important to keep the pressure on a not-so-easily entertained American

Pl. 36. John Fery (b. Hungary; c. 1859–1934). *Kettle Geyser*, 1914. Oil on canvas;
11 x 15 in. Collection of Mr. John B. Fery.

public, and to counteract written and word-of-mouth reactions of ennui such as those
recorded by author Louise Elliott the year before. "Why, dear me," sighed one visi-
tor, "just see how uncomfortable one has to be on these dusty roads just to see a lit-
tle hole in the ground with a little hot water shooting out of it." Another commented
that "the in between places (I suppose she means the places between hotels) are awfully
boring, don't you know." But for many, like Elliott herself, it had been the "one trip
on all the earth I most desired."[28] More than 50,000 people, people like her, swept
through Yellowstone's gateways in 1915.[29] So the promotional dollars and the art it
bought to engender the spirit of "See America First" had been worth the effort.

By the middle of the first decade in the new century, the brink of the canyon was
teeming not only with tourists but with artists as well. And many of them, trained and
untrained, were women. Like the woman artist whom DeYong described, many came
burdened or enlightened, as the case may be, with the freshly acquired lessons of art

Pl. 37. John Fery (b. Hungary; c. 1859–1934). *Yellowstone Lake by Nature*, 1914.
Oil on canvas; 14 x 22 in. Collection of Mr. William P. Healey.

schools. Some evidenced exceptional talent. But in no case were the lessons so fresh or the talent more exceptional than with the spry, middle-aged painter from Tacoma, Washington, Abby Williams Hill (1861–1943).

Born in Grinnell, Iowa, Abby Hill was encouraged at a young age to pursue an art career. As it turned out, she accomplished just that, making a lifelong career of her innate talent and leading, as a consequence of her professional devotion, a rather unconventional and exciting, peripatetic life. Like many young ladies of her day, Hill studied art in accepted, traditional circumstances—first in 1882 with a private instructor, H. F. Spread in Chicago, and later in 1888 with William Merritt Chase at New York's Art Students League. She stood out among the minions in paint-splattered smocks who labored adoringly in the shadow of Chase, the flamboyant master. He once told her, "You can go to the top if you want to. You have talent and you have genius

for work; they go together."[30] Hill accepted this encouragement and profited greatly from her teacher's lessons and his eclectic Munich style. She adopted Chase's appreciation for plein-air painting and the Munich-inspired bravura brushwork and blond palette that would eventually ally him with the ranks of American impressionism. He convinced her that through art, nature reveals its real beauty and human accessibility, reputedly telling her at one point that "artists make the world beautiful for others because they see more of its beauties and so teach others to see them."[31]

She married a young Iowa doctor, Frank Hill, in 1888. They had one child, a boy, and later adopted three daughters. All were schooled at home by their mother, who after the turn of the century became increasingly involved in social and educational reform, travel with her children, and painting landscapes and Indians of the West. She could readily have settled into a life of ease, as her doctor-husband's reputation and success grew. But she chose instead to travel and paint with her children. In 1903, through dint of her persuasive powers and the impressive portfolio of paintings that she had assembled, Hill was granted a commission from the Great Northern Railroad to sketch scenery along the railroad's routes in Washington state. In the next two years, under the auspices this time of the Northern Pacific Railroad, Hill moved farther afield, even reaching Yellowstone National Park by mid-August of 1905. It was there that she produced some of her most memorable work.

In preparation for her first Yellowstone jaunt, Hill renewed her art studies, spending six months in Washington, D.C., at the school of the Corcoran Gallery. Though a student in life classes, her prime accomplishment was a copy she made of the museum's Albert Bierstadt painting *Mount Corcoran*. When she left Washington for the Rocky Mountains, she was ready to face the challenges of Yellowstone's novel and daunting scenery.

Hill's troop took a quick swing through the geyser basins and along the lake on their way to her ultimate destination, Yellowstone Falls. Although the water features were curious and beautiful, they hurried past them, just as Joe DeYong had, because they had only a month to work and the railroad favored paintings of the falls. According to her journals, which she kept faithfully, their "permanent" camp was "under the pines near 'Uncle Loni's Trail' to the falls." She selected a view of the falls that was pictorially advantageous but rather precarious (fig. 58). It "was from a cliff extending over the canyon. It is not over three feet wide and a very sharp descent to reach it. I thought to pitch my little tent on it but after sitting there till noon, there came up such a wind, I crawled off between gusts and concluded a tent with a floor in it would fill and carry me with it."[32]

Hill completed her painting, *Yellowstone Falls* (plate 38), in a couple of weeks, despite interruptions by countless natural annoyances such as hailstorms, earthquakes, and rain, as well as the more irksome intrusions of unwanted tourist gawkers

Fig. 58. Unknown photographer. *Abby Hill at Yellowstone Canyon*, 1905.
Photograph. Permanent Collection, University of Puget Sound, Tacoma, WA.

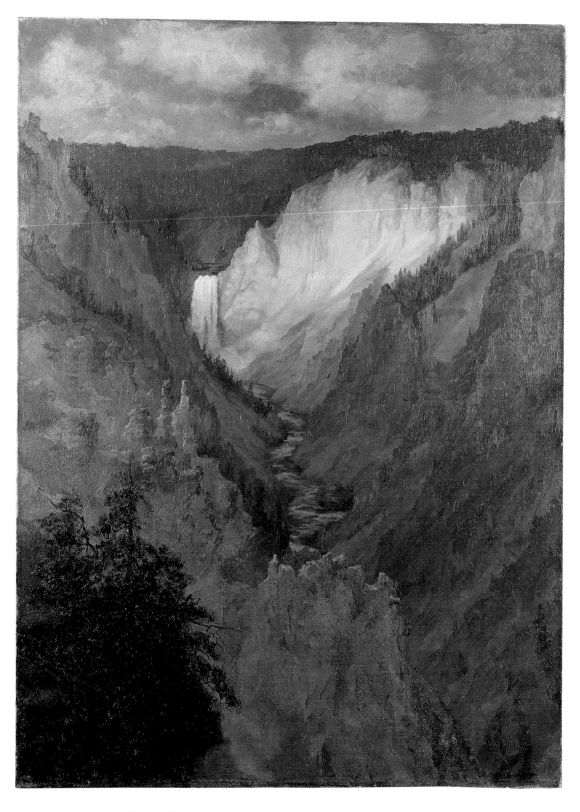

Pl. 38. Abby Williams Hill (1861–1943). *Yellowstone Falls*, 1905.
Oil on canvas; 38 x 28 in. Permanent Collection, University of Puget Sound, Tacoma, WA.

who demanded an opportunity to critique her efforts. At one point, as the painting neared completion, the most challenging obstacle of all confronted the artist: gale-force winds. On Monday and Tuesday, September 4 and 5, she recorded in her journal the following incident:

> Got out on my perch and painted a few hours with Eulalie [one of her daughters] as company when suddenly there came a roar and without more warning, a big twister struck us, wrenching the picture from its fastening, jerking it under the poles and away down the canyon, which is at least 400 feet deep and the sides almost perpendicular at this point. For a few moments, Eulalie and I attended strictly to keeping ourselves flat down on the cliff and hanging on. When it was safe, we crawled off with the things and walked up and down the edge to see if the picture was in sight, at last spied a corner some 100 feet below, just over the steepest part.
>
> We were a doleful couple and made our way to camp. Our camp is sheltered and does not feel much wind, but they had heard it and were afraid for us. I have worked all the time it was possible since coming and cannot bear to think it all gone and the season so advanced. I can hardly make more than one other.
>
> . . . I told Uncle Tom [H. F. Richardson] what had happened and early this morning he and one of his men came down with great coils of rope and said they were going to try to get the picture.
>
> I had little hope, even though they could reach it, that it could be saved, for a loosened rock could carry it beyond into the chasm. Uncle Tom fastened the rope about his waist, it was passed twice around a tree and they began to let it out. I was so frightened lest it cut on the rocks and he go to the bottom, I did not wish him to go. After he started, and it was terrible to watch, Helen [a friend] stood further over and said she was glad that I could not see him as he looked from there. He was very careful, threw loose stones out of the way and finally I could see only his hand as he signalled for the rope to be tightened or loosened. At last he held up the picture and we all shouted. It was whole.
>
> . . . "Doesn't need any sandpaper," he called. It was harder getting up than down, but was safely done, and the poor picture, covered with sand and dust, passed over the cliff to safety.
>
> Uncle Tom's little boy said, "I guess you're pretty glad to get that picture again." I assured him. "It would have been an awful waste of paint, wouldn't it," he commented.[33]

The painting was repaired, and Hill found time to complete two more canvases, one of the canyon below the falls and one of *Yellowstone Falls from Below* (fig. 59). She commented that

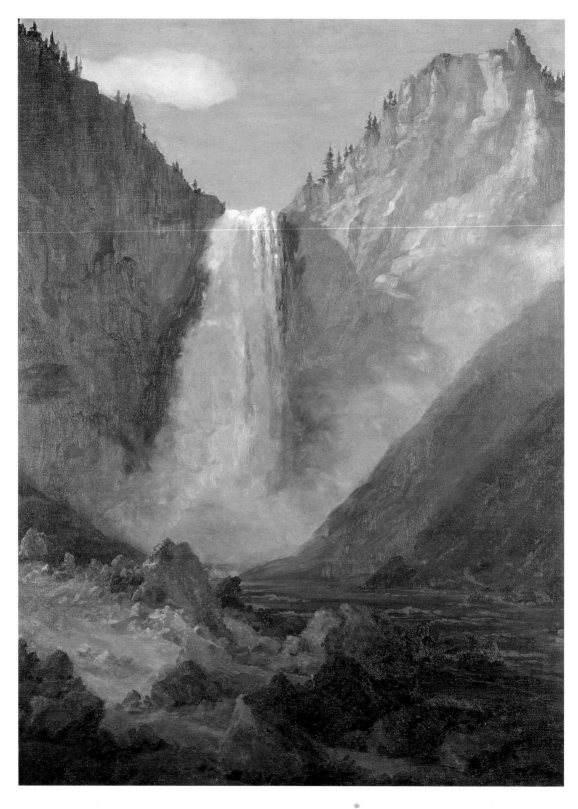

Fig. 59. Abby Williams Hill (1861–1943). *Yellowstone Falls from Below*, 1905.
Oil on canvas; 38 x 28 in. Permanent Collection, University of Puget Sound, Tacoma, WA.

One sees the colors better from below than from above. They do not seem like mineral stains, great patches of the most delicate pink, streaks of brilliant vermillion [*sic*], purple, red, lavender, yellow (of the chrome type), whitened. The whole canyon is not brilliantly colored, the main tone is whitish grey and yellow-white.[34]

Despite Hill's recent efforts at replicating Bierstadt's grand panoramic vision of Mount Corcoran, it was to Chase's example that she turned when presented with Yellowstone's canyon and falls. The vigorous brushwork and highly keyed, sunny palette are those learned in New York rather than Washington. And what is most apparent as a result of her Art Students League training is the finely resolved expression of tonal harmony. "Tonality is perhaps the masterful maturity of technique," Chase would write in 1908, "impressing more definitely than any other quality the beauty, the very best of ideal, Nature,—in art."[35] Whether perched on the canyon rim or huddled just out of spray's reach beneath the falls, Hill strove to reveal harmony in nature. Her achievement was indeed a "masterful maturity."

Hill crossed paths with many artists during her month's stay at the canyon. "Miss Crawley, an art-student friend," showed up early on and helped her select scenes to paint. Mrs. Louis Prang of Boston's chromolithography clan knocked at her tent door one day. And Mrs. Charlotte Lewis of Washington, D.C., came to call. Hill recalled the latter encounter with mild contempt.

> After my work, I was sitting in the tent when a voice called, "Is Mrs. Hill the artist here?" and with profuse smiles and bows, a woman introduced herself as Mrs. Charlotte Lewis of Washington, D.C. "I have painted all my life. I am an artist, my studio is in the old Corcoran Building, Corner 17th and Penn. Ave. This is grand here. Grand. If only I could stay. Fancy only one day. Oh, how I would do it as it should be done. It has never been properly rendered. I would paint it! It's just that if there was a woman brave enough, courageous enough to come here with her children and paint, I must see her. Yes, I congratulate you. It is fine, grand, sublime, and I like it." All this in a high-pitched key and delivered as fast as she could talk. I did not show her my pictures. She did not evince a desire to see them and we parted amicably.[36]

The railroad was impressed by Hill's Yellowstone canyon painting and asked her to produce a second version of the falls from the base for them to use in promotional exhibitions. They also asked her to return the next summer to concentrate on the geysers as subjects. Her husband joined her for part of that second trip, an eight-day grand tour of the park. The artist stayed on at the Upper Geyser Basin and, despite rainy conditions, poor health, and more persistent interruptions from tourists, she turned out a lively series of paintings of the pools and geysers.

A fellow park visitor, a gentleman who boasted to have predicted the San Francisco earthquake, claimed that Yellowstone was on the verge of blowing itself to atoms. Hill humored him, replying that she might well be on hand for the event and prepared to create her chef d'oeuvre for the occasion. A few days later, while she and her daughter Ione were studying Artemesia Geyser (plate 39), she got a hint of the gentleman's admonition.

> I have been sketching the Artemesia. We thought it would play, but there was almost no movement of the water. There is a small geyser on the formation below it. Ione and I went to look at it and judging it would soon play, stood to watch it. There came a jarring of the earth and a thumping under our feet. Looking up, we saw a ridge of water moving down over the hill towards us as if all the water in the Artemesia had been raised and pushed off over the hill. We ran with all our might, jumped the little gully and climbed the hill where we sat down, but the thumping was so great we ran further. By this time, the water was agitated and soon a great mass was raised a hundred feet, rivers of boiling water poured out. The steam shut off a view of everything else and it was as if we were looking at an eruption in the ocean. The vibrations and thumping continued with increased and startling force. It seemed as if a new crater was about to yawn under us.[37]

Although Hill felt she might be launched from the park that day, it all worked quite a different way. Her two summers in Yellowstone had in reality launched her career as a landscape painter of the western wilds. Soon after her return to Tacoma, she was offered commissions from other railroads, the Canadian Pacific and the Union Pacific, for example, and in future years, eschewing the comforts of home in Tacoma, she would pitch her tent and erect her easel in many other distant corners of the West.

The Northern Pacific contracts allowed Hill to retain most of her paintings. The railroad company used the works temporarily to exhibit for promotional purposes in venues like world's fairs and other large public expositions. They were not alone in their thinking that Yellowstone images commanded broad appeal and helped market their services. The Anheuser-Busch Company, bucking a growing tide of disfavor from prohibitionist forces, embarked on a promotional campaign to neutralize the perception of its product name. To accomplish this, the company commissioned a Saint Louis artist, Oscar E. Berninghaus (1874–1952), who by 1910 had won for himself something of a national reputation for depictions of western life. Together the artist and the corporation, with Charles W. Spandinger at the helm of its advertising department, produced several poster series including "Epoch Making Events of American History" and one presenting different modes of travel in the West. Subsumed under the slogan "Making Friends Is Our Business," Busch broadcast its name nationwide, from classrooms to pubs.[38] They also created calendars featuring America's scenic

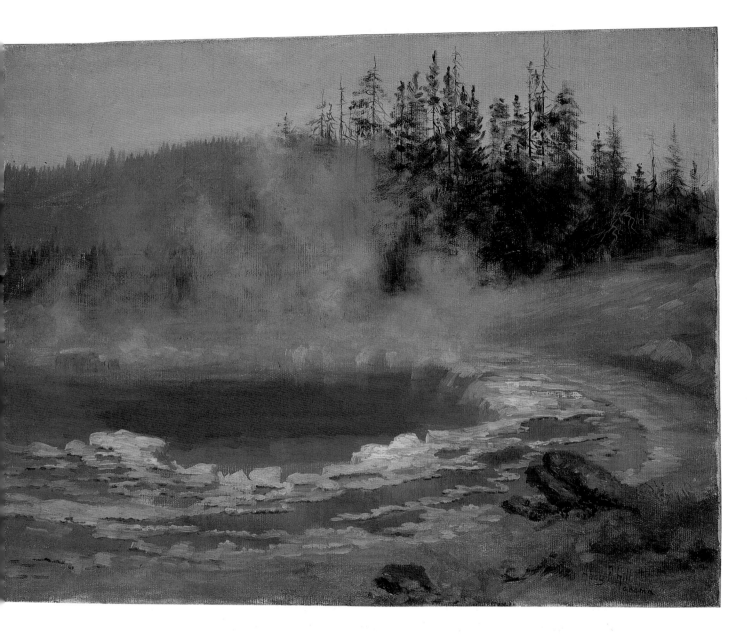

Pl. 39. Abby Williams Hill (1861–1943). *Artemesia [Geyser] Pool*, 1906.
Oil on canvas; 17 x 22 in. Permanent Collection, University of Puget Sound, Tacoma, WA.

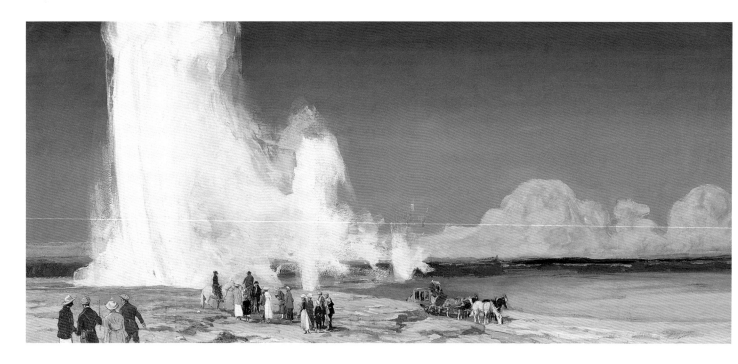

Pl. 40. Oscar E. Berninghaus (1874–1952). *Old Faithful, Yellowstone*, 1914.
Oil on canvas; 18⁵/₁₆ x 42¹/₈ in. The Saint Louis Art Museum, Saint Louis, MO.

wonders, for which Berninghaus, without benefit of having ever visited the area, painted his sweepingly engaging oil *Old Faithful, Yellowstone* (plate 40).[39]

Berninghaus was a native of Saint Louis. He had received training at the Saint Louis School of Fine Arts at Washington University and profited by employment as a lithographer during his early career with the Woodward & Tiernan Printing Company. By the time of the Busch commissions, he had also branched out beyond Saint Louis and its active art scene. As part of the young and burgeoning Taos Art Colony, Berninghaus was spending summers in New Mexico, where his contact with painters like Joseph Henry Sharp and Ernest L. Blumenschein expanded his professional horizons. In his canvas *Old Faithful, Yellowstone*, Berninghaus combined his talents as an illustrator, seen in the tightly drawn figures in the foreground, and painter, carried forward in the sweeping gesture of his brush that portrays the foamy white plume of the geyser's eruption.

Berninghaus was attempting to make a grand American statement with his Yellowstone painting. At this time the Saint Louis papers were proclaiming him the logical successor of Frederic Remington, who had died late in the previous decade. To Remington's forthright representation of the western scene, Berninghaus added "awe and mystery," wrote one observer.[40] Berninghaus updated the calendar on Reming-

ton's search for unique American themes in the West. Whereas Remington had sought to champion the military's role in preserving the park, Berninghaus viewed its popular dimension as his *cause célèbre*. Yellowstone was America's "pleasuring ground," and by 1915 the level and predictability of public enjoyment was comparable to the height and regularity of its most famous natural spectacle.

Alexander Phimister Proctor (1860–1950), an energetic and talented *animalier* sculptor, had an opportunity to connect with Yellowstone Park in a dramatic, if rather roundabout way. One of his most powerful sculptures, *Panther with Kill* (plate 41), was fashioned after a mountain lion captured specifically for him in Yellowstone in 1907. The park's superintendent that year, Major John Pitcher, was an old friend and hunting crony of Proctor's. Stories had been circulating among park cognoscenti for some years about the impact that cougars were having on mountain sheep, deer, and elk populations.[41] Pitcher felt a need to reduce the number of cougars in Yellowstone and set out with men and dogs, in the spring of that year, to accomplish his goal. One lion, affectionately nicknamed Yellowstone Pete, was treed and about to be dispatched, when Pitcher thought of his friend Proctor. Pitcher, according to an article in the *New York World*,

> remembered that in the Bronx in New York, was the most extraordinary art studio in the country—a big building, where a former westerner, now a sculptor worked

Pl. 41. Alexander Phimister Proctor (b. Canada; 1860–1950). *Panther with Kill*, 1907. Bronze; 11½ in. (height). Photograph by Scott Church. A. Phimister Proctor Museum, Poulsbo, WA.

from live animal models in the moist clay and afterward fixed the forms into bronze and marble. The major had hunted across the Rocky Mountains with A. Phimister Proctor, the sculptor, when Proctor lived with the cowboys and mountaineers and spent his life studying the denizens of the plains and the hill country. They had gone hungry together among the crags and slept under the same blanket and cut the same venison before the camp fires in the wilds. He determined to capture Pete alive and send him to Proctor.[42]

Proctor studied the cat for a while in the New York Zoological Park. However, he soon found his "wild and unwilling model" too uncooperative, and he persuaded the zoo keepers to loan him the animal to take to his farm north of the city near Bedford, New York. Yellowstone Pete spent the summer of 1907 in a cage in the country, "a captive to the interests of art."[43]

After some months of work, the model was completed and sent to the foundry for casting.[44] In its finished form, the bronze was a romantic tribute to the West, to the wild passion for survival, and to one of Proctor's artistic heroes, the French nineteenth-century *animalier* sculptor Antoine-Louis Barye. Proctor, who had collected Barye's works in the 1890s, flattered the Frenchman by mimicking a convulsively powerful bronze, *Jaguar Devouring a Hare*, that Barye had sculpted around 1850. Proctor was not alone in this appreciation of Barye's talent. The French modernist Henri Matisse produced his first sculpture in the round in 1901. Its inspiration came directly from Barye's piece as well.[45]

Albert Lorey Groll (1866–1952), a New York painter and contemporary of Berninghaus, was also attracted to the American Southwest. Groll had learned landscape painting in the 1890s at two Royal Academies, one in Antwerp and the other in Munich. In 1904, while trying to eke out a living in New York, he was invited to join Professor Stuart Culin of the Brooklyn Museum on an ethnographic expedition to Arizona and New Mexico. Almost immediately two fortuitous events occurred—Groll fell in love with western scenery, and the critics in the East proclaimed their favor with the results. His painting *Arizona* of 1906 won a gold medal at the annual Pennsylvania Academy show.

"No artist ever creates a national art," observed the designer Gustav Stickley in a critique of that exhibition. "The utmost the greatest genius can do is to help develop it, to make himself the means of interpretation . . . so that the national imagination of his land can find in him a means of utterance." The man who in Stickley's estimation gave that utterance its grandest expression was Albert Groll, for his discovery and revelation of "the wild, strange beauty of our desert land." What the artist had captured for those untutored eastern audiences was "the fear of it, the dignity of its space, the terror of its desolation and the splendor of its color."[46]

These, of course, were all characteristics that had attracted artists to Yellowstone for over a generation. And so, it was not surprising to read in *American Art News* in 1908 that Groll had "spent the summer in Arizona and the Yellowstone Park. He brought back a number of sketches and pictures, among them an exceedingly interesting one of the Emerald Pool."[47] From his earliest Arizona canvases through at least the next decade, collectors and critics of Groll's work admired his virile color and bold, painterly treatment.[48] His focus on abstract shapes and chromatic symphonies as seen in *The Morning Glory Spring, Yellowstone, Montana* (plate 42) is reminiscent of John Twachtman's manner of a decade earlier. Groll's palette was less blond, his values less harmoniously balanced, thus producing a richer, slightly more robust and austere interpretation. The two blanched trees in the upper left-hand corner afford nature, albeit in mordant form, a presence in an otherwise reductive, lyrical composition. As with his Arizona and New Mexico landscapes, there is an air of remoteness to the scene, almost doleful and lonely. Perhaps that is how Groll felt as he looked into the pool's azure depths.

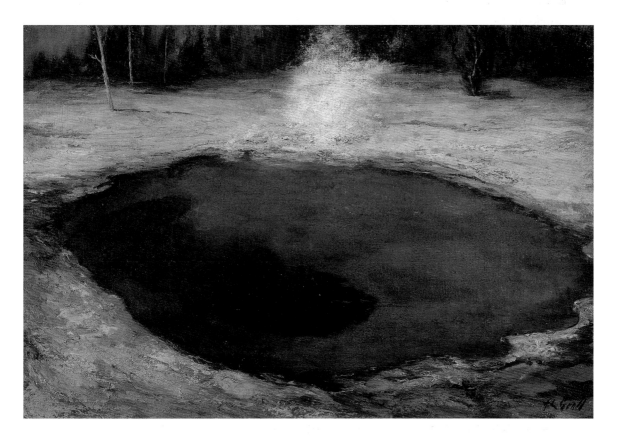

Pl. 42. Albert Lorey Groll (1866–1952). *The Morning Glory Spring, Yellowstone, Montana*, c. 1907. Oil on canvas; 16 x 24 in. Fine Arts Museum of San Francisco. Gift of Sewell C. Biggs in memory of Ernestine McNear Nickel Carpenter, 1983.85.2.

Through the first quarter of the twentieth century Groll's career advanced. His works were awarded many honors and discussed glowingly in the art literature of the day. Even with this remarkable acclaim, Groll is lamentably remembered more for introducing another artist to the West than for his unique and powerful renditions. That other artist is William Robinson Leigh (1866–1955), who, at the instigation of Groll, took the rails west for the first time to Laguna, New Mexico, in 1906. Groll and Leigh had studied together in Munich and were each searching for a special part of the American landscape to prove their mettle. When Leigh stepped off the train in Laguna, he knew immediately that this was that special place. "At last I was in that wonder land," he recalled years later, "the land I had dreamed about so many years; the land where I was to prove whether I was fit—worthy of the opportunity—able to do it justice."[49] He spent the remainder of his long career meeting that challenge.

He and Groll were not alone in Laguna. Another artist friend from their Munich days was present as well, Joseph Henry Sharp. He had been painting in Montana during the early years of the new century, but Laguna fascinated him too. Between the two of them, Sharp and Groll harbored a collective enthusiasm that found a receptive adherent in the new initiate, Leigh. Enchanted with Laguna and a subsequent two weeks at the Grand Canyon, Leigh was transformed.

> My entire horizon had now been revamped; I knew now that my old, original conception was correct; my field was in the frontier west. From now on I knew I must return as often to that field as possible; I must widen it—must know it from Mexico to Canada; know it as thoroughly as it was possible for me to know it.[50]

Yet, as much as the Southwest had beguiled Leigh on his first trip there, he had also long dreamed of confronting scenery farther north. After several treks through the Bavarian Alps during his Munich days, he wrote wishfully to his parents about America's promise as a subject for the artist.

> Europeans can say what they wish but they have no scenery like the bold wild American mountains and streams. Even the world-wide famous alps I do not believe are as wild as American mountains, for every peak has been ascended and is marked with names, or perhaps an iron cross and every where one looks habitations come in sight. But in America's range of western rocky mountains the gorges yet exist where never mortal eye except some wild hunter or indian has scanned the scene. . . . Even they [the Alps] are in some respects tame to our rocky mountains, so a San Franciscan told me.[51]

He was a bit apprehensive about going there to paint, however, since he was also convinced that American art patrons bought mostly European scenes. Yet having witnessed Groll's professional and financial success with western landscapes, and given

166

his eagerness for the region, Leigh soon headed for the Rockies. As it turned out, his next venture also resulted from his contact with Groll.

In 1910 a fellow New York painter, Charles Courtney Curran, received a letter from a Wyoming taxidermist, Will Richard of Cody. The letter invited Curran to come to Wyoming on a hunting or pack trip, all expenses paid, so long as the taxidermist could watch the artist at work and perhaps paint side by side with him. Curran, not inclined to such pursuits, handed the letter over to Groll, who in turn passed it on to his friend Leigh. Richard and Leigh reached an understanding, and a few months later the artist had set up his easel in Cody.

Leigh and his new protégé traveled to Yellowstone, a site they would revisit during several summers over the ensuing years. Leigh enjoyed the hunting scene outside the park, to which Richard introduced him. Although a skilled draftsman and animal painter, in the park the artist found that the Yellowstone canyon and falls consumed his attention. Leigh had studied with the same German painter, Professor Ludwig Loefftz, who had taught Groll. He had learned to employ the same rich hardiness of color and the same relish for unspoiled light. To this was added Leigh's superior grasp of drawing, his pleasure at rendering texture, and his skill at portraying the vast sweep of distance. One of Leigh's proudest accomplishments as a young artist had been assistance he provided in the production of a giant German panorama. He now brought his experience and the full range of his talents to bear in dealing with this colossal and magnificent sight. Small color studies such as *Grand Canyon of the Yellowstone* (plate 43) were converted later in Leigh's studio to larger, finished works like *Lower Falls of the Yellowstone* (plate 44). The studio piece seems to explore a conscious juxtaposition of vibrant red in the foreground, mellow ochers in the mid-distance, and gray blue sky in the distance, in an effort to achieve a greater sense of depth than revealed by the field study. This effect was accentuated by the alternating sunlit and shadowed areas leading the viewer's eye back to the falls.

An article written on Leigh for *Time* magazine late in his career noted that he had "painted more postcardy scenery than most men see in a lifetime."[52] And still, his landscapes, like those generated during his Yellowstone summers, deserved recognition for unpretentiously and uncompromisingly addressing reality. "His works are interesting," an earlier writer had concluded, "for their suggestion of texture and for their rendering of space, two elements in landscape composition often neglected by artists preoccupied with design."[53]

In later years, Leigh claimed to have joined the ranks of Remington and Russell as one of the three paragons of early-twentieth-century western art. His publicists made much of the similarities in the selection of his themes and the animation of his scenes. Art historian Eugen Neuhaus conceded these points, adding that Leigh's "pictures have a sophistication and finesse of the schooled painter," two qualities on which

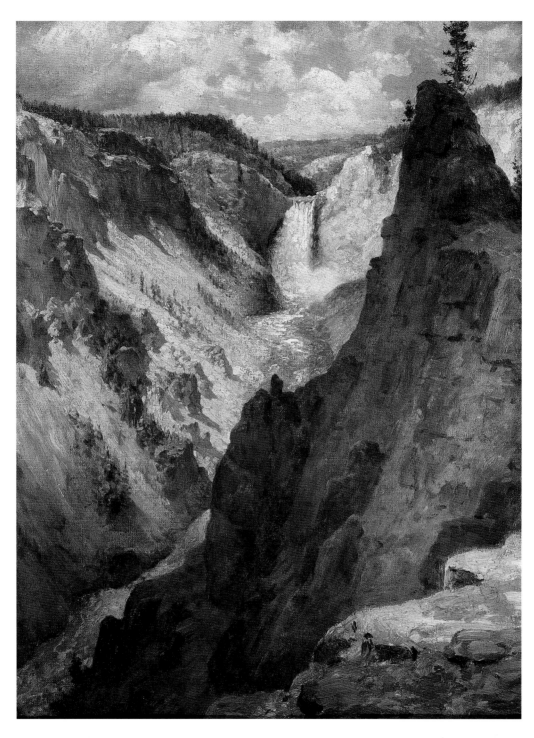

Pl. 43. William Robinson Leigh (1866–1955). *Grand Canyon of the Yellowstone*, 1911.
Oil on canvas; $16^3/_4$ x 13 in. 0136.986. From the Collection of the Gilcrease Museum, Tulsa, OK.

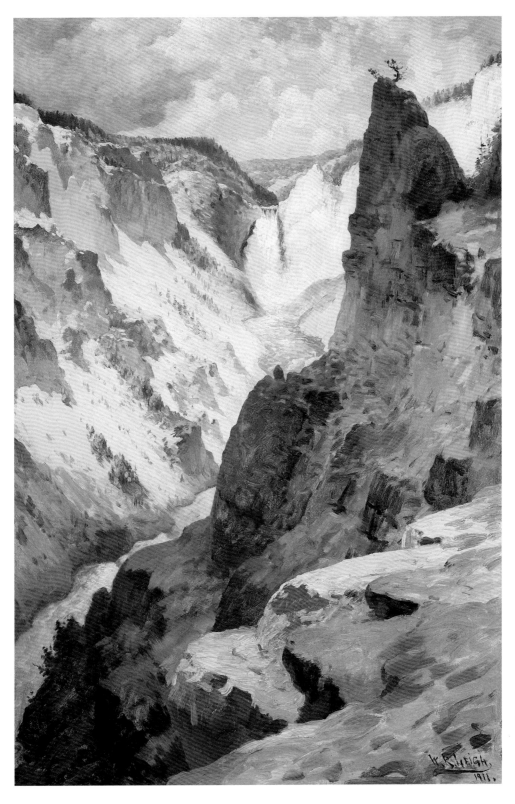

Pl. 44. William Robinson Leigh (1866–1955). *Lower Falls of the Yellowstone*, c. 1915.
Oil on canvas; 36 x 24 in. Buffalo Bill Historical Center, Cody, WY. William E. Weiss Purchase Fund.

Remington and Russell were short, in his estimation. On the other hand, Neuhaus noted that Leigh's works lack the freshness and vigor "of those two contemporaries."[54] Leigh's unbridled use of color, the tactile exuberance of his painting surfaces, and the bold reckoning of his eye for western light set him, if not beyond the reach of Remington and Russell, at least on a scale complementary to their most ambitious artistic expressions.

An artist from Butte, Montana, Edgar S. Paxson (1852–1919), shared several things in common with one of that triumvirate, Charles Russell. The first was a professional bond and personal friendship that evolved over their many years of contact as two of the state's most highly regarded "pioneer" artists. Paxson had established his studio in Butte in 1881, the year after young Russell moved to Montana from his home in Saint Louis. The second was their mutual pride in never having taken formal art classes. According to his family, Paxson was "completely self-taught," too much of a native "genius" to be spoiled by the imposition of the academy's pedantry.[55] The third was their dedication to picturing the narrative flow of Montana's early history.

Paxson was born in Orchard Park, New York, and there became an apprentice to his father, a carriage builder. Young Paxson found his niche in the painting department, decorating the doors with fanciful scenes. Impelled by wanderlust, he moved to Montana in 1877 and worked at a variety of jobs, from guard for the Overland Stage Company to scout in the Nez Perce Wars, until setting up as an artist in the early 1880s. His studios in Butte (1881–1905) and Missoula (1906–1919) were gathering places for artists from across the country who wished to learn something of the West through Paxson's dramatic work and charismatic life.

In 1912 the Missoula County commissioners invited Paxson to produce eight murals for the south entrance to the courthouse. He selected themes not dissimilar from those chosen by Berninghaus for the Busch commissions—famous western events and personalities. In 1916 Enos Mills, who had written an affectionate biographical sketch of Paxson in 1902, asked the artist to provide a frontispiece of John Colter for his book *Your National Parks*.[56] The resulting image, *John Colter, the Discoverer of Yellowstone Park* (fig. 60), resembles in style and composition several of the murals Paxson had completed earlier. A boldly statuesque figure dominates the landscape, dwarfing even the majesty of Yellowstone Falls with the hero's imperious pose and stony stare. It is, in fact, history made over in the image of the artist and his perceptions of epic conquest. The year before completing this painting, Paxson had been honored as marshal of a July 5 historical parade. He dressed in mountain-man garb assembled from his famous studio collection and was photographed on the occasion. Although slightly stooped with age, he could have posed that day for Colter, looking down his nose contemptuously at nature's magnificence in a haughty gesture of self-assurance (fig. 61).

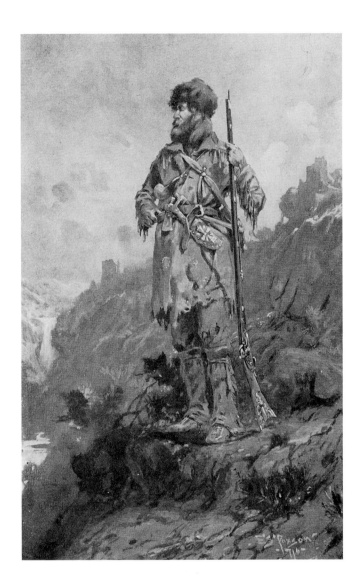

Fig. 61. Unknown photographer. *Edgar Paxson as Missoula Parade Marshall*, 1915. Photograph. Courtesy of Mr. William S. Paxson.

Fig. 60. Edgar S. Paxson (1852–1919). *John Colter, The Discoverer of Yellowstone Park*, 1917. From Enos A. Mills, *Your National Parks*. Photomechanical reproduction; 5$\frac{1}{2}$ x 3$\frac{1}{2}$ in. Uncat. 363503. Reproduced by permission of the Huntington Library, San Marino, CA.

Enos Mills had written an article on Colter in which he proclaimed the explorer's discovery of the park as standing out in "heroic proportions." That was certainly how Paxson viewed the situation, his favorite book being Theodore Roosevelt's polemical *The Winning of the West* (1889), which opens with the following sentence: "During the past three centuries the spread of the English-speaking peoples over the world's waste spaces has been . . . the most striking feature in the world's history."[57] Remington would have registered similar sentiments, but Paxson's friend Russell, who saw even the most celebrated of western historical figures as regular men like himself, would have bridled at the conceit.

Also contrary to Paxson's histrionic cant were the Yellowstone images of a group of landscape painters who visited the park in these years. The famous craftsman-designer, Louis Comfort Tiffany (1848–1933), sought inspiration for his paintings in Yellowstone. His honeymoon found him in the park in 1886, and he returned twice, in 1916 and 1917, to paint its stunning features. Although he had studied the richly suffused Barbizon mode with George Inness, Tiffany's subsequent travels in the Orient had engendered a taste for the exotic elements of nature, rendered with precision. Yellowstone met his needs for such scenery closer to home. Additional lessons from America's preeminent watercolorist, Samuel Coleman, brought him the skills to achieve great success in his fieldwork in that medium.[58] His watercolor *Yellowstone Canyon* (plate 45), with its golden, orientalist palette and refined, elegant detail, captures the crystalline elegance of nature's masterwork. The light dances off the walls of the canyon as if playing through one of the artist's finest stained-glass windows.

Despite Tiffany's three visits to Yellowstone, few of his paintings of the area are known today.[59] More productive and stylistically vigorous was the painter from Princeton, New Jersey, Howard Russell Butler (1856–1934). After graduating from Princeton College in 1877, Butler received a gift from his father, a train trip west to California. He went with three of his classmates, and among their adventures was a bouncy one-hundred-mile coach ride to Yosemite. They met John Muir there at Black's Hotel and debated with him the theories of the valley's formation. The experiences of the journey had a profound determining effect on his later life. "The West has always had a fascination for me," he later wrote in his autobiography. "It began with this trip and has been increased with many years."[60]

Butler later attended law school at Columbia and practiced in New York City. But he was not cut out for that life and happily diverted to a career as a painter in 1884. He established a studio in Mexico, shared with Frederic E. Church, then studied at the Art Students League and ultimately in Paris. By 1908 he was exhibiting paintings of the California coast at the Buffalo Fine Arts Academy. The catalogue for the show noted numerous awards and other professional accolades he had won by that time.[61] In 1911 Butler moved to Princeton and there established his residence and studio.

Pl. 45. Louis Comfort Tiffany (1848–1933). *Yellowstone Canyon*, 1917.
Watercolor; 19 x 13 in. The Charles Hosmer Morse Museum of American Art,
Winter Park, FL. © The Charles Hosmer Morse Foundation, Inc.

Western trips must have been a fairly frequent experience for the artist. In 1920, as he wrote in his "Biographical Notes," "The lure of the West had again got possession not only of me, but of my wife and son. So toward the end of June we left for Eaton's Ranch, Wolf, Wyoming."[62] The family enjoyed ranch life for several weeks. Butler explored the Big Horn Mountains on horseback with his sketch box, and in late July they all trotted off on one of Eaton's famous pack trips through Yellowstone. This was the same park tour taken by Joe DeYong. Records indicate that they were reasonably luxurious affairs, with staff to serve food and make beds. Still, for eastern dudes, especially one like Butler who wanted to get off the beaten path alone, adventures and challenges abounded.

At the close of July we left for the Yellowstone Park, entering by way of Gardiner. In the park I made many water colors of the Mammoth Hot Spring, Emerald Pool, Morning Glory Pool, Old Faithful—which against different colored skies makes beautiful effects—and the Lower Falls. I also did quite a number of oils. This led to more or less tramping, sometimes being picked up and carried by good natured autoists. One couple invited me to ride, although they had but one seat in the auto, the rest being occupied by a bed, and the running board carrying a stove and a cupboard for general supplies. . . . These were certainly auto hoboes.

On another occasion I was driven four miles and left to paint, the auto to return for me in a couple of hours. But as it came on to rain I packed up and started back to the hotel on foot, carrying my traps. Going around a curve I was confronted by a large brown bear. As he occupied the middle of the road and was coming toward me, I thought it best to let him have the whole road, and clambered up the steep bank and got behind a tree. The tree was on the edge of the Yellowstone Canyon. I could go no further that way. It was gratifying to see the bear pass and take to the woods on the other side of the road. I am told they are harmless unless they have been given sweets and think that they can get more from you. . . .

The Yellowstone Canyon is a marvel of color, too phenomenal for intimate painting. I could not fall in love with it. I do, however, admire [Thomas] Moran's great picture painted from near Artist's Point, which is now in the National Gallery at Washington [plate 21]. When making notes of Emerald Pool I found a man looking over my shoulders. I turned and we recognized each other. It was Mr. Basore, my next door neighbor in Princeton. We came out of the park as the cold weather was approaching, in fact there had been snow flurries.[63]

Butler belonged to New York's Century Club, which offered him a one-man show of his Yellowstone paintings upon the artist's return to the East Coast. There were thirty-five works included, of which twenty-five depicted Yellowstone subjects. By his own admission, Butler's was an intimate art—a purposeful assignation of priority to light,

to naturalistic but dynamic rhythms. His *Yellowstone Park: Old Faithful Geyser at Noon* (plate 46) and *[Riverside] Geyser: Yellowstone National Park* (fig. 62) evidence his skill at exploiting gesture as a mirror of nature's physicality and avoiding pseudo-transcendence by substituting the grand expression with a feeling of personal proximity and accessibility to the scene. His friend, admirer, and fellow Princetonian, Herbert Adams Gibbons, commented that the Yellowstone paintings "call forth an immediate reaction of joy."[64] Other artists praised Butler's ability to handle western light and air. Frederick S. Dellenbaugh, who had been painting southwestern landscapes since the 1870s, commented in 1924 that Butler was able to "get the real atmosphere in the Western subjects" that few could achieve. "Groll's pictures, for example, are excellent as pictures but they never look like the West to me."[65] DeYong's Yellowstone works were small but, in his insistence on painting the canyon and falls, lacked the intimacy and thus the veracity of Butler's.

In 1932 Alden Eaton, one of the brothers who operated Eaton's Ranch, wrote to Butler inviting him to visit Wyoming again.[66] However, Butler's peripatetic bent called him to other places in the West, and he never returned there. As a final gesture to the park, though, he left an additional artistic legacy beyond his fresh studies of its geysers and pools. In 1922, while living temporarily in California, he painted a portrait of Thomas Moran standing at his easel.[67] Butler listed the venerable dean of Yellowstone artists as one of his most prominent sitters.

It was in California that same year that another artist, soon to win the sobriquet of "painter of the National Parks," would come to the attention of Stephen Mather. The artist, a Swedish painter named Gunnar Widforss (1879–1934), had recently settled in the United States and was focusing his attentions on the splendors of Yosemite. Mather, impressed with the Swede's technical facility and the exhilarated naturalism of his style, persuaded him to expand his vision to include all the parks of the West.

In 1924 Widforss journeyed to Yellowstone and produced a series of gem-like watercolors of its unique scenery. As with Butler, the visit was a once in a lifetime event, but in paintings like *Yellowstone Canyon* (plate 47), the best of his talents were manifest. Whereas Twachtman, and to some degree Butler, had explored nature's varieties to reveal inherent abstract beauty, Widforss worked the other way. He searched the park's features, like the Yellowstone Canyon, for abstractions that through aesthetic transmutation could be visually reified. The Taos painters were said to have regarded Widforss as one of America's greatest living painters in the 1920s, but for his wont to "copy nature so closely."[68] Yet Mather appreciated Widforss for exactly that trait, perceiving it as a virtue rather than a liability. The director of the National Gallery of Art, William Henry Holmes, also felt that way, offering Widforss a one-man show in the ensuing years and thrusting him into the national limelight.

Widforss was a modest, self-effacing man whose gracious and generous manners

Pl. 46. Howard Russell Butler (1856–1934). *Yellowstone Park: Old Faithful Geyser at Noon*, 1920.
Oil on canvas; 17 x 10 in. Courtesy of the Estate of Howard Russell Butler Jr.

Fig. 62. Howard Russell Butler (1856–1934). *[Riverside] Geyser: Yellowstone National Park*, 1920.
Oil on canvas; 10 x 14 in. Courtesy of the Estate of Howard Russell Butler Jr.

Pl. 47. Gunnar Widforss (b. Sweden; 1879–1934). *Yellowstone Canyon*, 1924.
Watercolor; 19³/₄ x 17¹/₄ in. Buffalo Bill Historical Center, Cody, WY. Gift of Mrs. Horace M. Albright.

won for him many affectionate admirers. He had trained in the late 1890s as a muralist at the Institute of Technology in Stockholm but, like Butler, reached his aesthetic stride in the production of intimate works even when confronted with some of nature's boldest statements. He eventually settled at Grand Canyon and ended his career painting its veiled beauties.

Another foreign-born artist, Gustav Krollman (1888–1962), painted in Yellowstone in the 1920s. Born in Vienna and trained there at the Academy of Fine Arts as a portrait painter, Krollman immigrated to the United States in 1923. He settled in Minneapolis where he enjoyed a prosperous career as an art instructor, portrait painter, and muralist.[69] In the late twenties he signed on with the Northern Pacific Railroad to carry out a promotional poster campaign. Like Abby Hill a decade before, Krollman painted spots along the route that would entice visitors.[70] Since Yellowstone Park was one of the highlights, Krollman is said to have visited there several times.

Krollman's watercolors exhibit qualities similar to Butler's freely washed oils. *Old Faithful Geyser* (plate 48) is one of a series completed for sale in the Haynes shops. Its fresh naturalism contrasts sharply with the more stylized renditions of the same scene produced for a railroad poster. In the latter, nature's formidable force is pendant to the pleasant intrusion of man's accessories; the hotel on one side, the tent camp on the other, and a carload of static, oddly disinterested tourists in the foreground. It is likely that Krollman had seen a similar, though considerably more animated, poster executed a decade earlier by the German master of poster art, Ludwig Hohlwein (1874–1949). If Krollman's Yellowstone posters were enticing for the railroad's patrons, Hohlwein's were utterly seductive. His *Yellowstone-Park* (plate 49), a color lithograph ca. 1910, carries the quintessential message of tourist pleasuring without the slightest hint, beyond the bold letters, of its locale.

Unlike Krollman, Hohlwein never came to Yellowstone. He knew, though, from Haynes's photographs that the excursionists, wrapped in dusters and bonneted against the sun, loved the clamor of the coach rides that whirled them past their preselected views on their prepackaged adventures. Produced the year before automobiles were allowed to enter the park, Hohlwein's stunning image captures a passing era, thus selling nostalgia and novelty with an art nouveau nudge. It was advertising art at its best, all elements reduced to the purest form of decorative message.

Although born in Wiesbaden, Hohlwein passed most of his productive life in Munich. He trained as an architect but ultimately elected to specialize in interior decoration and exhibition design. In 1906 Hohlwein decided on a career change to become a *Gebrauchsgraphiker*, a graphic artist concentrating on commercial work. By 1910 he was winning international awards, and by the time of his published biography in 1926 he was "internationally acknowledged as the most important and significant master of the poster."[71] It is little wonder that the Yellowstone National Park Transportation

Pl. 48. Gustav Krollman (b. Austria; 1888–1962). *Old Faithful Geyser*, c. 1925.
Watercolor; 18 x 13 in. Courtesy of the Montana Historical Society, Helena, MT.
Haynes Foundation Collection. Gift of Mrs. Isabel Haynes.

Pl. 49. Ludwig Hohlwein (b. Germany; 1874–1949). *Yellowstone-Park*, c. 1910.
Lithograph; 34 x 47⁵⁄₈ in. Buffalo Bill Historical Center, Cody, WY.
Gift of Mr. and Mrs. Clyde Erskine.

Company would seek out such a talent and commission Hohlwein to promote its services. For its time and its purpose, Hohlwein's *Yellowstone-Park* may well rank as the park's most compelling image.

Despite its significance, Hohlwein's contribution to the iconography of Yellowstone appears to have been a singular one. Perhaps the sole image is all that the commission demanded. Or perhaps World War I interrupted what could have been a powerful series of graphic depictions. As the war broke out, there was an American artist who stepped into the Yellowstone picture equally briefly, someone equally consumed with the importance of design as the foundation of art. This was Arthur Wesley Dow (1857–1922), an extremely influential professor of art education at Teachers College of Columbia University, an early theorist on the precepts of modern painting, and a savant and aficionado on Oriental, especially Japanese, art.

At the time of Dow's visit to the park in 1917, he was living in Ipswich, Massa-

Fig. 63. Arthur Wesley Dow (1857–1922). *At Mammoth Hot Springs*, 1917.
Watercolor; $5^3/_4$ x $8^7/_8$ in. Ipswich Historical Society, Ipswich, MA.

chusetts. He had been invited for the summer to Portland, Oregon, to offer a five-week course on art appreciation at the Museum of Art and a public lecture addressing "Art in Relation to Preparedness, Patriotism and Nationalism."[72] The course earned great praise and the lecture succeeded similarly. In the spirit of the day, with America's involvement in the war less than six months old, Dow filled his audience with notions of an emerging national aesthetic. This, he declared, was an "awakening." "A real American art is coming into being." In the process of urging American artists to seek individual means of expression, Dow stressed a reliance on good design based on a handful of formal elements combined to capture the spirit, rather than the visage, of place.[73]

Dow pleaded for public recognition of the "fineness of design" within pictures, based on the organizing principles of Japanese painting and printmaking. Regardless of subject, if a picture were sensitive to a few simple principles of spacing, rhythm,

Fig. 64. Arthur Wesley Dow (1857–1922). *Mammoth Hot Springs, Yellowstone National Park*, 1917.
Watercolor; 5³/₄ x 8⁷/₈ in. Ipswich Historical Society, Ipswich, MA.

dark and light, and color, then even the most average of viewers could comprehend and appreciate them as "great art."[74]

Notes and studies in Dow's Yellowstone sketchbook made at Jupiter Terrace in early September reveal his consuming focus on light and color (figs. 63 and 64)— aide-mémoire for a studio piece that might be worked up later at home. *Yellowstone National Park* (plate 50), a finished watercolor of the same scene, was probably also completed in situ. Like many of his late paintings, its quixotic and ethereal under-statement confirms his primary lesson as a teacher, that "the artist does teach us to *see* facts: he teaches us to *feel* harmonies and to recognize supreme quality."[75] While Hohlwein had employed his bold design to sell pleasuring amid the marvels of nature, Dow explored the park's features for the perfect arrangement of elements to speak quietly to the unified spirit of modern art and the most national of its public scenery.

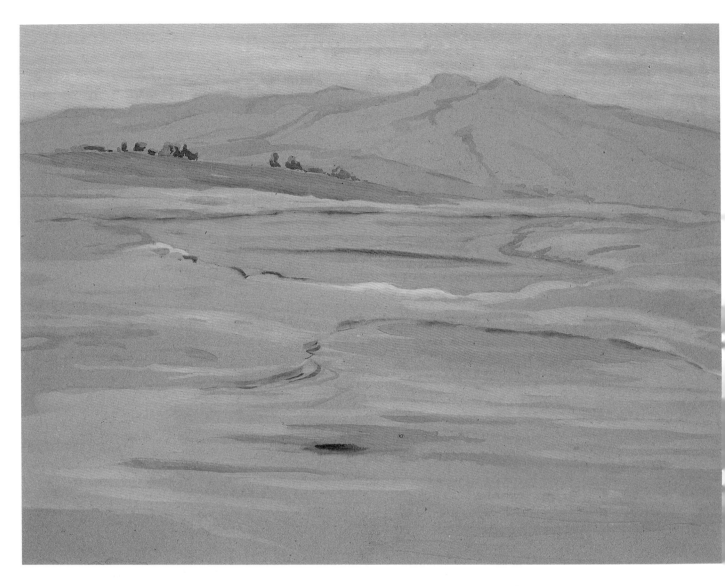

Pl. 50. Arthur Wesley Dow (1857–1922). *Yellowstone National Park*, 1917.
Watercolor; 17$^7/_8$ x 23$^3/_4$ in. The University of New Mexico Art Museum,
Albuquerque, NM; purchased with funds from Friends of Art.

Steamy Angels and Vague Bears

During the early 1920s, Yellowstone National Park witnessed a surge in public appeal. At the same time that conservationists Aldo Leopold and Arthur Carhart were convincing the National Forest Service to set aside "primitive areas" with restricted use and accessibility, the country's parks were experiencing a dramatic democratization. Horace M. Albright became superintendent of Yellowstone in 1919 and championed the cause by working to make the park open and available to the broadest possible cross section of the public. In this he was reflecting the viewpoint of his mentor and boss, Stephen Mather, and would accomplish his goal over the next decade of service as superintendent by upgrading roads and facilities throughout the park's boundaries.[1]

As a result, gateway communities prospered, in-park concessionaires were consolidated and blossomed, and the railroads took full advantage of the inviting new prospects. Artists were called upon to complement these efforts and often, in the process, to commodify nature's flagship preserve for more appealing and popular consumption of its charms. At times, such endeavors to ally art and promotion had surprising results with impact well beyond mundane public titillation. One case in point developed from the vaporous eruption of Old Faithful as recorded by the park's official photographer, Frank J. Haynes. The photograph, unceremoniously titled *Old Faithful* (fig. 65), had gratified the souvenir appetites of countless tourists over the years and had graced the pages of Northern Pacific Railroad brochures for some time. It proudly carried the caption of "the most celebrated picture of this geyser" and represented no small feat of photographic art. Haynes no doubt was thinking of this and similar works when he explained to author Emerson Hough the technique for elevating geyser photography to a form of fine art:

> All amateurs . . . think they have to have the sun at their backs. You'll find this is wrong: if you get the sun to one side and catch the shadows, you get a "Rembrandt-lighted" picture with good contrasts. If you try to photograph a geyser in action, you get nothing with the sun at your back because there is no contrast between the steam and the background. Better squarely face the sun and the light shining in against the cloud of vapor will give you a sharp clear negative.[2]

Haynes's geyser photograph had impact well beyond its model as the "Rembrandt-lighted" paradigm for the amateur. He was surprised to learn in 1925 that it had also

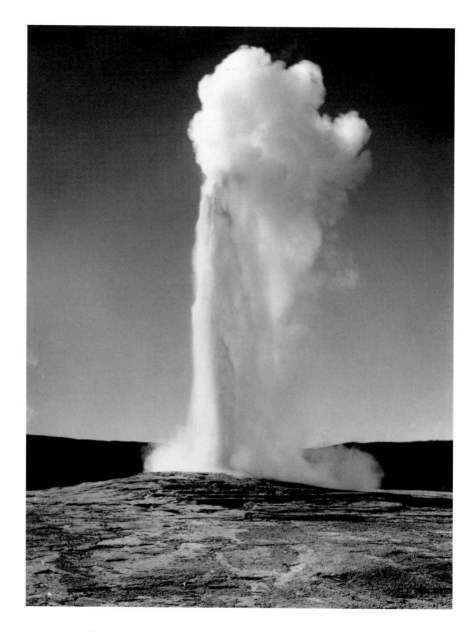

Fig. 65. Frank J. Haynes (1853–1921). *Old Faithful*, c. 1920.
Photograph on promotional brochure; 6 x 4 in. Courtesy of the Montana Historical Society,
Haynes Foundation Collection. Gift of Mrs. Isabel Haynes.

provided the inspiration for one of America's preeminent sculptors, Daniel Chester French (1850–1931). In 1924 the Corcoran Gallery of Art in Washington, D.C., acquired an elegantly graceful marble sculpture by French, *And the Sons of God Saw the Daughters of Men That They Were Fair* (plate 51). The museum's acquisition records state that French was moved to "create this piece through seeing its silhouette in 'Old Faithful Geyser.'" Washington newspaper accounts of the museum's purchase, with head-

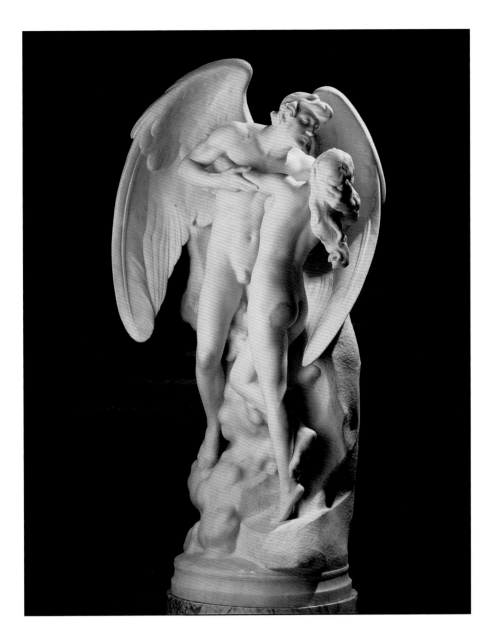

Pl. 51. Daniel Chester French (1850–1931). *And the Sons of God Saw the Daughters of Men That They Were Fair*, 1923. Marble; 98 in. (height). In the Collection of the Corcoran Gallery of Art, Washington, DC. Museum Purchase. 24.1

lines boasting "New Masterpiece Here," mirrored the museum's internal record. "The composition was inspired by the billowy monumental form of 'Old Faithful' geyser in eruption . . . and through his genius the indefinite shape took on definite form and meaning."[3]

When Haynes saw these notices, he knew right away that the sculptor's genius was based at least in part on the photographer's image. He wrote French inquiring if

his photo had not been the sculptor's model and received the following, slightly embarrassed response.

> My dear Mr. Haynes:
>
> I am very interested in your kind letter of February 2nd.
>
> It is true that a marble group which I completed recently, and which had been acquired by the Corcoran Gallery, was suggested by a reproduction of a photograph of the "Old Faithful" geyser in Yellowstone Park. Many years ago I came across this picture in a magazine and saved it, thinking that some day I would develop, in sculptural form, the human figures that I saw in it. Three or four years ago I took the matter up seriously, and made the group to which you refer.
>
> In taking the picture out of the magazine I failed to make a note of what magazine it was, and I do not now know whether it was the *Geographic*, or an advertisement in some other magazine.
>
> I shall be most happy to send you a photograph of my group, and to acknowledge the debt that I owe you in suggesting the motif for the group, to my mind.[4]

Subsequent promotion of the statue credited Haynes's model.

French, recognized as one of America's most popular and gracious sculptors of his day, was reaching the end of a long and prosperous career. He received the title of "dean of American sculptors" for his prolific output and his devotion to naturalism over the neoclassical idealism that had pervaded the discipline during the generation preceding him. As with the best of his work in these years, French's marble *And the Sons of God* or *Love* (as he sometimes called it) is strongly pictorial and narrative. According to the Corcoran, it derives its story line from the account in Genesis "of the recreation after the flood; of the mating of the sons of God with the daughters of man." The dominant male figure, an angel, steps from a heavenly cloud to embrace an earthly female who reaches skyward from a rock. Symbolically, man is invested with spiritual ordination to quicken the earth, bolstered by the physical perfection of his presence. The metaphor might be read as virginal Yellowstone surrendering to divinely guided man for his pleasure. It took about five years to create and, in the critics' estimation, was one of "the finest works yet produced by an American sculptor."[5] When, in 1937, Dr. Clyde Max Bauer published his then-definitive volume on *Yellowstone Geysers*, the Haynes photograph of Old Faithful was juxtaposed to French's statue. Here was a remarkable union of science and two branches of art, sculpture and photography.[6]

More generally in these years, the union came between art and commerce. A Nebraska painter, Henry Howard Bagg (1853–1928), and a Texan, Frederic Mizen (1888–1964), typified that trend. Bagg spent much of his professional life, 1905–1918, as an art instructor at Nebraska Wesleyan University in Lincoln, where he earned the

title of professor that usually preceded his name. His publicists and his students knew that Bagg's forte was the rendition of the majestic in nature and popularization of its beauty. In his mature years he worked closely with the Thos. D. Murphy Co. of Red Oak, Iowa, in the production of calendar images that glorified American scenery.

In 1925 Murphy, who referred to his company as the birthplace of the art calendar, published a lavishly illustrated volume on *Seven Wonderlands of the American West*.[7] It boasted "pictures by Thos. Moran" and also featured the somewhat less vital imagery of the eminent artist's admirer, Professor Bagg. His style, for the 1920s, stood out from most moderns, observed a local Lincoln reporter. Unlike Moran's late works, Bagg relied on detail and a realistic replication of nature's charms "rather than on 'effects' to express his reaction to . . . landscape. He loves the highlights of nature and prefers to depict the happy phases of her moods rather than her bursts of temper."[8] His staid and palatable renditions suited the era and the popular taste in art. His painting of *Yellowstone Falls* (plate 52) that adorned one of Murphy's seasonal greetings was exemplary of his sober, yet engaging, views of wonderland's features.

A considerably more sensate and spirited interpretation of the park and its appeal to the common fold came from the brush of another teacher, Frederic Mizen. Like Bagg, Mizen was noted for his calendar images. But he preferred a larger scale, being ultimately remembered in American art for his engaging billboards for Coca-Cola and other companies. During the twenties and thirties he found a particularly profitable association with American automobile manufacturers. He created illustrations for Packard, Oldsmobile, Cadillac, and many others, awakening interest in travel, design, and American industry with his powerful and intriguing compositions.

In 1931, working for Coca-Cola, one of his most supportive clients and a company with whom he had associated since 1914, Mizen produced the quintessential statement of Yellowstone as an ebullient pleasuring ground. Reflecting a national zeitgeist of delectation, Mizen's *Old Faithful Inn at Old Faithful Geyser* (plate 53) makes bizarre though seemingly humorous connections between human thirst and nature's innocence.[9] The tony crowd of dudes and jeunesse dorée (gilded youth) has trouble restraining its jubilation at the spoliation of the beast. The lesson in consumption, tipping bottles of mellifluous fizz, stands center stage to the incidental eruption of Old Faithful and the fascinating architectural eccentricities of the Old Faithful Inn.

Mizen had studied art at the J. Francis Smith Academy in Chicago during the early years of the century and later at the Chicago Art Institute and the Académie Julian in Paris. At the Art Institute he formed a close friendship with one of his instructors, Walter Ufer. From him Mizen learned about the West and especially Taos, where Ufer loved to paint the "infinite variety of moods and types."[10] Mizen later established his own art school in Chicago (1936), known as the Frederic Mizen Art Academy. He spent summers in Taos, sometimes with his students in tow, and enjoyed painting every-

Pl. 52. Henry Howard Bagg (1853–1928). *Yellowstone Falls*, 1927.
Lithograph. Sales Promotion Associates, Inc., from the Thos. D. Murphy Co. Calendar Archives.

Pl. 53. Frederic Mizen (1888–1964). *Old Faithful Inn at Old Faithful Geyser*, 1931.
Oil on canvas. The Coca-Cola Company, Atlanta, GA.

thing from Indian subjects to society portraits. He ended his teaching career at Baylor University, where he served as chairman of the art department from 1952 to 1960.[11]

Levity was not generally Mizen's fare, but his satire proved poignant despite its probable effectiveness at selling soft drinks. His contemporary Joseph Jacinto Mora (1876–1947) published a series of humorous illustrated poster maps of the national parks in 1931 and is remembered for his refreshing spoofs. Mora was born in Montevideo, Uruguay, and moved with his family to New Jersey and later Boston. His father, the Spanish sculptor Domingo Mora, taught his son at New York's Art Students League. Joseph also studied with William Merritt Chase. In his early career as an artist, Mora worked as a newspaper illustrator in Boston. A fascination with the West led him to the Southwest after 1900. He eventually settled in Pebble Beach, California, and established a studio there.[12]

Like Mizen, Mora looked at the lighter side of modernization and human activity in the park. His Yosemite maps, published in 1931, stated his rationale. "There is so much grandeur and reverential solemnity to Yosemite that a bit of humor may help . . . to happily reconcile ourselves to the triviality of Man."[13] Mora intended the same "tithe of mirth," as he called it, with his Yellowstone maps (plate 54). They found such broad appeal that the Haynes curio and photographic shops soon negotiated for the copyright and publishing rights. The maps were sold in the mid-thirties, wrapped and ready to mail, for twenty-five cents.[14]

The Haynes Picture Shops offerings ranged widely in quality and type of product. In his 1936 catalogue, which featured the Joe Mora map, Jack E. Haynes (the photographer's son, who had taken over the shop business fifteen years earlier) advertised a series of William Henry Jackson photographs. Frank J. Haynes had died in 1921, but his cohort Jackson was still alive and active. In fact, in 1935 the National Park Service had commissioned Jackson to paint four large oils commemorating landmark events in the history of the Geological Survey. It did not take Jackson long to accept the offer and to determine that Ferdinand Vandeveer Hayden in Yellowstone would be the subject of one of his paintings.

As a leader for half a century in the image-making industry, as a profound public communicator, and as a prolific disseminator of multitudinous pictures of America's scenery, Jackson was now faced with the need to be uncharacteristically selective. Saturation marketing and photography had made him famous. Painting had been an avocation, a sideline for him in his later years, and the federal commission represented quite a challenge. He was also well into his nineties when the request came for the four thirty-by-sixty-inch canvases. As a demonstration of his undiminished energy, by the time he was done with the work Jackson had also completed another half-dozen twenty-five-by-thirty-inch canvases and forty watercolors for distribution among several of the national parks, including Yellowstone.[15]

Pl. 54. Joseph Jacinto Mora (b. Uruguay; 1876–1947). *Yellowstone.*
Lithograph; 28 x 22 in. National Park Service, Yellowstone National Park, WY.
Photograph by W. Garth Dowling, Jackson, WY.

Pl. 55. William Henry Jackson (1843–1942). *First Official Exploration of the Yellowstone,*
Wyoming Region, 1935. Oil on canvas; 30 x 60 in. The U.S. Department of the
Interior Museum, Washington, DC.

The "murals," as Jackson referred to the four commissioned works, were completed by spring of 1938 and put on display in a museum setting at the Department of the Interior. The premiere piece, *First Official Exploration of the Yellowstone, Wyoming Region* (plate 55), was a deliberate and rather awkward parade of characters posed like museum mannequins with their frozen gazes directed at an erupting

194

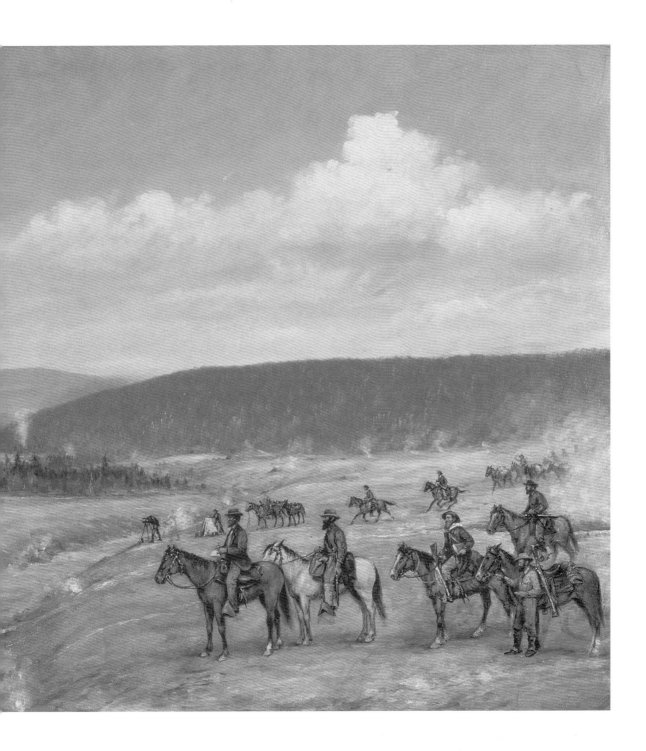

Old Faithful. The Firehole River transects the scene, a symbolic barrier between the explorers and their phenomenal "discovery," a watery gate to paradise.

Appropriately enough, Jackson painted himself into the picture. And interestingly, he is the only animated one of the troop. Positioned with his tripod in the middle-distance, he has approached the river, as well as the wonders beyond, closer than anyone else. Hayden and Moran, both prominently portrayed in the foreground, sit spellbound and static in their saddles as if awaiting a cue from some greater force on

what to do next and how to react. But Jackson, without any external prompting, has leapt from his horse and is bringing his considerable talents to bear on the situation.

This and the other paintings in the series comprise what is obviously a conclusory artistic statement for Jackson. One scholar has surmised that with these Jackson had "completed the full circle of the photographer's involvement with the government in the marketing of the American West." This was a "classic example of New Deal documentary-as-propaganda," and the Geological Survey's participants were "emissaries of a benevolent government."[16] Without question that is true, but on a more intimate note, the Yellowstone painting at least is a monumental, if stilted, autobiographical statement for Jackson. It places the role of photography in the forefront of discovery. It documents and commends one art form to another. And it positions the photographer himself, a man who had stayed with the survey throughout its entire duration, humbly in the shadow of the great leader Hayden and Yellowstone's master painter Moran. If Hayden's dream had been to use the surveys collectively as a construct for visualizing the American West, certainly too this painting of his halt at the Firehole should count as a provocative frontispiece for the monumental opus.

Despite Jackson's effort, one of the freshest views of Old Faithful to be painted in the 1930s was produced by Edward Brewer (1883–1971), a gifted commercial artist from Saint Paul. Through the teens and well into the twenties, Brewer had made a name for himself producing signature advertisements for Emery Maples, the marketing genius behind the Cream of Wheat Company. Several artists had preceded Brewer in the assignment to promote the breakfast cereal. In the first decade of the new century, James Montgomery Flagg, Philip R. Goodwin, and N. C. Wyeth were among the painters to try their hand. Then, in 1911 Brewer got his chance and continued, almost without interruption or competition, cooking up weekly ads for the next fifteen years.[17]

In the early 1930s Brewer, who was prospering as a portrait painter in the Twin Cities, approached the Northern Pacific Railroad with a proposition. He would paint scenes along the rails west if they would provide transportation and lodging for him and his family. They went along with the idea. One of the resulting images is an impressive chromolithograph of Old Faithful titled *Yellowstone Park* (plate 56). Rendered in a delicate range of pastel colors, from mauve to azure, animated with pointillist splashes of sparkling contrasting dots and punctuated by a strong, clear white shaft of water and spray, this differs markedly from the depictions by Bagg or Jackson. Free to explore the scintillating effects of light and water with a palette of reduced values and a penchant for harmonious visual expression, Brewer in his portrait of Old Faithful had created a postimpressionist spectacular.

Postimpressionism was also the artistic language of a Swedish painter from Kansas, Birger Sandzén (1871–1954), who visited Yellowstone in 1930 at the peak of his career. A professor of art and art history at Bethany College in Lindsborg, Kansas, Sandzén

Pl. 56. Edward Brewer (1883–1971). *Yellowstone Park*, c. 1935.
Lithograph; $39^7/_8$ x $27^1/_4$ in. Buffalo Bill Historical Center, Cody, WY.

Fig. 66. Birger Sandzén (b. Sweden; 1871–1954). *Yellowstone Lake, Wyo.*, 1930.
Pencil; 5 x 7³/₄ in. Greenough Trust Collection, Birger Sandzén Memorial Gallery, Lindsborg, KS.

and his family spent the early summer that year in Logan, Utah. He taught in the summer school at Utah State University. From there they traveled to Yellowstone, then through the new national park at Grand Teton and on to Estes Park for another five weeks.[18] In the course of his travels, he made sketches for several Yellowstone paintings (figures 66 and 67). However, only one, *Yellowstone National Park* (plate 57), is known to survive.

By this date, Sandzén's style had evolved from pointillism into a boldly individualistic combination of fauve color with a heavy, almost forced impasto technique that placed painting structure on a par with adventurous chromatic adaptation. The walls of the Yellowstone River canyon provided a perfect subject in scale, texture, and color to explore this bold, expressionist idiom. The critic L. Merrick had written of Sandzén that he disregarded "unimportant details and extreme realism" in search of "essentials." "With direct brushwork and a love for brilliant color," Sandzén "adopted nature to express artistic emotion."[19] His structured, analytical formality has suggested to some a comparison with Paul Cézanne, while the excitement of his elongated, ladened strokes and heightened color have led others to associate him with Vincent van Gogh.[20] Yet in his search for a novel and personal interpretation of the western landscape,

Fig. 67. Birger Sandzén (b. Sweden; 1871–1954). *Grand Canyon, Yellowstone*, 1930.
Pencil; 5 x 7³/₄ in. Greenough Trust Collection, Birger Sandzén Memorial Gallery, Lindsborg, KS.

Sandzén dashed new colors and swirls on his canvases that ultimately separated his daring expression from apparent European antecedents.

Frank Tenney Johnson (1874–1939), a California painter who frequented the northern Wyoming mountains in the 1930s, could use paint almost as adventurously as Sandzén. His palette was far less explosive, however, and he has generally been appreciated for his narrative scenes of western life rather than for his landscapes.

After working as a Milwaukee newspaper illustrator and studying with Chase and Joe Mora's father at the Art Students League, Johnson went in search of cowboy adventure in Colorado. He ultimately combined his love of ranch life with a burgeoning career as a western illustrator. In 1920 he established a studio in Alhambra, California, and settled into a successful artist's life. But a decade later he discovered a more invigorating place to spend his summers. A cousin of his had started a dude ranch near Cody, along the north fork of the Shoshone River just outside Yellowstone's east gate. There, Johnson built a cabin and studio and passed his summer months hiking, packing, and painting in and around the park.

Although there seem to be no finished, typical western narrative paintings with Yellowstone backdrops, several studies large and small survive from Johnson's seven

Pl. 57. Birger Sandzén (b. Sweden; 1871–1954). *Yellowstone National Park*, 1930.
Oil on canvas; 48 x 36 in. Greenough Trust Collection,
Birger Sandzén Memorial Gallery, Lindsborg, KS.

years (1931–1938) in the area. *Cove in Yellowstone Park* (plate 58) is exemplary of his Wyoming work. Larger by two or three times than his known field studies of the period, this painting nonetheless has the spontaneity and freshness of a plein-air piece. The freedom and scale of the brushwork suggest an immediacy of response to morning light on one of Yellowstone's many secluded lakes. When he was lucky, even the composition was provided by nature. Design was critical to the success of his pictures no matter how natural the setting. "Design is what I search for in composition," he commented in 1931. "Working so the painter is able to bring all the parts of the picture into harmony with a simple whole" is what he strove to accomplish.²¹ *Cove in Yellowstone Park* evinces that harmony of the whole with its evenness of tone, its pleasing balance of elements, and its absorbingly quiescent mood.

A simple harmony of the whole was the aesthetic principle that motivated another artist of the time, the Denver sculptor Gladys Caldwell Fisher (1906–1952). Inspired by a love of animals and steeped in the lessons of modern sculpture, Fisher garnered two important federal commissions—one actuated by Yellowstone experiences and another that found a place of permanence in the park itself.

Fisher's biography holds her up as a hometown prodigy whose sculptures of animals had won local praise even before she graduated from high school. A Denver organization, Allied Arts, offered her a special scholarship in 1926 to study at Alexander Archipenko's School of Art in New York City. She later continued her education in Paris, returning to Colorado to teach art at the University of Denver, raise a family, and enjoy an active career as an independent sculptor.

In the mid-1930s Fisher entered and won a competition to produce sculptural decorations for the central post office building in Denver. It was a Treasury Relief Art Project that she completed in late 1936, comprised of two seven-and-one-half-ton Indiana limestone Rocky Mountain bighorn rams (fig. 68 and plate 59). In order to initiate the commission, Fisher had spent several weeks in Yellowstone observing bighorn sheep in their natural habitat. A group of rangers who were then studying sheep behavior and survival rates assisted the artist in her studies and engaged her in their own. One of the high points for her was witnessing the birth of twins through a telescope. Months later she was still describing the thrill of that day.²²

A few years later, encouraged by the success of the Denver post office project, Fisher accepted another federal commission, this time for the post office steps at Mammoth Hot Springs. Under the Treasury Department's section of Fine Arts, she was mandated to produce sculptures of animals characteristic of the park.²³ The project was interrupted a couple of times, first by an emergency appendectomy that set her back several months and then by the birth of her second child, Nora. Yet in the spring of 1941 two wonderfully curious limestone bear cubs took their places on the front steps of Yellowstone's post office (fig. 69).

Pl. 58. Frank Tenney Johnson (1874–1939). *Cove in Yellowstone Park*, c. 1938.
Oil on canvas; 30 x 40 in. Buffalo Bill Historical Center, Cody, WY.
Gift of Mr. Fred Machetanz.

Fig. 68. Unknown photographer. *Gladys Fisher with Rams*, 1936.
Western History/Genealogy Department, Denver Public Library, Denver, CO.

Despite the favorable reaction to the statues in Washington, D.C., and the park postmaster's claim that they were "welcome additions," Yellowstone residents seemed confused and rather less charitable toward the new cubs. The postmaster reported to the commissioner's office:

> These sculptured Bears' resemblance to real bears is rather vague, especially here in Yellowstone park where bear are so common, and everybody is very familiar with real bear. "Mrs. Fisher's conception of a bear must be rather vague" is the opinion of most of the residents of Yellowstone Park.[24]

Pl. 59. Gladys Caldwell Fisher (1906–1952). *Rocky Mountain Big Horn Ram*, 1936.
Limestone; 60 in. (height). U.S. Post Office, Denver, CO.
Photograph by Eric Stephenson, Lakewood, CO.

No doubt the residents would have lent a deaf ear to Fisher had she been able to attend the dedication and speak to her achievement. They would not have been the least impressed with Archipenko's lessons on the virtue of reduction and streamlining of form toward abstract simplification that had won for him tintinnabulous praise

Fig. 69. Gladys Caldwell Fisher (1906–1952). *Bear Cubs*, 1941. Limestone;
50 in. (height). U.S. Post Office, Yellowstone National Park, WY.
Photograph by W. Garth Dowling, Jackson, WY.

in Paris and beyond three decades before. They clamored only for realism and were, no doubt, even being gracious in their own minds by allowing no harsher term than "vague" to stand for their provincial critique. The same residents who spun fantasies for the tourists—when the geysers froze up in winter, they would cut the ice into conveniently sized blocks and use them as foot warmers[25]—could not believe in the veracity of bears without every muscle and hair articulated.

The Modern View

Artistic response to Yellowstone after World War II seemed to languish. The falls still rumbled in sublime splendor, and the geysers gushed their steamy plumes with as much breathless pomp as ever. The public motored through, and the park experience, solidified as a requisite function of familial culture in America, was as de rigueur as chocolate malts and drive-in movies. But where were the artists? The Yellowstone that had provided an outdoor studio for so many generations of painters and even an occasional sculptor had lost its appeal somehow. Artists were more introspective, perhaps too focused on their personal lives and the East Coast dilettante scene to regard the refreshing allure of Yellowstone as anything more than the aim-and-click province of the holiday photographer.

As a matter of fact, aside from Arthur Wesley Dow and a few like-minded intrepids, American modernists of the previous generation had basically ignored Yellowstone. Unlike the American Southwest, this isolated corner of the northern Rockies—what Moran and his generation had claimed as the generative heart of the nation's continent—was now little more than a spot on the summer tourist itinerary. Unlike the American Southwest, no avatars of the then deific French cubists or German expressionists except for Gladys Fisher found the park inspirational ground. No John Marin came to slash at his watercolor paper while teetering at the canyon's brink. No Marsden Hartley exercised his emotive, cosmically mystical touch on its mountain contours. The later New York school of abstract expressionists, with its pack-of-Camels, bourbon-soaked lives and artistic hegiras of fancy, could not see west much past the Hudson River. This was despite the fact that the movement's progenitor, Jackson Pollock, was born near Cody, Wyoming, just fifty miles from Yellowstone's eastern border. And the park was left unsullied by the pop artists, though surely their captain, Andy Warhol, had he been inclined toward landscape, might have chosen such a subject. In his paeans to American commercial sensationalism, the park that had long been known as a place where commerce was disguised as art would have been a logical target for his vision of "art disguised as commerce."[1]

As it turns out, landscape painting in America had become simply passé by the 1950s. And art with western subjects was even more so, finding itself consigned to the province of philistines. Steps toward establishment of even a serious landscape idiom relevant to the times would have been considered retrogressive and dilatory to the cli-

maxing crescendos of modern expression. And to compound its problem, Yellowstone had become aesthetically obscure to the general public as well. Clichéd postcard image after clichéd postcard image followed by redundant, derivative paintings saturated the nation's vision. What had once been a pictorially potent force drifted into the realm of invisibility, rubbed away by overuse and faded through overexposure.

In preparation for the nation's bicentennial, the federal government, through the auspices of the Department of the Interior, stepped in to remedy the situation. Hoping to revive the national art community's interest in the light and sky, topography and texture of the land around them, they selected forty-five artists and pointed them into the hinterlands to find inspiration. It provided a refreshing first step as well as a poignant reminder of the century that had passed since 1872 and the federal government's use of American landscape art for political, polemical, and promotional purposes. Once again, as with the congressional commission of Thomas Moran's *The Grand Cañon of the Yellowstone*, paintings of the American countryside were pulled into the service of national unity. Through a celebration of artistically interpreted folds and dips, the crests and crevices that make up America's physical countenance, the nation could set aside its internal sociopolitical tensions and the tragic events and consequences of the Vietnam War to pay homage to its scenic splendor. The program provided a salve for the national conscience.

A bit more than a decade later, a nonprofit support group, the National Park Foundation, joined forces with an enterprising consortium of art marketers, who adopted the slightly unwieldy but appealing appellation of the National Park Academy of the Arts, Inc. They set about to identify a good, round number of artists—settling on one hundred—"whose paintings best captured the 'essence' of the landscapes, wildlife, and history of the more than 300 units of our National Park System."[2] An annual, juried sale exhibition would feature their selected artists, with a percentage of the proceeds reserved for the benefit of the parks.

The program had a tremendously salubrious effect on the art community, exciting painters and patrons of many variant persuasions to look harder or again at places in America where nature had been "preserved." It was the catalyst for directing artists back to nature or, for those who already thrived in that realm, for encouraging them to consider the parks as subjects. Several of the artists turned to Yellowstone, and some of those produced exceptional work for the organization's inaugural 1987 exhibition, *Arts for the Parks*. One among the ranks was a Utah artist of considerable talent. Michael Coleman (b. 1946), though acknowledging in his work the allure of nature's abstractions, is propelled by a preference for rendering its most compelling moods through precise delineation and a recognition of its full range of chromatic intensity. Using opaque watercolor, Coleman suffuses those details and colors into a softened reality hidden by Yellowstone's mists and atmosphere. One result was his 1987 paint-

ing *Yellowstone Park* (plate 60), in which the park's animals and geothermal features are presented as jewels sewn into a luminous mantle of light and landscape. "I inhale the natural world and love it most when it's moody, stormy, wet, snowy and dusky colored," he remarked in 1978.[3]

Coleman combines remarkable personal skills with two artistic traditions that have been time-honored in Yellowstone. The first is an ability to paint landscape, nature's color, and atmospheric effects that approaches Moran's most ambitious watercolor treatments of the preceding century. The second is his connection with one of history's premier animal painters, Carl Rungius. In Coleman's works, as with those of his proclaimed artistic inspiration, animals move with an ease and presence that suggest an innate harmony of spirit among the painter, the wildlife, and nature's rhythms (plate 61).

One of the judges for the first *Arts for the Parks* exhibition was a painter whose work should have been included. He is generally regarded as the leading landscape painter of western scenes today, and he had painted Yellowstone and other parks for years. His name is Wilson Hurley (b. 1924), and he brings to his subjects a studied eye, an uncommon regard for the scientific underpinnings of art, a penchant for stunning effects of light and dramatically unusual compositions, and a potent dedication to his craft.

Although Hurley's specialty has been the sun-swept mesas and bald peaks of New Mexico, he has visited Yellowstone a half-dozen times or more. The geysers never engaged his attention, but Yellowstone's cascades have become a favorite theme. *Lower Falls from Red Rock Point* (plate 62) was completed in 1983. It was produced from a small field study in oil, a method he uses because of its flexibility compared to watercolor and its chromatic subtlety compared to photography. He defines the process as follows:

> I put the field study on the taboret and mix all the colors as I see them in the light before me in the studio. That way I make sure I have the right colors for my finished work. I like sketching in oil because I can go back, I can correct, and work on the color relations. I'm not working for details. I'm looking for what the shadow colors are, what the overall mountain colors are, and it's surprising how much grey and umber and ochre show up in western mountain landscapes compared with what a camera's film records. A camera would have us believe that mountains are made of colored candy.[4]

The finished large painting is a frontal view of the falls which carries, along with its vast scale, the full range of visual and emotional effects that might be experienced by a firsthand view. Everything is there but the tremor underfoot and the roar in the ear. Hurley, who is assiduous about resolving pictorial concerns in his art, demon-

strates here a fully resolved orchestration of perspective, color harmonies, naturalistic lighting, and atmosphere. When compared with Moran or Bierstadt of several generations back (and he often is), Hurley responds that he comes to scenes like Yellowstone's falls rather matter of factly.

> I see it in a larger frame of reference, at a greater distance, and, because of that, a lot of the awe and the fear and the reverence that they had is not in my work. What I record with my paints provides more stark reality, I hope. And compared to earlier work it is not as "romantic" nor as awe-inspiring. You don't get the same emotion when you see my work as you do when you look at a Moran or Bierstadt version. Primarily this is true because I don't have the same emotion. If I were to describe *my* emotion, though, it would be—look at reality, divest yourself of the notion of any finite scheme of things you can comprehend.[5]

If Hurley's wish is to elicit a sense of oneness with nature, of immediacy and presence, there is another painter, Russell Chatham (b. 1939), who prefers to enshroud his views in velvet reverie. While Hurley spends hours softening the edges of his nuanced geological details in order to make his pictures seem more naturalistic, Chatham strives for an ethereal whole that gentles the realities of nature into poetic rhythms. His is a stilled and elegant place that, through works like *Heart of Winter on Swan Lake Flat* (plate 63), speaks of serenity and keeps the cacophony of the thundering falls at a comfortable distance. With hushed reverence and a delight in the dignity of pattern, he presents the other side of Yellowstone's temperament.

Chatham also addresses themes of man in Yellowstone with paintings and lithographs of anglers tempting trout to the surface of its lakes and streams, as in *The Gibbon River on a Summer Evening* (fig. 70). The men and women in his works, like his bison and trees, are veiled in the tonal suffusion of his misty vision and as such become part of his dreamy serenade to nature's harmonies.

There are others who see humans' place in Yellowstone today in terms of far more striking contrasts. It is surprising that of the hundreds of paintings shown in the multiple annual exhibitions of *Arts for the Parks*, not one has dared to make a comment, even a humorous one, about the human impact on the park. Many books have been written on the subject, for example Richard Bartlett's seminal treatise, *Yellowstone: A Wilderness Besieged*, a historically revealing yet optimistic summary of the park's myriad problems. And there is Alston Chase's disputatious *Playing God in Yellowstone*, a bitingly critical account and harbinger of a less hopeful future.[6] But in modern times, it is more often the artists as well as the historians who observe and critique society, exposing human foibles, capriciousness, and hubris. And so it is sad that, for most of the artists portraying Yellowstone, it is as if the park had never gone through a tumultuous history, as if it represented the same quaint, picturesque, remote quar-

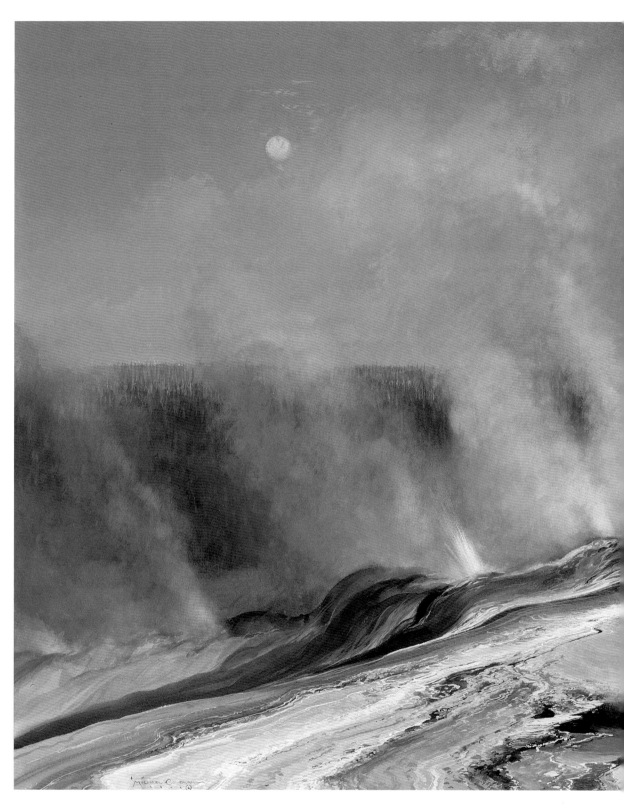

Pl. 60. Michael Coleman (b. 1946). *Yellowstone Park*, 1987.
Gouache; 22 x 38 in. Collection of Mr. and Mrs. W. D. Weiss.

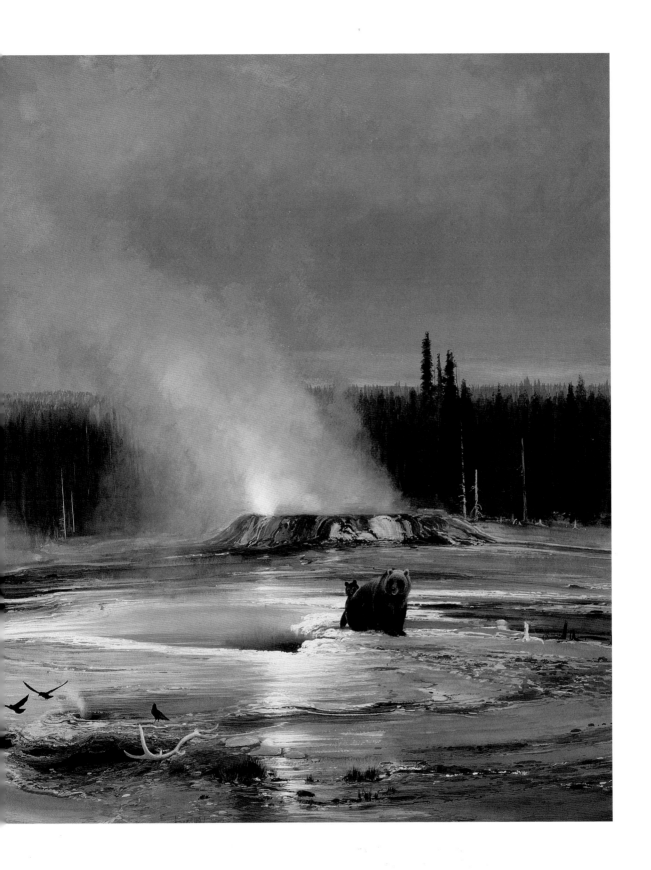

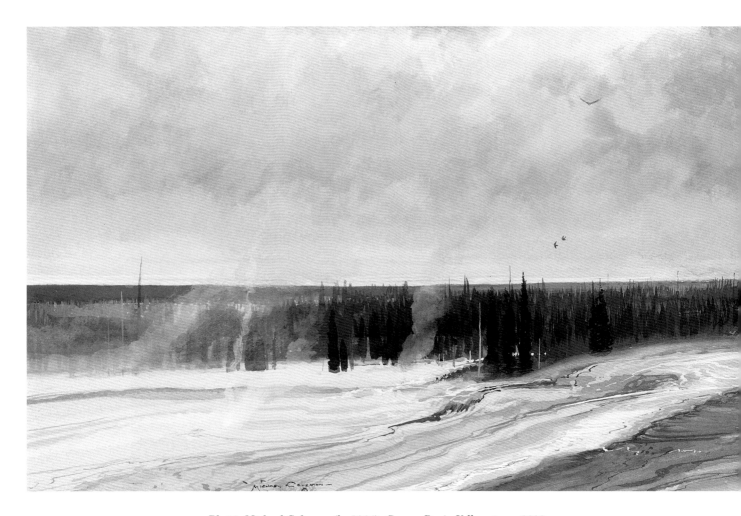

Pl. 61. Michael Coleman (b. 1946). *Geyser Basin Yellowstone*, 1998.
Oil on canvas; 8 x 25 in. Courtesy of the artist.

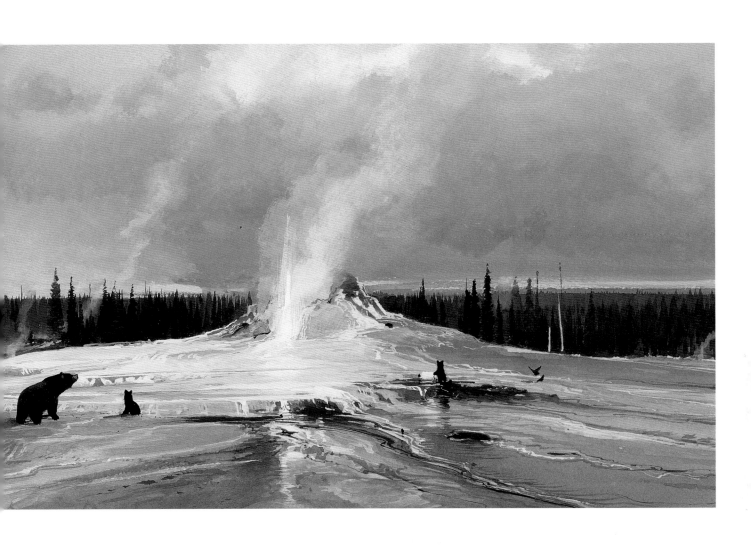

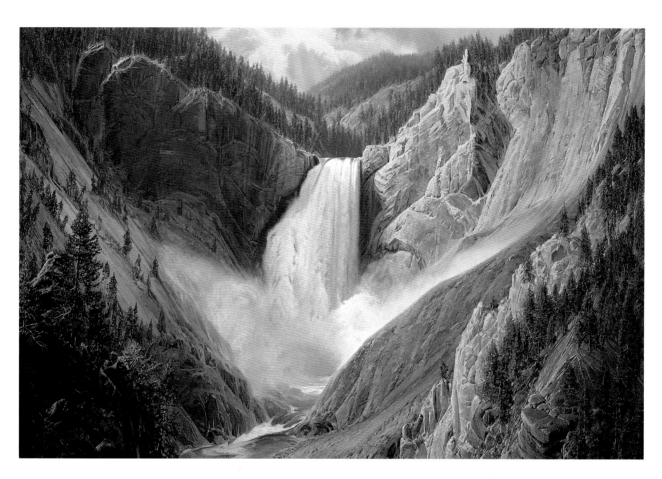

Pl. 62. Wilson Hurley (b. 1924). *Lower Falls from Red Rock Point*, 1983.
Oil on canvas; 66 x 102 in. Collection of Mr. and Mrs. W. D. Weiss.

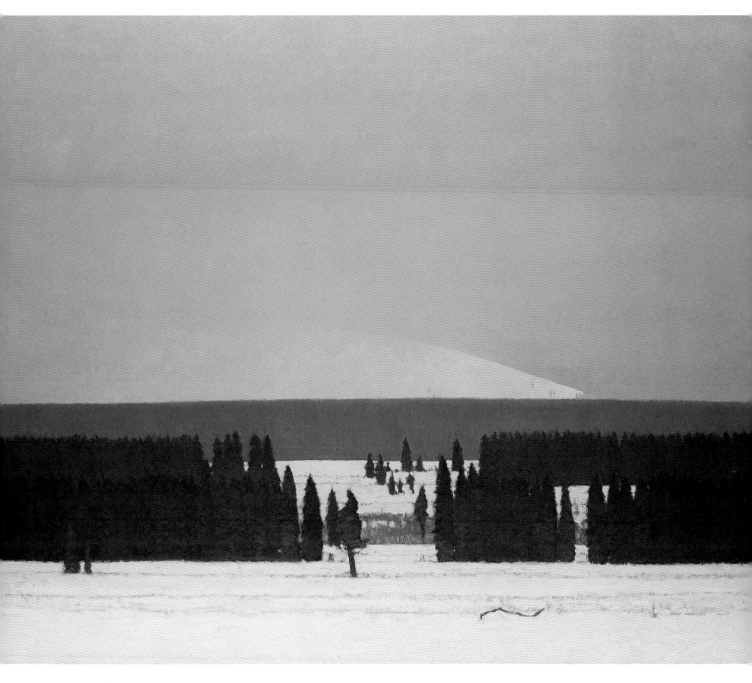

Pl. 63. Russell Chatham (b. 1939). *Heart of Winter on Swan Lake Flat*, 1994.
Oil on canvas; 70 x 90 in. Courtesy of the artist.

Fig. 70. Russell Chatham (b. 1939). *The Gibbon River on a Summer Evening*, 1993.
Lithograph; 22 x 26 in. Courtesy of the artist.

ter today as yesterday, despite a current annual attendance of several millions of people. In a time of intellectual ferment, frothing with revisionist polemic, Yellowstone as a theme for art has remained as protected from that scourge as its elk herds from the voracious appetites of trophy hunters on her four flanks. Chatham glibly boasted of the political correctness in his Gibbon River print—he had pictured a left-handed female at water's edge.[7] But that was pabulum to a baby in this contentious era of readjusting national values in the management and treatment of public spaces.

An Idaho printmaker, David W. Wharton (b. 1951) produces work that intentionally avoids the "purple majesty" business and aims to humor his audience with lighthearted reference to quotidian human greed and racism. His print *Who's Cheating, Who's Cheating, Who?* (fig. 71) establishes in his words a "peaceful coalition of Indian and buffalo" that in a fanciful Yellowstone setting "are being nickel-and-dimed to death by the hand of a white 'concessionist.'"[8] Although conceptually imperfect, the theme is at least moderately testy and somewhat thought-provoking.

Fig. 71. David W. Wharton (b. 1951). *Who's Cheating, Who's Cheating, Who?*, 1979. Lithograph; 30 x 22 in. Courtesy of the artist.

Another artist, the Idaho painter Will Caldwell (b. 1944), unmasks with humor his sentimental yearnings for the Yellowstone of a previous era. Caldwell's art echoes Mather's contention that the more people come to the parks, the broader will be the base for a national park ethos. As his symbolic centerpieces, he utilizes the nostalgic leitmotif of classic 1950s cars. "The advent of the American family automobile," he has written, "changed the park from the domain of the train-traveled few, to the favorite destination of the American masses." Through auto vacations to the park as a child, Caldwell came to realize "that Yellowstone represents the soul of America." He later shaped that into the artistic mission for a series of paintings he would call "Yellowstone Remembered," in which he endeavored to "document the important moment of connection between the American people and their great treasures in wildlife and the land." He hoped to recall "the sense of wonder we felt that can influence our relationship with nature today."[9]

In Caldwell's painting *Bear Meets Chevys at Geyser Basin* (plate 64), he presents a summary artistic statement of "that unique place" he knows as Yellowstone, "where unforgettable landscape and intimate encounters with wildlife harmoniously converged with the American psyche."[10] The cars and boardwalks make Yellowstone's wonders publicly accessible. The chrome, whitewalls, and fins harken back to bygone childhood innocence. And while the humans exploit and enjoy the park's beauty, the bears as mendicant tailgaters scheme of ways to exploit and enjoy the humans. It was a workable and amusing relationship until science exposed its folly and management forced the scene into history's pages.

Anne Coe (b. 1949), a painter from Arizona, also uses humor to reveal her sentiments about nature. Conservation-minded like Caldwell, she laments the sanctimonious conceit of the human species. "On a global scale, human beings see themselves as the only species of any importance on earth," she asserted in 1992. "We can do anything because we're in control."[11] Her comic allegories, such as *Breakfast at Yellowstone* (plate 65), poke fun at this arrogance, turning the tables on the picnic and shaking faith in the supposed "control" humans have over nature.

For Coe, Yellowstone is a special corner of our national landscape and mind. Surely, as she says, it is more than a place of strange beauty.

> It is the place where the center of the earth finds an exit and gives us a glimpse of its soul. Boiling paint pots, spewing fountains and ancient petrified trees reveal nature's true magic. When I go there I learn more but I realize how much I don't know. I feel naïve and small in the grandeur of this wild place. Vulnerable too, for there are wild beasts that lurk here: huge lumbering and horned ungulates, massive grizzlies with claw and fang and packs of wolves and lions too. That this is still American, this wild uncivilized place, is its greatest gift.[12]

Pl. 64. Will Caldwell (b. 1944). *Bear Meets Chevys at Geyser Basin*, 1997.
Oil on canvas; 22 x 28 in. Courtesy of Mickey MacIntyre and Scollary Petry.

Pl. 65. Anne Coe (b. 1949). *Breakfast at Yellowstone*, 1997.
Acrylic on canvas; 55 x 55 in. Courtesy of the Karen Towne Collection.

There are no idyllic passages in Coe's paintings and usually only secondary references to humans. The parks, which are now seen as sanctuaries for the people, away from the discomforts and uncertainties of modern urban life, do not always meet the customer's expectations. Sustenance, for example, is not guaranteed there. Though she commented in 1992 that "the cities are places where God doesn't live" and that "we go to the wilderness to find peace and solace and sanctity,"[13] her bears mitigate against such wishful thinking.

The program of *Arts for the Parks* set out with the dual objectives of perpetuating and reviewing "America's pride in the diversity of its parks and its artists." While accomplishing the first of these goals, it failed fundamentally to present any diversity of artists. Neither Caldwell nor Coe nor any other artist with a vantage point of satire or parody seemed to be involved with the effort. In like manner, there were few painters who, searching for design over detail and emotive essence over representational transcription, treated the park from a purely aesthetic perspective. But there were artists outside the fold who happily filled the void. One of the most striking artistic interpretations of the latter mode, for example, has been provided by a New Mexico painter, Alyce Frank (b. 1932). In her high-keyed, visually explosive fauvist interpretations like *The Falls at Yellowstone* (plate 66), Frank demonstrates her conviction that local color and the visible details of landscape are meaningless except as the most rudimentary, initial building blocks for a painting from nature.

Frank found her artistic voice in 1981 when she saw an exhibition of German expressionist paintings. From them she learned how to avoid a reliance on the numbing nuances of light and, through chromatic exaggeration, still paint "the power of the scene" before her. She insists that she will not paint what she sees and that she wants to be "free from the restraints of the actual colors of the landscape."[14] The red outlines emerging from the underpaint on her canvases (something she also learned from the Germans) define the spaces Frank wants to articulate. The broad areas of color flatten the surface, obscuring the illusion of space and effecting a nearly abstract contradiction of reality. In her quest for "harmony, balance and surprise,"[15] Frank reveals an emotionally charged vision of Yellowstone that at once enchants and startles the viewer.

Less abstract but equally well designed and captivating are the works of Wyoming painter Robert Seabeck (b. 1945). He too relishes exploring large planar areas of color to define the essence of a scene. These abstracted elements are pieced together into recognizable portraits of the park's most impressive features. In the painting *Yellowstone* (plate 67), the park's treasures are, in his words, "arrayed in colors that are intensified and exaggerated from the first light of dawn to the final oranges and blues of sunset."[16] He celebrates the diversity of subjects by creating a montage of images.

Pl. 66. Alyce Frank (b. 1932). *The Falls at Yellowstone*, 1993.
Oil on canvas; 48 x 40 in. From the collection of Edgar E. Coons and Liane Waite.

Pl. 67. Robert Seabeck (b. 1945). *Yellowstone*, 1997.
Acrylic on paper; 28 x 21 in. Property of the artist, Laramie, WY.

Pl. 68. Dan Downing. *Buffalo*, 1990.
Acrylic on canvas; 5 x 14 in. Collection of Miss Terry Altemus.
Photograph by Rob S. Wilke.

Pl. 69. Geoff Parker (b. 1951). *Pelican Creek*, 1996.
Oil on canvas; 23 x 48 in. Courtesy of Charles Cary Rumsey Art Company, Inc.

Pl. 70. Douglas Allen (b. 1935). *Yellowstone Study*, c. 1997.
Oil on canvas; 9 x 11 in. Courtesy of the artist.

But mostly through the elegant felicity of his exquisite touch, the park's colors are reborn on canvas and endure in the collective memory.

A host of other artists have, like Seabeck, been drawn to Yellowstone's inviting array of hues and textures to explore their talents, challenge their abilities, and exercise their genius. Dan Downing, who has lived at the park's doorstep for nearly twenty years in Gardiner, Montana, has never tired of its beauty. The park's animals are a specialty for him, and his *Buffalo* (plate 68) attests to the subtle merging of animal and landscape into a unified aesthetic vision. Near the east gate lives Geoff Parker (b. 1951) of Cody. His view of *Pelican Creek* (plate 69) reveals an allegiance to naturalistic color and atmospheric effects and a devoted intimacy with the park's less hackneyed though still grand views. Through his unaffected yet subtle brushwork and a studied review of Yellowstone's mood and temperament, Parker reveals its less celebrated vistas with a clear-headed but pleasing restraint.

These works are miles apart from the wild electricity of Alyce Frank's interpretations. They are reminiscent of a generation of painters who visited the park in the 1950s and 1960s, there to seek a union with its beauty through naturalism. Some like Bob Lougheed (1910–1982) and Douglas Allen (b. 1935) would explore the quiet yet brilliant plein-air statements of the shorelines, meadows, and lodgepole forests (plate 70). Others like John Clymer (1907–1989) looked for history to reveal itself in hidden recesses.

That search has continued with younger generations of painters exemplified by Gary Carter (b. 1939). His painting *For the Benefit and Enjoyment of the People* (plate 71) freezes a series of critical moments in the park's history and reflects the significance of the congressional decision to set Yellowstone aside for public recreation and contemplation. With Carter, art in Yellowstone has come full circle. His historical recreations, painted in the 1980s, add pictorial dimension to the written accounts of the first explorers in Yellowstone much in the same way, and for a similarly enthusiastic audience, that William Ranney had in the 1850s with his *Trapper's Last Shot* (plate 1). Likewise, the great landscape painters today, like Coleman and Hurley, attest to the fact that Yellowstone engages the same formidable creative energy now that it did in Moran's and Bierstadt's day. In all, these many generations of artists affirm the park's incredible stature as an unflagging symbol of American wilderness and a fertile ground for nurturing the nation's creative spirit.

Pl. 71. Gary Carter (b. 1939). *For the Benefit and Enjoyment of the People*, 1997.
Oil on canvas; 30 x 48 in. Courtesy of the artist.

Notes

Introduction

Chapter epigraph: Quoted in Thurman Wilkins, *Thomas Moran: Artist of the Mountains* (Norman: University of Oklahoma Press, 1966), p. 65.

1. For discussion on the origins of the name Yellowstone, see Hiram Martin Chittenden, *The Yellowstone National Park* (Norman: University of Oklahoma Press, 1964), pp. 3–8, and Aubrey L. Haines, *The Yellowstone Story: A History of Our First National Park*, vol. 1 (Yellowstone National Park: Yellowstone Library and Museum Association, 1977), pp. 3–7. The Potts letter is quoted in full in *Niles Register* 9, no. 6 (Oct. 6, 1827): 90–91.

2. "The Yellowstone National Park," *Scribner's Monthly* 4, no. 1 (May 1872): 102.

3. Nathaniel P. Langford, "The Wonders of the Yellowstone," *Scribner's Monthly* 2, no. 1 (May 1871): 12.

4. Frederic Remington, "Policing the Yellowstone," *Harper's Weekly* 39, no. 1986 (January 12, 1895): 35. John Muir, "The Yellowstone National Park," *in Wilderness Essays* (Salt Lake City: Peregrine Smith Books, 1980), p. 199.

5. Letter from Bill McKenzie to author, September 2, 1995. McKenzie, a past public relations director for the railroad, recounted this story told to him by Max Goodsill, one of his predecessors.

6. See "Public Park on the Yellowstone River," *The Congressional Globe*, part 2, 2nd session, 42nd Congress, 1872, p. 1243.

7. "Fairmont," *Scribner's Monthly* 1, no. 3 (January 1871): 226.

8. "Public Park," *Congressional Globe*, p. 1243.

9. See Anne Whiston Spirn, "Constructing Nature: The Legacy of Frederick Law Olmsted," in William Cronon, ed., *Uncommon Ground* (New York: W. W. Norton & Company, 1996), p. 93.

10. Quoted in Paul Schullery, ed., *Old Yellowstone Days* (Boulder: Colorado Associated University Press, 1979), p. 178.

11. "An Appreciation of Yellowstone National Park" was published in a Burlington Route/Northern Pacific Railroad promotional brochure, *Yellowstone National Park* (1926), p. 3.

12. George Catlin, *Letters and Notes on the Manners, Customs, and Condition of the North American Indians*, vol. 1 (London, 1841), pp. 294–295.

13. Rudyard Kipling, *From Sea to Sea: Letters of Travel* (Garden City, New York: Doubleday, Page and Company, 1913), p. 102.

14. Ibid.

15. William O. Owen, "The First Bicycle Tour of Yellowstone National Park," *Outing* (June 1891).

16. Remington, "Policing the Yellowstone," p. 35.

17. P. F. Jr., "Across the Continent," *The Penn Monthly* 1 (April 1870): 139.

18. Samuel Bowles, *Our New West* (Hartford: Hartford Publishing Company, 1869), p. 132. See also Albert P. Richardson, *Beyond the Mississippi* (Hartford: American Publishing Company, 1867), p. 429–430

19. Albert P. Richardson, *Garnered Sheaves* (Hartford: Columbian Book Company, 1871), p. 297.

20. General Nelson A. Miles, *Personal Recollections . . .* (Chicago: The Werner Company, 1897), p. 305.

21. *The Congressional Globe*, vol. 1, 42nd Congress, 2nd session (January 30, 1872), p. 697.

22. Lisa Strong, "There for the Taking: Thomas Moran and Eastern Attitudes towards Yellowstone National Park" (graduate thesis, Barnard College, 1989), p. 8.

23. Roderick Nash, *Wilderness and the American Mind* (New Haven: Yale University Press, 1967), p. 108.

24. See Richard A. Bartlett, *Yellowstone: A Wilderness Besieged* (Tucson: University of Arizona Press, 1985).

25. Theodore B. Comstock, "The Yellowstone National Park," *American Naturalist* 8, no. 2 (February 1874): 72.

26. *The Congressional Globe*, vol. 1, 42nd Congress, 2nd session (January 30, 1872), p. 697.

27. Theodore B. Comstock, "The Yellowstone National Park," part 2, *American Naturalist* 8, no. 3 (March 1874), p. 165.

28. William Cullen Bryant, ed., *Picturesque America*, vol. 1 (New York: D. Appleton and Company, 1874), p. 316.

29. General John Gibbons, "Rambles in the Rocky Mountains," *American Catholic Quarterly Review* 1 (July 1876): 475. For further discussion of this point, see Anne Farrar Hyde, *An American Vision: Far Western Landscape and National Culture, 1820–1920* (New York: New York University Press, 1990), pp. 15–17.

30. John Burroughs, *Camping and Tramping with Roosevelt* (Boston: Houghton, Mifflin and Co., 1907), p. 16.

31. See William Cronon, "The Trouble with Wilderness," in Cronon, ed., *Uncommon Ground*, pp. 69–90.

32. "Notes," *The Nation* 14, no. 349 (March 7, 1872): 153.

33. "Wonders of the Yellowstone Park," *The Northwest Magazine* (November 1886): 6.

34. Ibid.

35. David H. Coyner, *The Lost Trappers . . .* (Cincinnati: E. D. Truman, Publisher, 1850), p. 87.

36. For further discussion of this, see Dan Flores, "Spirit of Place and the Value of Nature in the American West," *Yellowstone Science* 1, no. 3 (Spring 1993): 6–10.

37. S. G. W. Benjamin, "Pioneers of the Palette," *Magazine of Art* 5 (February 1882): 89–90.

38. L. E. Sissman, "A Light of Sentiment," *The New Yorker* (September 1972): 123.

39. See Eleanor Stirling, "Wilderness and American Art," *Sierra Club Bulletin* (June/July 1975): 32.

Chapter 1. Brushes with Discovery

1. Ake Hultkrantz, "The Indians and the Wonders of Yellowstone: A Study of the Interrelations of Religion, Nature and Culture," *Ethnos* 19, no. 1 (April 1954): 34–68; Joel C. Janetski, *Indians of Yellowstone Park* (Salt Lake City: University of Utah Press, 1987), pp. 77–83; and Joseph Weixelman, "The Power to Evoke Wonder: Native Americans and the Geysers of Yellowstone" (master's thesis, Montana State University, 1992). A new study is under way in which oral histories are being compiled on the subject and compared with archaeological findings. The effort is being led by anthropologist Peter Nabokov and archaeologist Larry Loendorf. See "Indian Use of Yellowstone Seen in New Light," *Powell Tribune* (September 5, 1995).

2. "Indian Use of Yellowstone Seen in New Light," *Powell Tribune* (September 5, 1995).

3. For a description of how the "Yellowstone Expedition" changed its focus to the Platte and Arkansas Rivers, see Maxine Benson, ed., *From Pittsburgh to the Rocky Mountains: Major Stephen Long's Expedition, 1819–1820* (Golden, Colorado: Fulcrum, Inc., 1988), pp. iii-v.

4. For an analysis of this story, see Aubrey L. Haines, *The Yellowstone Story: A History of Our First National Park*, vol. 1 (Yellowstone National Park: Yellowstone Library and Museum Association, 1977), pp. 53–59. See also Hiram Martin Chittenden, *The Yellowstone National Park* (1895; reprint, Norman: University of Oklahoma Press, 1982), pp. 49–50.

5. Haines, *Yellowstone Story*, vol. 1, pp. 53–59.

6. See Marie M. Augspurger, *Yellowstone National Park: Historical and Descriptive* (Middletown, Ohio: The Naegele-Auer Printing Company, 1948), pp. 31–32. What Catlin actually called for was a "nation's park" to include most of the trans-Mississippi West as a preserve for Native American populations and wildlife like the buffalo. See George Catlin, *North American Indians*, vol. 1 (Philadelphia: Leary, Stuart and Company, 1913), pp. 294–295.

7. Mary Bartlett Cowdrey, *American Academy of Fine Arts and American Art-Union, 1816–1852* (New York: New-York Historical Society, 1953), p. 295. See also Francis S. Grubar, *William Ranney: Painter of the Early West* (Washington, D.C.: The Corcoran Gallery of Art, 1962), pp. 33–34, and

"Ranney's *The Trapper's Last Shot,*" *The American Art Journal* 2, no. 1 (Spring 1970): 92–99.

8. Frances Fuller Victor, *The River of the West* (Hartford: R. W. Bliss & Company, 1870), pp. 229–230. For a description of the scene, see also Bernard DeVoto, *Across the Wide Missouri* (Boston: Houghton Mifflin Company, 1947), pp. 303–305, and Peter Hassrick, *The Way West: Art of Frontier America* (New York: Harry N. Abrams, Inc., 1977), pp. 78–79. The actual date and location of this event are not clear. Victor, who interviewed Meek in the late 1860s for her original account, said they were in the headwaters of the Henry's Fork, just to the west of the park border in 1829 (p. 228). Others, including Haines, *Yellowstone Story*, vol. 1, p. 43; Chittenden, *Yellowstone National Park*, p. 36; and Chittenden, *The American Fur Trade*, vol. 1 (Stanford, California: Academic Reprints, 1954), p. 290, suggest Meek was just north of the park in 1829. DeVoto also places him in or just north of the park, but in 1837 (p. 304).

9. See Grubar, *William Ranney*, pp. 34–48, for a list of these works.

10. J. M. Stanley, *Portraits of North American Indians, with Sketches of Scenery, Etc.* (Washington, D.C.: Smithsonian Institution, 1852), numbers 59 and 60, pp. 40–41.

11. Regarding Meek's attendance at the 1837 rendezvous, see DeVoto, *Across the Wide Missouri*, p. 435, and David L. Brown, *Three Years in the Rocky Mountains* (1845; reprint, New York: Edward Ebeistadt and Sons, 1950), pp. 11–13.

12. See DeVoto, *Across the Wide Missouri*, p. 435, and Victor, *River of the West*, p. 223. The artist's catalogue raisonné, Ron Tyler, et al., *Alfred Jacob Miller: Artist on the Oregon Trail* (Fort Worth: Amon Carter Museum, 1982), does not mention these works.

13. For references to Pietierre, see "The Rocky Mountain Expedition," New York *Tribune* (May 18, 1843), and Charles H. Carey, ed., *The Journals of Theodore Talbot* (Portland: Metropolitan Press, 1931), p. 34.

14. Quoted in Matthew C. Field, *Prairie and Mountain Sketches*, ed. Kate L. Gregg and John Francis McDermott (Norman: University of Oklahoma Press, 1957), p. 145.

15. William Clark Kennerly, *Persimmon Hill: A Narrative of Old St. Louis and the Far West* (Norman: University of Oklahoma Press, 1948), pp.

156–157. Several Yellowstone scholars are skeptical of the veracity of this story. See, for example, Aubrey Haines, *Yellowstone National Park: Its Exploration and Establishment* (Washington, D.C.: Government Printing Office, 1974), p. 18.

16. Bvt. Brig. Gen. W. F. Raynolds, *Report on the Exploration of the Yellowstone River . . .* (Washington, D.C.: Government Printing Office, 1868), p. 4.

17. Ibid., pp. 10–11.

18. Little is known about either artist except that Schonborn died in Omaha in 1871. See Franz Stenzel, *Anton Schonborn, Western Forts* (Fort Worth: Amon Carter Museum, 1972), and Patricia Trenton and Peter H. Hassrick, *The Rocky Mountains: A Vision for Artists in the Nineteenth Century* (Norman: University of Oklahoma Press, 1983), pp. 107–112.

19. Raynolds, *Report*, p. 10.

20. Ibid., p. 86.

21. Ibid., p. 11.

22. J. L. Wisley, "The Yosemite Valley," *Harper's Monthly* 32 (May 1866): 700, 705, and unknown author, "The Central Park of New York," *Harper's Monthly* 33 (November 1866): 796.

23. Alfred E. Mathews, *Pencil Sketches of Montana* (New York: the author, 1868). For a full treatment of Mathews, see Robert Taft, *Artists and Illustrators of the Old West* (New York: Charles Scribner's Sons, 1953), pp. 72–85.

24. *The Montana Post*, Helena, November 13, 1868.

25. *Putnam's Magazine* 4 (August 1869): 257–258.

26. Abby Williams Hill diary, August 15, 1905, p. 118, unpublished manuscript, Department of Art, University of Puget Sound, Tacoma, Washington.

27. Mathews, *Pencil Sketches*, p. 75.

28. *The Montana Post*, Yellowstone City, August 18, 1867.

29. John H. Raftery, "Historical Sketch of Yellowstone National Park," *Annals of Wyoming* 15, no. 2 (April 1943): 111. The article was originally written in 1907. See also W. Turrentine Jackson, "The Cook-Folsom Exploration of the Upper Yellowstone," *Pacific Northwest Quarterly* 32 (1941): 307–322.

30. David E. Folsom, *The Folsom-Cook Exploration of the Upper Yellowstone in the Year 1869* (St. Paul: N. L. Collins Co., 1894), pp. 16–17.

31. Ibid.

Chapter epigraph: Nathaniel Pitt Langford, *The Discovery of Yellowstone Park* (1870; reprint, Lincoln: University of Nebraska Press, 1972), pp. 31–32.

1. G. A. Crofutt, *Crofutt's Trans-Continental Tourist's Guide . . .* (New York: G. A. Crofutt, 1871), p. 192.

2. Quoted in Nancy K. Anderson and Linda S. Ferber, *Albert Bierstadt: Art and Enterprise* (New York: Hudson Hills Press, 1991), p. 173.

3. Langford, *Discovery*, p. ix.

4. Ibid., p. 74.

5. Nathaniel Pitt Langford, *The Discovery of Yellowstone Park* (1870; reprint, Saint Paul: J. E. Haynes, 1923), p. 150.

6. Nathaniel Pitt Langford, "The Wonders of the Yellowstone," *Scribner's Monthly* 2, no. 1 (May 1871): 13.

7. Orrin H. Bonney and Lorraine Bonney, "Lieutenant G. C. Doane: His Yellowstone Exploration Journal," *Journal of the West* 9, no. 2 (April 1970): 227.

8. Walter Trumbull, "The Washburn Yellowstone Expedition, No. I," *Overland Monthly* 6, no. 5 (May 1871): 432.

9. Walter Trumbull, "The Washburn Yellowstone Expedition, No. II," *Overland Monthly* 6, no. 6 (June 1871): 496.

10. The Moore drawing of the Upper Falls illustrated here is slightly different from one pictured in the first edition of Hiram Martin Chittenden's *The Yellowstone National Park* (Cincinnati: The Robert Clarke Company, 1895), p. 252. Another Moore drawing of the Lower Falls illustrated in that same edition of Chittenden's book, p. 255, is inscribed "NO 3," indicating that at least two others were produced at some point.

11. For a detailed discussion of this project, see Anne Morand, *The Art of the Yellowstone: 1870–1872* (Tulsa: Thomas Gilcrease Museum Association, 1983).

12. W. H. Jackson, "With Moran in the Yellowstone," *Appalachia* 82 (December 1936): 151.

13. See "Fairmont," *Scribner's Monthly* 1, no. 3 (January 1871): 225–238, for Moran's views of Philadelphia's refurbished park.

14. Mike Foster, *Strange Genius: The Life of Ferdinand Vandeveer Hayden* (Niwot, Colorado: Roberts Rinehart Publishers, 1994), p. 217.

15. Nettleton to Hayden, June 7, 1871, quoted in Joni Louise Kinsey, *Thomas Moran and the Surveying of the American West* (Washington, D.C.: Smithsonian Institution Press, 1992), pp. 69–70.

16. See Anderson and Ferber, *Albert Bierstadt*, p. 223.

17. Jackson is quoted in Fritiof Fryxell, "Thomas Moran: An Appreciation," *Sierra Club Bulletin* 19 (June 1934): 56–57.

18. Jackson, "With Moran in the Yellowstone," p. 152.

19. F. V. Hayden, *Preliminary Report of the United States Geological Survey of Montana and Portions of Adjacent Territories* (Washington, D.C.: Government Printing Office, 1872), p. 65.

20. Captain J. W. Barlow and Captain D. P. Heap, *Report of a Reconnaissance of the Basin of the Upper Yellowstone in 1871* (Washington, D.C.: Government Printing Office, 1872), p. 3.

21. Jackson, "With Moran in the Yellowstone," p. 154.

22. Ibid. Moran continued through the years to use Jackson's photographs as aide-mémoire. For example, when they traveled to Denver, Devil's Tower, and on to Yellowstone in 1892, Moran wrote home that "Jackson's negatives are turning out splendidly and they will furnish me materials for innumerable pictures." Amy O. Bassford, *Home-Thoughts, from Afar* (East Hampton: East Hampton Free Library, 1967), p. 97. See also W. H. Jackson, *Time Exposure* (New York: G. P. Putnam's Sons, 1940), p. 201.

23. Hayden, *Preliminary Report*, pp. 66–67.

24. Ibid., p. 115.

25. F. V. Hayden, "The Wonders of the West–II. More about the Yellowstone," *Scribner's Monthly* 3, no. 4 (February 1872): 394.

26. Hayden, *Preliminary Report*, p. 84.

27. "A Picture Gallery of the Yellowstone," *Newark Daily Advertiser*, October 6, 1871, quoted in Nancy K. Anderson, *Thomas Moran* (New Haven: Yale University Press, 1997), p. 52.

28. Isaac H. Bromley, "The Big Trees and the Yosemite," *Scribner's Monthly* 3, no. 3 (January 1872): 261–277.

29. See Aubrey L. Haines, *The Yellowstone Story*, vol. 1 (Yellowstone National Park: Yellowstone Library and Museum Association, 1977), pp. 165–173.

30. On Moran's watercolors being used in Con-

gress, see Jackson, "With Moran in the Yellowstone," p. 157, and Kinsey, *Thomas Moran*, pp. 60–62.

31. Quoted in Kinsey, *Thomas Moran*, p. 65.

32. Barbara Novak, "Grand Opera and the Small Still Voice," *Art in America* 59 (March-April 1971): 64–65. Also Lee Parry, "Landscape Theater in America," *Art in America* 59 (November-December 1971): 52–61.

33. James Jackson Jarves, *The Art-Idea: Sculpture, Painting, and Architecture in America* (1877; reprint, Cambridge, Massachusetts: Harvard University Press, 1960), p. 205.

34. "Fine Art: Mr. Thomas Moran's Picture," *New York Times*, May 5, 1872, p. 4.

35. *New York Post*, May 8, 1872, quoted in Anderson, *Thomas Moran*, p. 202.

36. "Art at the Capitol," *Scribner's Monthly* 5, no. 4 (February 1873): 499, and "Art in New York. Past and Present," *New-York World*, January 2, 1868, p. 2. See also William H. Gerdts and Mark Thistlethwaite, *Grand Illusions: History Painting in America* (Fort Worth: Amon Carter Museum, 1988), pp. 112–114.

37. "Culture and Progress: The Yellowstone National Park," *Scribner's Monthly* 4, no. 1 (May 1872): 126.

38. Anthony Lacy Gully, "Sermons in Stone: Ruskin and Geology," in *John Ruskin and the Victorian Eye* (New York: Harry N. Abrams, Inc., 1993), p. 173. See also Thurman Wilkins, *Artist of the Mountains* (Norman: University of Oklahoma Press, 1998), pp. 35–37, and William H. Truettner, "'Scenes of Majesty and Enduring Interest': Thomas Moran Goes West," *Art Bulletin* 58, no. 2 (June 1976): 241–259.

39. Wallace Stegner, *Beyond the Hundredth Meridian* (Boston: Houghton Mifflin Company, 1953), p. 178.

40. "Art," *The Atlantic Monthly* 34, no. 203 (September 1874): 375.

41. Clarence King, quoting a California artist Hank G. Smith in *Mountaineering in the Sierra Nevadas* (Boston: James R. Osgood and Company, 1872), p. 210.

42. "Art," p. 377, and James Jackson Jarves, *Art Thoughts* (New York: Hurd and Houghton, 1871), p. 299.

43. "Thomas Moran Water Color Drawings," *Scribner's Monthly* 5, no. 3 (January 1873): 394.

44. "The New York Exhibition of Water Colors," *Penn Monthly* 4 (April 1873): 259.

45. "The Yellowstone Landscape at Washington," *The Nation* 15 (September 1872): 158. For a full discussion of Moran's watercolors, see Carol Clark's seminal work, *Thomas Moran: Watercolors of the American West* (Austin: University of Texas Press, 1980).

46. Quoted in "The Arts," *Appleton's Journal* 14, no. 334 (August 4, 1875): 218.

47. See Ron Tyler, *Prints of the American West* (Golden, Colorado: Fulcrum Press, 1994), pp. 139–149.

48. The most definitive treatment of Elliott is found in Robert L. Shalkop, *Henry Wood Elliott, 1846–1930: A Retrospective Exhibition* (Anchorage: Anchorage Historical and Fine Arts Museum, 1982).

49. Hayden, *Preliminary Report*, p. 98.

50. Hayden, "Wonders of the West," p. 394.

51. Letter from Elliott to Baird, May 1872, in the possession of Carl H. Droppers, the artist's grandson-in-law.

52. Elliott's letter appeared in the August 27, 1929, issue of the *New York Herald Tribune* under the heading "Yellowstone Park Integrity," p. 24. I am grateful to Carl H. Droppers for bringing this letter to my attention along with much other information on Elliott and his art and career.

53. Quoted in Foster, *Strange Genius*, p. 203.

54. From "Extracts from the Diary of W. H. Holmes," p. 15, a typescript in the Yellowstone National Park Library.

55. Hayden, *Preliminary Report*, p. 112.

56. John R. Swanton, *Biographical Memoir of William Henry Holmes, 1846–1933* (Washington, D.C.: The National Academy of Sciences, 1936), p. 236.

57. F. V. Hayden, *Twelfth Annual Report of the United States Geological and Geographical Survey of the Territories, . . . 1878, Part I* (Washington, D.C.: Government Printing Office, 1883), p. xiii.

58. Stegner, *Beyond the Hundredth Meridian*, p. 189. For a similar assessment, see William H. Goetzmann, *William H. Holmes: Panoramic Art* (Fort Worth: Amon Carter Museum, 1977).

59. Quoted in Clifford M. Nelson, "William Henry Holmes: Beginning a Career in Art and Science," *Records of the Columbian Historical Society, Washington, D.C.* (Charlottesville: University of Virginia Press, 1980), p. 254.

60. "Extracts from the Diary of W. H. Holmes," p. 16.

61. These chromolithographs, inscribed "NR" on the stone, are smaller versions of several of the Prang

chromos issued in 1876. For a comparison, see *Great Blue Spring Lower Geyser Basin* illustrated opposite p. 180 in Hayden, *Twelfth Annual Report*.

62. General John Gibbon, "The Wonders of Yellowstone," *Journal of the American Geographical Society of New York* 5 (May 1874): 112–137.

63. E. S. Topping, *The Chronicles of the Yellowstone . . .* (Saint Paul: Pioneer Press Company, 1883), pp. 86–87. Topping's troop is discussed in Holmes's 1872 journal and referenced in Haines, *Yellowstone Story*, vol. I, p. 191.

64. See William C. Brownell, "The Younger Painters of America, Second Paper," *Scribner's Monthly* 20, no. 3 (July 1880): 323.

65. For a full discussion of these commissions and the competition between Moran and Bierstadt for federal patronage at this time, see Anderson and Ferber, *Albert Bierstadt*, pp. 40–53.

66. "Extracts from the Diary of W. H. Holmes," [Diary for 1878], pp. 3 and 4. For his White House stay, see Gordon Hendricks, *Albert Bierstadt: Painter of the American West* (New York: Harry N. Abrams, Inc., 1973), p. 256.

67. Bierstadt had been invited to Montana as early as 1866 by folks in Virginia City. See *Montana Post*, July 14, 1866, quoted in Haines, *Yellowstone Story*, vol. 1, p. 75.

68. See John Sherman, *Recollections of Forty Years in the House, Senate, and Cabinet*, vol. 2, (1895; reprint, New York: Greenwood Press, 1968), pp. 823–829.

69. Excerpted in "Albert Bierstadt, the Artist, in the Yellowstone Park," *Denver Republican*, November 7, 1881, p. 3.

70. See Richard S. Trump, "Life and Works of Albert Bierstadt" (Ph.D. dissertation, Ohio State University, 1963), p. 189.

71. Quote from Sherman, *Recollections of Forty Years*, p. 826. See also A. Pendarves Vivian, *Wanderings in the Western Land* (London: Sampson Low, Martson, Searle, & Rivington, 1879), and Donald S. Strong, "Albert Bierstadt, Painter of the American West," *American Art Review* 2 (September/October 1975): 138.

72. S. G. W. Benjamin, *Art in America* (New York: Harper & Brothers, 1880), p. 97.

73. His painting *Domes of the Yosemite*, for example, completed on commission in 1867 for $25,000, had resold in 1872 for only $5,100. See Anderson and Ferber, *Albert Bierstadt*, p. 48.

74. Ibid., p. 98.

75. Sherman, *Recollections of Forty Years*, p. 827.

76. William W. Wylie, *Yellowstone National Park; or, The Great American Wonderland* (Kansas City: Ramsey, Millett & Hudson, 1882), p. 61.

77. Donald D. Keyes, *Albert Bierstadt's Lower Falls of the Yellowstone* (Athens: The University of Georgia, 1986), pp. 16–19.

78. See Edward J. Nygren, "Washington, National Gallery: Albert Bierstadt," *Burlington Magazine* 133, no. 1063 (October 1991): 735.

79. "Bierstadt at the White House," *Kansas City Times*, April 13, 1884, p. 5.

80. Letter from Bierstadt to Haynes, February 4, 1883, Special Collections Library, Montana State University, Bozeman.

81. Benjamin, *Art in America*, p. 98.

82. "Art Notes," *The Argonaut* (August 23, 1884), p. 6.

83. Benjamin, *Art in America*, p. 98.

84. See Marjorie Dakin Arkelian, *Thomas Hill: The Grand View* (Oakland: Oakland Museum Art Department, 1980), p. 31.

85. Information from the curatorial files of the Detroit Institute of Arts, with thanks to Nancy Rivard Shaw.

86. John Muir, ed., *Picturesque California* (San Francisco: J. Dewing Company, 1888).

87. John Muir, *Wilderness Essays* (Salt Lake City: Peregrine Smith Books, 1980), pp. 191–192.

88. See Marjorie Dakin Arkelain, "Artists in Yosemite," *The American West* 15, no. 4 (July/August 1978): 41–42, and Tyler, *Prints of the American West*, p. 137.

89. "National Park Surveyors," The *Livingston Enterprise*, July 10, 1883, p. 3. A subsequent citation in the *Livingston Enterprise* for July 26, 1883, announced Renshawe's arrival at the park entrance (p. 3).

90. I am grateful to Cliff M. Nelson of the USGS, Reston, Virginia, for this important biographical information on Renshawe.

91. Renshawe's artistic production was first revealed to modern audiences in William Truettner's exhibition *National Parks and the American Landscape* (Washington, D.C.: National Collection of Fine Arts, Smithsonian Institution, 1972), p. 86.

92. "A Mountain Painter," *Rocky Mountain News*, June 18, 1892, p. 4.

93. See Thomas Moran, "A Journey to the Devil's Tower," *Century Magazine* 47, no. 3 (January 1894): 450–455.

94. Letter from Moran to [Mary] Moran, July 26, 1892, quoted in Bassford, *Home-Thoughts*, pp. 119–120.

95. Ruth B. Moran, "Thomas Moran: An Impression," *The Mentor* 12, no. 7 (August 1924): 38.

96. *New York Post*, February 16, 1892, quoted in Anderson, *Thomas Moran*, p. 253.

97. Letter from Ruskin to Moran, December 27, 1882, Moran Papers, Gilcrease Museum, Tulsa, Oklahoma.

98. See Joseph S. Czestochowski, *The American Landscape Tradition: A Study and Gallery of Paintings* (New York: E. P. Dutton, 1982), p. 35. For a comparison of Moran's late style with Inness's, see William H. Gerdts, *Thomas Moran: 1837–1926* (Riverside: University of California, 1963), p. 17.

99. Quoted in Elizabeth McCausland, *George Inness, an American Landscape Painter, 1825–1894* (Springfield, Massachusetts: George Walter Vincent Smith Museum, 1946), p. 65.

100. See Barbara Novak, "Thomas Moran and the Grand Canyon of the Yellowstone," *Honolulu Academy of Arts Journal* 1 (1974): 31–35.

101. "A Mountain Painter," p. 4.

102. Letter from Holmes to Moran, January 17, 1917, Moran Papers, Gilcrease Museum, Tulsa, Oklahoma.

103. *Catalogue of a Loan Collection of Forty-Five Paintings Illustrating Scenes Mainly in the National Parks . . .* (Washington, D.C.: National Gallery of Art, 1917), p. [3].

104. "Mr. Pratt Presents Moran's Masterpiece to the National Gallery," *Art Digest* 2, no. 20 (September 1928): 1.

105. Thomas Moran, "Knowledge: A Prime Requisite in Art," *Brush and Pencil* 12, no. 1 (April 1903): 14–15.

106. William H. Goetzmann, *New Lands, New Men* (New York: Viking, 1986), p. 411.

107. Benjamin, *Art in America*, p. 100.

108. Fritiof Fryxell, *Thomas Moran: Explorer in Search of Beauty* (East Hampton, New York: East Hampton Free Library, 1958), p. 80.

Chapter 3. Yellowstone by the Book

Chapter epigraph: Dr. I. Winslow Ayer, *Life in the Wilds of America, and Wonders of the West . . .* (Grand Rapids: The Central Publishing Company, 1880), pp. 310–311. Many lines from this quote were appropriated from observations made by David Folsom of the 1869 Folsom-Cook-Peterson expedition to Yellowstone. See Aubrey Haines, ed., *The Valley of the Upper Yellowstone* (Norman: University of Oklahoma Press, 1965), p. 32.

1. See Christine Bold, *Selling the Wild West: Popular Western Fiction, 1860–1960* (Bloomington: Indiana University Press, 1987).

2. See Earl Pomeroy, *In Search of the Golden West: The Tourist in Western America* (New York: Alfred A. Knopf, 1957), p. 6.

3. F. V. Hayden, "Wonders of the Rocky Mountains, the Yellowstone Park," in William T. Henry, *The Pacific Tourist* (New York: William T. Henry, 1878), p. 326. The Victorian paradigm is discussed in Peter B. Hales, *William Henry Jackson and the Transformation of the American Landscape* (Philadelphia: Temple University Press, 1988), p. 119.

4. Dean MacCannell, *The Tourist: A New Theory of the Leisure Class* (New York: Schocken Books, 1976), p. 80.

5. Pomeroy, *In Search of the Golden West*, p. 48.

6. Earl of Dunraven, *The Great Divide* (London: Chatto and Windus, 1876), p. xxv.

7. Ibid., pp. xxv and xxvii.

8. For a biography of Bromley, see the *Illustrated London News*, May 19, 1877, p. 469, and Paul Hogarth, *Artists on Horseback* (New York: Watson Guptill, 1952), p. 281. On the matter of Bromley's physical presence in Yellowstone, Hogarth contends that Bromley traveled west with Dunraven in 1874. Marshall Sprague, *A Gallery of Dudes* (Boston: Little, Brown and Company, 1966), p. 146, suggests that there is no proof of such a trip by the artist. Newspapers in Denver and Bozeman that mention Dunraven's passing through in 1874 do not mention Bromley as part of the troop, and the general nature of the landscape backdrops would indicate that the artist worked strictly from Dunraven's verbal accounts.

9. Dunraven, *The Great Divide*, p. 262.

10. Edwin J. Stanley, *Rambles in Wonderland*

(New York: D. Appleton and Company, 1883), p. 109.

11. *Encyclopedia of New Orleans Artists: 1718–1918* (New Orleans: The Historic New Orleans Collection, 1987), pp. 403–404.

12. Stanley, *Rambles in Wonderland*, pp. 124–125.

13. Robert Taft, *Artists and Illustrators of the Old West, 1850–1900* (New York: Charles Scribner's Sons, 1953), p. 58.

14. Rossiter W. Raymond, *Camp and Cabin: Sketches of Life and Travel in the West* (New York: Fords, Howard, & Hulbert, 1880), p. 189.

15. Robert E. Strahorn, *Montana and Yellowstone National Park* (Kansas City: Ramsey, Millet & Hudson, 1881).

16. See Mary Anne Goley, *John White Alexander* (Washington, D.C.: Smithsonian Institution, 1977), for a full biographical and analytical treatment of the artist.

17. "The Yellowstone Geysers," *Harper's Weekly* 27, no. 1403 (November 1883): 713 and 718.

18. For information on Cronau, see Gerold Wunderlich, *Rudolf Cronau, 1855–1939: In "Wilden Westen"* (New York: Gerold Wunderlich & Company, 1996), and Patricia Trenton and Peter H. Hassrick, *The Rocky Mountains: A Vision for Artists in the Nineteenth Century* (Norman: University of Oklahoma Press, 1983), pp. 255–261.

19. See Wunderlich, *Rudolf Cronau*, and *R. Cronau: Topographical Views of America* (New York: Gerold Wunderlich & Company, 1993).

20. "Park Notes," *The Daily Enterprise*, July 16, 1883, p. 1. The actual numbers are noted in Aubrey L. Haines, *The Yellowstone Story*, vol. 2 (Yellowstone National Park: Yellowstone Library and Museum Association, 1977), p. 478.

21. Quoted in "English Writings about the Park," *The Daily Enterprise*, August 18, 1883, p. 2.

22. Quoted in Lee H. Whittlesey, "A Lady's Trip to Yellowstone, 1883," *Montana* 39, no. 1 (Winter 1989): 2–15.

23. *The Daily Enterprise*, September 5, 1883, p. 3.

24. "Park Pictures . . . by Arthur Brown the Scholarly Artist of Newcastle England and Eloquent Lecturer," *The Daily Enterprise*, March 1, 1884, quoting the *New Castle Weekly Chronicle*.

25. "Paintings from the Park," *The Daily Enterprise*, July 25, 1885, p. 3. The railroad, as late as 1887, was boasting of Arthur Brown's prowess. See "The Yellowstone National Park: Its Antiquities and Its Wonders," *The Northwest* 5, no. 5 (May 1887): 1, in which he is compared to Thomas Moran and Grafton Tyler Brown.

26. Albert Tissandier, *Six Mois aux États Unis* (Paris: G. Masson, 1886), p. 176.

27. "Personal Items," *The Northwest*, November 1883, p. 9. For a further tribute to Graham's abilities, see "*Harper's Weekly* and Colorado," *Denver Tribune-Republican*, November 26, 1886, p. 4.

28. See Henry P. Wells, "Winter in Yellowstone Park," *Harper's Weekly* 31, no. 1581 (April 9, 1887): cover and 259. Also, Haines, *The Yellowstone Story*, vol. 2, pp. 8–11; Jack Ellis Haynes, "The First Winter Trip through Yellowstone National Park," *Annals of Wyoming* 14, no. 2 (April 1942): 89–97; and William C. Lang, "'At the Greatest Personal Peril to the Photographer,' the Schwatha-Haynes Winter Expedition in Yellowstone, 1887," *Montana* 33, no. 1 (Winter 1983): 14–29.

29. "Yellowstone Park Illustrated, II," *The Graphic* 38, no. 977 (August 18, 1888): 190.

30. "Yellowstone Park Illustrated, I," *The Graphic* 38, no. 976 (August 11, 1888): 158.

31. "Yellowstone Park Illustrated, II," p. 190, and Rudyard Kipling quoted in Paul Schullery, ed., *Old Yellowstone Days* (Boulder: Colorado Associated University Press, 1979), p. 88.

Chapter 4. The Nation's Art Gallery

1. See, for example, "The Nation's Art Gallery!: Sights and Scenes in the Yellowstone National Park," Watertown, South Dakota *Public Opinion*, August 7, 1891, p. 1.

2. Robert Underwood Johnson, "Open Letter, III," *Century Magazine* 39, no. 4 (April 1890): 477–478.

3. John Muir, "The Treasures of the Yosemite," *Century Magazine* 40, no. 4 (August 1890): 483–500, and "Features of the Proposed Yosemite National Park," *Century Magazine* 40, no. 5 (September 1890): 656–667.

4. John Muir field notebook, *Yellowstone Park/ Columbia River, etc.* [1885], John Muir Papers,

University of the Pacific, Stockton, California.

5. John Muir, "The Yellowstone National Park," *Atlantic Monthly* 81, no. 486 (April 1898): 516.

6. Ibid.

7. K. E. M. Dumbell, *Seeing the West: Suggestions for the Westbound Traveler* (Garden City: Doubleday, Page & Company, 1920), p. 51.

8. Biographical information is drawn from a sales brochure, *The Famous Collection of American Paintings by James Everett Stuart* . . . (San Francisco: Stuart Gallery, [1941?]), published at the time of the artist's death, and from Edan Milton Hughes, "Genius of the Peaks, Re-examining the Works of James Everett Stuart," *Antiques & Fine Art* (September/ October 1990): 85–86.

9. This and subsequent Stuart quotes are extracted from his diaries in the J. E. Stuart Collection, California State Library, Sacramento, California.

10. "The Art Club," *Morning Oregonian*, March 18, 1886, p. 3.

11. Quoted in *The Famous Collection of American Paintings by James Everett Stuart* . . . (San Francisco: Stuart Gallery, 1941), p. [3].

12. Biographical information on Brown is drawn from the exhibition catalogue, *Grafton Tyler Brown: Nineteenth-Century American Artist* (Washington, D.C.: The Evans-Tibbs Collection, 1988), and Peggy and Harold Samuels, *The Illustrated Biographical Encyclopedia of Artists of the American West* (Garden City: Doubleday & Company, Inc., 1976), p. 68.

13. Grafton Tyler Brown, *Yellowstone National Park and Pacific Coast Scenery* (Portland: G. T. Brown, 1886).

14. Samuels, *Illustrated Biographical Encyclopedia of Artists*, p. 73, illustrates another view by Brown, *The Grand Canyon from Lookout Point, Yellowstone National Park*, 1886; oil on canvas, $30^1/_2$ x 18 in.

15. "The Art Club," *Morning Oregonian*, March 18, 1886.

16. "The Yellowstone National Park," *The Northwest* 5, no. 5 (May 1887), p. 1.

17. The *Livingston Enterprise*, July 24, 1886, p. 5.

18. Owen Wister journal, 1891, in Franny Kemble Wister, ed., *Owen Wister Out West* (Chicago: University of Chicago Press, 1958), p. 60.

19. Frederic Remington, "Policing the Yellowstone," *Harper's Weekly* 39, no. 1986 (January 12, 1895): 35.

20. Letter from Remington to Poultney Bigelow, August 19, 1893, Frederic Remington Papers, Owen D. Young Library, St. Lawrence University, Canton, New York.

21. Ibid., p. 37.

22. Emerson Hough, "Forest and Stream's Yellowstone Park Game Expedition," *Forest and Stream* 42, no. 18 (May 5, 1894): 377–378.

23. Remington, "Policing the Yellowstone," p. 36.

24. Wister, *Owen Wister Out West*, pp. 181–182.

25. Remington, "Policing the Yellowstone," p. 38.

26. Martha Summerhayes, *Vanished Arizona* (Salem, Massachusetts: The Salem Press Company, 1911), pp. 292–293.

27. This and other diary entries from the 1895 trip are derived from "My Wild West Trip," a handwritten journal in the Rungius Collection, Glenbow Museum, Calgary, Alberta. I am grateful to Jon Whyte of the Whyte Museum of the Canadian Rockies, Banff, Alberta, for sharing with me an English translation of those Wyoming diaries.

28. Quoted in Robert C. Manchester, *Majesty & Wilderness: Works by Carl Rungius* (Corning, New York: The Rockwell Museum, 1985), p. 5.

29. Quoted in Susan Danly, *Light, Air, and Color: American Impressionist Paintings from the Collection of the Pennsylvania Academy of the Fine Arts* (Philadelphia: Pennsylvania Academy of the Fine Arts, 1990), p. 16. The event was the sixty-second annual exhibition of the Academy, which ran that year from January 21 to March 5.

30. Robert W. [no last name], "The Stranger at the Art Shows: His Impressions of Impressionist Pictures," *Philadelphia Inquirer*, Feb. 7, 1892, p. 16.

31. See Richard Boyle, *John Twachtman* (New York: Watson-Guptill Publications, 1982), pp. 40 and 56, and William H. Gerdts, *American Impressionism* (Seattle: The Henry Art Gallery, 1980), pp. 64–69.

32. Many students of Twachtman's work have faulted the Niagara series as too literal and thus an artistic stretch for the painter. See especially the biography by Eliot Clark, *John H. Twachtman* (New York: private printing, 1924), pp. 50–51, and Boyle, *John Twachtman*, p. 60.

33. Twachtman to Wadsworth, September 22, 1895, Wadsworth Family Papers, College Libraries, SUNY Geneseo, Geneseo, New York.

34. Hiram Martin Chittenden, *The Yellowstone*

National Park, Historical and Descriptive (Cincinnati: Robert Clarke Co., 1895), p. 155.

35. Novelene Ross, *Toward an American Identity* (Wichita: Wichita Art Museum, 1997), p. 252.

36. Hiram Martin Chittenden, *The Yellowstone National Park* (Cincinnati: The Robert Clarke Company, 1904), pp. 294–295.

37. For a list of known Yellowstone paintings by Twachtman, see Lisa N. Peters, "John Twachtman (1853–1902) and the American Scene in the Late Nineteenth Century: The Frontier within the Terrain of the Familiar" (Ph.D. dissertation, City University of New York, 1995), pp. xxxvi-xxxvii. Contained here is also the most definitive discussion of Twachtman's experience in Yellowstone and the importance of the resulting work, pp. 367–377. For reference to the Wadsworth showing, see *Catalogue of an Exhibition of Paintings and Pastels by the Late John H. Twachtman* (The Buffalo Fine Arts Academy, Albright Art Gallery, 1913). For the critique of Twachtman's own show, see "Society of American Artists, First Notice," *New York Evening Post*, April 9, 1896, p. 7.

38. Theodore Robinson Papers, Frick Art Reference Library. My thanks to Sonya Johnston, Baltimore Museum of Art.

39. Both Dewing's and Weir's quotes are found in a collective eulogy "John H. Twachtman: An Estimation," *North American Review* 176, no. 557 (April 1903): 555 and 562.

40. For biographical information on Seton, see John G. Sampson, *The Worlds of Ernest Thompson Seton* (New York: Alfred A. Knopf, 1976). Ernest Thompson Seton, *Art Anatomy of Animals* (1896; reprint, Philadelphia: Running Press, 1977), p. [2] of introduction.

41. Seton, *Art Anatomy of Animals*, p. [2] of introduction.

42. Ernest Thompson Seton, *Wild Animals at Home* (New York: Grosset & Dunlap, 1913), pp. 204–205 and 208.

43. Ibid., pp. v and vi.

44. See H. Allen Anderson, "Ernest Thompson Seton in Yellowstone Country," *Montana* 34, no. 2 (Spring 1984): 46–59. Seton's monumental eight-volume opus, *Lives of Game Animals* (Garden City: Doubleday, Doran & Company, Inc., 1929), contains many images of and references to Yellowstone.

45. John Burroughs, "Real and Sham Natural History," *Atlantic Monthly* 91, no. 145 (March 1903): 298–309.

46. See Hans Huth, *Nature and the American* (Lincoln: University of Nebraska Press, 1990), p. 180.

Chapter 5. The Coming of Age of Aesthetic Conservation

Chapter epigraph: Enos Mills, *The Rocky Mountain Wonderland* (Boston: Houghton Mifflin Company, 1915), p. 329.

1. Donald C. Swain, "The Passage of the National Park Service Act of 1916," *Wisconsin Magazine of History* 50 (Autumn 1966): 17. Also, Donald C. Swain, "The Founding of the National Park Service," *The American West* 6, no. 5 (September 1969): 6–9.

2. *A Loan Collection of Fourty-Five [sic] Paintings Illustrating Scenes Mainly in the National Parks and Monuments of the United States* (Washington, D.C.: Smithsonian Institution, 1917).

3. Quoted in Alfred Runte, *National Parks: The American Experience* (Lincoln: University of Nebraska Press, 1987), p. 77. Also see pp. 75–77 for an informed discussion of the founding of these two parks.

4. Robert Shankland, *Steve Mather of the National Parks* (New York: Alfred A. Knopf, 1970), p. 109.

5. Letters from Russell to Maynard Dixon, August 21, 1917, and to Philip Goodwin, May 26, 1908, quoted in Brian W. Dippie, *Charles M. Russell, Word Painter* (New York: Harry N. Abrams, Inc., 1993), pp. 240 and 98.

6. *The River Press* (Fort Benton), June 22, 1892, p. 6C1.

7. C. M. Russell, "Russell, the Cowboy Artist, and His Work," *Butte Inter Mountain*, January 1, 1903, p. 9. See also Russell's letter to his friend Guy Weadick, ca. July-August 1922, in Dippie, *Charles M. Russell*, p. 323.

8. The visit is recorded in both *The Livingston Enterprise*, August 23, 1902, p. 6, and *The Gardiner Wonderland*, August 21, 1902, p. 1.

9. Alice Harriman-Browne, *Chaperoning Adrienne: A Tale of the Yellowstone National Park* (Seattle: Metropolitan Press, [c.1907]).

10. Carrie Adell Strahorn, *Fifteen Thousand Miles by Stage* (New York: G. P. Putnam's Sons, 1911), pp. 254–286.

11. From *Nature's Realm* magazine (April 1891), quoted in Ramon F. Adams and Homer E. Britzman, *Charles M. Russell: The Cowboy Artist, a Biography* (Pasadena: Trails West Publishing Company, Inc., 1948), p. 114.

12. "Russell's Art in the Park," *Great Falls Daily Tribune*, July 2, 1915, p. 6.

13. "Increase of Tourists in the National Parks," *American Forestry* 21, no. 264 (December 1915): 1113.

14. Robert Sterling Yard, *The National Parks Portfolio* (1916; reprint, Washington, D.C.: Government Printing Office, 1931), p. 19. Dwight L. Elmendorf, "Yellowstone National Park," *The Mentor* 3, no. 7 (May 15, 1915): 1–11.

15. Shaw to Russell, February 22, 1917, C. M. Russell Museum Collection, Great Falls, Montana.

16. Russell to Shaw, March 2, 1917, Rockwell Museum Collection, Corning, New York.

17. See, for example, the Haynes Studio *Catalogue*, no. 36 (Yellowstone National Park, 1936), p. 11, which lists seventy-eight different Russell prints for sale. Russell's role in the Eaton dedication is mentioned in "Local Shriners Help to Dedicate the Eaton Trail," *The Livingston Enterprise*, July 3, 1923, from a clipping in the Haynes Collection, Montana State University Library.

18. R. D. Kenney, *From Geyserdom to Show-me Land* (Clyde Park, Montana: the author, 1926).

19. Biographical information is derived from DeYong's obituary, "DeYong Rites," *Santa Barbara News Press*, April 18, 1975, and Richard Flood, *Joe DeYong* (Scottsdale: Main Trail Galleries, 1980).

20. See "Joe DeYong A Coming Young Montana Artist Who Knows the West He Paints," *Bynum Herald*, January 6, 1922, p. 1.

21. DeYong to his parents, August 9, 1920, C. M. Russell Museum, Joe DeYong Papers.

22. See "Joe De Yong, Montana Artist and Protégé of Late Charles Russell . . . ," *Great Falls Tribune*, July 3, 1927, p. 1, and John Taliaferro, *Charles M. Russell* (Boston: Little, Brown and Company, 1996), p. 267.

23. DeYong to his parents, August 17, 1921, National Cowboy Hall of Fame, Joe DeYong Papers.

24. See Earl Pomeroy, *In Search of the Golden West* (New York: Alfred A. Knopf, 1957), pp. 131–132.

25. Richard A. Bartlett, *Yellowstone: A Wilderness Besieged* (Tucson: University of Arizona Press, 1985), p. 73.

26. Don Hedgpeth, *Mountain Majesty: The Art of John Fery* (n.p.: William P. Healey and John B. Fery, 1997), p. 4.

27. The name of the magazine is not known. The quote comes from a transcript translation provided to me by the artist's grandson, John B. Fery. For further discussions of Fery's outfitting enterprise, see Michael David Zellman, *American Art Analog, Volume II (1842–1874)* (New York: Chelsea House Publishers, 1986), p. 553.

28. L. Louise Elliott, *Six Weeks on Horseback through Yellowstone Park* (Rapid City: The Rapid City Journal, 1913), pp. 117 and 139.

29. "Increase of Tourists in the National Parks," *American Forestry* 21, no. 264 (December 1915): 113.

30. This quote and general biographical details derive from Ronald Fields's seminal study of Hill, *Abby Williams Hill and the Lure of the West* (Tacoma: Washington State Historical Society, 1989). Quoted material is on p. 11.

31. Ibid., p. 12.

32. Abby Williams Hill diaries, entries for August 19 and 23, 1905, unpublished typescript in the collection of the Department of Art, University of Puget Sound, Tacoma, Washington. I am grateful to Ron Fields for sharing these with me.

33. Ibid.

34. Ibid.

35. William M. Chase, "Artists' Ideals," *The House Beautiful* 23, no. 3 (February 1908): 12.

36. Hill diaries, entry for September 5, 1905.

37. Ibid., entry for September 3, 1906.

38. "Anheuser-Busch Posters Create Enthusiasm," *The Poster* (September 1911): 36. See also Mary Kimbrough, "Oscar Berninghaus: St. Louis Portrayer of the West," *St. Louis Globe-Democrat, Sunday Magazine*, February 27, 1977, p. 7.

39. I am grateful to James Burke, past director of the Saint Louis Art Museum, for the insight that this Yellowstone image was part of a calendar.

40. "Annual Display of Paintings of Indians," *St. Louis Post Dispatch*, undated clipping ca. 1914, from the files of Mrs. John M. Brenner, Taos; Harry R. Burke, "St. Louis Artists—No. III; O. E. Berninghaus," *Lardner's Weekly*, September 27, 1925.

41. Theodore Roosevelt, in an article that appeared in George Bird Grinnell, ed., *American*

Big Game in Its Haunts (New York: Forest and Stream Publishing Company, 1904), p. 36, suggests that despite the serious attrition in elk herds caused by cougars in the park, elk were "rather too numerous" and the cougars threatened little long-term damage. Frederic Remington's article, "Mountain Lions in Yellowstone Park," *Collier's* (March 17, 1900), however, suggests that the cougars were a menace, to be dealt with summarily. An article in the *New York World* (April 23, 1907) that discusses the Proctor bronze *Panther with Kill* states clearly that Superintendent Pitcher, at least, considered the cougar population to be increasing rapidly and that they posed a danger that "seriously threaten[ed] the extinction of the deer and other game" in the park.

42. Ibid.

43. Ibid.

44. Alexander Phimister Proctor, *Sculptor in Buckskin* (Norman: University of Oklahoma Press, 1971), p. 148.

45. John Elderfield, *Henri Matisse: A Retrospective* (New York: The Museum of Modern Art, 1992), p. 85.

46. Gustav Stickley, "The National Note in Our Art—A Distinctive American Quality Dominant at the Pennsylvania Academy," *The Craftsman* 9 (March 1906): 752–753.

47. "Among the Artists," *American Art News* (December 28, 1908): 3.

48. Clara Ruge, "A Landscape Painter Who Has Discovered the Color Values of Western Plains," *The Craftsman* 9 (March 1906): 826, and Charles H. Parker, "A Painter of Silent Places," *The International Studio* 64, no. 256 (June 1918): cvii.

49. William R. Leigh, "Autobiography," unpublished typescript in the Leigh Papers, Gilcrease Museum, Tulsa, Oklahoma, p. 276.

50. Ibid.

51. Letter from Leigh to his parents, September 29, 1884, in the Leigh Papers, Gilcrease Museum, Tulsa, Oklahoma.

52. "Nature Painter," *Time* (March 10, 1941), p. 66.

53. "Local Notes," *New York Times*, April 29, 1928, Section 10, p. 19.

54. Eugen Neuhaus, *The History and Ideals of American Art* (Stanford: Stanford University Press, 1931), p. 324.

55. Paxson's daughter, Lelia Paxson Hale, quoted in Franz R. Stenzel, "E. S. Paxson, Montana Artist," *Montana* 8, no. 4 (September 1963): 60.

56. Enos A. Mills, *Your National Parks* (Boston: Houghton Mifflin Company, 1917). His article on Paxson was titled "A Western Artist," *Outdoor Life* 10, no. 2 (1902): 2–8.

57. Mills's article on Colter is titled "The Endurance and Courage of John Colter," a manuscript in the Western History Collections, Denver Public Library. For reference to Roosevelt, see Mills, "A Western Artist," p. [4], and for Roosevelt quote, see *The Winning of the West*, vol. 1 (New York: G. P. Putnam's Sons, 1889), p. 1.

58. See Michael John Burlingham, *The Last Tiffany: A Biography of Dorothy Tiffany Burlingham* (New York: Atheneum, 1989), pp. 44–45.

59. Joan Elliott Price, *Louis Comfort Tiffany: The Painting Career of a Colorist* (New York: Peter Lang, 1996), lists only a handful of Yellowstone watercolors.

60. Howard Russell Butler, unpublished autobiography, Howard Russell Butler Papers, Archives of American Art, Washington, D.C.

61. *Catalogue of a Collection of Pictures by Howard Russell Butler* (Buffalo: Buffalo Fine Arts Academy, 1908). This lists thirty-five oils, two watercolors, and nine pastels, almost all of which are California subjects.

62. "Biographical Notes," vol. 3, in the estate of the artist's late son, H. Russell Butler Jr., Princeton, New Jersey.

63. Ibid.

64. Letter from Gibbons to Butler, February 1, 1921, Butler Papers.

65. Letter from Dellenbaugh to Butler, March 23, 1924, Butler Papers.

66. Letter from Eaton to Butler, June 26, 1932, Butler Papers.

67. See illustration in Zellman, *American Art Analog*, p. 524.

68. Bill and Frances Spencer Belknap, *Gunnar Widforss: Painter of the Grand Canyon* (Flagstaff: Northland Press, 1969), p. 74.

69. Biographical details are drawn from two sources, Krollman's obituary, "Krollman, City Artist, Dies at 74," Minneapolis *Morning Tribune*, November 10, 1962, p. 16, and "Town Toppers," *The Minneapolis Star*, January 12, 1953, p. 9.

70. See "Plan [*sic*] Art Exhibit," *Protestant Episcopal* 63, no. 2 (February 1940): 11.

71. H. K. Frenzel, *Ludwig Hohlwein* (Berlin:

Phönix Illustrationsdruck Verlag, 1926), p. 37.

72. Discussed in a series of letters between Dow and Anna B. Crocker, curator of the Portland Museum of Art, March and April, 1917, in the Archives of the Portland Art Museum.

73. "Individuality of Expression Said to Be Greatest Need of American Artists," *Sunday Ore-gonian*, August 19, 1917, p. 4. See also Arthur W. Johnson, *Arthur Wesley Dow: Historian, Artist, Teacher* (Ipswich, Massachusetts: Ipswich Historical Society, 1934), p. 99.

74. Arthur Wesley Dow, "Talks on Appreciation of Art," *The Delineator* (January 1915): 15.

75. Ibid.

Chapter 6. Steamy Angels and Vague Bears

1. Stephen Fox, *John Muir and His Legacy: The American Conservation Movement* (Boston: Little, Brown, 1981), p. 203.

2. Freeman Tilden, *Following the Frontier with F. Jay Haynes* (New York: Alfred A. Knopf, 1964), p. 369.

3. Accession card, Corcoran Gallery of Art, 1924. The review appeared in Leila Mechlin, "New Masterpiece Here," *Washington Daily News*, December 27, 1924, p. 1.

4. Letter from French to Haynes, February 7, 1925, in the collections of Chesterwood, French's restored home and studio in Stockbridge, Massachusetts.

5. Mechlin, "New Masterpiece Here," p. 1.

6. Clyde Max Bauer, *Yellowstone Geysers* (Yellowstone Park: Haynes, Inc., 1937), pp. 10–11.

7. Thomas D. Murphy, *Seven Wonderlands of the American West* (Boston: L. C. Page & Company, 1925). Murphy had earlier published a similar work, *Three Wonderlands of the American West* (Boston: L. C. Page & Company, 1912), with Moran imagery of Yellowstone.

8. Wilma Winter, "Artistic Settings Don't Necessarily Consist of Fine Oriental Draperies and Egyptian Incense, Bagg Proves," *The Lincoln Star*, January 30, 1921. See also John Clabaugh, *H. H. Bagg: The Life and Times of Henry Howard Bagg* (Lincoln: Nebraska Wesleyan University, 1994).

9. The painting was published as an illustration for Coca-Cola in *The Saturday Evening Post*, in 1931.

10. Walter Ufer, "The Santa Fe-Taos Art Colony," *El Palacio* 3 (August 1916): 75.

11. See Gwilyan G. Griffiths, "Packard's Artists: Frederic Mizen," *The Packard Cormorant* 29 (Winter 1982–83): 6–9, and an unidentified Waco, Texas, newspaper clipping from the Baylor University Art Department files, "Former BU Art Chairman Succumbs."

12. Biographical information derived from Peggy and Harold Samuels, *The Illustrated Biographical Encyclopedia of Artists of the American West* (Garden City: Doubleday & Company, Inc., 1976), pp. 331–332.

13. Quoted in David Robertson, *West of Eden* (Yosemite: Yosemite National History Association, 1984), p. 141.

14. The Haynes Studio *Catalogue*, no. 36 (Yellowstone National Park, 1936), p. 18.

15. W. H. Jackson, *Time Exposure* (New York: G. P. Putnam's Sons, 1940), pp. 334–335.

16. Peter B. Hales, *William Henry Jackson and the Transformation of the American Landscape* (Philadelphia: Temple University Press, 1988), p. 292.

17. This and subsequent information on Brewer is drawn from Patricia Condon Johnston, "Edward Brewer: Illustrator and Painter," *Minnesota History* 47, no. 1 (Spring 1980): 2–15. I am also indebted to Rena N. Coen, who provided me with much useful information on Edward Brewer.

18. Letter from Sandzén to Charles W. Matthews, September 18, 1930, Sandzén Papers, The Birger Sandzén Memorial Gallery, Lindsborg, Kansas.

19. Quoted in Peter H. Hassrick, *Birger Sandzén: 1871–1954* (Fort Worth: Amon Carter Museum, 1969), p. [3].

20. Emory Lindquist, *Birger Sandzén: An Illustrated Biography* (Lawrence: University of Kansas Press, 1993), p. 66.

21. Quoted in E. C. Sherburne, "A Painter of the West," *Christian Science Monitor*, February 28, 1931, p. 6. See also, for a discussion of Johnson's stylistic tenets, Melissa J. Webster, *Frank Tenney Johnson: The Rimrock Years* (Cody: The Buffalo Bill Historical Center, 1986).

22. Alan Fisher, "A Day Away from Kiowa," *Southwestern Art* 1, no. 4 (1967): 39.

23. See H. R. Dieterich and Jacqueline Petravage, "New Deal Art in Wyoming: Some Case Studies," *Annals of Wyoming* 45, no. 1 (Spring 1973): 65–67.

24. Ibid., p. 66.

25. Emerson Hough, *Maw's Vacation* (Saint Paul: J. E. Haynes, Publisher, 1924), p. 29.

Chapter 7. The Modern View

1. Steven Henry Madoff, "Publicist, Prankster, Parvenu, Andy Warhol Was the Pan of Modern Art," *Time* 151, no. 22 (June 8, 1998): 77.

2. *1987 Arts for the Parks Catalogue* (Jackson Hole: National Park Academy of the Arts, Inc., 1987), p. 3.

3. Quoted in Peter H. Hassrick, "Introduction," *Michael Coleman* (New York: Kennedy Galleries, 1978), p. [3].

4. Quoted in James T. Forrest, "Wilson Hurley: A Study of American Landscape Painters Today and Yesterday," in *Wilson Hurley: A Retrospective Exhibition* (Kansas City: The Lowell Press, 1985), p. 37.

5. Ibid., pp. 45–46.

6. Richard A. Bartlett, *Yellowstone: A Wilderness Besieged* (Tucson: University of Arizona Press, 1985), and Alston Chase, *Playing God in Yellowstone: The Destruction of America's First National Park* (Boston: Atlantic Monthly Press, 1986).

7. Russell Chatham, "About the Prints for the Old Faithful Inn," promotional literature published by Deep Creek Productions, Livingston, 1993.

8. E. Richard Hart, ed., *That Awesome Space* (Salt Lake City: Westwater Press, 1981), p. 49.

9. Will Caldwell, "Yellowstone Remembered," unpublished commentary provided to the author, 1998.

10. Ibid.

11. Quoted in Kiana Dicker, "Anne Coe," *Southwest Art* 22, no. 1 (June 1992): 80.

12. Anne Coe, "Yellowstone Statement," unpublished commentary provided to the author, 1998.

13. Quoted in Todd Wilkinson, "Artist Vignette: Anne Coe," *Wildlife Art News* (March/April 1992): 120.

14. Alyce Frank, "Artist Statement," unpublished commentary provided to the author, 1998.

15. Martha Burnett Goodwin, "Alyce Frank," *Southwest Art* 21, no. 6 (November 1991): 76. See also Mary Terrence McKay, *Alyce Frank* (Santa Fe: Zaplin Lampert Gallery, 1991).

16. Robert Seabeck, "Artist Statement," unpublished commentary provided to the author, 1998.

Index

Page numbers in boldface type indicate illustrations.